THE HIGH
RENAISSANCE AND
MANNERISM

p227 - French Mannerism

LINDA MURRAY

The High Renaissance and Mannerism

ITALY
THE NORTH AND SPAIN
1500–1600

NEW YORK AND TORONTO
OXFORD UNIVERSITY PRESS

To my mother-in-law and to the memory of my mother

CONTENTS

PART I *Italy* 7

CHAPTER ONE
The New Century 7

CHAPTER TWO
The High Renaissance in Rome 35

CHAPTER THREE
The High Renaissance in Venice 71

CHAPTER FOUR
Michelangelo in Florence 99

CHAPTER FIVE
Michelangelo in Rome 109

CHAPTER SIX
Mannerism 124

CHAPTER SEVEN
Florence 144

CHAPTER EIGHT
Parma 171

CHAPTER NINE
Venice and the Veneto 179

ENVOI 204

PART II *The North and Spain* 209

CHAPTER TEN
The Renaissance in the North 209
 Flanders 209
 France 226
 Germany 238
 England 251

CHAPTER ELEVEN
The Renaissance in Spain 263

BIBLIOGRAPHY 277

LIST OF ILLUSTRATIONS 279

PHOTOGRAPHIC ACKNOWLEDGMENTS 284

INDEX 285

The New Century

When the beginnings of the High Renaissance are being discussed, Leonardo da Vinci, Michelangelo and Raphael are so frequently spoken of as a group that it is often forgotten how much older Leonardo was than the other two men. This tendency to think of the three artists almost as if they were a unit is a clear reflection of contemporary opinion in Florence, which recognized very quickly that Leonardo was an artist different not only in degree but in kind from the other painters of his day. The age gap was considerable: almost a whole generation lay between Leonardo's birth in 1452 and that of Michelangelo in 1475, and greater still for Raphael, born in 1483, so that before the youngest man finally arrived in Florence in about 1504 or 1505 Leonardo's major works were behind him and he was already an elderly man of fifty-two or fifty-three. Why was there this great divide between Leonardo and his strict contemporaries? Partly it stemmed from the fact that his major works were known only by repute rather than being present in Florence, since he had gone to Milan by 1483, leaving behind him the *Adoration of the Kings*, which was sensational enough to cause artists and admirers to crowd to see it despite its unfinished state. There was also the handful of smaller paintings – an *Annunciation*, the angel in Verrocchio's *Baptism of Christ*, a group of three small *Madonna and Child* pictures – which displayed such strikingly new qualities of technique, such outstanding intellectual powers in the treatment of the figures and the world about them, as to make very obvious the gap between this new young virtuoso and competent practitioners like Ghirlandaio, Lorenzo di Credi, and even so imaginative an artist as Botticelli.

Why Leonardo went to Milan has never been fully explained. There was nothing in Milan to attract any Florentine painter of more than run-of-the-mill abilities, since artistically the Sforza patronage was of the most prosaic kind, though enlightened in mathematics, architecture and science. The artist had been in trouble over an accusation of homosexuality when he was still in Verrocchio's studio, but this had been smothered – nothing further was heard of it, anyway. Politics may have entered into it, since the eventual owner, and therefore the probable patron, of the *Adoration* was a political opponent of the Medici. He went, so Vasari records, as the bearer of a magnificent musical instrument sent by Lorenzo de' Medici to Ludovico Sforza, yet it is quite clear that he did not expect to return, since he drafted a letter to the Duke of Milan which is a long list of his abilities in virtually everything from the design of fortifications to bronze casting, with his talents as an artist merely tacked on in a last paragraph, even though

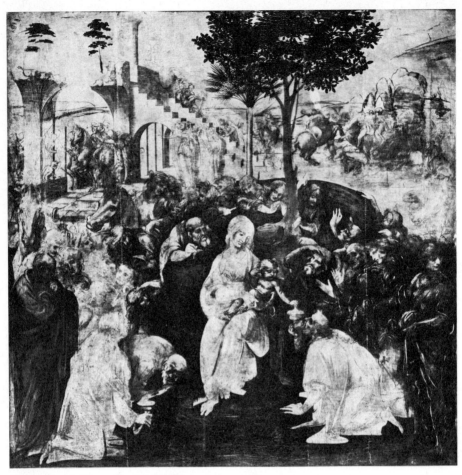

1 LEONARDO DA VINCI *Adoration of the Kings* 1481

it is one suggesting pride in consummate powers: 'Item, I can carry out sculpture in marble, bronze or clay, and also in painting I can do as well as any man' – a long-distant echo of Jan van Eyck's motto 'Als Ich Kan'.

The fruits of his Milanese life as a court artist are a couple of portraits, the huge mass of his researches into everything under the sun which interested him from natural history to architecture, from anatomy to meteorology, from war machines to canal systems, from hieroglyphics to aerial perspective, accumulated pell-mell in the famous notebooks, and three masterpieces: the two versions of the *Virgin of the Rocks*, and the *Last Supper*.

When the Sforza dynasty fell, Leonardo fled first to Mantua, and then to escape the devouring egoism of its Duchess, Isabella d'Este, fled on to Venice. He was now forty-seven, and his comfortable, stable

world was in ruins about him. By April 1500 he was back amid the strife and tensions of Florence. He began working on cartoons for the group of the *Madonna and Child with St Anne* and on the portrait of the *Mona Lisa*, works which took up ideas first put forward in the abandoned *Adoration* and which were to revolutionize the treatment of a group of tightly knit figures conceived not in a triangular design but as a pyramid in space, and a sitter seen against a landscape background – as often Venetian sitters were depicted – but in an easy, three-quarter length relaxed pose, confident and assured in dignity. He cannot have found Florence particularly congenial, since he contracted himself in 1502–03 as military engineer to the adventurer Cesare Borgia, who sought to carve a private princedom for himself out of the papal states, and who through his violence and cruelty changed the character of Italian internecine strife from a chessboard type of careful move and countermove by mercenary armies into wars of a new brutality and horror, of sacks, massacres, treacheries and murders. He also faced from 1504 onwards, probably unwillingly, the public contest with the young Michelangelo in the commission for the battle pictures for the Signoria which neither artist ever did more than begin, and then in 1506 he went back to Milan to work for the French conquerors. There he toyed with the project for the equestrian monument to Prince Trivulzio, the Governor of Milan under the French domination, changing his stately, classically Roman horse of the lost Sforza monument into a group of violent movement and struggle; but in these years he settled to the study of human anatomy and scientific subjects, which he pursued with patient yet avid curiosity, enquiring into all, yet unable to build on his discoveries since the cast of his mind forced him to start always at the beginning again, for he

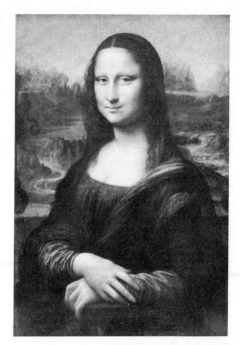

2 LEONARDO DA VINCI *Mona Lisa*

could never construct a theory nor accept a generalization which could serve as a springboard to further discoveries.

In 1513 he visited Rome as the guest of Cardinal Giulio de' Medici, but there he found himself like a man of the past lost in a new world which had little meaning for him. As an artist, his bolt was shot, and he had outlived his own achievements. Finally, in 1516, he accepted Francis I's invitation to become one of his collection of prestigious Italian captive artists, and eventually he died at Cloux near Amboise in 1519.

The two versions of the *Virgin of the Rocks* immediately raise a difficult problem: how did an artist whose dilatoriness in execution became a byword, whose unwillingness to complete anything seems almost to have been pathological, come to execute two almost identical versions of a

9

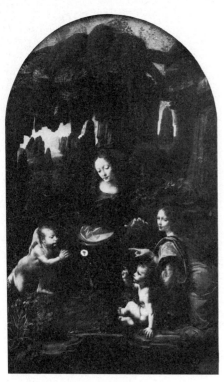

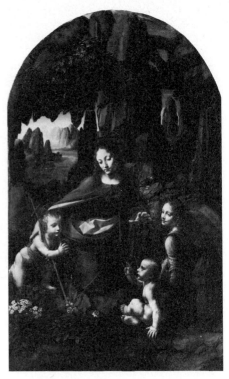

3 LEONARDO DA VINCI *Virgin of the Rocks*
(Louvre, Paris)

4 LEONARDO DA VINCI *Virgin of the Rocks*
(National Gallery, London)

composition? After the cleaning of the London picture, the idea that it was a studio work (that is, a variant painted by someone else) had to be abandoned since the execution refutes this, and it is the London version that is supported by the history of the commission and the contract. Did he take the Louvre version to Milan with him, and if he did, why? Pictures of this degree of complexity, size and importance were only executed on commission, never as speculations by an artist. Neither does anyone know how it reached the French Royal Collection, from which it passed to the Louvre, though the guess is that it came either by purchase or by looting from Milan where it may have

remained after Leonardo fled from the city when Ludovico Sforza fell from power before the French invaders in 1499.

The differences between the two versions are, basically, the differences between two ages, two kinds of thought, two attitudes to form and the relationships between the figures within the pictures, two techniques. In the Louvre version, beneath the murk of old yellow varnish, there is tension: the angel's pointing finger is sharp, breaking the current between the Virgin and her Son, nestling against the angel who protects Him with a tender gesture and looks down at Him with sharp, questioning gaze. The little figure of the Baptist kneels suddenly, eagerly,

before his Cousin. The Virgin's irregular features have the attractions of accidental forms, brought together in unexpected harmony. In the London version all is more carefully thought out, more consciously and deliberately harmonized and smoothed out. The Virgin's features are rounded and soft, the angel sags back in pensive tenderness, the Christ Child, alert and more upright, more conscious of His role, blesses His cousin – all humanity sheltering within the Virgin's protective arm – not with a sketchy, tentative gesture, but firmly, authoritatively, so that the pointing angel no longer needs to indicate His role, but has withdrawn his hand to let it lie on the Child's shoulder. The little Baptist, much larger, plays his part in a receptive and submissive acquiescence. The rocks that in the earlier work opened to show the sky above them now fill the whole picture so that the 'garden enclosed' is an inward world enveloping the group in the timeless, eternal world of mystery made the more strange and mysterious by being so precisely delineated – made real as only the works of the imagination can be.

If a diligent search be made for the watershed between the Early and the High Renaissance – that moment when the culmination of the first becomes the point of departure of the second – then surely it must be found in Leonardo da Vinci's *Last Supper*. Here, for the first time, the playful artifices of so many cherries to each place, of little dogs begging, of a Christ displaced from his central position to allow for an intrusive corbel in the architectural setting of the picture, of a Judas marked out by singularity of position, lighting, or features, of elegant observers masquerading as servants, of virtuoso still-life painting in displays of victuals and rich vessels, are completely rejected. The great picture at the end of the refectory in S. Maria delle Grazie in Milan is now a noble ruin, ravaged by time, by the results of the artist's faulty technique, by restoration and by the accidents of war, but enough survives to show that what Leonardo sought to portray was the impact upon the very different personalities of the apostles of the revelation of the coming betrayal and the presence among them of a betrayer. The picture does not, as do other, earlier, representations, set before us a

5 LEONARDO DA VINCI *The Last Supper c.* 1497

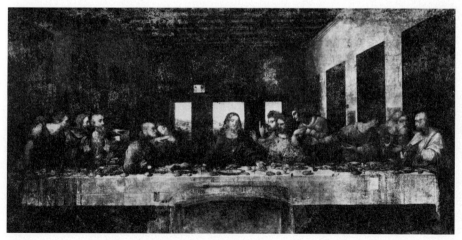

narrative account of a Passover meal, but is the outward expression of the inward drama of recognition: recognition of the import of the moment, of the fulfilment of prophecy, of the nature of Christ, the consequences of their belief; that they were no longer involved merely in a sectarian argument with a purely local significance, but were present at the birth of a new conception of the meaning and nature of God which was to shatter the fabric of their lives and bring most of them face to face with violent death. Incredulity, acceptance, horror, protest, resignation, bewilderment, all are portrayed in the groups ranged on either side of Christ, who waits for the tumult to subside before continuing to speak.

This was not Leonardo's first attempt at the portrayal of general rather than particular aspects of humanity. The *Adoration of the Kings*, which he had left unfinished in Florence when he went to Milan, contained in the figures of the Magi and their followers characterizations of the various ages of man and the states of mind that were associated, ideally, with them: eagerness and vitality in the youthful, decisive faith in the vigorous, the pathos of grateful and unquestioning belief in the aged. The seeds even of this division – the momentary from the eternal, the ideal, the spiritual from the material – lay in his very earliest works, for his angels always expressed the extra dimension of the Divine, his Virgins were the personifications of a supranormal state of womanhood. His ability to use nature to express the non-natural, to transcend reality so as to render the immaterial, to generalize, synthetize, so as to give a precise form to a state of mind or soul, is

6 Rubens after Leonardo *Battle of Anghiari* (1503–05)

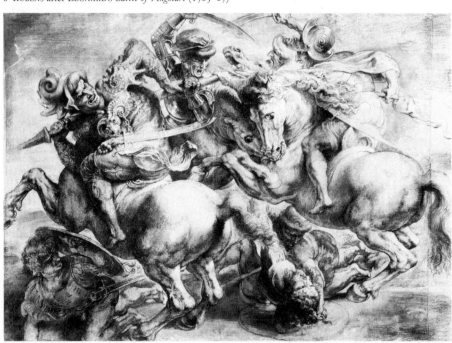

inherent in all his works, even in his portraits. The great divide between the Louvre *Virgin of the Rocks* and the later London version lies in just that difference between the attitude of the Early Renaissance and that of the sixteenth century, so that the Louvre picture has much of the naïve wonder and excitement of a genius able to render every aspect of natural objects and to do justice to an imaginative idealization of nature in the Virgin, the angel and the two Children, where the London picture uses a much more considered, deliberate, and intellectual idealization to give adequate expression to supernatural states of being.

Once the distinction had been made, then the rest followed almost inevitably. The new viewpoint did not conquer overnight, because the ideas that it expressed demanded a different kind of vision and ability, but it was recognized and accepted overnight, and from that moment Leonardo clarified the future role of art, and in particular of religious art. The change in style which it involved was set slowly in train, and was certain to supplant the intensely personal, more fragmented, more naïvely poetic, accidental and endearing features of Early Renaissance art.

There was another factor as well, which contributed powerfully to the acceptance of the ideas implicit in Leonardo's art. One of the less attractive aspects of Florentine art from the 1460s onwards was the increasing vehemence, violence even, of expression. Pollaiuolo's strained poses and exaggerated muscularity, Ghirlandaio's insistence on the minutiae of representation, Botticelli's mounting tension in movement and expression, Filippino's fantastic over-elaboration, Verrocchio's heightened naturalism, forced the tone of Florentine art to a curiously high-pitched resonance in the later half of the century. The dissonant voice was Perugino's. His

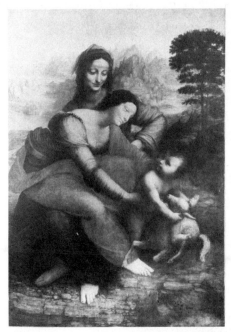

7 LEONARDO DA VINCI *Madonna and Child with St Anne*

Umbrian training, outside the fevered atmosphere of Florence, led him to create large, simple forms, with few figures, reticent in gesture and slightly vacant in expression, carefully related to each other in an ordered calm. Perugino, in the late 1460s and early 1470s, worked in Florence in Verrocchio's workshop, when Leonardo was also there, and, in the early 1480s, worked in Rome with most of the major Florentine painters on the commission for the fresco decoration of the Sistine Chapel. Despite the powerful example of his very different style, few Florentines were induced to abandon the strident overemphasis of their manner; but it would seem reasonable to believe that the young Leonardo did profit by the contact. When Leonardo came to express the most violent of emotions and actions in the *Battle of Anghiari*, where violence is inherent in the

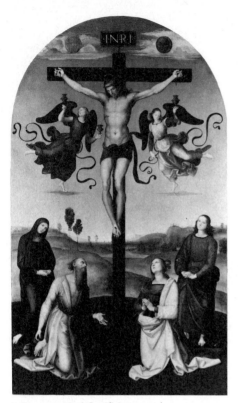

8 RAPHAEL *Mond Crucifixion* c. 1502/03

courage. Restraint was to become one of the most striking features of High Renaissance art: sober gestures, carefully controlled *contrapposto*, calm expressions, placid draperies, unhurried pace, accompany and underline the generalizations of form, the idealizations of nature.

In 1500, Leonardo returned to Florence after the collapse of his Milanese patron's power, and with more or less lengthy intermissions he stayed in Florence until he returned to a Milan under French domination in 1506. In 1501, after making his reputation in Rome, the twenty-six-year-old Michelangelo returned to Florence where he was to remain until 1505. Verrocchio and Ghirlandaio had long been dead; Botticelli, though still alive, had sunk into oblivion; Perugino had retired to Perugia, there to decline into repetitive nonentity; Signorelli had dropped out of the Florentine field when he had gone to Orvieto in 1499 to paint the huge cycle of the End of the World; the Pollaiuolo brothers had gone to Rome to make Papal tombs in the 1490s and had both died there; Piero di Cosimo was active in Florence, but was never a force to be reckoned with, since his art was uncertain and the artist distinctly eccentric; Filippino was to die in 1504. The most considerable artist of the day was Fra Bartolommeo, who had been a promising painter before he became a Dominican friar after the Savonarola storm had swept over Florence at the turn of the century, and who was to rise in 1504 to become head of the S. Marco workshop, a position that Fra Angelico had once held. Fra Bartolommeo's art also expressed a serenity and repose stemming from Perugino, but with a strong strain of sentimental religiosity, and with a studied generalization of forms, features, draperies, gestures and poses, dedicated to the didactic purposes of church art, which, if it owed anything to Leonardo's example –

subject, he expresses a quintessence of violence, a kind of idealized and epitomized violence, rather than a detailed enumeration of separate violent gestures and expressions. He applied to this extreme of movement and strain the same principles of analysis and synthesis that he applied to a static group; he knits his warriors into a single mass of struggling men and horses with the same studied science that he uses for the creation of a block of closely related figures such as those in the *St Anne* cartoon. From the first there is in Leonardo's paintings a self-control and discipline even more taut than Perugino's, but which the Umbrian's example must have done much to en-

and it probably did – was closer to an unconscious caricature than to an imitation.

It was into this world full of a vivid and recent past, and pregnant with new and potent ideas and examples, that the young Raphael arrived about 1504 at the age of twenty-one. He had . been trained in Perugino's placid and spacious style, though he brought to the rather empty figures of his master's inspiration a clearer draughtsmanship and a firmer grasp of character. Nevertheless, he must have realized that if he were to compete with the Florentines on anything like equal terms, their rigorous drawing and sculptural sense of form would have to be learned. He came determined to learn them, and succeeded so well that he eventually supplanted them as the criterion by which draughtsmanship is assessed. Though Raphael spent the years from about 1504 to 1508 working on commissions in various places in central Italy, he was probably in Florence for fairly long visits. Possessed of a marvellously intuitive and ratiocinative intelligence, he analysed and absorbed from the art around him those things which had made it more vital, more interesting, more intellectually satisfying than the art of any other period since antiquity. The simple workshop formulae of triangular composition, perspective, naturalism, meaningful gesture and expression, grace, the interplay of setting, colour, light and shadow, all these he examined anew in the context of Florentine thought and practice, and his enquiring mind sorted the results into perfectly solved experiments which could themselves be used as a basis for further experiments. This is clear if his pre-Florentine works are compared with those done under the impact of the new inspiration: the *Mond Crucifixion* of about 1503 shows his typically Umbrian use of decorative flourishes in the floating rib-

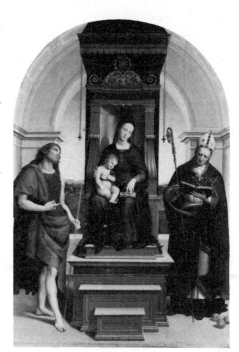

9 RAPHAEL *Ansidei Madonna* 1505–07

bons, the little angels each perched upon its tiny triangle of cloud, the placid expressions of sorrow, the rather flaccid elegance of poses; the *Ansidei Madonna* of, probably, 1505 (the date could be read as 1507, but 1505 is stylistically more likely) shows the point from which he developed Perugino's architectural setting, and the mild expressions of his gently pious Madonnas and Saints. It is customary to dismiss the della Robbias, as if Luca, in turning from serious competition with Donatello as a sculptor in order to develop his successful enterprise as a maker of glazed terracotta reliefs, had also abandoned serious thinking for more superficial notions contaminated by money-making. But even a cursory look at many of the Madonna and Child plaques made by the della Robbia workshop will suffice

15

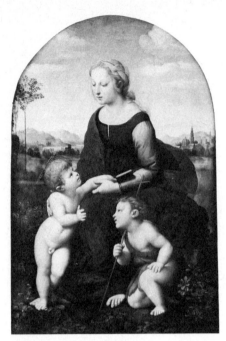

10 RAPHAEL *La Belle Jardinière c. 1507*

11 LUCA DELLA ROBBIA *Madonna and Child*

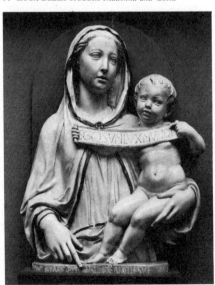

to show that the revolt against the increasing complexity of late Quattrocento Florentine detail started there long before the arrival of Perugino – probably because the technique itself demanded simple forms and an uncluttered surface. This lesson was not lost either.

The developments adumbrated by Leonardo – pyramidal rather than triangular compositions, the grouping of several figures in a meaningful relationship, the background of landscape or of shadow darkness, the contrasts of soft modelling, the enquiry into form, the idealization of nature to express the Divine – all these Raphael experimented with in the series of small Madonna and Child compositions of the type of the *Granduca Madonna*, the *Belle Jardinière*, and the *Madonna with the Goldfinch* or *in a Meadow*. The problems presented by the interplay between the personality and appearance of a sitter, and the slight idealization, the aggrandizement of nature, demanded by the very concept of portraiture, were considered in the portraits of Angelo and Maddalena Doni, and these too stem from Leonardo so closely that the female portrait is almost an imitation of the *Mona Lisa*. The representation of movement, stress, emotion, coherence between figures in a dramatic context was taken up from Mantegna and Michelangelo and elaborated in the Borghese *Entombment*. The general composition is derived from Mantegna's engraving of the *Entombment*, which also inspired Michelangelo. In Raphael's version, the seated woman turning to catch the fainting Madonna is Michelangelo's Madonna in the *Doni Tondo* of the *Holy Family* [29] swivelled still further round; the figure of St John carrying Christ's legs is adapted from Michelangelo's unfinished *Entombment* now in the National Gallery, London [28]; while the figure of Christ is so close to

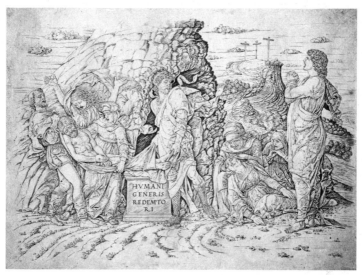

12 MANTEGNA *Entombment* (engraving)

13 RAPHAEL *Entombment c.* 1507

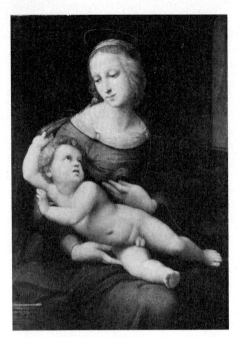

14 RAPHAEL *Bridgewater Madonna c. 1505*

Michelangelo's *Pietà* in St Peter's [25] that a knowledge of this group in Florence can be deduced from it. Michelangelo's marble roundel of the *Madonna and Child* with the infant St John grasping a bird [30], itself a motif used by Leonardo, reappears in Raphael's *Bridgewater Madonna*, where the sprawling Child is derived from Michelangelo, and the Virgin's *contrapposto*, her sweet smile, and the shadowed background from Leonardo.

In the late 1480s the custom of portraying figures in religious pictures dressed in contemporary costume began to give way to an increasing use of enveloping draperies of a timeless and fashionless type. At first the two continued to be mingled, as they had been from the Trecento onwards: the 1481 fresco decoration on the walls of the Sistine Chapel, Ghirlandaio's frescoes in the choir of S.

Maria Novella in Florence finished in the 1490s, Botticelli's late *Adorations* are examples. Leonardo never does it; Perugino only rarely, for such figures as Tobias, St Michael in armour, or saints in religious habit. Raphael compromises in his early works, for instance in the *Marriage of the Virgin (Lo Sposalizio*: Brera) of 1504, but once he had been subjected to Florentine influence he abandoned the practice for good.

In this he was certainly helped by the example of Fra Bartolommeo, who also rejected the mixture of the timeless and the contemporary, and in all his works pursued, with a sometimes aggressive insensitivity, a conventionalized rendering which has little in common with the kind of heightened idealization of nature that inspired Leonardo. At his best Fra Bartolommeo could achieve a noble simplicity, tenderness and sweetness; his compositions are straightforward, carefully symmetrical or pyramidal, his essays on the Leonardesque theme of the closely knit group of figures, linked emotionally, are of great beauty and pathos. Where he fails to please, it is usually through striving too much: the feeling in his grand altarpieces is often inflated, their didactic piety is too vehement, the figures are too conscious of their roles, and, like poor actors, exaggerate in sentiment and gesture, while the billowing draperies and the relentless *contrapposto* are mechanically contrived. But he was clearly one of the important formative influences on the young Raphael, just as he himself was inspired by the man he influenced. In 1508 Fra Bartolommeo visited Venice and after this his colour became more tender, his art mellower; but by this time Raphael had left for Rome, and when in 1514 or 1515 Fra Bartolommeo visited Rome the current of influence was then running in an entirely opposite direction, for the artistic centre of gravity had shifted from Florence to

Rome, and Florence was never to regain its former preponderant position. In the last decade of his life – he died in 1517 – he had first the layman Mariotto Albertinelli as a partner from 1508 to 1511 in the monastery workshop, and later another monk, Fra Paolino. Albertinelli was an artist of ability and charm, but was sufficiently discouraged by the difficulties of art to abandon it for innkeeping; Fra Paolino was a nonentity under whom the workshop dwindled into insignificance.

Raphael was born in Urbino in 1483; Bramante in a village just outside in 1444. Whether there was a family connection between them is uncertain; however, it seems likely that it was Bramante who suggested that his young compatriot should come to Rome, probably towards the end of 1508, since Raphael was quite certainly employed on the decoration of the new papal apartments in the Vatican – the Stanze – early in 1509. This move to Rome brought him once again within the orbit of Michelangelo (who was in Florence during part of the time Raphael had spent there), occupied, from 1508 onwards, with painting the ceiling of the Sistine Chapel, a commission which, to his disgust, he found himself saddled with instead of being allowed to continue with the work for which he had originally been summoned to Rome. This was the tomb which Pope Julius II planned to have made for himself during his own lifetime. It appears from surviving accounts that there was no love lost between Michelangelo and Bramante, and fairly soon Raphael himself seems to have been involved in the hostility, as is evidenced by Michelangelo's sour remark that 'all he knows he learnt from me'.

Bramante started life as a painter, developing out of Piero della Francesca and Mantegna, whose pupil he probably was. His earliest known works are some fragments of a fresco representing a sage in

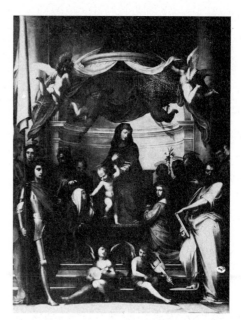

15 Fra Bartolommeo *Mystic Marriage of St Catherine* 1512

16 Fra Bartolommeo *Madonna and Child with St Anne and the Baptist* 1516

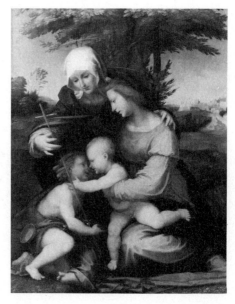

19

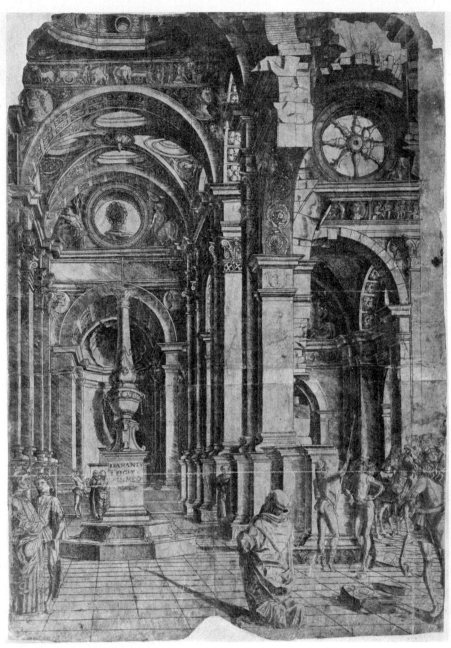

17 BRAMANTE *Architecture with figures* 1481

an architectural setting, still in the Palazzo del Podestà, Bergamo, painted in 1477, and some rather more considerable fragments of a fresco cycle once in the Casa Panigarola in Milan, and now in the Brera. These were probably painted in the 1480s, and consist of figures, well over life-size, standing in niches, together with a pair of half-length figures of Democritus and Heraclitus with a globe between them: a cycle, in other words, based on the popular type representing Worthies. They are bright in colour, illusionistic in perspective, bold in handling. There is also a celebrated engraving so rare now that only two copies are known, but which must have had considerable currency in its day, since borrowings from it are found from Germany to Spain. It is inscribed as by Bramante in Milan, is datable 1481, and depicts a number of mysterious figures in a semi-ruined building, the architecture of which depends in some measure on the chapel-like setting of Piero's *Madonna and Child with Federigo Montefeltro* (*c.* 1475: Milan, Brera), only in Bramante's version the building is much larger and far more complicated. He is next found building a church adjoining the tiny ninth-century church of S. Satiro. This building, apparently his first work in architecture, contains a *tour-de-force*, in that from the centre of the nave the altar appears to be in a deep choir, with a coffered vault above and shallow niches between pilasters on either side. Above the crossing formed by wide transepts is a coffered dome. In fact, this apparently cruciform church is T-shaped, since a street runs immediately outside the east wall of the transepts, leaving no space at all for the choir, which is a perspective illusion only a few feet deep, an illusion which deceives perfectly from the nave. The niches in the east wall of the transepts, with a shell filling the rounded upper portion, the treatment of cornices, of the piers with applied pilasters

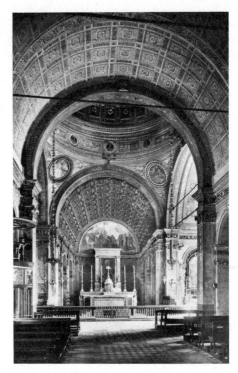

18 Bramante S. Maria presso S. Satiro, Milan (interior) 1470s

that support the nave and transept arcades, of the coffering of the dome and the barrel vaults, again recall austere, Piero-inspired, classical forms. The specifically Milanese element is in the profusion of ornament which covers the forms and does its best to obscure their purity and exactness. This passion for ornament, characteristic of Milanese art (it is perhaps the most striking aspect of the famous fifteenth-century Certosa of Pavia, where it reaches the proportions of a *horror vacui*), is particularly vivid in the little octagonal baptistry tucked into the angle of the nave and south transept. Here, the pilasters, bent round the angles of the octagon, are covered with a delicate tracery of relief ornament, the terracotta frieze above the

21

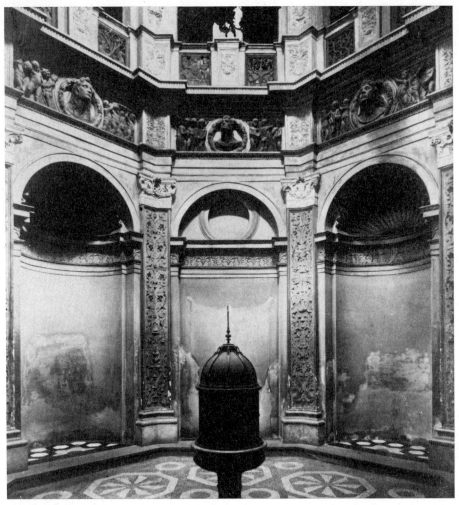

19 BRAMANTE Baptistry of S. Maria presso S. Satiro

varied capitals consists of high-relief *putti* supporting roundels from which project free-standing heads, and in the upper storey the pedestals, pilasters and frieze of the piers are covered with the same kind of profuse arabesque and foliage decorations as those in the lower part, so that the simplicity of the plan, with four deep niches extending and moulding the in-terior space of the octagon, is almost lost under layers of ornament.

During the 1490s Bramante was em-ployed to build the east end of the church of S. Maria delle Grazie, which had recently been completed. Here he develops an architecture concerned with space and volume, rather than with the scenographic qualities that had governed his design at

S. Maria presso S. Satiro. The carefully proportioned spaces grow one out of the other; a hemispherical dome over the great cube of the main choir, with a proportionate cube surmounted by another hemisphere backed by a semi-domed niche, and the body of the main choir extended at the sides by deep semi-circular niches, the whole design articulated by a broad, strong cornice. Small windows at the base of the dome flood the interior with light. One can, of course, endlessly conjecture the influence that Leonardo, then painting the *Last Supper* in the refectory of the monastery, exercised on Bramante. The existence among Leonardo's notebooks of a mass of architectural drawings concerned with designs for centrally planned, domed churches suggests that this problem was one that both men were experimenting with, though the character of Leonardo's little drawings suggests, not that he was creating architectural designs, but rather that he was concerned with the expression of three-dimensional problems on paper, so that the solutions might be easily understood.

In 1499, the French, invading Italy for the second time, conquered Milan. The Sforza ruler, Ludovico il Moro, was captured and eventually spent the remainder of his life in a French prison. Leonardo took refuge in Venice, both from the Milanese disaster and from the attempts at patronage of Isabella d'Este, his former patron's sister-in-law, before he returned to Florence in 1500. Bramante went to Rome.

The family of Michelangelo, who were of the lesser nobility, at first opposed his desire to become an artist, and though he himself said later that he absorbed a love of sculpture with the milk of his wet-nurse, a stone-cutter's wife, he was eventually apprenticed for three years in the work-

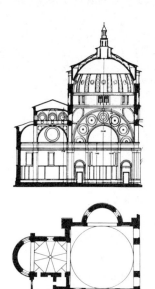

20 BRAMANTE Section and plan of S. Maria delle Grazie, Milan 1490s

21 BRAMANTE S. Maria delle Grazie (interior)

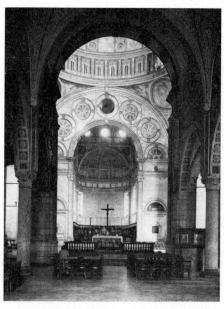

shop of the important and fashionable Florentine painter Domenico Ghirlandaio. This was in 1488, when the splendid fresco-cycle in the choir of S. Maria Novella was the painter's main concern; Michelangelo was then thirteen. In years to come, he repudiated this period of formal schooling, and maintained that his genius was untutored, God-given, but it seems probable that he acquired a knowledge of fresco technique – of which Ghirlandaio was a great master – and that he made the drawings that still exist after the frescoes of Giotto and Masaccio, then regarded as basic training for a pupil.

Very soon, however, he appears to have been allowed to transfer to a sculpture studio run by Bertoldo, who had once been one of Donatello's assistants, and who was now, as an old man, keeper of the Medici collection of fragments of antique sculpture, which was kept in a garden near the monastery of S. Marco. Two reliefs are the earliest works attributed to the young sculptor; the *Madonna of the Steps*, in which the brooding figure of the Virgin is placed in profile against a staircase with figures modelled in very low relief, and the *Battle of the Centaurs*, a tightly knit mass of struggling nude figures. Both probably have their origins in antique art; great subtlety in low relief was a characteristic of Donatello's art and Bertoldo is known to have been passionately interested in Roman sculpture. At the same time, the sources of classical inspiration available to

22 MICHELANGELO *Battle of the Centaurs c.* 1492

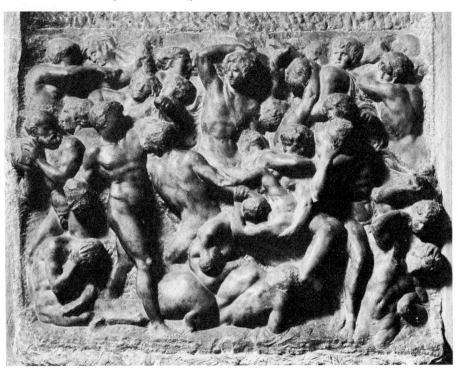

the young Michelangelo included not only the classical fragments in the Garden, but antique cameos, of which there were many in the Medici collection, and these exploit the infinite gradations of modelling in delicate superimposed layers. When Bertoldo died in 1491, Michelangelo appears to have stayed on and to have been a familiar of the Medici household, but this incipient patronage came to a brusque conclusion with the death of Lorenzo de' Medici in 1492, and the expulsion of the Medici family from Florence when Savonarola came to power. During the period of much confusion and little opportunity that ensued, the young Michelangelo seems to have occupied himself with carving a crucifix, identified with one now in Casa Buonarroti, and a *Hercules*, of which the only record is in a crude print by Israel Silvestre made in 1649 showing it standing in the garden of the palace at Fontainebleau: a Hercules, a classical mythological figure, despite the fulminations of Savonarola against pagan frivolities and nudities. Then, suddenly, the French armies advancing victoriously, or at least unopposed, were at the gates of Florence, and Michelangelo perhaps feeling himself compromised by his Medici associations, prudently removed to Venice, and then, closer at hand, to Bologna.

There he made, between 1494 and 1495, two small free-standing figures for the Shrine of St Dominic in S. Petronio, and one of the pair of angel candelabra for the altar of the chapel. Clearly, he had been looking at S. Petronio's major masterpiece, the great portal carved by Jacopo della Quercia nearly sixty years before. He adapted the older master's directness of characterization, his admirable economy of gesture which concentrates the impact of the figure, and also the use of bulky draperies to give mass and weight, with a plethora of small, thick folds to indicate

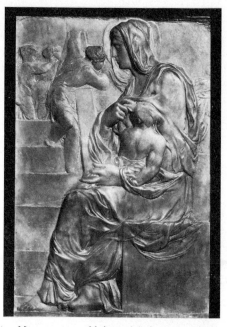

23 MICHELANGELO *Madonna of the Steps c.* 1491–92

24 MICHELANGELO *Angel* for the Shrine of St Dominic 1494–95

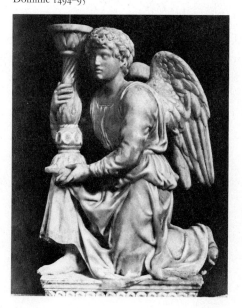

25

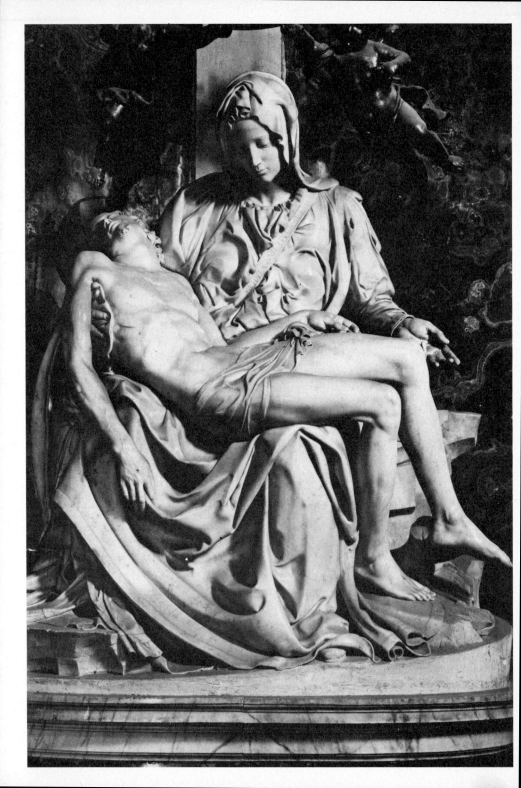

the form and movement of the limbs; this is also a device used by Cosimo Tura, and, though ultimately Donatellesque, it is used by both artists in a totally unFlorentine manner. There is also the strengthening of Michelangelo's feeling for *gravitas*, for the angel has nothing in common with the playful, spritely little figures found on Florentine Quattrocento tombs. He is a classically inspired, wholly supernatural being, whose dignity is a reproof to his earlier companion.

In 1496, he arrived in Rome, where he had been preceded by a small statue of a *Sleeping Cupid*, sold to an unscrupulous Roman dealer who passed it off as an antique. His first Roman patrons were the banker Jacopo Galli, and a French Cardinal, Jean Bilhères de Lagraulas. Galli bought the *Bacchus* rejected by its first commissioner – a life-sized figure of a smooth, plump, vacant-faced young man, tottering light-headedly, wine-cup in hand. The anatomy and characterization are perfect; the technique supreme; at twenty-one he has no more to learn from anyone. For the Cardinal he made the *Pietà*, now in St Peter's. This is the final solution to the problem, which had long beset the artists of the Early Renaissance, of how to place the body of an adult man across the knees of a woman; it is also the unsurpassed expression of the resigned acceptance of suffering, of the acquiescence of the Divine will in the sacrifice, of God's surrender of Himself to be martyred by man. Technically, it is Michelangelo's most meticulously finished sculpture. No part but is completed to the last stroke of the chisel and polished to a high refinement of surface. The lessons learned from Quercia's use of draperies, from Leonardo's grouping of figures in a meaningful relationship, are combined with an understanding of the necessity for a timeless, unlocalized dress and for the evolution of an ideal beauty expressive of

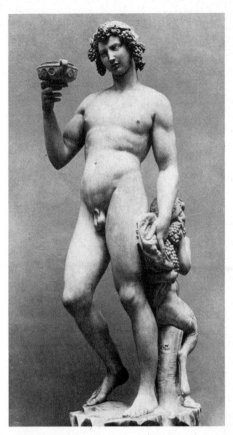

26 MICHELANGELO *Bacchus* 1496–97

both the Divine and the human – an artistic form which shall be the equivalent of that Limbo between the Cross and the Resurrection. The forms of the heads are a trifle thin, but admirably defined and sensitive, with small, tensely flaring nostrils, sharply cut lips, and strongly marked lower lids. These contrast with the substantial modelling of the hands, the sense of the dead weight of Christ's body sagging heavily between His mother's knees, the arrested movement of the dangling legs. This is the new century's rendering of the theme so poignantly

27

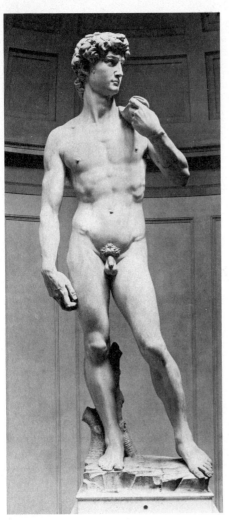

27 Michelangelo *David* 1501–04

which softens the starkness without rendering it less pathetic. It is also important that the *Pietà* was commissioned by a northerner, for the subject itself was a northern idea, linked with German and French devotional themes of the Suffering Christ popular since medieval times in the North; there was, in fact just such a German carved group of the *Pietà* in S. Petronio.

He returned to Florence, preceded by his fame, in 1501, and during the next four years worked on a number of commissions, not all of which came to fruition. The gigantic *David*, symbolic of the prized Florentine civic virtue of Fortitude, was envisaged as a gangling adolescent, full of the pride of youth and strength, but with something also of its uncertainty, its faroucheness, and in this differed considerably from the more urbane self-confidence of the *Davids* by Donatello and Verrocchio. The idealization of the head is allied to an astonishing accuracy of anatomical detail in the body. The relaxed pose, with its strong links with antiquity, also expresses the medieval concept of the different affinities of the two sides of the body: the right side closed and defended against attack, the left side open and exposed, vulnerable to evil. The block from which Michelangelo carved the figure had been started on by Agostino di Duccio in 1464, but abandoned; only from the side is one aware that the imposing breadth lacks a corresponding depth, so that his achievement was a *tour-de-force*. The final position of the *David* was chosen with great care, since the figure has so strong a frontality, and its site – next to the main door of the Palazzo della Signoria – was selected not only to enhance the statue, but also to replace the Donatello *Judith*, taken by the City from the Medici at the time of their expulsion, and placed originally in front of the palace with an inscription celebrating the victory of courage and

stated in the little predella panel of the *Pietà* painted by Ercole de' Roberti in the late 1480s, forming part of an altarpiece later completed for S. Giovanni in Monte in Bologna. Where Ercole de' Roberti stretches Christ's dead body rigidly across the Virgin's knees, Michelangelo bends and twists it into a measured *contrapposto*

28

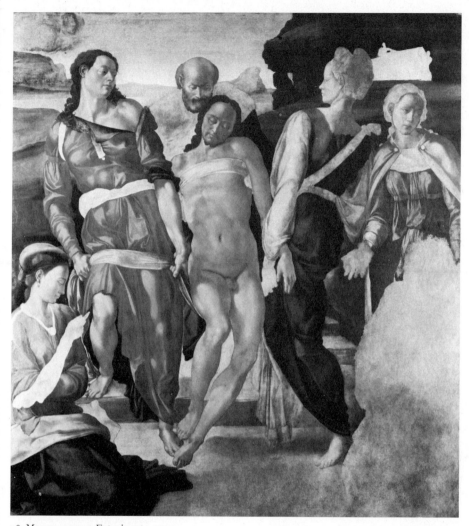

28 MICHELANGELO *Entombment c.* 1504

energy over tyranny (it was then removed to the Loggia dei Lanzi). These political overtones were fundamental to the impact made by the *David* on the Florentine public; Vasari comments on this aspect of the *David* as a symbol of good government.

Experiments in panel painting in tempera included the *tondo* of the *Holy Family*

painted for the patron Angelo Doni, who also employed Raphael, the *Entombment* and the *Madonna and Child with Angels* (both London, National Gallery), both unfinished. The *Entombment* leans heavily on Mantegna's engraving; the *Madonna* has been spoilt by other hands. His lack of perseverance suggests that already Michel-

29

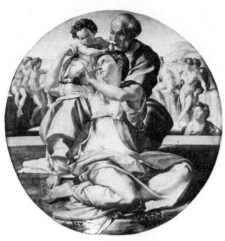

29 MICHELANGELO *Holy Family* (*Doni Tondo*)
1503–04

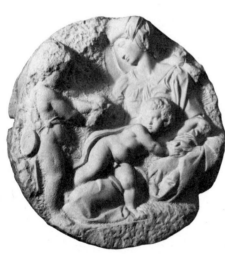

30 MICHELANGELO *Taddei Tondo* 1505–06

angelo had formed the opinion he later expressed – that oil painting was fit only for women and the lazy. The *Holy Family* is like a relief in paint, with a hard clarity and a dazzling accuracy of drawing in difficult foreshortened poses. The Madonna's elbow and right knee mark the extreme front limit of the 'block'; the background consists of figures of nude youths – not the prophetic Old Dispensation, but unheeding antiquity with its worship of male virility, upon which the linking figure of the young Baptist turns his back as he moves towards the different plane of existence of the New Dispensation. Here, the God-Child, borne by an adoring woman and protected by an old man, uplifted as conqueror and King upon the shoulders of His ancestry, proclaims the spiritual message of the New Law, its utter separation from the Old, and the gulf between Sacred and Profane Love. Two marble reliefs are the parallel in sculpture to the *Holy Family*. Both are unfinished, as if Michelangelo had already discovered the charm of a fully finished fragment emerging from the roughly sketched-out block, like an aria soaring above an orchestral background.

The *St Matthew*, struggling to free himself from the block, was the only one of the twelve apostles ordered in 1503 for the Cathedral to be even partially completed. This was probably because work was interrupted by the commission, given in the autumn of 1504, to paint a battle scene for the Palazzo della Signoria as a companion piece to Leonardo's *Battle of Anghiari*, ordered in May 1504. This grand project came to nothing: the cartoon was finished – at least in part – by February 1505, but the urgent summons from Pope Julius II prevented Michelangelo from continuing with the work, for which only some drawings survive. But the impact of the cartoon for the *Battle of Cascina* was such that it became the main source of

study for the next generation of artists, thereby emphasizing in a practical manner Michelangelo's tacit argument that only the male nude, in poses of energetic movement, was the proper subject for the artist, and the most expressive if not the only vehicle of artistic thought.

The *Madonna and Child* now in Bruges was the only other completed group of this period. Deliberately harking back to the hieratic forms of Byzantine and medieval iconography, Michelangelo represents the Child standing between His mother's knees and enveloped in her robe, expressing both His divine and His human nature in an almost literal rendering of the ideas 'born of the Virgin Mary', and 'the Word was made flesh'. This work, just under life-size and highly finished with the same care and refinement as the *Pietà*, was crated and shipped to Flanders immediately it was finished, so that it was almost unknown in Florence. Michelangelo's letters to his father from Rome in 1505 give careful instructions about its dispatch. For in

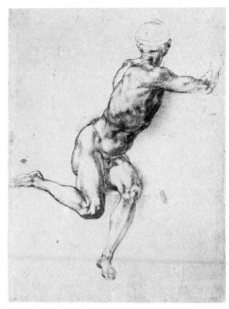

31 MICHELANGELO *Drawing of a Man* (study for *Battle of Cascina*) 1504–05

32 MICHELANGELO *Battle of Cascina* (copy by Aristotile da San Gallo)

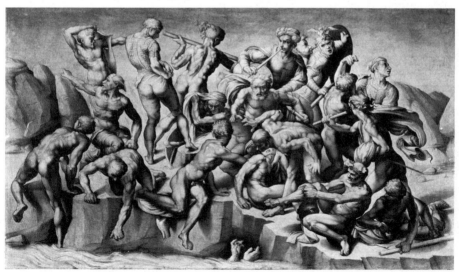

March 1505, Julius II sent for Michelangelo and commissioned a grandiose tomb to be set up in St Peter's. This was the work which Michelangelo never finally completed, and which he called the tragedy of his life.

The works of this first decade of Michelangelo's career have one characteristic in common: they all show the artist affronting a technical, an artistic, problem. The earliest known work, the *Madonna of the Steps*, is concerned with the creation of a real world of considerable spatial depth, in terms of the lowest possible relief. The *Battle of the Centaurs* first shows him confronting his major theme: nude figures in violent action; it contrasts with the Madonna in being in very high relief, some figures being almost free-standing. In the Bolognese works he explores problems of characterization; the *Bacchus* is a life-size free-standing nude; the *Pietà* a tightly knit group; the *David* is a technical triumph won in the teeth of the problems presented by its size and its having to be cut from a botched block, besides its qualities of surface modelling, anatomy, and its complex inner meaning. The *Battle of Cascina*, abortive though it may have been and through no fault of his, was Michelangelo's first large-scale painting, using the theme of the virile nude; the *Doni Tondo*, his only finished panel painting, explores the problems of composing a meaningful group within a circle, with a precise definition of the spatial planes and relationships within the picture space, and the two marble *tondi* adumbrate similar problems in reliefs. The Bruges *Madonna* is a modern restatement of an old theme, which restores the hieratic quality of the subject by turning away from the sweetness, the sentimentality, by which recent sculptors had diminished its significance.

An appreciation of significance is basic to an understanding of High Renaissance art; certainly it is more complex in the variety of meanings which it presents. The medieval and Early Renaissance directness of symbolism is now replaced by multilayers of meaning, each of which adds to the richness of intellectual content in the work. This accounts for certain difficulties, such as the confusing variety of interpretations offered quite plausibly for a large work, particularly when no written programme has survived to settle problems of exact meaning (such survivals are, in fact, extremely rare). Yet this does not invalidate contradictory views, since it is not impossible – indeed, it is very likely – that the artist himself was aware of, and deliberately exploited, such complexities of interpretation as an addition to the pleasure of the discerning spectator. The *David* is a fairly straightforward example. The divinely inspired shepherd-boy who saved his people and became a king is the simplest level of symbolism in its use of David as an Old Testament prefiguration of Christ, but added to this are the connotations of religious strength and self-sacrifice and civic fortitude, the inspiration from antiquity and from medieval moral apologetics in form and pose, the equation of David and Hercules as expressions of heroic virtue in religious history and classical mythology. This ever-expanding world of inner meaning was understood and highly prized by those for whom these works were made, and as time went on deliberate complexities of interpretation become a major factor in a Mannerist work of art.

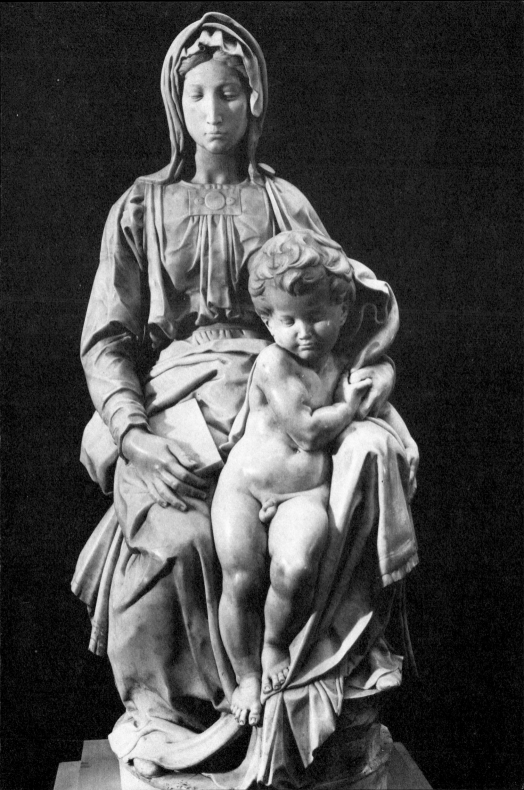

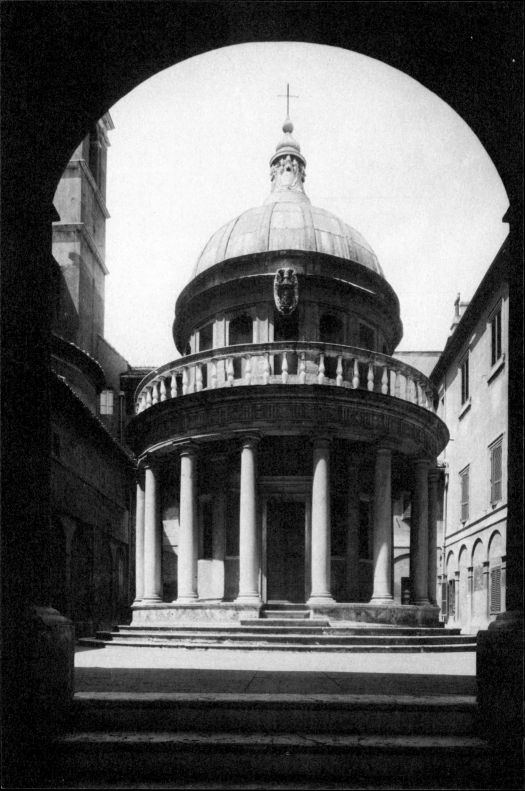

The High Renaissance in Rome

Bramante's first Roman work was a cloister built adjoining the church of S. Maria della Pace, and an inscription on the frieze gives the date 1504 for its completion. In Milan, in one of his last works there – the Doric Cloister of S. Ambrogio – he was still using the Early Renaissance type of colonnaded loggia which derives from Brunelleschi's Foundling Hospital in Florence, or the courtyards of the Medici Palace in Florence and the ducal palace in Urbino; since he was an Urbinate, the last must have been familiar. But in this first Roman courtyard, he adopted the pier with applied pilasters to support his main arcades, using the Roman example of the unfinished courtyard of the Palazzo Venezia, a work of the 1460s inspired by antique Roman buildings such as the Theatre of Marcellus or the Colosseum. The impact of classical Roman architecture is also clear in the little Tempietto at S. Pietro in Montorio, which was commissioned in 1502 as a memorial or *martyrium* on the spot on the Janiculum Hill where, traditionally, St Peter was crucified. This tiny church (it holds about ten people) looks back to antique circular temples such as that at Tivoli where there is a similar arrangement of a pair of interlocked cylinders, but the inner cylinder of Bramante's little temple projects above the outer encircling colonnade to form an upper storey crowned by a hemispherical

35 BRAMANTE Cloister of S. Maria della Pace, Rome 1504

dome. Originally, the courtyard of S. Pietro in Montorio was to have been rebuilt as a circular court with the Tempietto in the centre, but this part of the project was never carried out. The very carefully worked out proportions of this little building are in terms of both the traditional root-two measurements, used

34 BRAMANTE Tempietto at S. Pietro in Montorio, Rome, after 1502

35

here to determine the relationship of inner and outer cylinder in width and height, and total width to total height, and the mathematical relationship of 1:1 and 1:2 in the proportions of both cylinders taken together. So far as can be ascertained from the only known plan of the whole project, published in Serlio's Third Book of Architecture in 1540, these systems govern the relationship of the Tempietto to the courtyard of which it should have been the centre. The original project is of interest in that it is an instance of the persistent attitude of the Italians towards architecture: the building is not considered for itself alone, however much effort and imagination may be lavished upon it; it is a part of a complex, an element in an overall scenic effect, which it may dominate, but without which it loses its most important visual function.

In 1503 Julius II was elected to the papal throne. The ten years of his reign were not only filled with the vigour and determination of his political aims; his artistic patronage was one of the facets of his policy, and it restored Rome to a position of dominance in the arts which endured until the nineteenth century. Julius II's detestation of his Borgia predecessor extended to the rooms in the Vatican decorated for Alexander by Pinturicchio on the theme of Borgia power and success, and liberally displaying the Borgia arms and device of the bull; he ordered another suite to be prepared on the floor above the Borgia Apartments, and it was these rooms that, probably on Bramante's suggestion, the young Raphael was employed to decorate.

Julius was also faced with a formidable problem in St Peter's. The basilica built by Constantine in the fourth century had been in constant use for over a thousand years; teeming thousands of pilgrims had passed through it; Goths, Vandals, and countless other invading armies had swept over it;

fires, pillage, storms, earthquakes had devastated it. Efforts had been made to repair it and to enlarge it, but by the end of the fifteenth century it was obvious that the structure would no longer endure; the walls of the nave were by this time some three feet out of the true. The papal palace was also totally inadequate. The Pope's patronage was concentrated upon five projects: the rebuilding of St Peter's, and the enlargement of the Vatican by Bramante; the decoration of the new rooms in the Vatican by Raphael; the making of a splendid tomb for himself, and the decoration of the ceiling of the Sistine Chapel, by Michelangelo.

The project for the new St Peter's was certainly decided upon by 1506, when a foundation medal was struck having on one side a portrait of Julius II and on the other a view of the projected new basilica. This was to be a centrally planned church, based on a Greek cross, with four smaller Greek cross elements in the angles, the central crossing surmounted by a hemispherical dome borne on a colonnade. The decision to replace a long-nave basilica with a centrally planned building must be seen in terms of the combination of the Early Christian type of *martyrium* – almost always centrally planned – with the concept of the central plan as the expression of mathematical perfection symbolizing the perfection of God. When Bramante began to work on designs for the new church he was confronted by five main problems: the position of the tomb of St Peter, which lay before the high altar, and had to become the focal point under the dome; the presence at the back of the apse of extensive foundations prepared for a new choir in the 1450s, but never completed; the restriction of the site by the presence of the Vatican buildings on one side and the requirement of continued access to the Apostle's tomb for pilgrims; the necessity of providing a benediction loggia on the

façade for the great yearly papal ceremony of the blessing 'Urbis and Orbis' – the City and the World. There was also the factor that, though the dome of Florence Cathedral and the choir of S. Maria delle Grazie in Milan were considerable works, nothing yet built since classical days in Italy involved construction on the scale envisaged at St Peter's. While the projects for the new church were being worked out, Bramante was already employed by Julius to reconstruct part of the Vatican, and to link the high point of the Belvedere with the rest of the palace by building a huge, elongated courtyard in rising levels, culminating in a niche on the top of the hill. Also, the main internal courtyard of the Vatican, the Cortile di S. Damaso, was started with a four-storey block on one side which showed how thoroughly Bramante had absorbed the classical heritage of ancient Rome. Tier upon tier of open arcades surmounted by an open loggia (now unfortunately all glazed in) repeat the form of the Colosseum, and established this as the most enduring type for the design of courtyards.

When Bramante died in 1514 – the year after his great patron Julius II – foundations at the new St Peter's had been prepared for the piers of the crossing and for the choir arm, but the piers upon which he proposed to erect his enormous dome were totally inadequate. All his successors progressively increased the size of these main piers and the abutments for the dome, and simplified his project. He seems to have left no detailed designs; in fact, he bequeathed to his successors the problems that had confronted him, plus the extra commitment of the scale determined by the interior space of the crossing. His pupil Peruzzi, Raphael, Antonio da San Gallo the Younger, all attempted to devise solutions modifying his plans, while retaining the basic element of the centrally planned east end. Money troubles, wars

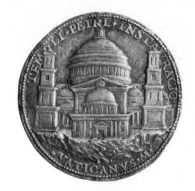

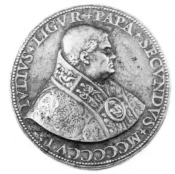

36 CARADOSSO Foundation medal for St Peter's 1506. Reverse: project for St Peter's. Obverse: Julius II

culminating in the Sack of Rome in 1527, the repercussions of the Reformation, so delayed the work that it was not until Michelangelo finally assumed direction in 1547 that any real progress was made. Bramante's great achievement lay not so much in what he actually built, but in the scale of his conception and his confidence that his ideas were capable of realization: no project was beyond the man of his age.

By 1509, Raphael was working in the Vatican on the decoration of the suite of rooms – the Stanze – designed to be used by Julius II as papal offices. The scheme of decoration is therefore a formal one with a carefully worked out programme, linking the rooms in an ordered sequence. For three rooms, Raphael was either totally or in part responsible; these open one into the

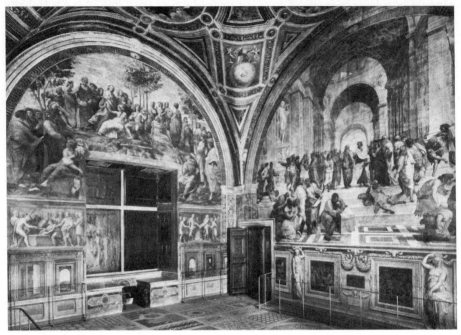

37 RAPHAEL Stanza della Segnatura 1509–11

next and are lit from both sides. They are cut into more or less awkwardly by doors and windows, and part of Raphael's genius was that he was able to accommodate, and even use, these interruptions, rather than to allow them to disrupt his compositions. Originally, the areas of wall below the frescoes, now decorated with a painted dado by Perino del Vaga, had *intarsie* (decorative panels of wood inlays) and probably also bookrests, but these were all destroyed by occupying soldiery after the Sack of Rome.

The room in which he began work was the middle one, the Stanza della Segnatura, so called because documents were sealed there. Here the theme is the divinely inspired human intellect, represented by Theology, Philosophy, Poetry and Law. The room beyond it, named the Stanza

dell'Eliodoro after one of the incidents portrayed, is based on the theme of Divine intervention on behalf of the Church. The first room one comes to, called the Sala dell'Incendio, also from one of the frescoes, is dedicated to miracles performed by Popes; it contains only one fresco that can claim to have any direct intervention from Raphael, as distinct from his supervision of the project. In the fourth and much larger room at the end, the Sala di Costantino, which gives on to the Loggie at the top of Bramante's new wing, are scenes from the History of Constantine and the Establishment of the Church, completed after Raphael's death by his chief assistant, Giulio Romano.

The Stanza della Segnatura was painted between 1509 and 1511, and the frescoes represent the High Renaissance at its

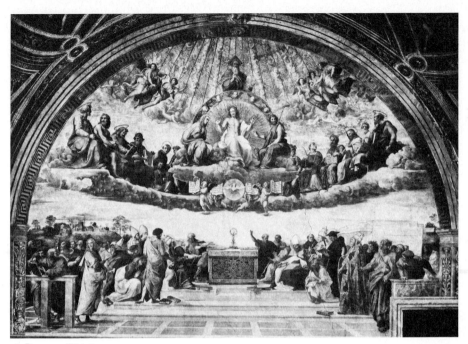

38 RAPHAEL *Disputa* 1509

culminating point. All the lessons of order, calm, the subordination of detail to total effect, the involvement of every part of the design in the meaning of the whole, have now been learned and are used triumphantly. The fresco representing Theology, the *Disputa*, or, more properly, 'Disputation concerning the Blessed Sacrament', must have been the first of the series to be painted. Though organized with masterly care so as to unify both halves of the composition – the celestial and the terrestrial spheres – there are certain archaisms, certain dependencies on earlier examples which · suggest that Raphael was still feeling his way. The *Last Judgement* by Fra Bartolommeo, which he must have seen in S. Marco in Florence, is clearly the source for the rows of saints enthroned upon the semi-circle of clouds;

the use of raised plaster for the gilded rays and bosses representing the effulgence of Heaven are ideas probably adapted from such precursors as the *Paradise* in the Signorelli frescoes in Orvieto. But these are minor aspects, of importance only in that they point the more emphatically to the break between Raphael and his predecessors. The Host exposed on the altar is the centre of the perspective of both halves of the composition; it not only unifies the whole picture in a common focus, but is also, quite naturally, the spiritual focal point of the picture, so that there is complete harmony between means and purpose. The central figures round the altar represent the Doctors of the Church; each is characterized broadly and simply, and the movement of each figure contributes not only to the pictorial movement,

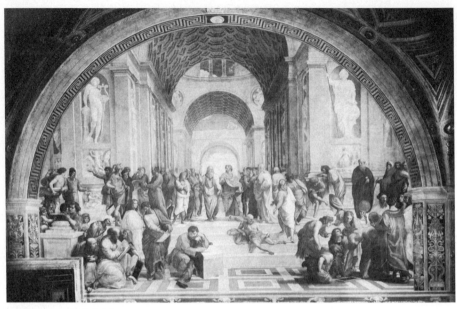

39 RAPHAEL *School of Athens* 1509–11

but also the inner meaning, just as the man with upraised arm links the two worlds physically, as well as spiritually. The movement of even peripheral figures is designed to contribute to this unity of meaning and form, to control the spectator's interest so as to direct it to the main subject mentally and visually.

The opposite wall is dedicated to Philosophy, represented by what is known as the *School of Athens*. The device of the flight of steps, used in the *Disputa* to enable the swathe of figures on the earthly plane to balance those in the heavenly sphere, is a time honoured one, a modernized form of the composition of any Trecento Coronation of the Virgin, for instance. In the *School of Athens* it is the key to the composition, in that the much steeper flight allows Raphael to compose his groups of philosophers so that they flow into, as well as across, the picture space, and permits also the construction of an architectural framework which is not only rational spatially, but is in harmony with the significance of the subject. Here, as in the *Disputa*, the placing of groups and of individual figures is done with such masterly skill that it is difficult to realize how much the eye is being directed to the focal point; at the same time, each figure is characterized so that it is not a mere compositional device, but a shorthand statement, so to speak, epitomizing the philosophical system of the figure represented. Plato and Aristotle hold the centre of the stage, the one with upraised hand pointing idealistically to a world above that of men; the other expostulates with hand spread downwards, so as to suggest the reality of the physical sciences underlying his teaching. Around them other philosophers are epitomized: Socrates, ticking off the questions on his fingers; Pythagoras with his musical scales; Ptolemy and Zoroaster the astronomers;

Euclid demonstrating a mathematical problem; Heraclitus gloomily turning his back on mankind; Diogenes in rags, sprawling like a beggar on the steps. Each group is a unity, yet each group is tied to the whole by some detail that serves as a hyphen: the Socrates group by the antithesis of pose, particularly in the legs, between the philosopher and the white clad figure near him; the Pythagoras group by the still, upright young man, light against the dark profile of the figure in sharp *contrapposto* – this young man being the only upright in a succession of curves; the man walking up the steps by his position links the groups of the geometers, and by his gesture connects Diogenes in his isolation with the world about him. Through the whole of this great work there is a unity, a grasp of the construction of a design so that its complexity is concealed and all that first strikes the eye is a satisfying disposition of the parts, a feeling of order, clarity, and repose. The architecture is important in this respect; the great halls recede, high, full of light, majestic in their massive elements. The most distant point of the building, far away at the end of the transept beyond the crossing, is a light-filled arch which frames Plato and Aristotle, so that they stand out from the crowd, of which otherwise they would only be a part. This is architecture in the grand manner, the kind of thing of which Bramante must have dreamed for his new St Peter's, but never lived to build. In the far right-hand corner, Raphael looks out from behind Sodoma, but to seek identities in the other figures is a waste of time, for they represent not people but formal concepts, and Raphael has listened to Alberti's warning that when portraits and ideal figures are mixed the portraits always dominate. So brilliant is his handling of the formal relationships that it is only with an effort that one recognizes here and there the source of his inspiration

40 RAPHAEL Study for the figure of *Poetry* 1509

41 RAPHAEL *Poetry Roundel* 1509

in a figure adapted from Leonardo or some other predecessor. But it is futile to speak of borrowings here; the personality of the painter is so overwhelming that what he borrows becomes utterly his. This is the true meaning of tradition in the arts: the absorption of ideas and their re-use for new purposes.

The *Parnassus* presented less straightforward problems – the fresco is badly cut into by the window and in his endeavour to overcome this intrusion into his picture space, Raphael has constructed a complicated composition around it, and into depth, so as to suggest that the window embrasure is behind rather than in the midst of the fresco. Perhaps the most beautiful part of the theme is the roundel of *Poetry* in the ceiling, above the fresco. The scenes representing Law are divided between three fields: two scenes representing the establishment of civil and canon codes, and, above the window, *The Judicial Virtues*: personifications of Fortitude, Truth and Prudence, figures full of movement and grace, seen in sharp perspective from below and in poses of strong *contrapposto*.

Raphael appears to have started on the Stanza dell'Eliodoro in 1511, before the Segnatura was finished. He made the larger compositions easier for himself by setting their base lines higher on the wall, so that the doors no longer cut into the picture space, and by means of painted proscenium arches, made more illusionistic by cast shadows, he set the frescoes more deeply into the wall. They are very different indeed from those in the Segnatura. The subjects are highly dramatic, as befits the theme of miraculous preservation; the content is matched by a far more energetic use of light and shadow, and by the portrayal of figures in violent movement. The completion of the first part of Michelangelo's Sistine Ceiling in 1510 was not without repercussions on Raphael's art (as, for instance, in the *Judicial Virtues*) and the vehemence of certain passages in the Stanza dell'Eliodoro suggests that here again he was prepared to adapt another man's ideas

42 RAPHAEL *Expulsion of Heliodorus* 1511–14

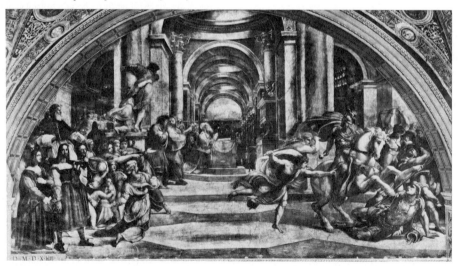

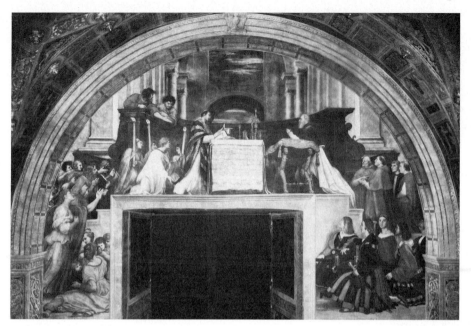

43 RAPHAEL *Mass of Bolsena* 1511–14

to his own purposes. The unity prevailing in the *School of Athens* is patent; that which governs the *Expulsion of Heliodorus* is of a more subtle kind. The story is taken from II Maccabees 3, which tells how Heliodorus was sent to rob the temple at Jerusalem of treasure which included monies held in trust for widows and orphans, and how at the prayer of the High Priest Onias a heavenly horseman and two angel warriors appeared and fell upon him, so that he was defeated in his wicked purpose. The key to the composition is the still figure of the High Priest, praying for deliverance before an altar in the temple. Like the two balances of a scale pivoting on this figure is the group of Heliodorus, violently overcome by his heavenly assailants, and that of Julius II borne by his attendants on a litter, with, in front of him, the group of widows and orphans preserved by the efficacy of the High Priest's

prayer. The High Priest does not see his prayer being answered; Julius looks towards the lone figure at the altar, not at the violent struggle going on in front of him. Three different worlds are combined here: an incident in biblical history; its contemporary counterpart, in the reference to Julius's struggle against the French invaders; and the spiritual aspect of miraculous deliverance present to both, linking it with the other scenes. Stylistically, the composition hinges on the figure of the High Priest, and the union of the two sides is by a subtle counterpoint of masses and contrasting movements. Alberti's warning against the mixture of living and ideal persons has here been flouted more openly than in the *School of Athens*, though Raphael minimizes the contrasts by placing the Pope in profile, like a classical coin, and by deliberately idealizing the heads of the bearers.

43

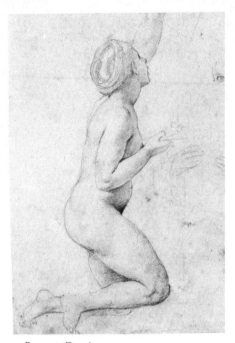

44 Raphael Drawing *c.* 1517

The *Mass of Bolsena* portrays the miraculous effusion of blood from the Host lying on the corporal before a priest who doubted the transubstantiation, and this miracle was popularly, though wrongly, believed to have been the cause of the institution of the feast of Corpus Christi in the mid-thirteenth century. Julius II had a particular devotion to this miracle, since it epitomized for him Divine intervention for the justification of faith, and the vindication of the Church against the vacillation of doubters and the onslaughts of heresy, at a moment when fundamental articles of belief were being questioned. Artistically, the division between historical personages and ideal ones is far better managed than in the *Heliodorus*. Raphael uses the window as a podium for the event, and for the portrait of the kneeling Pope. The worldly side contains some of the finest portraits he ever painted – the wonderful Swiss Guards, and the formidable presence of the old, bearded Pope – while the spiritual side is dominated by the moving figure of the woman with outstretched arm, personifying faith and adoration.

The counterpart to the miraculous delivery in the temple is the fresco of Attila repulsed from the gates of Rome by Leo I in the person of the Medici Pope Leo X, who succeeded Julius in 1513. But here the imagery is trite, and the workshop hands competent but dull, and addicted to movement and gesture for their own sake.

The finest and most imaginative fresco in the room is the *Liberation of St Peter*. It tells the story from Acts 12 of Peter's deliverance by the angel from Herod's prison: this is Divine intervention to ensure the establishment of the Church in the person of Christ's appointed successor at the most desperate moment of disruption and despair in the persecution that followed the first attempts to obey the injunction 'Go ye into the world and preach the gospel to every creature'. It is expressed almost literally as light shining miraculously out of darkness – *lux ex tenebris*. One of the unusual features is that it makes use of continuous representation, a narrative device common enough until the end of the fifteenth century, but one almost wholly abandoned by the High Renaissance in the interests of logic and decorum. The placing of the prison with its barred window immediately over the real window, the marvellous mixture of lighting effects – the dazzling radiance of the angel, the flaring orange torchlight of the frightened guards contrasting with the cool moonlight – are examples of Raphael's mature imagination and inventiveness unsurpassed in any other work.

The remaining room – the Stanza dell'Incendio – is so called from the fresco

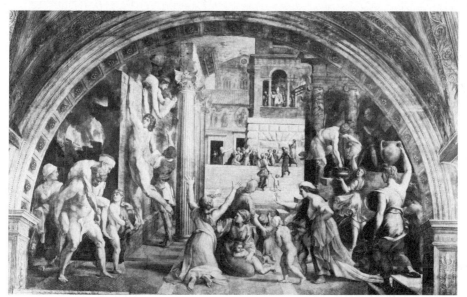

45 RAPHAEL *Fire in the Borgo* 1514–17

46 RAPHAEL *Liberation of St Peter* 1511–14

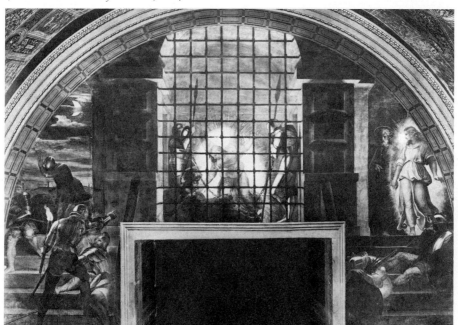

depicting Leo IV praying that a conflagration in the congested area outside the Vatican might be halted – practically, one might say, saving the city by the force of his invocation. Here the execution is almost totally by the workshop, and the increasing vehemence of expression coupled with the isolated character of the individual figures, their lack of cohesion as groups, as interlocking blocks with which the composition is built up, results in a diffusion of interest fatal to the impact of the whole. There are marvellous individual figures: the group of the old man on the shoulders of the young man, commonly known as Aeneas and Anchises, from the deliberate classical parallel of their escape from burning Troy; the man hanging from the wall; the splendid water-carrier with her pitcher on her head, lineal descendant of the classical Maenad figure striding through so many Quattrocento pictures, basket on head and draperies fluttering behind. These are quintessentially Raphael, but the rest is boredom. Yet the reason for this boredom is itself important. It lies in the constant over-inflation of minor figures at the expense of the relationship of part to part, of whole to content. Also, movement and gesture, so satisfying and meaningful in the *School of Athens* because there related to and controlled by the content, have now become ends in themselves with the consequent debasement of the language.

Julius II's patronage of Michelangelo was at first concentrated upon the tomb which he commissioned from the sculptor in 1505. The artist was then working on the painting of the *Battle of Cascina*, for which the cartoon was partly completed, but at the Pope's request the Florentine Signoria sent him to Rome in March 1505; it is significant of his already great reputation that he should be used in this way for political ends. The project for the tomb underwent so many changes that it is difficult to reconstruct all the stages of the work, but originally it was conceived as a free-standing monument, about 20 feet by 30 feet, and about 50 feet high, with a room inside containing the Pope's sarcophagus. It was designed in at least two storeys, or zones, bearing about forty over-life-size and life-sized statues, as well as reliefs and decorative sculpture in a complicated architectural setting. One of the most difficult problems is where the tomb was going to be put; an edifice of these dimensions would have fitted ill into Old St Peter's (and at the time it was planned, projects for rebuilding the basilica were still tentative) except in the new choir projected from 1450 onwards, but never developed. Alternatively, a separate building may possibly have been considered. Michelangelo spent eight months in Carrara selecting the marble, and was doing preparatory work while awaiting delivery of the blocks when, in April 1506, the Pope laid the foundation stone of Bramante's new St Peter's, which meant that his resources would have to be concentrated upon the new basilica. Michelangelo's relations with the Pope deteriorated badly; he found that he could get no payment for materials or work, nor could he obtain an audience; in obedience to the Pope's orders his servants turned the sculptor away. Michelangelo flung back to Florence in a rage of humiliation, resumed his lapsed contract with the Opera del Duomo for the series of apostles, and had partly carved the tormented figure of *St Matthew*, when Julius, equally furious over the defection of his sculptor, forced the Signoria to compel Michelangelo to appear before him in Bologna, which he had captured in August 1506 during his campaign to recover lost provinces of the papal states. Michelangelo had to sue for pardon, and when a foolish cleric attempted to excuse the artist by saying that ignorant artisans of his kind could offend

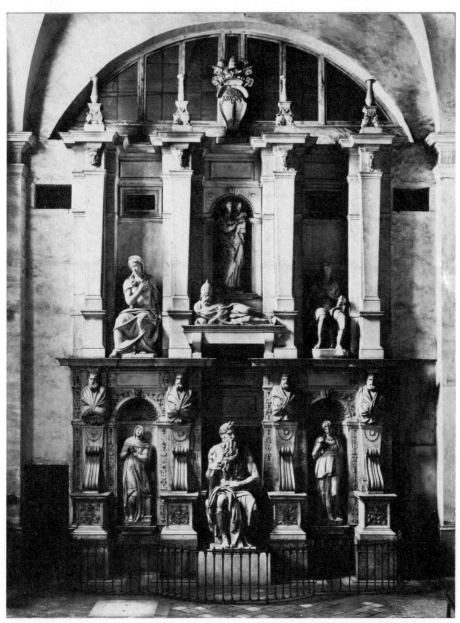

47 MICHELANGELO Tomb of Julius II

unwittingly, the Pope drove out the meddler with blows.

The further history of the tomb, which the sculptor described as the tragedy of his life, was fraught with trouble. When Julius died in 1513, a new contract was made with his heirs, but succeeding popes forced him to whittle down the project so that he should work for them; also, the project was enormously expensive, and Michelangelo was embittered by accusations that he had embezzled monies paid to him on account. Furthermore, Julius's heir was the della Rovere Duke of Urbino, who sided against Leo X in the wars against the French, and in 1515 the angry Pope deposed him from his duchy, and later confiscated all his wealth. Michelangelo had to let the contract lapse while he worked for both Medici popes (Leo X and Clement VII). Further contracts were signed in 1516, 1532, and finally in 1542,

48 MICHELANGELO *Moses c.* 1515–16

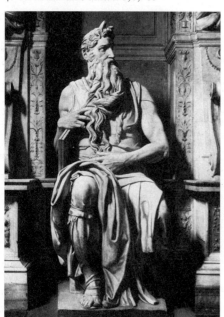

and under the terms of this last one a mutilated version of the original scheme was erected in Julius's titular church, S. Pietro in Vincoli in Rome, in 1545. The first plans for a free-standing monument were abandoned in favour of a wall-tomb – that is, a project which combined Imperial classical with Gothic precedent was abandoned in favour of a restatement of the traditional Florentine type of tomb. Only the titanic figure of *Moses*, surviving from the 1513 contract, gives any idea of the superhuman grandeur of the original conception, which was also to include a series of figures representing the states of the soul, now known as the *Slaves*. Two unfinished ones of 1513 are in the Louvre, and four barely roughed out in their blocks are now in the Accademia in Florence, having once been used in the grotto in the Boboli gardens of the Pitti Palace: these were part of the work done under the 1516 contract. The original scheme also projected Victories, of which the large group of *Victory* now in the Palazzo della Signoria [150] was the only one executed, and this also under the 1516 contract, though it was made while he was working on the Medici Chapel. Finally, as the project contracted, room was only found for the great *Moses*, and for two figures of *Leah* and *Rachel*, representing the Active and Contemplative Life; a recumbent effigy of the dead Pope, and a *Virgin and Child*, flanked by a prophet and a sibyl, were executed by pupils and assistants and form the upper zone.

One of Michelangelo's characteristics was that any work on which he was intermittently engaged was always modified in the direction of whatever major work he had on hand at the time. This accounts for the strong 'family likeness' between the *Moses* and the prophets *Jeremiah* and *Joel* in the Sistine Ceiling; between the architecture of the monument and the architectural framework in the

Ceiling; between the later development of the tomb design, and the tombs in the Medici Chapel in Florence. The commission for the ceiling of the Sistine Chapel was forced on him, rather then given, in 1508, more or less as a substitute for the tomb, and he accepted it unwillingly, resentfully, complaining that he was a sculptor not a painter. The first projects were for something rather simple – an illusionistic architectural structure with twelve figures of apostles enthroned in it. But as he began to work, the project grew under his hand until it developed into a cycle containing the most complicated perspective systems, hundreds of figures, a wealth of elaborate decorative detail, based on the richest, deepest and most thoughtful programme that has ever been devised. The programme itself, in a literary form, has not come down to us, which has permitted the most varied interpretations, but this is another instance of the multi-layers of meaning which the work was intended to have, and which it quite easily sustains. His disappointment over the fresco in Florence and over the tomb was worked off by adapting the figures which he had mentally – and sometimes in drawings – created for them, but had hitherto been unable to use. The imagination which had been stimulated to the highest pitch of creativeness by his two abortive commissions now had a field large enough and important enough in which to deploy to the full – the only trouble was that it was not the opportunity he wanted.

The ceiling of the Sistine Chapel is a shallow barrel vault, about 118 feet long by 46 feet wide, with windows in both long sides which cut into the vault so as to produce a series of pendentives between the windows, which are surrounded by lunettes, and have triangular shaped areas, called spandrels, above them at the junction of wall and ceiling. The central

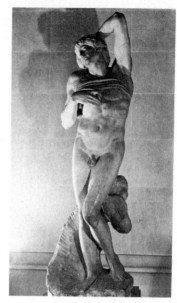

49 MICHELANGELO *Dying Slave* 1513

50 MICHELANGELO *Rebellious Slave* 1513

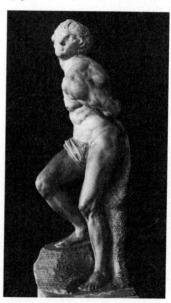

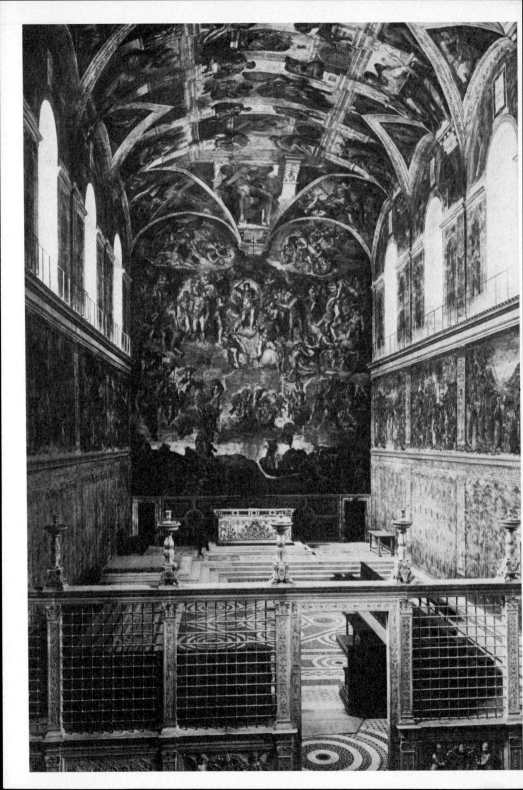

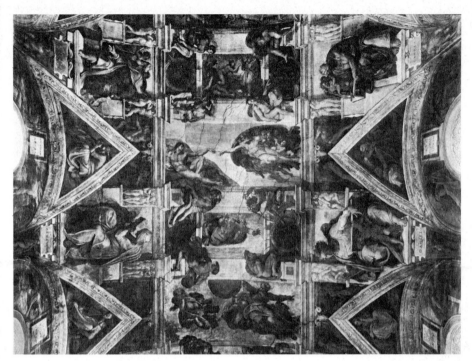

52 MICHELANGELO Sistine Chapel ceiling (detail)

part of the vault is almost flat, and it was probably because of this that Michelangelo defined the centre by means of a painted cornice which appears to be cut by five pairs of painted ribs running from side to side. The spaces so obtained form five small and four large rectangles, and these were filled with scenes from the Old Testament. The choice of subject was conditioned by the existence of the two series of frescoes painted in 1481–82 on the lower parts of the walls; these consist of scenes from the Life of Moses and the Life of Christ, treated as parallels from the Old Law and the New. The obvious choice, therefore, was of scenes from the history of the world before the Mosaic Dispensation, begin-· ning with the Creation. It is important to remember that the sequence of the frescoes

runs from the altar to the entrance wall, whereas the order in which they were painted is the reverse, so that the most important scene, from the standpoint of iconography, – the *Primal Act of Creation*, which occupies the small rectangle immediately above the altar – was almost the last to be painted. At the opposite end, over the entrance used by the laity, the first small rectangle to be painted contains the *Drunkenness of Noah*, symbolic of man in his lost state wholly unconscious of God, and the biblical order of the narrative is slightly adjusted, partly to enable the complex scene of the *Deluge* to occupy a large rectangle, and also to obtain a progressive ascent, spiritually, from the pit of man's degradation to the ultimate splendour of God. There is also a break in

51

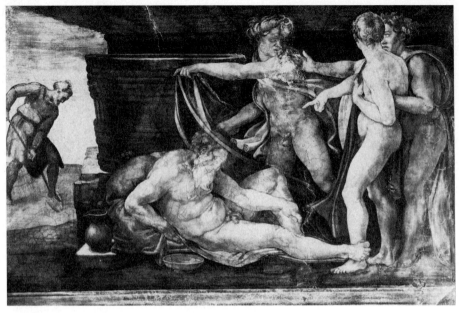

53 MICHELANGELO *Drunkenness of Noah* 1508–10

the narrative corresponding to the original division of the chapel by the screen and the pattern of the floor mosaic into two equal parts – a nave for the laity and a presbytery for the clergy – but the resiting of the screen in later years to make the nave smaller and the presbytery much larger has destroyed the significance of this division.

In the first project, Michelangelo had arranged that most of the actual execution should be entrusted to skilled fresco painters working under his direction. This was normal procedure, and the Raphael frescoes in the Stanze show that extensive use of highly trained assistants does not necessarily rob the original creation of imaginative force: this only happens when the direction slackens.

As the project grew in scale and scope, however, Michelangelo was not satisfied with the workmanship of his assistants and soon dismissed most of them, retaining only such help as he needed for transferring cartoons, and painting the enormous area of architectural and decorative detail. As the sixteenth century understood it, the work was his alone, and in all the major parts it is entirely by his own hand, and has come down to us very nearly intact, so that it is the first of his great paintings, and the highest point of his early maturity. From the spring of 1508 until September 1510 he worked on the first half of the Ceiling; from 1510 there was a long break during which fresh scaffolding was put up for the second half – the part nearer the altar. The first half was officially unveiled on 15 August 1511, and after this work proceeded so rapidly on the second half that the whole was unveiled on 31 October 1512. The second part is more freely painted and simpler in colour, as well as

much larger in scale. This progressive increase in scale is apparent from the beginning: the Delphic Sibyl, the first of the pendentive figures, is larger than the corresponding Prophet Joel on the other side of the *Drunkenness of Noah*, and the nude youths framing the third history are larger than those framing the first. In the *Fall and Expulsion* scene, and in the *Creation of Eve*, the figures are much bigger and simpler than in the three earlier histories, and such was the enlargement that the figure of God in the *Creation of Eve* is so large that if He stood upright His head would be cut off by the frame. High up on the scaffolding, Michelangelo must have found it difficult to get a proper view of his work, though clearly he took measures to see part of it after the third history; it was not until the break in 1510–11 that he could examine his work critically, and the greater breadth, and the abandon of such finicking details as gold used in the decorative parts, is the result.

The most important parts of the decoration iconographically are the nine Histories, which are generally simple in subject and easily identified. For instance, the *Expulsion from Paradise* is treated in much the same traditional way that Masaccio had used nearly a century before; yet not all are so obvious in meaning, nor have all of them precedents in earlier Italian art. The *Deluge*, with the ark in the background, is plainly recognizable, but it is not a common subject – the famous Uccello in Florence is the best-known earlier example – neither is it treated in quite the same way, since it stresses not so much Divine punishment for sin, as the helplessness of man and his hopeless condition if, by abandoning God, he cuts himself off from his means of salvation. The *Creation of Eve* marks the completion of the first half of the Ceiling; the later frescoes are not only simpler and grander in style, but are also entirely new pictorial

54 MICHELANGELO *God separating Light from Dark* 1511–12

equivalents for the first verses of the Book of Genesis. The last four scenes over the choir end of the Chapel deal with the world before the Fall of Man: the *Creation of Eve* is exactly half-way – before the Fall, but the Creation of the means of the Fall. The change is evident in the *Creation of Adam*, with its now famous symbolism of the huge and sluggish form of Adam vivified by the spark of life which seems to pass between his limply upraised hand and the outstretched, commanding finger of God. The other scenes represent the Creation of the Earth, the Sun and Moon, the Vegetable and Animal Kingdoms, with God swinging round in one vast orbital movement; but it is the last scene of all, immediately above the altar, which has always caused the most comment. This – one of the smaller fields – consists of a single figure, much less than full length,

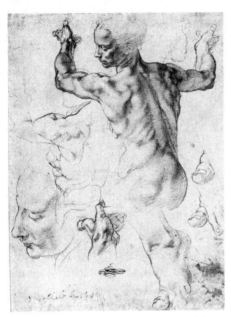

55 MICHELANGELO Studies for the *Libyan Sibyl*
1511–12

56 MICHELANGELO *Jonah* 1511–12

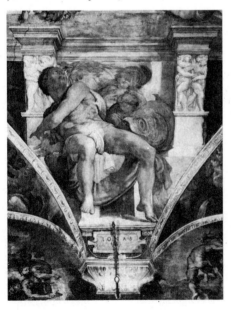

and therefore proportionately larger than the others, symbolizing God dividing light from darkness, or the creation of form from chaos. No one before Michelangelo – and few since – have had the hardihood to imagine the beginning of things in pictorial terms, and it is a measure of the gulf which separated the Early Renaissance from the great period at the beginning of the sixteenth century that no fifteenth-century artist, not even Donatello, would have been capable of this image. But the image is not isolated, and it is in its context with the rest of the Ceiling that its true importance lies, for the Histories are linked with the figures of Prophets and Sibyls and the scenes from the Old Testament in the angles. There are seven Prophets and five Sibyls. From among a multitude of each these twelve were chosen, the men because their particular prophecies accorded with the iconography of the central field or because the tenor of their prophetic thought was in harmony with contemporary circumstance and ideas; the women because they are classical pagan equivalents of prophets, rhapsodic describers of the Creation who, from non-Jewish origins, testified to a belief in the chosen people specially favoured by God, from among whom the Redeemer should be born, not just to the Jews, but to all mankind. Each of these figures occupies the pendentive extending between the windows, level with the smaller Histories; each figure epitomizes pictorially the character of the Prophet or Sibyl chosen. Thus the Prophet immediately above the altar is *Jonah* who is the accepted prefiguration of the Resurrection; this figure of Jonah leans backward in a fantastically complicated and difficult pose, so that he – the Resurrection symbol – looks up at God the Father in the Act of Creation. On either side of Jonah are large triangular spaces, made by the junction at the corner of a pair

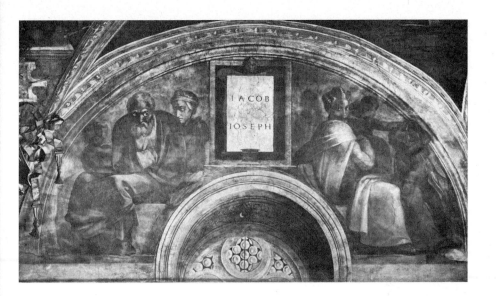

of pendentives, and these contain scenes from the Old Testament traditionally regarded as prefigurations of the Crucifixion and the Redemption of Mankind – the Crucifixion of Haman, and Moses and the Brazen Serpent above the altar wall; David and Judith above the entrance wall. At various points during the celebration of the Mass the priest was directed by the rubrics to raise his eyes to Heaven, and thus the celebrant at the altar in the Sistine Chapel, looking upwards, would have been aware of the two symbolic representations of the Crucifixion, another of the Resurrection, and finally, and most appropriately, of the only possible pictorial equivalent for the words of invocation to the Holy Ghost. It is evident that each scene was very carefully planned and dovetailed in with the representations of the Prophets and Sibyls. Below these figures in the lowest and darkest part where the window cuts into the vault and the wall, are representations of ordinary human beings who are the Ancestors of Christ – those whose names are listed in

57 MICHELANGELO *Ancestors of Christ: Jacob and Joseph*

58 MICHELANGELO *Zacharias* 1508–10

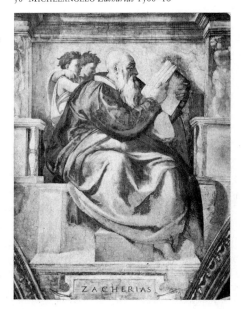

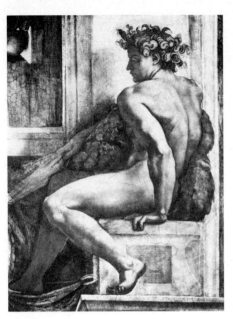

59 MICHELANGELO *Ignudo* 1508–10

the genealogies at the beginning of St Matthew's Gospel. These figures, some single, some in groups, are painted with extraordinary breadth and fluency; they were probably the last to be executed, and their importance as links between the Ceiling and the wall-frescoes is often overlooked.

One important element remains. The four larger Histories occupy the entire width of the vault between the painted cornices, but the alternating five smaller Histories fill only about half the space, the remainder being taken up by large, bronze-coloured medallions painted with small symbolic scenes, now very difficult to see. The medallions are the excuse for the introduction of the celebrated nude figures of young athletes – the so-called *Ignudi* – four of whom are seated at the angles of each of the smaller fields. Nineteen and one head survive – the rest of the twentieth, together with part of the sky

of the *Deluge*, was destroyed by an explosion in the Castel Sant'Angelo in 1797. The real purpose of these figures is difficult to determine. It has been suggested that they represent ideal versions of the human race during the first years of Humanity; this really means that they represent the Neoplatonic idea of the ideal Man, which may be right, since Michelangelo as a young man was in contact with Neoplatonic circles in Florence, and his theological views around 1510 were not necessarily the same as those he is known to have held at the end of his life. At the opposite end of the scale, it has been suggested that Michelangelo added these figures simply because of his passion for the male nude, and that they are a continuation of the ideas that had preoccupied him during his work on the Battle cartoon. This does not explain fully their very important part in the composition, nor is it likely that Julius II – a man of strict piety and rigid decorum – would have acquiesced in the view that the Vatican Chapel was a fit place for the display of Michelangelo's formal obsessions. From the artistic standpoint, it is clear that the possibilities offered by these seated figures fascinated the painter; the *Ignudi* are not controlled by the same rules of perspective as those governing the architectural framework they inhabit, but act as a kind of unifying element between the illusionism of the frame and the direct frontality of the Histories, and also as an intermediary in scale between the pendentive figures and those in the Histories. They too participate in the general increase of scale towards the altar, but even more significant is their diversity of pose.

In the first two sets each pair is derived from a single cartoon which is then reversed, so that with modifications to the lighting each figure has a different aspect. In the second set, Michelangelo introduced considerable changes, always in

the direction of more movement and greater complexity in the pose, so that each figure became an independent creation. At the beginning of the work, the use of reversed cartoons – which is done consistently for the *putti* on either side of the thrones of the Prophets and Sibyls, and under the labels at their feet, and for the shadowy figures in the small spandrels on either side of the thrones – was a labour-saving device probably introduced so as to make use of assistants. But as the quality of his helpers dissatisfied him, and he undertook more and more of the work himself, only the minor decorative parts were thus simplified.

When the Ceiling was completed and unveiled, Michelangelo's dominant position – even higher than that of Raphael – was established beyond any argument. But Julius II died only a few months after the unveiling of the Sistine Ceiling, and the new Pope, Leo X, was a man totally lacking in the titanic quality of his predecessor. He was, however, a great patron of the arts. He determined to employ both Raphael and Michelangelo, but it was clear that in order to do so he would have to circumvent Michelangelo's contract for the Tomb, and also find work for him which would both occupy him fully and not be competitive with Raphael. To employ Raphael in Rome and Michelangelo in Florence was the obvious course. He had known Michelangelo since boyhood, for as the son of Lorenzo de' Medici they had the same Florentine background, but, as he later remarked despondently, 'Michelangelo is impossible to deal with'. Michelangelo's work on the Tomb was, therefore, cut short, and he was dispatched to Florence on a project for a façade for the family church of S. Lorenzo.

During the next years Raphael's reputation and career was in an ever-mounting ascendant. The charm of his personality is attested by all who left any

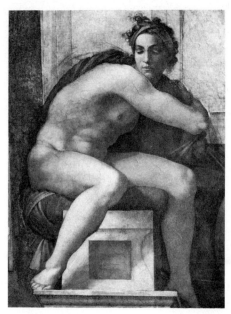

60 MICHELANGELO *Ignudo* 1511–12

record of him; no tantrums, no displays of temperament, the most perfect manners and urbanity, good humoured, convivial, with a lively appreciation of women to which Vasari, with rather envious smugness, attributed his early death. In his art, his ability was uncontested, his knowledge and understanding of antiquity deep and universally accepted by humanists and scholars such as his friend Bembo; commissions of every kind poured in on him – portraits, devotional easel pictures, religious and secular decorations, tapestry cartoons, architecture, the supervision of St Peter's after Bramante's death, the responsibility for listing and conserving the antique remains of Rome. Without a well-organized workshop he would have been lost, and it is yet another of his triumphs that his versatile and capable team achieved so much of passably good quality. In the case of Giulio Romano, he produced an artist of the first rank whose

57

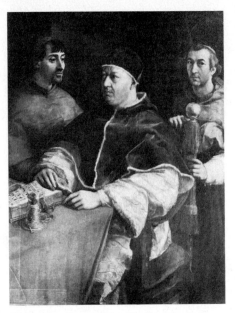

61 RAPHAEL *Portrait of Leo X and two Cardinals*
c. 1519

contributions were far and away superior to those of the average studio hand. Giulio developed a style personal, influential, and quite different from that of his master, upon whom he even came to have a certain effect.

Raphael needed all these things. Though the greatness of many single works – the *Stanze*, the *Sistine Madonna*, the portrait of Castiglione, the *Galatea* – is such that he could have triumphed in any one of his spheres singly, yet the quintessential quality of Raphael is that he is greater in the sum of parts than he is in any of them individually. The range of his mind, quick and intuitive, yet profoundly thoughtful in the attitude he brought to bear upon his problems, his gift for inspired borrowing, for assimilating the best ideas of others, his sensitivity to new trends, make him the most intelligent of the great creative brains of his age. Leonardo excelled because he first iden-

tified the problems, examined them – almost, one might say, created them by isolating the factors which constituted them. Michelangelo triumphs by pure intuitive genius, by creating in his mind, not problems, but forms, ready made, needing only to be freed from the matter imprisoning them – as he himself said in one of his sonnets, 'The greatest artist never had a thought The marble block itself does not enclose Within its shell . . .' Raphael is supreme because he faced the problems he had to solve, and then set about doing so with absolute certainty and confidence. He is the most deliberately intelligent of painters, because he accepted the patrons he had to work for and the limitations they imposed on him, and he understood his own strengths and weaknesses. It is, above all, the quality of his understanding, the strength of his intellect and humanity, the sublime power of his draughtsmanship, which make him the most deeply satisfying, the most inexhaustible artist of his age.

His main commissions in the next years were very varied: the decorations for Agostino Chigi, the Sienese banker who was his friend and patron, the cartoons for the tapestries designed to hang below the 1481 fresco cycle in the Sistine Chapel, numerous portraits, many inventive variations on the theme of the Madonna and Child group, a couple of palaces in Rome, and the Villa designed for Cardinal Giulio de' Medici. His easel portraits were rarely of the formal grand manner type: Julius II, in the Pitti, is more the sensitive reflection of an old man, wearied by his ceaseless struggles, than the proud and energetic pontiff who appears in the Stanze frescoes; Leo X and his two nephews, Cardinals Ludovico de' Rossi and Giulio de' Medici, the future Clement VII, is more an intimate and psychologically penetrating study of power and satellites. His greatest portraits were of those closest to him: the

reticent, unaffected beauty who was the model for so many of his Madonnas, and whom he painted with a veil over her head, looking calmly, confidently, at the spectator; the court poets Beazzano and Navagero, intimate friends, painted as if interrupted in a conversation; his other great friend, Count Baldassare Castiglione, an Urbinate like himself, author of 'The Courtier', preceptor of all who aspired to the conduct and manners of gentlemen. In dark clothes and simple white shirt, he looks out of the canvas calmly and dispassionately, the embodiment of his code that a gentleman wears sober colours and spotless linen, is restrained in behaviour, quiet of speech, and shows his breeding by his modesty and impeccable deportment. His artistic lineage is as grand as his hereditary honours, for Raphael has been inspired to remember the *Mona Lisa*, and the half-turned pose of head and shoulders, the clasped hands, the quiet colour and impassive expression with just a hint of movement in the mouth, prove that even as late as this – the portrait was painted about 1516 – he could still acknowledge a debt to Leonardo. It is, perhaps, pertinent to remember that Leonardo himself was possibly at this moment still resident in the Vatican, the guest of Cardinal Giulio de' Medici who hoped for great things from his patronage, but was totally disappointed, for in the three years from 1513 to the end of 1516 that Leonardo spent in Rome he was interested only in scientific problems, and not a hint of the great artistic developments taking place around him appears in any of his notebooks. Raphael's only considerable change is to substitute a plain background for Leonardo's fantastic landscape, and this change is one that accords not only with the personality of the sitter, but also with the essential stylistic differences between the first and the second decades of the century. In its

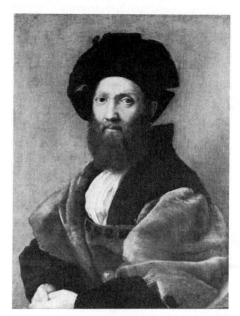

62 RAPHAEL *Baldassare Castiglione c.* 1516

turn, this portrait inspired both Rubens and Rembrandt.

During the years when he was working on the Stanze, Raphael continued to experiment with the Madonna and Child theme. One of his sketchbooks, the so-called 'Pink Sketchbook' now broken up and divided between a number of museums, contained little compositional ideas very like some of the Leonardo drawings which are the prelude to the *Adoration of the Kings* and the *Madonna of the Rocks*. In these sketches, the *Madonna di Foligno*, the *Bridgewater Madonna* inspired ultimately by Michelangelo's *Taddei Tondo*, the *Alba Madonna* and the *Madonna della Sedia*, to name only four, can be seen in their genesis. In general, Raphael's Roman Madonnas follow the new forms dictated by sixteenth-century theories on decorum: timeless draperies envelop the Mother of God, who appears as a Heavenly visitant to her votary on earth. The *Madonna di*

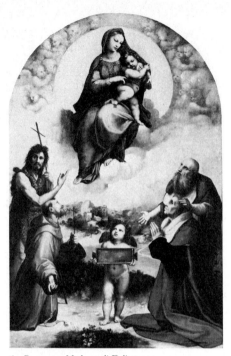

63 Raphael *Madonna di Foligno* 1512

Foligno shows the donor, the papal historian Sigismondo de' Conti who commissioned the picture for the high altar of the church of the Aracoeli in Rome where he intended to be buried (he died early in 1512), kneeling with his patron saints below such a vision, recalling the tradition that the church was built upon the site of an apparition of the Virgin. The Madonna is taken directly from Leonardo's *Adoration of the Kings*, and the Child is adapted from Michelangelo's *Doni Tondo*, but these deliberate borrowings are really no more now than the use of classical quotations in a new context. Unfortunately, the crude nimbus is a later restoration, and the group of saints and donor are heavily studio-handed. In the lower half, only the *putto* is authentic Raphael, brother to the tablet-bearing angels in the *Disputa*.

Raphael's most celebrated Madonna is undoubtedly the *Sistine Madonna*. This famous picture has suffered so badly from its fame that it is now almost impossible to see it with a mind uncontaminated by the distortions of pietistic imagery – holy pictures, plaster statuettes, gaudy enamelled plaques, embroidered banners, the debased artistic currency of good intentions crossed with sentimental religiosity. It is not Raphael's fault that his masterpiece is so universal in its appeal, so uncomplicated in its form and meaning, so direct and tender in its emotion, that the power to see it afresh and to recognize its artistic qualities have been almost destroyed by the repellent popularity thrust upon it by over four centuries of commercial exploitation. It was used as a *velarium* – a kind of screen – to be placed over the bier of Julius II; hence the papal crown standing on the balustrade upon which the two small angels prop themselves reflectively. Carefully placed in relation to the bier this surface would become an extension of the bier itself. Hence also the figure of St Sixtus, an Early Christian pope and martyr, adopted by the della Rovere as their family patron, wearing a cope patterned with the acorns and oak leaves of the family badge – the first della Rovere to become a pope, Julius's uncle, took the name of Sixtus IV. Hence also St Barbara, invoked against sudden death (Julius was in fact a long time dying), in whose commemorative mass the Lesson is a paean of gratitude for deliverance in war, and from calumny and sedition. The visionary aspect of the picture is stressed by the curtain running on the rail at the top, and parted so that the apparition shall appear framed in its folds over the dead Pope's coffin. The Madonna does not walk on the clouds, but is wafted forward, her cloak and veil billowing around her, serene, majestic, barefoot, not because she is a simple peasant woman, but

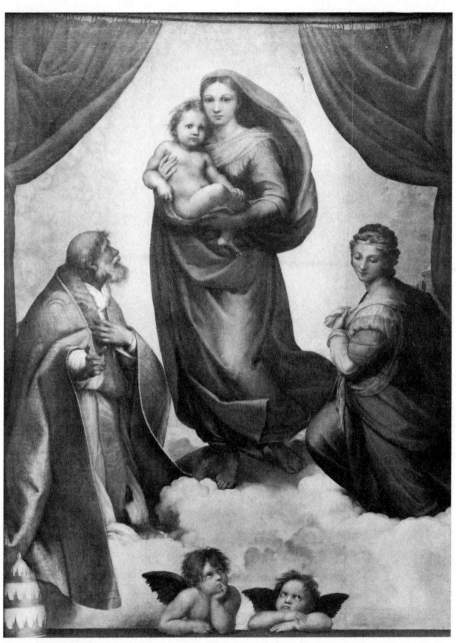

64 RAPHAEL *Sistine Madonna c.* 1513

because she carries the Godhead in her arms, and the 'ground' she walks on is holy. Sixtus looks up at her while gesturing towards the dead man he sponsors; Barbara looks down at the *putti* leaning on the bier; the movement of eye and mind travels up and down again in a coordinated process of thought, noting the frontality of the main group, where the two bodies are yet turned at right angles to each other, the compensating movements and gestures of the saints, and the way the whole is fitted together with such beautiful precision. Though Raphael pursued the theme until the end of his life, no other Madonna achieved the effortless splendour of this one.

The cartoons for the tapestries, commissioned by Leo X, were begun in 1515 and sent to Flanders to be woven in 1516; the first seven were hung in the Sistine Chapel in 1519, and received with acclaim. In subject matter, they completed the icono-graphical theme of the decoration of the chapel, for the Ceiling deals with the Creation and the redemptive promise made to Noah, the Prophets and Sibyls record the history of the Creation and the promises of God, the ancestors of Christ represent humanity in the expectation of redemption, the parallel Lives of Christ and Moses the two Dispensations, and the tapestries begin with the Miraculous Draught of Fishes and the injunction to Peter 'Feed my Sheep' – that is, with the establishment of the Church and its mission – and continue into the Acts of the Apostles with the lives of Peter and Paul, concentrating on those aspects of the apostles' careers which exemplify the Church as the means through which redemption is to be achieved. Naturally, the workshop played a large part in the execution, yet much of the designing, and possibly even of the actual handling, is by Raphael himself. For the '*Feed my Sheep*',

65 RAPHAEL '*Feed my Sheep*' 1515–16

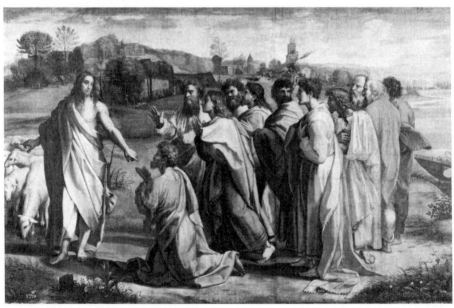

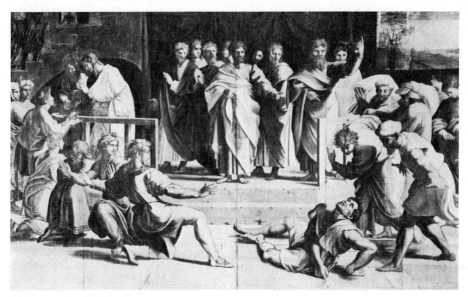

66 Raphael *Death of Ananias* 1515–16

for example, there is an autograph drawing which shows him working out the theme of the ripple of recognition and hesitation running through the group of apostles on the shore, to the telling hiatus that separates the kneeling Peter and the passionately believing John from the figure of Christ. So important is the significance of this theme that it is the only subject to appear twice in the chapel, for the tapestry echoes in several ways Perugino's fresco of the *Charge to Peter* on the wall above. In the *Miraculous Draught* and the '*Feed my Sheep*' the tension mounts with the flow of the action towards the still figure of Christ at one side, yet the action is contained entirely within the picture. In the *Healing of the Lame Man* the architecture of the Beautiful Gate of the Temple so threatened to overpower the miracle in the centre that a host of attendant figures was introduced to redress the balance, and some of these, in gesture and expression, or in, for instance, the musculature of the grotesquely adult child in the foreground, produce an extraordinary diffusion of effect. The two divine punishment scenes, the *Death of Ananias* and the *Blinding of Elymas*, are planned centrally; the *Ananias* in many ways resembles the *Heliodorus*, not only in the pose of the fallen Ananias, but also because the central motivating force is set back into the composition, and there is a distracting almsgiving scene on the left as a counterpart to the group of Pope Julius and his litterbearers. In both these scenes, in the equally dramatic *Sacrifice at Lystra*, and in two which are known only from the tapestries themselves, the *Stoning of Stephen* and the *Conversion of St Paul*, the composition flows on outside the scene with figures lopped off in mid-career as they come, so to speak, into the focus of the artist's concern. The *St Paul preaching at Athens* combines the two types: the figure of the apostle, arms upraised but otherwise still, faces an almost motionless group; only at the sides is there a hint of

63

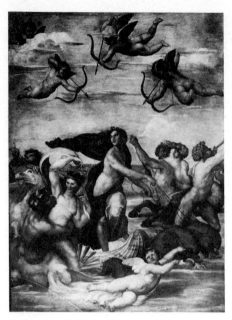

67 RAPHAEL *Galatea c.* 1511

movement outside the composition, in the two believers on the right and the similarly truncated forms of the doubters on the left.

The most striking artistic parallel is that in all the tapestries, except the *Miraculous Draught* and the '*Feed my Sheep*', there is an inflation of gesture, movement and expression similar to that found in the Stanze after the Segnatura. There are splendid details: the columns of the Beautiful Gate, the magnificent gesture of St Paul rending his garments, his majestic simplicity at Athens, and the fascinating architectural detail which includes, at Athens, a curious recension of the Tempietto rather clumsily altered from a rectangular building with green columns. The cartoons, of which only seven survive, remained in Flanders after the weaving was finished. There they became one of the chief vehicles for the dissemination of Italian ideas, but with the unfortunate corollary that the new style was equated with the over-inflation, so

that it was the superficial aspects of movement and drama that attracted the praise and imitation. These cartoons and others by his assistants were also one of the means whereby Raphael's international fame spread over Europe.

Contemporary with the tapestries are the small vaulted compartments of the Loggie, on the second floor of Bramante's range of the Cortile di S. Damaso, which Raphael completed after the architect's death in 1514. These are filled with illusionistic trellises and architectural perspectives, incorporating small biblical scenes – the so-called Bible of Raphael, finished in 1519. They are almost totally the province of the studio, but fascinating, however, in that they show, like the late Stanze, the tapestries, and the Chigi decorations, the evolution of a new style, going beyond the forms of the first years of the High Renaissance towards greater expressiveness and dynamic movement. It is unthinkable that this change in style should have been imposed on Raphael by his assistants, and if they display it with less sensitiveness than he does, it must still be because he himself was tending that way, though perhaps with more restraint, and they over-interpreted his tendencies. There is plenty of evidence that this change of style was intimately connected with the appreciation of the antique, particularly the type of classical art represented by the Laocoon and the Apollo Belvedere – that is, with a classical art expressive of powerful emotions and consciously poetic grace. These qualities, so highly prized in the antique, became also the main qualities which the modern artist sought to express, hence the elegant rhetoric of gesture and pose, and the deliberate elaboration which, from the second decade onwards, becomes the dominant stylistic preoccupation. Coupled with this pervasive influence from important and recently discovered antiques, was the inspiration of the illusionism and use of violent foreshortenings found in the

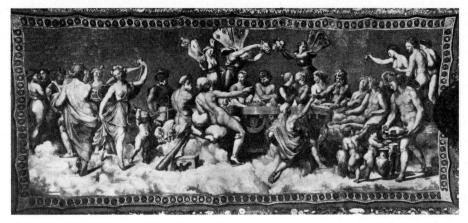

68 RAPHAEL *Wedding Feast of Cupid and Psyche* 1516–17

Sistine Ceiling. It can be argued that Michelangelo never ceased to influence Raphael; upon lesser talents his effect was almost wholly disruptive, because they believed that form and content could be divorced, whereas in Michelangelo they are indivisible.

For the banker Agostino Chigi, Raphael undertook two chapels, one in S. Maria della Pace, the other in S. Maria del Popolo, and the decorations in his Villa Farnesina. Again, the studio was necessarily extensively employed here, but it is astonishing how high a proportion of the planning and execution in these works is, in fact, autograph. The architecture of the chapel in S. Maria del Popolo is also his – a centrally planned building, with a compartmented dome rising to an illusionistic open 'eye', like the Pantheon, through which can be seen a vision of God the Father accompanied and supported by *putti* – a variation on the theme of the open dome which Mantegna had invented in the Camera degli Sposi in Mantua over forty years earlier. In the compartments of the dome are scenes representing the Signs of the Zodiac and the Astrological Houses, so that God the Father, as the Creator of Heaven and Earth, presides over Chigi's

horoscope and receives the soul that has completed its earthly cycle. The Farnesina decorations, done between 1516 and 1517, enlarge the programme begun by Raphael with the *Galatea* painted about 1511; this is a light-hearted sparkling fresco in which the central figure of the nymph is a secular version of the *Madonna di Foligno*. With no more than seven figures, a few *putti* and some sea-beasts, he suggests a riotous, revelling crowd, speeding over the waters. In the adjoining Loggia, Raphael re-created for his friend the classical garden room, hung with garlands and roofed by tapestries stretched beneath the open sky. Here the story of *Cupid and Psyche* unfolds itself slowly from pendentive to pendentive, culminating in the *Council of the Gods* and the *Wedding Feast* on the ceiling. The pictorial illusion of the tapestry hanging solves the problem of the perspective system of the ceiling paintings: since they pretend to be tapestries slung so as to provide a shady awning overhead, they were absolved from the need to create an illusion of space in which the figures should appear as if they were really disporting themselves among the clouds, while the pendentive figures are painted with a moderate illusionism, consistent

65

69 BRAMANTE House of Raphael. Engraving by Lafréry

with their being seen, as real actors in their garlanded stages, from the opposite side of the loggia.

Raphael's contribution to the designing of the new St Peter's was totally negative. There had always been opposition to Bramante's central plan: it was a difficult shape, liturgically; it did not provide enough room for processions or for large concourses; it was deficient in sacristies and subsidiary chapels; it set the façade of the church further back than the existing atrium front, and, therefore, wasted some of the space available which could be used to advantage inside. During Julius's lifetime his decisive personality made further protests unavailing, but Leo X was a much more easy-going man. After Bramante's death, the way was clear for the objectors, and Raphael's plan changed Bramante's project by adding the equivalent of another three bays to the eastern-most arm (St Peter's has a reverse orientation). Eventually, the objectors

won, for despite later returns to the central plan the final form was the present long-naved basilica — Maderno's seventeenth-century modification of Michelangelo's plan.

Raphael's own house was probably designed by Bramante; it was a simple, five-bay, two storey block on an island site; a basement of a range of shops – the open shops of classical antiquity such as are still commonplace in Italian towns – with storage mezzanines over, built with fairly heavily rusticated blocks so as to make a strong contrast with the smooth upper storey of the *piano nobile*, where each bay had a large pedimented window with a section of balustrade below, framed in a pair of applied columns. The plain Tuscan Doric order carried an entablature concealing an attic, and a simple cornice projected over the whole. This plain, unaffected form became the standard for perfect symmetry and balance, proportion and discipline. The building was later

66

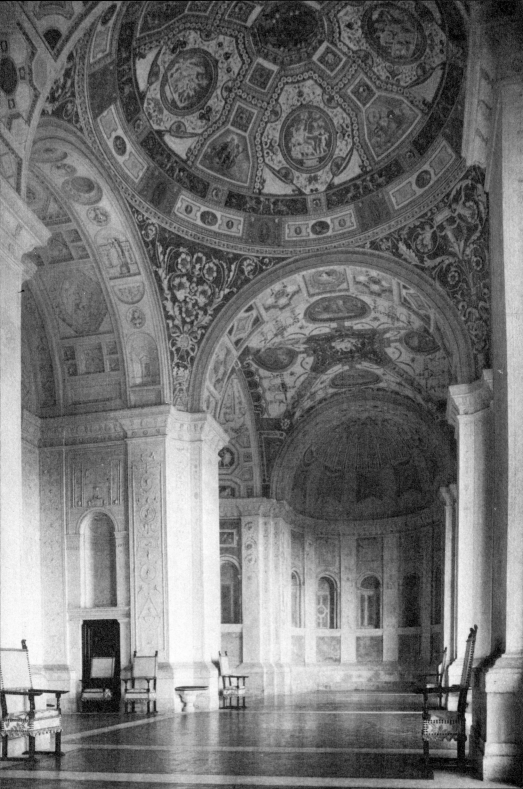

destroyed in a street widening scheme, and it is known only from this engraving and a delicate drawing by Palladio. Raphael's own palace designs are based upon this form, but with important alterations, nearly always in the direction of added richness – more complicated rustication in the basement, a wealth of stucco relief in the *piano nobile*, with niches and swags and variations on the window pattern, so that the rigidly compartmented bay system is broken up, more light and colour is introduced, and the architecture is subjected to a process of enrichment and ornamentation similar to the search for poetic grace and movement in painting. Basically, however, the Bramante House of Raphael type, with the Colosseum type of superimposed arcade, used either separately or combined as façade and courtyard, are the basic elements of Italian palace design for the next four centuries.

The Villa Madama is the reconstruction of another antique form: the country villa, close to the city, designed as a house for pleasure and recreation. Cardinal Giulio de' Medici commissioned it, but hardly lived in it, since Raphael died when it was little more than started, and in 1527 it was badly damaged during the Sack of Rome. Its remains were later restored for Margaret of Austria, 'Madama' or senior lady of the Austrian Imperial house. In the original project, a huge villa was designed round a circular courtyard, with a splendid open loggia giving on to magnificent terraced gardens stretching across the top of Monte Mario, then just outside Rome; only one wing was partly built, but this is one of Raphael's most influential works, since the form of the loggia, articulated by a Giant Order and with huge open bays and superb stucco decoration, was the model for many that came after. The stuccoes were based on grotesques and arabesques, with tendrils sprouting from slender vases, fan-shaped bat-wing mould-

ings, little sphinxes, cameos and medallions of late classical decoration, and the painted vaults repeat these themes with even greater richness and fantasy; their inspiration was the recently excavated Golden House of Nero, so that they offered an irresistible combination of the charm of novelty with the re-use of a classical type. The decoration in this loggia forms the greatest possible contrast to the little church of Sant'Eligio degli Orefici, the chapel of the Goldsmiths' Guild, built soon after 1509, almost certainly in association with Bramante. It is a domed Greek cross, of great purity and sparseness, with no ornament but its fine-drawn lines and a beautifully lettered inscription round the eye of the dome. But this bare, mathematical beauty, dependent on harmony of proportion, was soon found to be lacking in the excitement, in that learned quality present in the element of quotation, which adaptation of late classical decorative forms provided; the bare walls and empty volumes of pure form were then clothed in ornament, so that the same transitions can be found in Raphael's architecture from the beginning to the end of the decade of his Roman career as can be found in his paintings.

In 1517, Cardinal Giulio de' Medici, who was Archbishop of Narbonne, commissioned two altarpieces for his cathedral; one was the *Raising of Lazarus* from Sebastiano del Piombo (now in the National Gallery) [134], the other was the *Transfiguration* from Raphael. The scene is taken almost literally from Matthew 17, where the account of the Transfiguration is immediately followed by the story of the healing of the possessed boy, yet these two entirely separate incidents are conflated by the wide pointing gestures of the disciples in the lower part, who seem to be trying to make the screaming boy see the vision. The contrast between the divine radiance of the vision and earthly confusion and

71 RAPHAEL *Transfiguration* 1517–20

72 RAPHAEL *Study of heads of two Apostles c.* 1517

sorrow, between the means of salvation in which one must believe rather than just witness, and the blindness and suffering of unregenerate human nature, made insensible of its state by possession by sin, seems to be the programme behind this work, and this conflict and tension is stressed by every means in the painter's power. This ambivalence must have been intended by Raphael from the start, since some of his most beautiful drawings are studies for the heads of the apostles in the group in the centre of the crowd. In this, his last work, exhibited in an unfinished state over his bier at his funeral, and yet sufficiently far advanced to be so shown, Raphael is clearly moving towards a phase of his art characterized by mounting emotion and movement, vehemence and dramatic effect. The completion of the work was by his assistants, who may have stressed the new forcefulness at the expense of serenity and balance; but it is clear that this work was a new departure, long meditated in the later Stanze and the tapestries, but which his untimely and sudden death on Good Friday, 1520, left to be exploited by his successors.

The High Renaissance in Venice

In his life of Giorgione, Vasari makes two illuminating remarks. He says that Giorgione was deeply influenced by Leonardo and imitated Leonardo's soft and tender modelling; and he extends his comments by saying that Giorgione's imitation of nature rivalled that of Tuscans who were creating the modern style. He gives to Giorgione in Venice the same position that he gave to Leonardo in Florence in that he equates him with the creation of a new style, a modern style, which superseded that of Bellini and all his other predecessors and contemporaries. The comment on the imitation of Leonardo has usually been dismissed as another instance of Vasari's Florentinism – his determination to make all the best in art anywhere derive from a Florentine example. Yet it is not as improbable as it at first appears. Leonardo was actually in Venice, though only for a matter of weeks, in 1500 after he left Milan. His stay, however short, was not without leaving a deep impression behind, since in 1505 Dürer, in Venice for a visit, took up the theme of *Christ among the Doctors*, which Leonardo had been asked to paint by Isabella d'Este, and had evaded doing. Dürer's picture [258] is so Leonardesque that it may seriously be suggested that some work, possibly a cartoon, by him was in Venice, and that in this self-sufficient city he was known by more than mere hearsay. In 1500, Giorgione would have

been in his early twenties – he is said to have béen born at Castelfranco, some thirty miles north-west of Venice, about 1477/78, and to have been brought up in Venice as a pupil of Giovanni Bellini. He is recorded in the State archives in 1508 as receiving payments for an unidentified picture; he is known to have painted frescoes on the outside of the newly rebuilt Fondaco dei Tedeschi (the northern merchants' warehouse) in 1508; he died in 1510, for on 25 October Isabella d'Este wrote to her agent in Venice instructing him to obtain a 'Night' (which usually means a Nativity) from among his effects. He replied that Giorgione had recently died of plague, but that no such picture was in his estate; he had painted two, but neither owner would sell. On the back of a portrait now in Vienna, called *Laura* from the laurel leaves surrounding her head, is a label saying that it was painted on 1 June 1506 by Giorgione. For a major painter, founder of a new style with far-reaching repercussions on the art of a whole region, this is almost the least amount of documentation known. There are, also, the notebooks of a Venetian connoisseur, Marcantonio Michiel, who recorded pictures he saw in Venetian houses between 1525 and 1543. He records fifteen works by Giorgione, but of these only three can be positively identified, and of the three, two, he states, were finished by others.

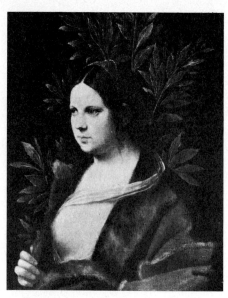

73 GIORGIONE *Laura* 1506

The *Three Philosophers* finished by Sebastiano del Piombo, the sleeping *Venus* finished by Titian, and the *Tempest* mentioned by Michiel, the *Laura*, a surviving battered fragment of the Fondaco frescoes, and the *Madonna and Child with Sts Francis and Liberale* in the cathedral at Castelfranco, which has never been questioned although the earliest mention of it is in 1648, are the core of the attributions to him. There are no signed works, nothing documented but the Fondaco frescoes. The field is enlarged by the two unknown *Nativities* mentioned by Isabella d'Este's agent, and a handful of ill-defined portraits and other subjects listed by Michiel. Yet the canon of accepted works is rather larger because, basically, Giorgione's style, as it can be defined from the hard core, is unmistakable; confusions with Titian occur, particularly in works from early in Titian's career, because Titian himself contributed to the confusion by completing works

left unfinished in 1510, and because he was himself so deeply involved with Giorgione's new style.

The Castelfranco *Madonna* can be seen as a grand manner *sacra conversazione* of the type begun in the 1470s by Piero's *Madonna* in the Brera, and the Venetian ones by Antonello and Bellini in the 1470s and 1480s, though by comparison with Bellini's great altarpieces it is quite a small picture, less than seven feet high and smaller even than the Piero. It is also part of the gentler, more tender tradition of Bellini's smaller devotional Madonnas set in a landscape. The Madonna has a distant, thoughtful, dreamy air, the Child lies passively in her lap, the two saints look neither at her nor at each other, but out at the spectator. The St Francis is a quotation, in reverse, from Bellini's St Francis in the S. Giobbe altarpiece, yet nothing could be more different than these two works. Its proportions are extraordinary: the Madonna is enthroned high upon an enormous pedestal, so high indeed that two saints' heads are well below the bottom of her throne, so that one is tempted to wonder whether Giorgione did not modify his composition from one in which the Madonna was seated originally upon the lower part of the pedestal where the beautiful brocade now hangs. The landscape is entirely in the upper half, and the saints are excluded from it by the high wall at the back of the throne; it is as serenely peaceful as any landscape in one of Bellini's late Madonnas. The light is undramatic, flowing softly round the figures, casting only the slightest of shadows and enhancing the mood of tender, reflective piety. While the separation of the Madonna from the world of the saints and the scene outside fits the change in feeling current in the early Cinquecento in Madonna pictures outside Venice, yet she and the Child are so close to Bellini's elegiac vision that only the

72

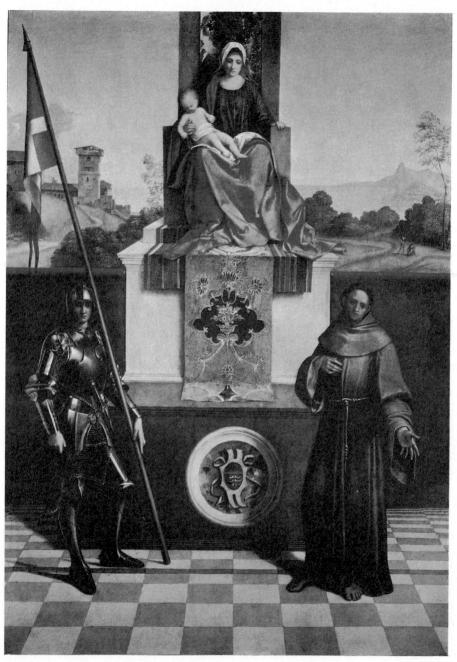

74 GIORGIONE *Madonna and Child with Sts Francis and Liberale*

physical separation of earthly and divine, and the personal appeal of the saints to the spectator, mark this as a sixteenth-century picture.

The *Tempest* is a mystery. No one, not even Michiel, who mentions it as early as 1530, has ever suggested a plausible subject; he records it merely as 'a small landscape . . . with the storm, and the gipsy and soldier . . .' Was there ever a precise subject? It is doubtful, since X-rays have revealed the ghost of another nude woman under the soldier's feet, which would suggest that Giorgione painted it as a landscape of mood, and added figures according to fancy. As a landscape of mood, however, it stands supreme. In the sultry heat, the woman suckles the child, with a kind of pensive tenderness as if she were an earthly form of Madonna with a purely human baby; a curious by-stander (why a soldier? He bears no arms, for his staff is not a lance. Only his slashed breeches suggest a *Landsknecht* – a German mercenary) watches her, and in the distance, beyond the little town to which the bridge leads, a storm has broken and rages furiously. Yet no hint of wind or even a ripple of breeze has reached the detached pair in the foreground. Does it represent the Elements: earth, water, air, and the lightning for fire? Or the Senses: sight, sound (presumably there is thunder in the lightning), touch, taste – but where is smell unless it is implied by the rosebush? Or does it represent Nature: man, woman and child, with the elements around them, and the architecture and his dress to suggest the intellect of man contrasted with her nudity as Nature elemental and unsophisticated? If the answer were known it would be just the answer to a puzzle; it would neither add nor detract from the picture, for its secret has little to do with its magic.

The *Three Philosophers* has been badly cut down on the left: an old copy shows much more of the rock, on which Michiel comments in 1525: '. . . with the rock imitated so marvellously . . .' The subject again is a mystery. Are they the Magi? The Three Ages of Man? The Active, the Contemplative, the Enquiring Mind? The Philosophies of Greece, the East and of Rome or the Middle Ages? Why did Giorgione alter the old man's head-covering from a diadem to a cowl, and does it have any bearing on the subject? What is certain is that upon this work, and ones like it, is based the argument that Giorgione's heightened perception of nature is what brings him into Leonardo's orbit. Bellini's *Stigmatization of St Francis* of the 1480s also has a minute approach to nature in its elaborate detailing of rocks, plants, animals, distant hills and town, and yet no one could call it Leonardesque; the difference between them, therefore, must be in their approach to nature. The Bellini is episodic, the forms assembled and juxtaposed rather like pieces in an exhibit; while the picture is full of marvels they are, somehow, individual marvels brought into a slightly artificial unity because it is essential for the religious content that St Francis should be adoring the works of his Creator. In the Giorgione, the parts of the landscape and the figures cohere; there is no violation of scale between the shelving steps of the rock and the men or the plants; the atmosphere envelops them all equally. As in Leonardo's *Virgin of the Rocks*, nature and humanity are one creation, different in kind but not in essence. The *Venus* expresses the same feeling. Michiel says '. . . nude Venus, sleeping in a landscape with Cupid . . . but the landscape and Cupid were finished by Titian'. X-rays show that the Cupid is under the landscape at Venus's feet, so that this part of the picture must have been finished by Titian and repainted at some time after 1525. Nude figures were no longer, at this date, a rarity, but she is astonishingly unusual.

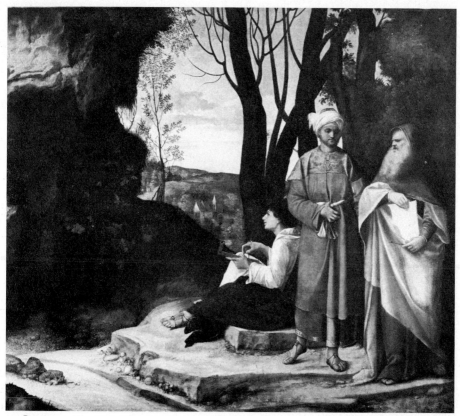

75 GIORGIONE *Three Philosophers*

Her peaceful sleep divorces her entirely from the spectator's world, and there is none of that self-consciousness later found in Titian's *Venus of Urbino*.

Attributions to Giorgione depend, as a rule, on four things. The atmosphere: there must be this feeling of common mood in man and nature, this almost mystical quality found in the Castelfranco *Madonna* or the *Venus*. The colour: Vasari, who wrote about Giorgione after visiting Venice and consulting people who had known him (Titian, for example), remarks in the Life of Sebastiano del Piombo that Giorgione introduced into Venice 'a harmonized manner, and a certain brilliance of colour'. There must be an emotional quality in the colour, a richness, a vibrancy, memorable as much in the modelling and the transitions of greys or creams as in passages of brilliant colour. The content: this is rarely straightforward; there must be a hint of mystery, a withdrawal from overt characterization, for instance in portraits, and in fancy subjects the equivocation becomes complete. Even in religious pictures (for instance, in the Prado *Madonna and Child with Saints* attributed to him, but probably partly by Titian) there is the detached,

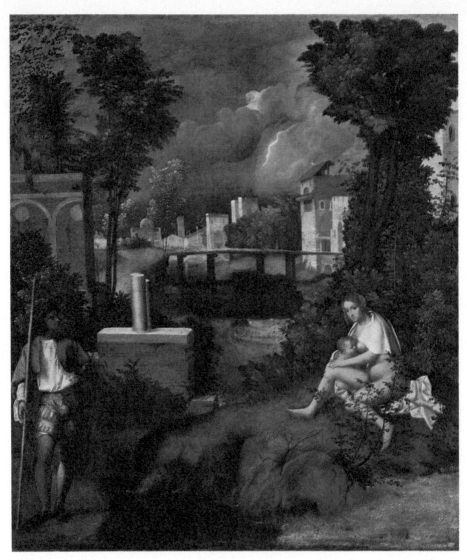

76 GIORGIONE *Tempest*

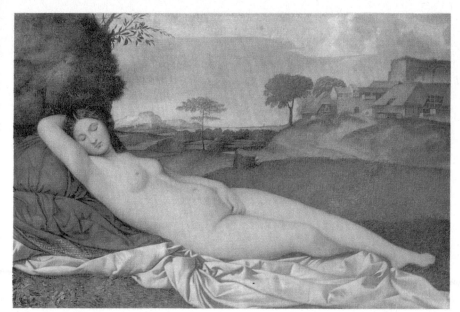

77 GIORGIONE *Venus*

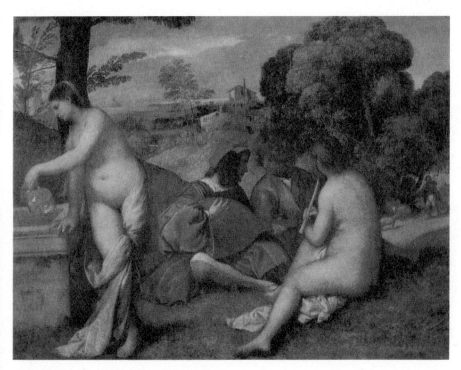

78 GIORGIONE *Concert Champêtre*

79 GIORGIONE *Portrait of a Young Man*

absent quality found in the Castelfranco *Madonna*. The actual forms: Giorgione's heads tend to be round with firmly rounded chins, straight noses and short upper lips; the compact, slightly plebeian features of Laura recur frequently. Even the Castelfranco *Madonna* and the *Venus* have this type, though in both these cases rather more idealized than, say, in the *Tempest*, the Oxford *Madonna*, or the Madonna in the Allendale *Adoration* (Washington).

What of the problem pictures? The *Shepherd Boy* at Hampton Court, the *Young Man* in Berlin, the Louvre *Concert Champêtre*, the *Woman taken in Adultery* (Glasgow), the *Concert* (Pitti), the *Judith* (Hermitage), are the main ones, and there is also a group of male portraits, particularly of men in armour, and a number of small landscapes with figures, usually a classical story or myth. The Berlin portrait is universally accepted; the *Shepherd Boy* is accepted as a very damaged original: both

have the sensitive tenderness and the delicacy of handling agreed as hallmarks. The *Judith* is now generally accepted; certainly it has the astonishing flaming colour, the sensitive withdrawal, the deliberate abstention from the more sensational aspects of the subject. Was this, by any chance, the painting done for the State commission? Was it a Justice subject for an official position? Is not the *Adulteress* too active, the poses too energetic, seen from too unusual a viewpoint to fit in with the mystery and restraint characterizing his other works? The colour, too, though very startling and strong, is just enough on the crude side to suggest an adventurous follower rather than the master himself. The *Concert* and the *Concert Champêtre*, so different in every way, have one thing in common: in both, two musicians turn and look into each other's faces with a yearning, hauntingly intimate glance. The haunting look is a favourite device of Titian's; most of his figure compositions, religious or secular, have it, for it is one of the ways in which he ties a composition together internally, whereas the certain Giorgiones avoid this involvement between the figures. The women in the *Concert Champêtre* have a strongly Giorgionesque character, but the landscape, and the handling of the paint and brushwork are closer to Titian. Is it a work which Giorgione had begun before his death, and which Titian completed for its commissioner?

At most, Giorgione's career can have been no more than ten years long, but it sufficed to introduce four new features into Venetian art: the secular subject, painted in small size, for private houses, private enjoyment, collectors, much as Bellini had introduced small religious works never destined for a church; tender chiaroscuro, with infinitely delicate gradations of modelling, and richly evocative colour; the nude; and landscapes painted for their

own sake. In all these he not only set the style of the new century, but exercised a powerful influence on Bellini himself. The S. Zaccaria altarpiece of 1505, the exquisite *Madonna degli Alberetti* ('with the little trees') of 1510 in the Brera, the *Feast of the Gods* and the *Toilet of Venus* of his last years show how responsive the old Bellini was to the new ideas and feeling abroad. Then there was Giorgione's impact on the younger generation: Palma, Sebastiano, Titian, Savoldo, Paris Bordone, and Dosso Dossi, hastened to follow in the path he first trod. He also seems to have been the antithesis of the usual professional painter: like Leonardo, a lover of music; like Raphael, a lover of women (his

undoing, in that he is said to have caught the plague from his mistress); his delicate and poetic temperament bring him clearly into the Cinquecento orbit of Raphael, for the painter who is also a poet, a musician, a man of education and breeding, besides being a genius, is an essential feature of the new century. No one exemplified the duality of the artist of the Renaissance more than Titian, who was the heir, not only to Giorgione's unfinished pictures, but to the position his untimely death left open in Venice.

Titian was born at Cadore, a hill town in Venetian territory, and sent to Venice when still a child to be trained as a painter, first in the workshop of a designer of

80 TITIAN *Bishop 'Baffo' presented to St Peter c.* 1503

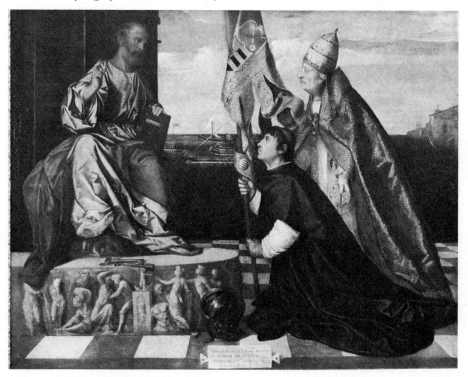

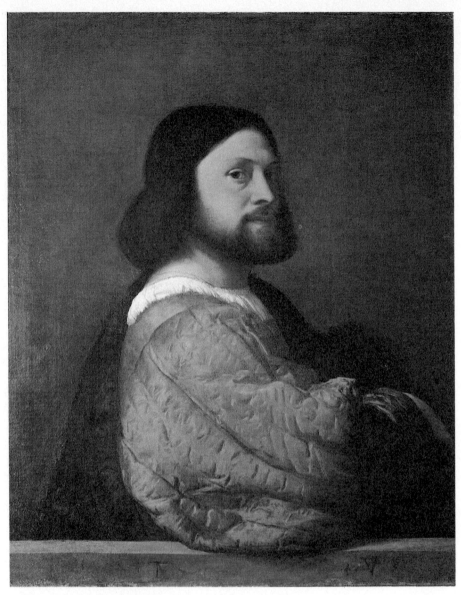

81 TITIAN '*Ariosto*'. *Portrait of a Man*

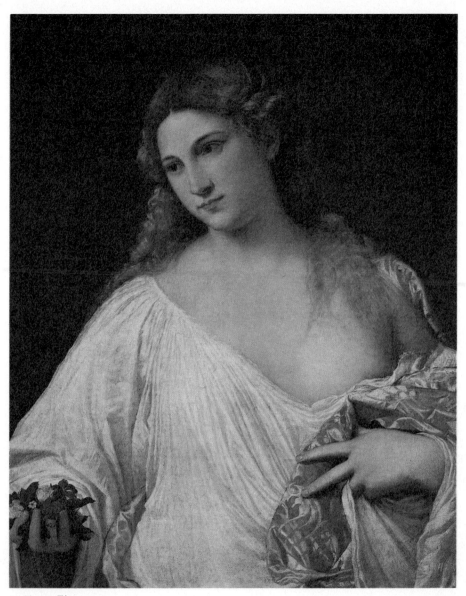

82 TITIAN *Flora c.* 1515

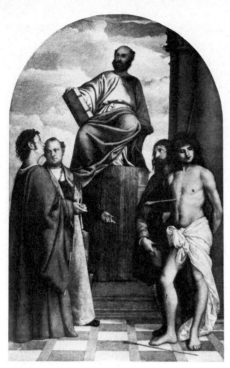

83 TITIAN *St Mark and the Plague Saints c.* 1511

mosaics, and then with the Bellinis. His immensely long and important career contains only one problem: his birthdate. In 1571, in a letter to Philip II of Spain, asking for overdue payment, Titian said he was ninety-five; this makes him born in 1476. Vasari, who knew him, begins by saying that he was born in 1480 and later says that he changed from Bellini's to Giorgione's manner of painting when he was eighteen, and another mid-sixteenth-century writer says that he painted frescoes at the Fondaco with Giorgione when he was twenty. This makes him born in 1488. Titian's earliest work is usually considered to be the portrait of Bishop 'Baffo' (Jacopo Pesaro, Bishop of Paphos in Cyprus) kneeling before St Peter and receiving from Pope Alexander VI the command of

a papal fleet. This took place in 1501, and Alexander died in 1503. The picture is evidence of just that change of manner to which Vasari refers, since St Peter is very Bellinesque, with tightly crumpled folds in his raspberry pink robe, while the figures of pope and bishop are more broadly and freely painted. If Vasari is right in his second dating, then Titian would have been born about 1484, and have been an assistant to Giorgione on the Fondaco when he was about twenty-four. A birthdate between 1484 and 1488 is a more rational one, since it is difficult otherwise to account for so great a genius as Titian being merely an assistant to a man of his own age when thirty-two. In December 1510 he was in Padua, where in 1511 he painted three frescoes in the hall of the Confraternity of St Antony, and in 1513 he declined an invitation to Rome in order to return to Venice. Sebastiano had gone to Rome in 1511; this meant that, with Giorgione dead and Bellini in his eighties, Titian could expect soon to achieve an outstanding position. Bellini, in fact, lived until 1516, and Titian caballed against him relentlessly in the last years of his life in an endeavour to displace him from his official position.

There are, in Titian's continuous output of masterpieces, certain works which are like landmarks; these are the pictures which mark some new development – a new treatment of an old theme, a new solution to a standard problem, a new approach in vision or meaning, a new technical departure. Giorgione, in the years following his death, has a strong influence on Titian. The so-called *Ariosto* portrait in the National Gallery with its use of the little parapet to set the figure into space, the softness of the modelling, the enveloping quality of the light and that sense of air around the sitter, stems from Giorgione. The *St Mark and the Plague Saints*, now in the church of the Salute in

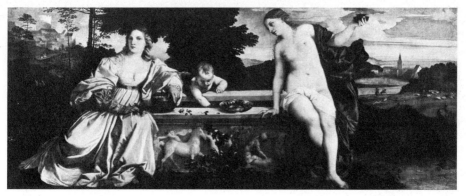

84 Titian *Sacred and Profane Love c.* 1515

Venice, was painted probably as a thank-offering for the end of the terrible 1510 plague, and it has – besides its startling innovation – a sense of unity of surface, of depth in colour and composition also basically Giorgionesque; the innovation is the rather gauche device of allowing the shadow of the great columns to fall across St Mark's head and shoulders. It enables Titian to achieve an exciting design by silhouetting the saint darkly against the creamy coloured clouds, and also detaches him effectively from the group below. The superb *Sacred and Profane Love*, of about 1515 is in the direct line from Giorgione's mysterious fancy pictures – no one has so far suggested a firm subject for a work clearly of the same 'family' as the Louvre *Concert Champêtre*; in a sense it is quite different, but this is because where Giorgione was a creature of mystery and obliquity, Titian is a direct, overt personality. His nudes are never diffident, and his pensive woman here is quite decided in her attitude. The small *Madonna and Child* in Vienna, known as the 'Gipsy Madonna', is clearly in the direct line from Bellini's late ones; but with the lovely Madonna groups of the years immediately after Giorgione's death (Edinburgh, London, Madrid, Dresden, Genoa) a new line is opened up. These are barely larger than the late Bellini Madonnas, but the feeling in them is of much more movement, the forms are fuller, and the composition depends on a more complex balance and rhythm of poses. The colour is more richly modulated, and the sweet and tender Madonna has given place to a more opulent, grander type of female beauty. The same process is at work in his portraits of women: Giorgione's rather shy Laura is succeeded by superb beauties, like the Louvre *Girl doing her Hair*, or the same girl posing as *Flora*, or as *Salome* (Rome, Doria Gallery). Whether true or fancy portraits is irrelevant; what matters is the new type of picture, for they are collectors' pictures, bought because paintings are now things to possess and admire and are not merely objects or stimulants of piety. Even the old Bellini understood this new current, for the *Feast of the Gods* and the *Toilet of Venus* painted in the last years of his life exploit this secular vein, just as he understood the import of Giorgione's new withdrawn approach to the Madonna picture, as his late *St Jerome* altarpiece in S. Giovanni Crisostomo shows.

With the *Assumption of the Virgin*, in the Frari, Venice, a new stage is opened. The commission was given in 1516, and the

83

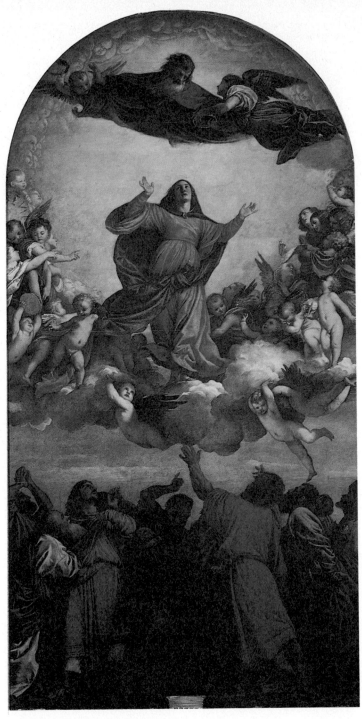

85 TITIAN *Assumption of the Virgin* 1516–18

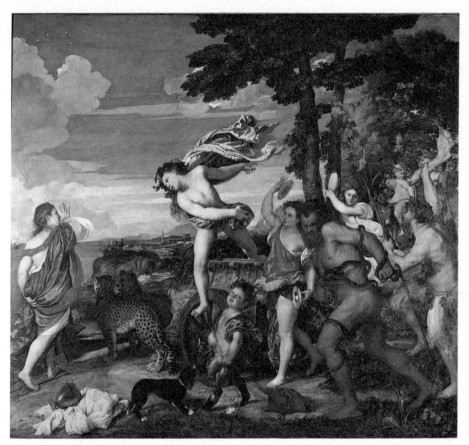

86 TITIAN *Bacchus and Ariadne* 1522

picture unveiled over the High Altar in 1518. It is a huge work, about 23 by 11 feet, half as large again as Bellini's biggest picture. The composition depends upon the surge of the figures, for here the Virgin is not merely rising into Heaven: she is virtually projected upwards by the compressed force emanating from the compact group around her empty tomb, and is poised against the radiance of golden light suffusing the sky behind her. The new attitude towards representations of the Virgin is very obvious here; like Raphael's *Sistine Madonna*, with which it is contemporary, this is no merely mortal woman, but the Mother of God, human in her rather timid and adoring confidence, yet aware of her glorious destiny. Just as Raphael in the *Disputa* had used one man's gesture to link the earthly and heavenly spheres, so Titian uses the same device, and the astonished apostle is the earthly link, as the little angel beneath the heavy load of his cloud is the heavenly link with the earthly zone. The handling of the light and shadow pushes the silhouette device

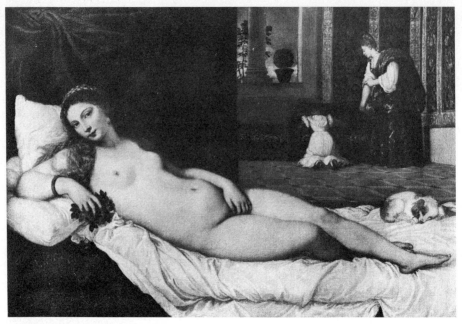

87 TITIAN *Venus of Urbino* 1538

tried out in the early *Plague Saints* much further. There is, throughout, a brilliant use of a rich texture of light, woven in and out of the composition, and obeying the logic of the movement, so that the apostles stand amazed in the shadow cast by the skein of angels tumbling about on the clouds which accompany rather than support the Virgin as she soars from darkness towards the source of light.

After this, nothing can astonish. The *putti* from the *Assumption*, as well as their heavenly role, also play in an infant *Bacchanal* round the feet of Venus, and flutter like little plump birds among the trees. This and the *Bacchanal of the Andrians*, were painted between 1518 and 1519 for Alfonso d'Este, Duke of Ferrara, for his '*studiolo*', for which the London *Bacchus and Ariadne* was painted in 1522, and the first picture in the series had been Giovanni Bellini's *Feast of the Gods*,

painted in 1515, in which Titian repainted the landscape to match the other pictures in the series. The *Infant Bacchanal*, or 'Homage to Venus', and the *Andrians*, are subjects taken from descriptions by Philostratus of ancient Greek paintings; the *Bacchus and Ariadne* is from one of the several accounts of the myth, as it is told by Ovid for example. The composition of the *Infant Bacchanal* is odd, in that the focus of the design is on the extreme right, in the statue of Venus, while in the *Andrians*, despite the energetic movement from the back to the foreground of the picture, the attention is riveted upon the superb nude in the very front. She is, of course, Titian's answer to Giorgione's Venus – sleeping, quiescent, oblivious; but her pose instead of the soft, relaxed Venus, is tense, and her nudity is a deliberate contrast with the semi-clothed figures of the other bacchantes, and almost a heightening of the

effect by the implications of moral progression. As in the *Assumption*, the light moves backwards and forwards in the picture, making islands of shadow amid the brilliant sunlight, and the poses of the figures in the foreground are so arranged as to lead the eye backwards into depth. Only the splendid nude is an isolated fixed point, and in the far background the drunken old man on the hillock epitomizes the degrading aspects of inebriety which her beauty and peacefulness effectively disguise. The *Bacchus and Ariadne* has the same remarkable feature as Raphael's *Galatea*: with no more than seven figures Titian suggests a riotous throng pressing forward upon the startled Ariadne, while Bacchus's movement, suspended in mid-career, suggests the godlike power of levitation. Between the two main figures the distant landscape looks towards quiet villages and sea-shore, and in all the series the landscape is as important a part of the composition as the figures, and is suffused with air and light; these are not landscape backgrounds, but figures in a landscape. There are subtle quotations, too, by which Titian proves that he knew what was happening elsewhere in Italy: from Michelangelo's *Battle of Cascina* in the *Andrians*, from the antique *Laocoon* in the *Bacchus*. In this group of works, painted for a discerning patron, Titian's imagination grows with his technical powers. The handling of the wonderful nude, or of the bacchante behind Bacchus, is full of tenderness in its management of light, and of the dappled effects of passing shadow. These mythologies look forward to the *Venus of Urbino* of 1538 – that even more deliberate challenge to Giorgione – though here he is really fighting in a different battle. This Venus is no goddess, caught unawares on a summer afternoon; this is an expensive and successful courtesan, her hair tumbling from her diadem over her creamy shoulders, her lovely face

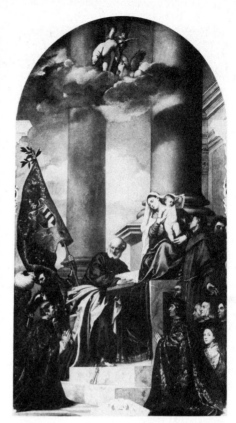

88 TITIAN *Pesaro Madonna* 1519–26

empty of all expression but that of self-confident self-admiration, displayed with the trappings of her art upon an all too suggestive bed, with her maids in the background laying aside her worldly store in rich chests while she lies contentedly, 'for where your treasure is, there will your heart be also'.

In 1526 he finished another of the turning-point pictures, not just of his own career, but of the whole history of Venetian painting: this is the *Pesaro Madonna* commissioned in 1519 by the same Bishop of Paphos who had been represented in the first of his major works in 1502/03. This is more a Madonna and

87

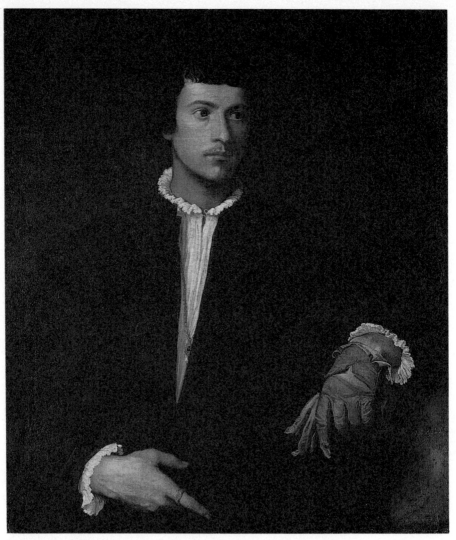

89 TITIAN *Young Man with a Glove c.* 1520

Child with Saints and donors than a *sacra conversazione*, but one very different from all earlier ones. For the first time the composition is oblique, with the Madonna seated upon a high throne well to one side, St Peter virtually in the centre below her; the male members of the Pesaro family, kneeling on either side below, are *repoussoir* elements which push the composition back into the picture space. The device of the huge columns is also important for the future: they punctuate the composition carefully, so that the great vertical rising from the kneeling Pesaro on the right

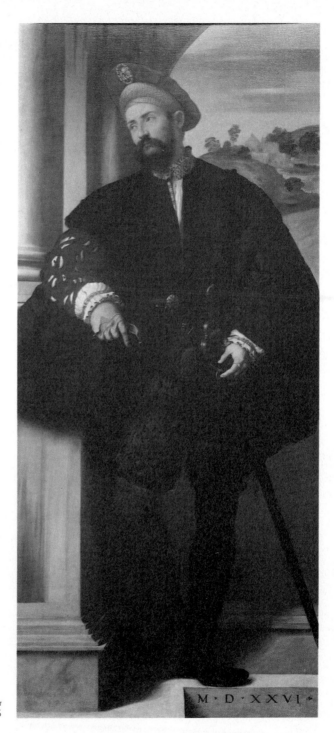

M · D · XXVI ·

90 MORETTO *Portrait of a Man* 1526

continues through the St Francis and the upright Christ Child, and the one on the left defines the back plane of the composition and accentuates the two figures leaning away from each other – St Peter inwards towards the Madonna, the standard bearer with his gorgeous banner outwards towards his captive Turk, to create a massive block above the kneeling Bishop. The sequence of the Madonna's head, the base of the column behind her, St Peter's bald head looking down and his brilliant golden robe lead across the picture down to the dark figure of 'Baffo' in his black silk gown, while at the top the columns pierce a small cloud bearing *putti* with a Cross; this device not only fills the upper part but also echoes the light and shadow below.

The next great landmark has been destroyed: his *Death of St Peter Martyr*, finished in 1530, was burnt in the same fire in SS. Giovanni e Paolo in 1867 in which the first big Bellini *sacra conversazione* was lost. The composition, known from copies and engravings, bursts open like an explosion; the murderer and the fleeing companion form a huge open V rising from the dying saint, and the trees soar upwards and outwards to echo and reinforce this movement. In the midst of the foliage, two *putti* brandishing a

91 After TITIAN *St Peter Martyr* (engraving by Martino Rota)

92 TITIAN *Presentation of the Virgin* 1538

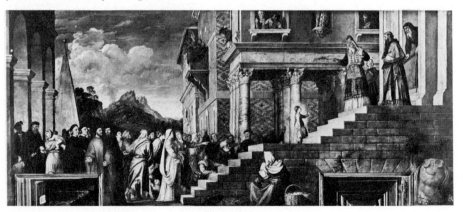

martyr's palm hover as if appalled at the deed below. The novelty here is not just in the movement, but in the way the trees are made to participate in the emotion of the scene.

The *Presentation of the Virgin*, finished in 1538, and still in the place for which it was painted in what is now the Accademia in Venice, marks another stage in his career; after this, something darker, more troubled enters his art, something which, later, his stay in Rome strengthened. He was now the foremost painter in Italy after Michelangelo. Of his major Venetian competitors, Palma Vecchio was dead, Pordenone – once his friend but his inveterate rival after Titian won the public competition for the *St Peter Martyr* – was to die the following year, Sebastiano had never returned from Rome except for a visit in 1529 when Michelangelo was also in Venice during his brief flight before the siege of Florence, Lotto worked outside Venice, and people like Cariani, Romanino, Savoldo, though interesting were not really competitors at all. Titian remained supreme, and it can be contended that his position in Italy was not seriously challenged even by artists of the stature of Andrea del Sarto, Pontormo or Correggio. Only Michelangelo was of the same metal, until Tintoretto appeared on the scene. During these years, he had also become the most important portrait painter in the world: the *Young Man with a Glove*, of about 1520, full of air and space; *Federigo Gonzaga, Duke of Mantua*, perfumed and gallant, playing with his pet dog, of about 1525–28; the full-length portrait of the *Emperor Charles V* with his mastiff, copied in 1532 from Seisenegger's similar portrait with such success that Titian immediately displaced the German as the Emperor's favourite portrait painter; the splendid pair of *Francesco Maria della Rovere, Duke of Urbino*, and his *Duchess, Eleonora Gonzaga*, which must have started

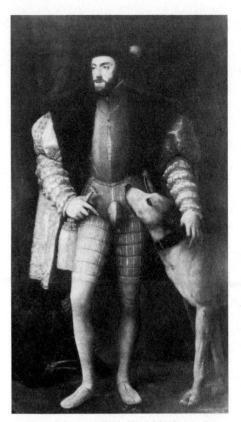

93 TITIAN *Emperor Charles V with his Dog* 1532

as full-length portraits since Titian's drawing of the warrior-Duke shows him standing; and the group of female portraits – *Isabella d'Este*, in clothes and headdress as pretentious and with a pretty but obstinate face as meanly hard as her whole personality; the gorgeous *La Bella* (she is the courtesan who is also the *Venus of Urbino*); they became the norm by which portraiture was judged. Though he does not seem at any point to be indebted to any non-Venetian inspiration, yet the largeness and spaciousness which informs all his portraits, even the least significant, partakes of the atmosphere and understand-

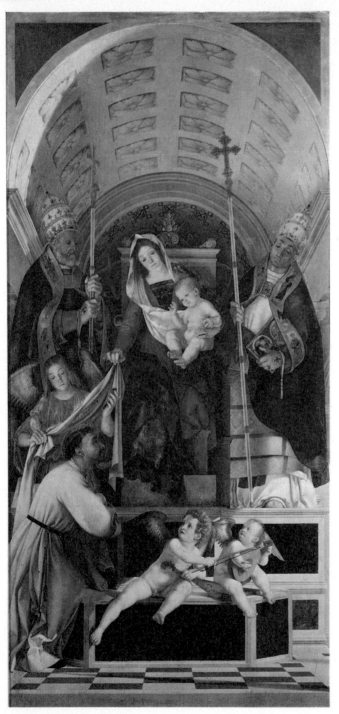

94 LOTTO *Madonna and Child with Saints* 1508

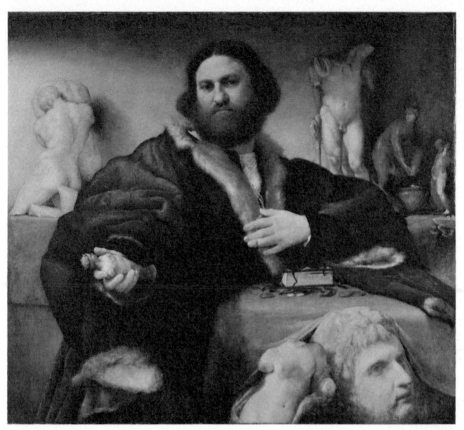

95 LOTTO *Portrait of Andrea Odoni* 1527

ing which is a characteristic of all Cinquecento Italian portraiture from Leonardo on. Dull though it is, since it is a spirited copy only, the *Charles V* is possibly the most important, since this full-length portrait marks a new development. Full-length portraits occur first in Germany – notably the pair by Cranach of *Duke Henry of Saxony* and his *Duchess* of 1514 [261–2] – and then spread south of the Alps with Moretto of Brescia, who dated one in 1526 [90], though of course the genre is inherent in donor portraits in religious works, which had only to escape

from their religious context to become subjects on their own. They represent, however, a distinct stage in the esteem for painting and collecting, and, also, in the liberation of the portrait from its earlier limitation to bust and half-length, one of great importance for the rest of the sixteenth century and during succeeding ones.

Palma Vecchio, born in 1480, and therefore of the same generation as Titian, was, like him, a pupil of Giovanni Bellini, and equally influenced by Giorgione, though he adds something derived from Lotto. He

93

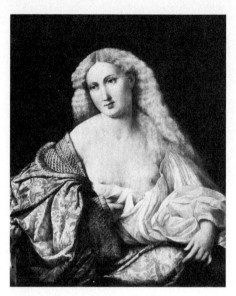

96 PALMA VECCHIO *Portrait of a Woman*

can be very Bellinesque in his early altarpieces, but rapidly adopted Titian's style in later Madonna groups. His speciality was the opulent female portrait – large expanses of creamy flesh, crimped blonde hair, idealized features, and rich brocades with a sharp contrast of fine white lawn. But they too follow Titian's example. He died in 1528. Pordenone, so called because he was born in 1483/84 in this small town forty-odd miles north-west of Venice, was trained outside Venice, and was only marginally affected by Giorgione. He was fully aware of Central Italian painting and strongly influenced by Mantegna's illusionism, and by Sebastiano del Piombo's later mixture of Venetian and Michelangelesque forms. He was in Rome about 1516, and Raphael impressed him deeply, so that his style becomes an amalgam of many different inspirations, reacting upon his own passionate and stormy temperament. His *Crucifixion* in the cathedral at Cremona of 1521, shows

an almost German lingering over emotional detail and irrational naturalism, but such works as the organ doors with *Sts Martin and Christopher* in S. Rocco in Venice, of 1528, pose problems about the introduction of Mannerist forms into Venice, for they use some of the commonest Mannerist devices such as large figures in too small a space, strained movement and strong chiaroscuro used for its own sake. He was a highly peripatetic artist whose works are scattered widely over the north-west of Italy, and he was in Venice a good deal from 1527 onwards, during which time he exerted himself to compete with Titian. But the outcome of the contest soon left him with fewer illusions, and changed his admiration for Titian into embittered rivalry, so that he endeavoured to displace him as official painter to the State. He died suddenly in Ferrara in 1539.

Lorenzo Lotto presents a very different kind of artist from any of the grand Venetians and their immediate imitators. He was probably born in Venice about 1480, and since his early works are strongly Bellinesque he was probably trained in the Bellini workshop. His first notable work, in a church near Treviso and painted about 1505, is clearly dependent on the type created by Giovanni Bellini in the S. Zaccaria altarpiece, since it has the same disposition of figures and architectural setting. In 1508, still in this strongly Bellinesque style, he painted the large polyptych at Recanati in the Marches, a picture suffused with light, and in particular with light reflected from the vaulting of the loggia which shelters the group of Madonna and Child with attendant saints and angels from the brilliant sun outside. By 1512, in an *Entombment* painted for a confraternity in Jesi, another small Marchigian town, a knowledge of Raphael's *Entombment* seems obvious, crossed perhaps with the dramatic effect of

Donatello's Paduan *Lamentations*. During the next ten years he pushed this influence from Central Italian art much further, profiting from Raphael and Fra Bartolommeo, and then in the mid-1520s from Correggio, then from Florentine Mannerists such as Pontormo. His colour too is forced to an incredible brilliance and emotional effect, with violent pinks and reds, cold yellows, and sultry olive greens. There is something German – Altdorfer and Grünewald come quickest to mind – about the colour of his later works, though how he could have seen any of their paintings is a problem: only perhaps in Venice to which he returned frequently between his many provincial commissions, since Venice contained German paintings imported by the northern mer-

chants established there. In some of his very late works his feeling is of a surprising intensity; the 1545 *Pietà* in the Brera has sixteenth-century forms, but the composition makes the picture almost a modernization of one of the late Botticelli *Pietàs*, like the one in the Poldi-Pezzoli in Milan. It is in his portraits, however, that Lotto reaches his highest point. Many of his altarpieces are mannered and unquiet; his portraits consistently show his respect for nature, his innate qualities of design, and a distinguished artistic personality. He always achieves a bold silhouette, an authoritative placing of the sitter on the canvas, and the choice of a telling gesture, or an evocative still-life. The colour range is superb: his favourite slaty blues, glowing scarlets, olive greens and a rich

97 PORDENONE *Crucifixion* 1521

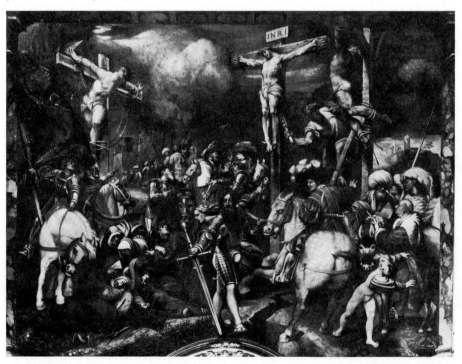

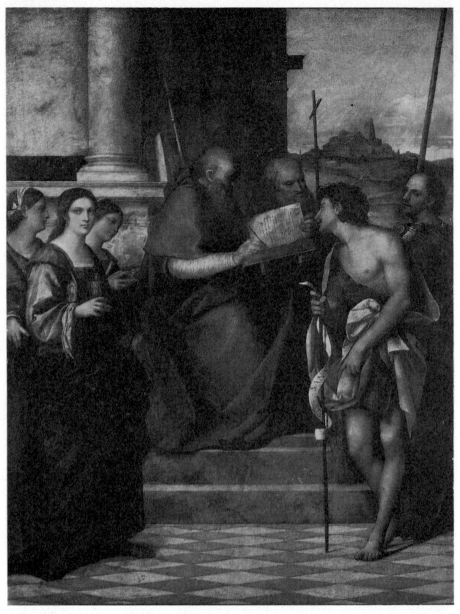

98 SEBASTIANO Altarpiece of S. Giovanni Crisostomo *c.* 1509

contrast of light and shadow give vivacity and movement to his portraits, which are as vivid, as masterly, though in an entirely different way, as any of Titian's. But his great gifts availed him little; he had a difficult career, struggling with ideas he could follow but never totally assimilate, and against competition he was ill-fitted to withstand. He abandoned the effort in 1552 by becoming a lay brother in the monastery of the Santa Casa at Loreto, and by 1556 he had died there, so lost and forgotten that no one troubled to record the date of his death. He left a detailed account book, begun in 1538 when he was in Ancona, and from this his later works can be identified; the book also casts much light on the life of a provincial painter in the sixteenth century, as well as providing an insight into Lotto's difficult and rather neurotic personality.

Michiel, in his notes on Giorgione's pictures, remarked that the *Three Philosophers* had been finished by Sebastiano. This was Sebastiano Luciani later called 'del Piombo', born about 1485, and probably also trained in the Bellini workshop. He was drawn, as Titian was, into the Giorgione circle, as is shown by the small handful of works executed before he removed to Rome permanently in 1511. The core of this group consists of the organ doors of S. Bartolommeo a Rialto of about 1508, an altarpiece in S. Giovanni Crisostomo, a Madonna, and two or three fancy female heads of indeterminate meaning, but usually exploiting under the guise of a saint the opulent type of beauty currently fashionable in Venice, and the tender and delicate *sfumato* modelling which Giorgione had introduced. The organ doors are painted inside with two life-size figures of Sts Bartholomew and Sebastian within a deep arch against whose darkly shadowed interior they stand silhouetted; the outside of the doors have figures of Sts Louis and Sinibald, each

within a deep gold mosaic niche. The colour glows magnificently: St Louis, in a red and gold brocade cope, with a white alb crossed by dark red ribbons, St Sinibald contrasting sombrely in plum and grey, both enveloped in the light which, falling strongly from the left, casts deep shadows into the glowing niches and reflects back on to the figures. In colour, the outside balances the inside; for here the strength of colour is reversed, the St Bartholomew providing the strongest tonal contrast, in his violet cloak lined with green over a dark red robe, to the dazzling nude figure of St Sebastian, his rich flesh tones enhanced by his white loincloth. The figures have a poise and an assurance which has a much more Tuscan quality than one expects in Venice, suggesting the impact of Fra Bartolommeo, who was in Venice in 1508, and the architectural setting, descended from the tradition of Bellini's *sacre conversazioni*, has an unusual – and rather Florentine – largeness and simplicity.

The altarpiece in S. Giovanni Crisostomo was painted about 1509; it, therefore, antedates Bellini's *St Jerome* on the right of the nave which is signed and dated 1513. The comparison is fruitful, for it demonstrates how the old Bellini, then in his seventies, could assimilate the ideas of younger men. Both altarpieces have at the centre an old man reading, oblivious of the saints about him; in fact, the Bellini is in many ways closer to Giorgione's Castelfranco *Madonna*, in that his St Jerome is placed higher and further within the picture space, delimited by a great arch, and the two saints in the foreground seem as detached from him as Giorgione's pair are from the enthroned Madonna. Sebastiano's group is tighter knit and more crowded, and the slightly yearning figure of the Baptist on the right looking inwards is balanced by a trio of grandly assured, superb Venetian beauties looking

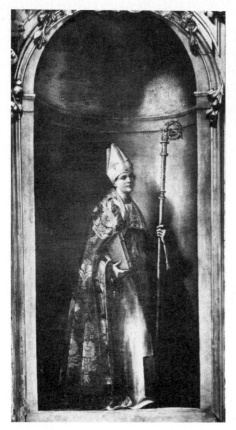
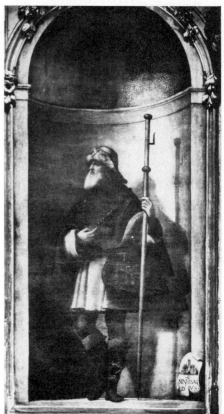

99 SEBASTIANO *St Louis c.* 1508 100 SEBASTIANO *St Sinibald c.* 1508

forwards and outwards at the spectator.
Again, these are figures in an architectural
setting, though one perhaps less well
developed than in the organ doors, more
accidental and less essentially part of the
composition; in this element the Bellini
transcends easily. Perhaps, also, the
Baptist's pose is too deliberately contri-
ved; in this he contrasts with the majestic

female saints who stand like columns come
to life below the pedestal of the giant shaft
behind the old man immersed in his book.

With Giorgione dead and Titian in
Padua, why should Sebastiano have
accepted the invitation extended to him by
Agostino Chigi? But in 1511 he left Venice
to enter, in Rome, first the circle of
Raphael and then that of Michelangelo.

Michelangelo in Florence

The first project upon which Pope Leo X proposed to employ Michelangelo was a façade for Brunelleschi's church of S. Lorenzo – the Medici family church, a stone's throw from the Medici palace in Florence. He began work in 1516; a contract was signed in 1518 for the façade, which was to be executed in eight years (this meant that it had to be worked on simultaneously with the Tomb, the marbles for which he ordered to be sent to Florence). The design called for an architectural frame to be filled with sculpture – 'in architecture and sculpture the cynosure of all Italy' as Michelangelo himself described it, and in fact from all accounts it is clear that it was to be a combination of the Julius Tomb and the Sistine Ceiling. Shortly after signing the contract, he was told that the marble was not to be bought from Carrara, but extracted from a new quarry at Pietrasanta in Florentine territory. To get the marble out a road had to be built; then the Carrarese, fearful lest their major export should be thus frustrated, organized a strike among the bargemen to prevent Pietrasanta stone from being shipped up the Arno to Florence; then Michelangelo's enemies in Rome persuaded one of the signatories to the 1516 Tomb contract to demand performance; finally, after further wrangles, mostly over money, the contract for the façade was abruptly annulled. Three years had passed.

More or less as a consolation for the disaster over the façade, Leo X then thought of the idea of commissioning, not just a tomb, but a funerary chapel for the family, to be built inside the empty and partially built shell of the walls of another sacristy in S. Lorenzo, a counterpart to Brunelleschi's Old Sacristy. In order to 'help' the sculptor, but possibly also with the idea of containing his enthusiasm within the limits of the possible, an architect was assigned to him for work on the structure, but Michelangelo soon disposed of him. The first plans for the Medici tombs – there were to be four of them – took the form of a free-standing edifice so ominously reminiscent of the Julius Tomb that Cardinal Giulio de' Medici would have none of it, and finally a series of wall-tombs was decided upon, to be erected within an architectural framework designed by Michelangelo himself.

The New Sacristy, as it is called, is a small centrally planned building, much higher than Brunelleschi's Old Sacristy, but vaguely like it in that it has a small domed choir at one end, and a system of *pietra serena* pilasters and entablature, and pedimented windows, and is surmounted by a hemispherical dome, though this one is coffered *all'antica*. Michelangelo began by so arranging the internal architecture that the doorway into the chapel from the church was placed obliquely, so that the inner part with the door did not come

99

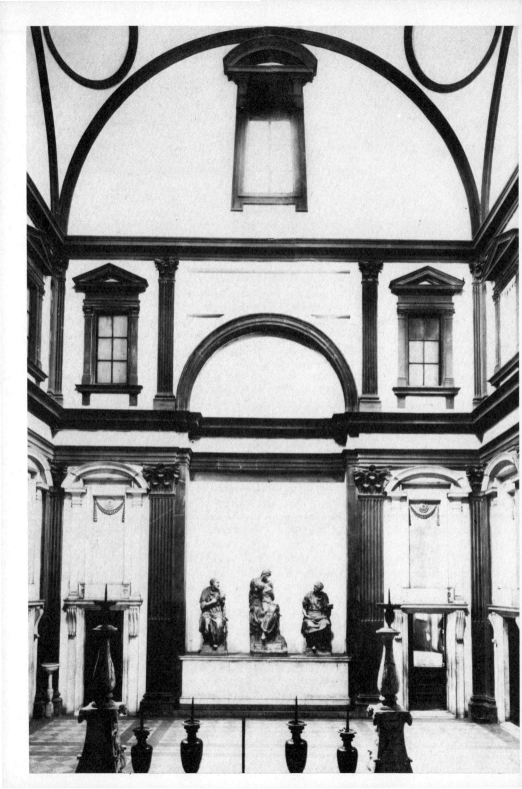

right in the corner of the chapel, as it does in the Old Sacristy, but matched the position of the small doors leading into the little vestries on either side of the choir. He then devised five more doors, so that there are two in each wall in a perfectly symmetrical arrangement. When all the doors are closed the chapel becomes a sealed world, inhabited only by the dead and by the priest at the altar. He placed the altar, not as it was in the Old Sacristy, well within the small choir, but on the outer edge of it, so that the celebrant faced into the chapel. Since this meant that there was no place for an altarpiece, he designed the wall facing the altar to contain a group of the *Madonna and Child*, flanked by *Sts Cosmas and Damian*, the Medici patron saints; this provided an altarpiece across the width of the chapel, and also a focal point. Furthermore, the final design of the two tombs on the side walls contained figures symbolical of the dead men, who look towards the Madonna group on the end wall: thus, at the memorial mass for the family, the priest's congregation is the dead, who turn towards the intercessory Madonna, while the patron saints plead their cause.

There are many drawings for Michelangelo's projects for the tombs; the final form seems to have been one on each side wall, and a double one facing the altar, but of this project only the two side tombs were erected, and they were never finished. The dead men so commemorated were, in fact, not particularly important members of the family – Giuliano, Duke of Nemours and son of Lorenzo the Magnificent, and his nephew Lorenzo, Duke of Urbino: it was to this Lorenzo that Leo X gave the duchy of Urbino when he took it from Julius II's heir, Michelangelo's much tried patron for the Julius Tomb, and it is one of the ironies of the situation that Michelangelo's work in the Medici Chapel was in many ways a substitute for the first

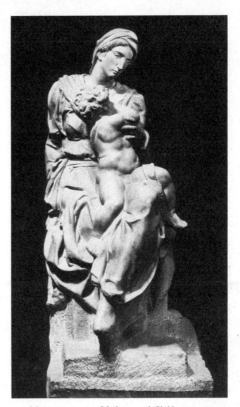

102 MICHELANGELO *Madonna and Child* 1524–27

Tomb, and like it also remained unfinished.

In deep niches over the sarcophagi are figures emblematic of the dead men, each conceived, not as a portrait but as an ideal representation of a state of mind – Giuliano as the Active Life, and Lorenzo as the Contemplative Life. On the lid of each sarcophagus are figures representing the Times of Day – the positive times of Night and Day for the Active Life; the more indecisive times of Dawn and Dusk for the Contemplative Life. Both men are clad in classical armour, Giuliano in an alert pose of arrested movement, Lorenzo relaxed and thoughtful, head resting on his

101

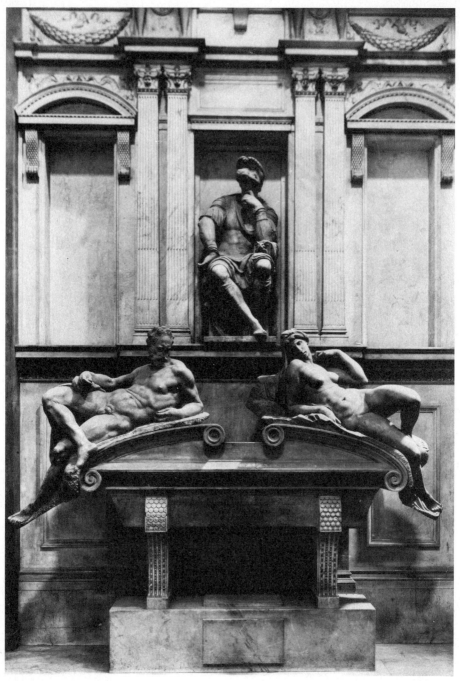

103 MICHELANGELO Tomb of Lorenzo de' Medici

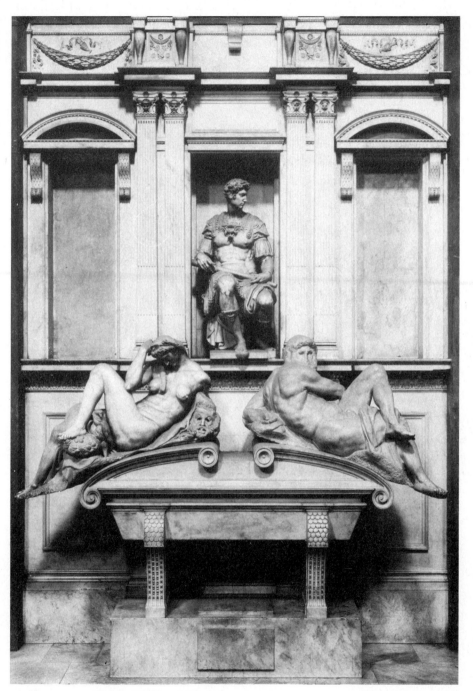

104 MICHELANGELO Tomb of Giuliano de' Medici

hand and face shadowed by the raised visor of his helmet. The Times of Day are massive, heavy figures, so large that they appear to be slipping off the lid of the sarcophagus which they overhang. *Night* with shadowed face and Athena's owl beneath her knee, leaning upon the grotesque mask of the unreality of dreams, poppies at her feet, a star and crescent moon crowning her bowed and sleeping head; *Day* is full of vigour and energy, glowering over his shoulder in a pose so uncomfortable that it underlines the transitoriness of his position; *Dawn* lifts herself from her uneasy sleep, half awake only, dragged unwillingly into consciousness, heavy limbed and lethargic; *Dusk* seems to be sinking into an old man's hazy dream, troubled and withdrawn. All the figures have expressions of grief and movements of unwilling action as if, to use Michelangelo's own idea, they had in truth been locked within the stone and he, by freeing them, had done them an injury by dragging them into a world of sorrow. They were to have been completed by four figures of River Gods, one below each sarcophagus figure, to personify the four Rivers of Hades, which Dante had equated with the tears of humanity. The *Madonna and Child*, towards whom the dead men turn, is a compact group, the Madonna leaning slightly forward as if to shelter the Child twisted round on her lap, burying His head against her and shielding His face with His arm, as if He were trying to escape from the sight of death and the transitoriness of earthly things. The patron saints are stalwart old men, like classical philosophers, but with troubled faces and expressions almost of foreboding. The imagery of the whole chapel, silent and enclosed, expresses, in a blend of Christian and Platonic thought, the idea of the House of the Dead, where the soul, freed from the travails of the world and returned to its state of pure immortality, in the realization of the uncertainty of human life and fortune, and in the contemplation of the eternal and the Divine, awaits the Resurrection.

The figures of the two dukes and the patron saints were brought to a high state of finish. Of the remaining figures none is complete, parts being barely freed from the block, other parts finished – like the *Night* – to a high polish. Michelangelo worked on them all together, and used his assistants for preparatory work, for finishing under his direction, and for the architecture. This is very complicated, for the various niches and the tabernacles over the doors create a mass of different planes within the structure, so that it is difficult to work out the relationship of the parts to each other. This complexity was deliberate, and fits in with the puzzling function of the doors, the difference in size between the dukes and the sarcophagus figures below them, and the curiously uncertain effect created by the huge figures balanced precariously upon the lids of the tombs. One thing is very clear: though the various elements are inspired by classical architectural forms, in detail and in their combination they are completely original. Michelangelo is not re-using the forms of the past so much as creating new ones: the *stipiti* – those narrow pilasters on either side of the niches in the tabernacles over the doors that become wider as they rise – the forms of the capitals, of the pediments jammed tightly between the pilasters of the *pietra serena* articulation, the swags in the frieze, the consoles supporting the pediments and the tabernacles, all these are classical ideas, but here they are given totally new forms and functions.

When Lorenzo de' Medici left his famous library to the city, it was decided to house it in the monastery of S. Lorenzo, adjoining the family parish church. The project for the Library became, therefore, like the family sepulchral chapel, part of

the S. Lorenzo complex which started with the abortive project for the façade. Michelangelo's first projects for the Library were on such a scale that they would have involved almost total reconstruction of the convent and the adjoining square. In 1524 more modest provision was eventually made, on Clement VII's instructions, by building a further storey over the top of the refectory and by making the access to it through a vestibule at one end, adjoining the church and giving on to the cloister. The Pope also rejected Michelangelo's first project for the top-lighting of this vestibule, and insisted that it should have normal windows: this meant that he was forced to make it very much higher in order to accommodate the windows in a top storey,

so as to retain the architectural system he had devised for the inside walls of the vestibule. The central part of the room is taken up by a huge flight of steps, free-standing like a piece of sculpture, with three flights separated by balustrades uniting into one flight immediately before the door, the steps of the central flight curved so that they appear to be flowing like molten stone down from the Library and spreading across the floor. In fact, Michelangelo did not build these steps, for they were made by Vasari and Ammanati and based freely on Michelangelo's sketchy projects sent from Rome in the 1550s. The walls of the vestibule present several odd features: they are divided into three bays each by pairs of columns engaged in the walls and supporting an entablature

105 MICHELANGELO Laurenziana Library. Vestibule and stairs

106 MICHELANGELO Laurenziana Library. Vestibule wall 1524–26

which breaks back over them, not forward as might be expected; between these pairs of columns are panels which project well in front of the columns, and these carry large tabernacle windows with fluted *stipiti* at the sides and pediments above, triangular in the centre and segmental at the sides. Above the windows are shallow niches surmounted by small lintels and surrounded by decorative beading; below the columns, and the string course on which they stand, are heavy consoles which appear to be bearing the weight of the order set into the wall. On the outside of the building, the system is reversed, with heavily pedimented blind windows inset between strip buttresses, though this part of the work is a twentieth-century

completion. Actually, the arrangement of the walls inside is not nearly so wayward as it at first seems, for the columns and consoles set into the wall are part of the piers which bear the weight of the building, while the projecting panels bearing the windows are really infilling between these structural members. Columns set into the wall are not, in any case, without classical precedents which Michelangelo could easily have known. They are a feature of the second-century tomb of Annia Regilla on the Appian Way, which figured in the fascinating sketchbook of Giuliano da San Gallo. Moreover, if we can trust Giuliano's drawings, which must date from the last quarter of the fifteenth century, and also the etching

of this tomb made by Piranesi in the eighteenth century, the small windows had the type of heavy and very decorative hood mouldings and frames which Michelangelo later used on the attic windows of St Peter's. The effect of the arrangement is of an exterior façade turned inwards. The Library inside continues the system with the great book-rests of the bays projecting inwards where the piers and buttresses strengthen the wall between the panels bearing the windows. The doors, too, present unusual features in that they have multiple frames and pediments, set tightly one within another, so that the system of planes is complex and difficult to work out. It is in connection with the Laurenziana that Vasari comments on Michelangelo's inventiveness, and his insistence that he never imitated the antique, but was creating new forms on a par with antiquity.

Despite Michelangelo's initial enthusiasm the progress of all the S. Lorenzo works was beset by troubles. Lawsuits were threatened by the Julius heirs; there were money troubles because Cardinal Giulio, when he eventually became Pope in 1523, faced grave political difficulties; also the Pope kept pressing other commissions on the artist (the commission for the Laurenziana Library was, in fact, given in 1524), and was fertile in new and grandiose ideas rather than helpful over providing for the completion of those already started. Michelangelo agreed to accept the commission for the Chapel in 1520; the structure was ready and the tombs themselves begun in 1524, but nothing was finished when work stopped in April 1527. In May came the Sack of Rome, followed in Florence by a republican rising, the expulsion of the Medici, and the setting up of a new Republic. In 1528, despite the Pope's pleas that he should continue working for him, Michelangelo began working on the fortifications of the city, and later became a member of the council for its defence. He fled in 1529 suspecting – rightly as it turned out – that Florence would be betrayed to the besieging armies of the reconciled Pope and Emperor, but returned to help defend it, and after its fall he was received back into papal favour on condition that he went on with the Chapel. He was now in his middle fifties; partly because of the trials he had undergone with the Tomb, and with the rigours of Pope Julius's patronage, partly because of the tragedy of recent events in Florence, partly because of his natural pessimism, the heart had gone out of him, and he wanted nothing more than to have done with Florence and the Medici and to return to Rome. Many years later, when the unfinished Chapel was finally opened to the public, an admirer addressed a poem to him, extolling the rendering of sleep in the *Night* as so lifelike that if one spoke to her she would reply; he answered with a quatrain of tragic bitterness: 'Sweet to me is sleep, and even more to be like stone While wrong and shame endure; Not to see, nor to feel, is my good fortune. Therefore, do not wake me; speak softly here.'

Work on the Library stopped in 1526, before the work on the Chapel. Together these two works, and the designs for the façade constitute Michelangelo's first essays in architecture. They are the prelude to his later career in Rome, and an extension of the architectural aspects of the Julius Tomb and the Sistine Ceiling.

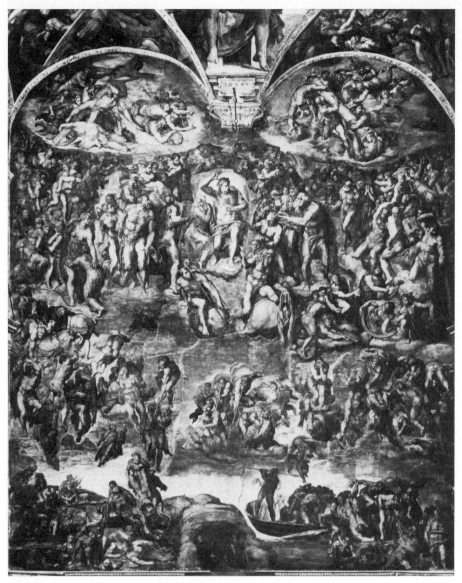

107 MICHELANGELO *Last Judgement* 1535–41

Michelangelo in Rome

In 1522, the Ghirlandaio fresco of the Resurrection on the entrance wall of the Sistine Chapel was badly damaged, and in 1525 a fire at the altar end of the chapel is thought to have damaged the Perugino frescoes on that wall. The idea of commissioning Michelangelo to paint new frescoes on both these walls seems to have occurred to Clement VII, and the first projects appear to have centred on a 'Resurrection' – a very suitable subject for the altar wall in view of the significance of Jonah above – and a 'Fall of the Rebel Angels' at the entrance. At one time, also, a fresco of the Resurrection was planned for the lunette over the altar of the Medici Chapel, and some drawings by Michelangelo exist which can be associated with this project. Nothing came of either idea for the Sistine Chapel, until it was clear that Michelangelo was not going to stay in Florence. This decision was probably prompted, not only by his revulsion against the new form which Medici rule had taken in Florence, but also by his passionate friendship for Tommaso Cavalieri, a young Roman nobleman whom he had met in 1532, and who fulfilled his ideals of physical beauty, elevated moral character, and intellectual power. For Cavalieri, he made a number of drawings – presentation drawings, not connected with any project in painting or sculpture, and executed in a technique specially invented for the purpose: they are very highly worked in a fine stipple, so that the forms are rather breathed upon the paper then visibly worked with pen or chalk strokes.

In 1534 he returned to Florence from a visit to Rome to attend the deathbed of his father. He then felt that there was nothing now to keep him there, for there was no prospect of finishing any of the S. Lorenzo works. He left the city in September 1534 to settle in Rome, where he remained for the rest of his long life. Two days after he arrived Pope Clement VII died: his next patron was the new Pope, the Farnese Paul III. The latter was determined that Michelangelo should work for him: he was an old man at the moment of his election, so that time was precious to him. He pursued a policy of fair words and blandishments which was entirely successful; yet it is also clear that he genuinely admired the artist, who returned his feeling.

The first project for a 'Resurrection' seems to have been changed almost imperceptibly from a Resurrection of Christ into a resurrection of the body, of all Christianity, which implies, therefore, a 'Last Judgement'. This choice of subject, while it did not fit in so well with the iconography of the rest of the Chapel, was well suited to the tenor of thought in Rome after the Sack, which was felt to be a

108 MICHELANGELO *Last Judgement* (detail)

divine judgement upon the city and the Church. Michelangelo's treatment of the theme also bears this out, since he abandons the earlier iconography of the subject, in which there is a definite hierarchical division between the saints, the angels, the saved and the damned, in favour of a swirling mass of figures rising to judgement and falling to hell, with the serried ranks of the saints in an accusatory rather than a passively adoring role. Christ Himself is not the impartial Christ of, for example, Giotto's *Last Judgement* in the Arena Chapel, but an angry, menacing figure, the Christ who has suffered for man's sake and who claims the penalty to be exacted for man's contempt of His Sacrifice, while the saints around him brandish the instruments of their martyrdom in a demand for justice. The dead rise from their graves, skeletal, blind-eyed in their newly reborn flesh, stunned, open-mouthed in astonishment, wonder, horror, fear; they rise in swirling, twisting movement, not in groups but in the isolation of their individual character and

fate, all together, yet entirely separate. Below Christ's feet the trumpeters blow with fearful energy, and the pages of the book of life are turned. No Archangel Michael weighs out souls trembling in a balance of good and evil; in this final moment of self-knowledge man knows his fate, and with the realization of his own responsibility, knows himself as the author of his own doom. While the just crowd behind the saints, the wicked throw themselves downwards, away from the sight of God, and falling are driven forward into the mouth of Hell. Above the hosts in heaven are angels bearing the instruments of the passion, turning, tumbling, struggling with cross and column, crown and nails and lance, as if the burden of these things was too great even for the angels to bear. The Virgin here does not attempt her intercessory role; she sits resigned, her head turned away, as if she knew that the moment for pleas for mercy was past, and that only justice remained.

Of all the *Last Judgements* of the past, only Signorelli's at Orvieto approaches Michelangelo's in its dramatic character and insight. Where previous painters – and sculptors – had relied on telling detail such as the damned dragged to Hell by horrible fantastic creatures, and the resurrection, and the weighing of souls by Michael, treated realistically, Signorelli realized that man was more inhuman and cruel than any fantasy devil, so that his devils in his *Damned in Hell* are humans, livid in the colours of decayed and rotting flesh, but full of the energy and violence that only humans can bring to the torture of their fellows. Michelangelo has gone a step further; there are devils, and in human form, grotesque and horrible, but they are envisaged as man distorted and deformed by his vices and sins. The real tormentors are not these, however – they are merely the instruments of man's actions against

himself; the real evil spirits are those who have condemned themselves to exclusion from communion with God and therefore from fellowship with the just, and who understand when it is too late what they have done to themselves. Some of the figures are derived from very obvious sources. The fulminating Christ is the classical *Jupiter fulmens*; the devil-boatman driving the damned before him with his oar is Charon, the ferryman of Hell; the presiding demon is Minos with his asses ears; the gesture of Niobe sheltering her child becomes Ecclesia receiving the faithful soul; St Catherine holds her wheel as Fortuna drives hers; the trumpeting angels blow like wind-gods. Some figures are obvious characterizations of the seven deadly sins, or of Despair, but over all these re-uses of old ideas, which, by awakening echoes either from outside the limits of Christian interpretation or from earlier representations of Judgement, add to the immediacy of the meaning, are the powerful echoing cadences of the 'Dies irae' and the fearful pleading of the Requiem Mass.

The scaffolding was erected in April 1535, and almost a year was spent preparing the wall, which involved the destruction of the earlier paintings, the pilasters and the cornice, and the filling in of the two windows. Michelangelo had the wall given a slight tilt forwards – a matter of eleven inches in fifty-five feet – in order, as Vasari records, to prevent dust from settling on the painting. At some time, probably in the late sixteenth century, a strip about eighteen inches was obliterated across the width of about forty-three feet at the bottom, so that the altar could be placed higher. Later, prudishness caused many of his nudes to be disfigured by added draperies, some – St Catherine for example, originally entirely nude – to be repainted clothed, but otherwise the fresco is in fairly good condition, except for some chemical changes in the lower part (possibly caused by heat from candles) which have changed light colours to dark and vice versa. Using only one assistant, mainly for the preparation of his colours, Michelangelo worked from the spring of 1535 until the autumn of 1541; the official unveiling was on the Eve of All Saints, 1541 – exactly twenty-nine years after the final unveiling of the ceiling.

Its impact was tremendous. Any work of Michelangelo's was certain not only to reflect current stylistic trends, and sum them up, but also to strengthen – if not anticipate – those aspects of contemporary ideas which fitted in with his personal style. By contrast with the ceiling, the mood is darker, the colour more sombre, the imagery stresses the importance of the nude as the major weapon in his armoury of expression. The conception of the scene is of one vast moving mass of figures, rising and then falling, summoned and impelled by Christ's gesture. The changes of scale, with the figures becoming larger as they rise, until Christ is surrounded by heroic titans, suggests a subjective approach through meaning rather than a purely visual one – though it must be stressed that reproductions that show the vast fresco in small compass distort the effect of these scale changes which, because of perspective, are less striking in the chapel itself. The search for poses expressive of movement and of the emotions inherent in the subject, the deliberate isolation from one another of the figures, each enclosed within his own fate, and the concentration on the nude as the only means of expressing his thought, encouraged other artists to create pictures also dependent on nude figures in twisted, convoluted poses, each figure created more for its effectiveness than for its part in an organic whole. A line can be traced quite clearly from the nude warriors in the *Battle of Cascina*, through the *Adam* and the

109 MICHELANGELO *Conversion of St Paul* 1542–45

Ignudi of the ceiling, the *Times of Day* of the
Medici Tombs, the *Risen Christ* in S. Maria
sopra Minerva in Rome (done in the same
years as the Medici Chapel), and on to the
Last Judgement. This development, mixed
with the influence of Raphael and Late
Antique art, can be seen emerging in other
painters – in Vasari and Salviati for
instance – as a concentration on the much
admired *figura serpentinata*, which rapidly
became almost the chief characteristic, and
certainly the most striking one, in their
works. Michelangelo's *Last Judgement*
remained virtually the last word on the

subject: Rubens was later to paint a *Fall of
the Rebel Angels*, said to be inspired by a
design made by Michelangelo for the
entrance wall of the chapel but never
executed, but no other artist has competed
with his cosmic view of the final act of
man's earthly career.

The *Last Judgement* was not even
finished at the moment when Pope Paul III
commissioned the frescoes in the newly
built Cappella Paolina. Two frescoes were
planned, one on each of the walls flanking
the altar niche: the *Conversion of St Paul* was
probably the first to be executed from the

110 MICHELANGELO *Crucifixion of St Peter* 1546–50

autumn of 1542 until the summer of 1545; followed by the *Crucifixion of St Peter* from March 1546 until 1550 (Paul III died in November 1549). By the time, therefore, that these frescoes were finished Michelangelo was seventy-four, and was also weighed down with his work on St Peter's. Both frescoes share an extraordinary quality of movement. The *Conversion* explodes across the picture, the frightened horse charging into depth, Saul and his immediate helpers falling and fleeing to the left and his other followers flinging themselves to the right, while one man

stumbles stupidly into the picture at the bottom. Towards this explosive centre, Christ descends like a thunderbolt scattering the angels surrounding Him from his plummeting path, yet He is directed rather upon Saul than upon the void in the centre. Saul, raising himself upon his arm, blinded and semi-conscious, has the tormented face of one who sees more clearly in the dark than he did in the light, and whose conversion is a final acceptance of the divine will travailing in him.

The *Crucifixion of St Peter* shows the moment when the cross is raised and

111 MICHELANGELO *Christ on the Cross*. Drawing
c. 1541

dragged towards the hole prepared for it. Here the movement is circulatory, not with the violent swinging movement of the *Last Judgement*, but with a slow, heavy pace, the plodding action of men who have embarked upon a course without understanding, or even caring, what they do, yet with a foreboding over the consequences expressed in apathy or resignation. The only action is in the group of soldiers, where a centurion points and another allows his horse to rear, yet this movement quickly dies away and the faces of the soldiers express no more than sullen curiosity. No heavenly visions comfort the dying Apostle; he raises his herculean shoulders from the cross and glares out of the fresco, summoning mankind to witness that unflinchingly he pays the debt incurred in that awful moment when the cock crowed, and for which all his life has been a preparation.

Is this the final resignation of an old man, oppressed by age, depressed by the consciousness of increasing infirmity, by the steady growth of his pessimism, his feeling that all mankind is evil, all action bad, or at best useless, and that the only justification is the strength of one's faith? There is no doubt that in the years of his Roman career Michelangelo was closely associated with a group of thinkers advocating reforms in the Church, and imbued by doctrines which later came to be associated with Protestantism. These much discussed ideas concerning the supreme necessity of faith alone as the means to salvation, later caused some of the group to be pursued as heretics. Vittoria Colonna, who is a central figure in Michelangelo's spiritual life in these years, and who represented for him the most perfect qualities of womanhood, was one of the group that met to discuss the Pauline Epistles in which this doctrine is enshrined. For her he made many drawings, though she seems to have had only a conventional appreciation of art; but her intelligence and the profundity of her religious feeling was such that she had considerable influence over him. The development of his faith, in that it seems at this time to have turned from a normal· observance to a deeply reflective piety was largely her work. The course of his spiritual journey can be traced in his poems, for while graceful sonnet-making is quite a normal part of artistic expression – Raphael, for instance, also wrote passable poetry – Michelangelo's poetry is on a par with his art, and forms a perfect gloss upon it. Certain aspects of the *Last Judgement* reflect the ideas that grace is acquired by faith, and faith is the supreme personal achievement of the soul, while sin is the negation of faith, through concentration on purely human qualities which are thereby transformed into vices; and that judgement is not just a judgement

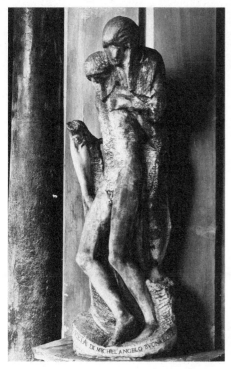

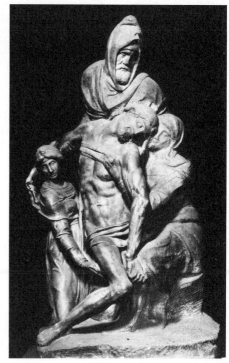

112 MICHELANGELO *Rondanini Pietà* worked on until 1564

113 MICHELANGELO *Pietà* late 1550s

of the consequences of sin, but a judgement on the strength, the purity, the essence of the soul's faith, and thereby of its relationship to God. The Pauline frescoes push these ideas a stage further. The original idea for the St Peter fresco was for a 'Giving of the Keys', and it was changed into a martyrdom possibly at the wish of the painter; there is no official record to suggest that it was the Pope who wanted the change, and the two frescoes do not form a natural pair, as the first choice of subjects would have done. But they do express the force of faith: in the *Conversion* the overwhelming impact of faith, which can lead, as the Christian knows, along a long road of suffering and effort to a final martyrdom; in the *Crucifixion*, the moment of martyrdom itself, the culmination and testing point of faith.

Michelangelo's religious thought at the end of his life is also expressed in the last *Pietà* groups. Both are unfinished, both were worked on in his last years, one to within days of his death in February 1564. Both express the thought of God made Man, and triumphing not by the majesty or power of Godhead, but by the acceptance of suffering and sacrifice, on the same terms, that is, that are open to man for his eventual union with God. The group with Christ upheld by the Virgin and Joseph of Arimathea – whose features are those of the sculptor himself, and who therefore personifies the humanity for whom the

115

sacrifice was made – and lamented over by the Magdalen, now stands as his memorial in Florence Cathedral. This group was being worked on in the 1550s, but Michelangelo, dissatisfied with it because the block was flawed, and because he was importuned to finish it, smashed it in a fit of rage and frustration. One of his assistants pieced it together and finished the Magdalen. The second group, the Rondanini *Pietà*, seems to have been worked twice over, once with a Christ slumped forward but held almost upright by the Virgin, and then again as a figure almost melting into the body of the supporting Virgin. What happened to the original conception and the first state of the block can only be surmised from its present state: it is an expression of the most

profound pathos, heightened by its unfinished state, in which the forms are barely sketched in, and the two bodies seem to merge one into the other. In the form these last works take, and in the emotion they express, Michelangelo comes very close to Donatello's final pulpits, and in turn Titian, Rembrandt and Cézanne are his companions in old age.

In 1546 Antonio da San Gallo the Younger died. The main works occupying him at the end of his life were the Farnese Palace, built for the papal family, and St Peter's. The palace was the largest and grandest in Rome, a hundred feet high by about two hundred feet wide, a freestanding block on a site stretching down to the Tiber. In 1545 Michelangelo won a

114 SAN GALLO Farnese Palace, courtyard

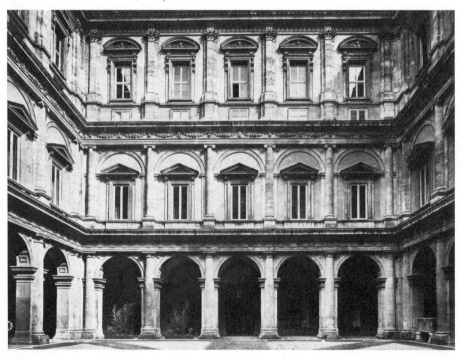

competition for the design for the cornice, much to San Gallo's mortification, and after his death completed the palace. The problem with the cornice was to design one proportionate to the bulk of the whole building, but which should not appear to crush the upper storey. Michelangelo's solution was to increase the height of the top floor, so that the cornice was lifted well above the window pediments, and thus appeared to float above the whole. He also built the top storey of the courtyard much higher than the arcaded floor below, and introduced the complications in levels in the pilasters of the order and of the framing elements in the windows themselves, so that the storey is richly decorative and strikingly different from the sober massiveness of the arcades below with their infilling of simply pedimented windows. His first purely architectural work in Rome continues directly, therefore, from the wealth of complicated layers and mouldings of the Medici Chapel. The great window in the façade, too, he redesigned so that it tells as a void, wider and apparently tightly clamped between the columns framing it.

He was appointed architect to St Peter's from January 1547, and immediately set about redesigning the basilica. At Raphael's death in 1520, the plan of the church had been altered to make a long nave, but Bramante's pupil Peruzzi had prepared designs based on Bramante's own reworking of his original Greek cross plan, simplified and with larger central piers. Antonio da San Gallo compromised; he returned to the central plan in a somewhat condensed form, but added to it a large vestibule in front to contain a benediction loggia. The model for his project still exists. It is an extraordinary compendium of practically every known architectural form: arcades, colonnades, variously pedimented windows, orders of pilasters, an enormous dome with a multi-

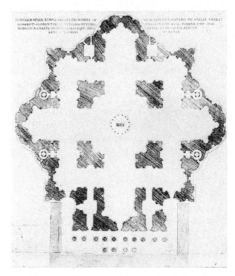

115 DUPÉRAC Michelangelo's plan for St Peter's c. 1547. Engraving 1568

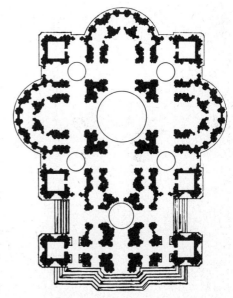

116 SAN GALLO Plan for St Peter's

117

layer colonnaded drum like a Milanese *tiburio*, smaller domes, lanterns, towers, an enormous void in the centre for the loggia and a straggling irregular outline. Many years before, when Michelangelo was painting the Sistine Ceiling, there had been no love lost between himself and Bramante; however, faced with the same problem as his predecessor he recognized the basic rightness of Bramante's inspiration. 'It cannot be refuted', he wrote, 'that Bramante was as able in architecture as any man since antiquity. He laid down the first plan for St Peter's, not full of confusion, but clear and precise, luminous and free-standing, so that it did not impair the palace, and was considered a beautiful thing, as is still manifest; so that whoever departs from Bramante's plans, as San Gallo has done, departs from the truth . . .' Michelangelo also objected to San Gallo's

design that it was dark inside, and would be unnecessarily expensive to build. He proposed to return to a central plan, much simpler than Bramante's since the minor Greek cross elements in the four corners would be replaced by a grand ambulatory encircling much enlarged central piers. The internal space was envisaged as flowing in such a way that it defined the basic square of the plan, while the projecting apses and the subsidiary enclosed spaces flanking them would, on the outside, create that modulation of shape essential to give movement to the great entablature, and variety of size to the bay system of the giant pilasters. In this way, the mass of the building would become an interesting and vital block as a podium for the dome. The façade was to be a large colonnaded portico, with a pediment, though this leaves the problem of the

117 San Gallo Model for St Peter's

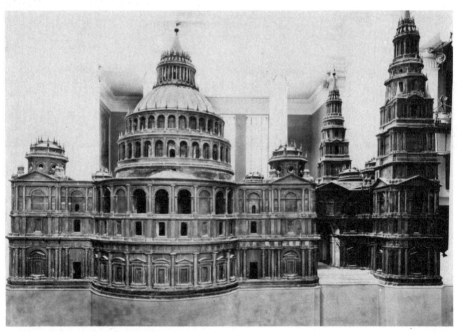

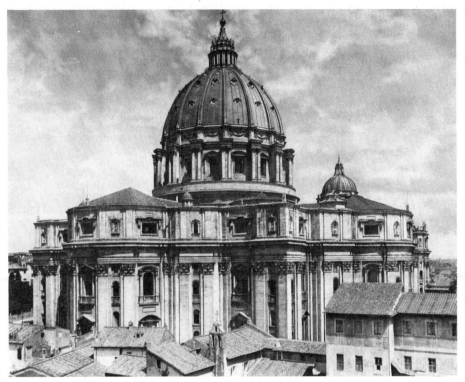

118 MICHELANGELO View of the apse and dome of St Peter's

benediction loggia unsolved. The whole was to be surmounted by a hemispherical dome, encircled on the upper drum by a colonnade of coupled columns framing pedimented windows.

He built most of the exterior on the north and south, though the western apse was hardly started, and his dome had only reached the top of the colonnaded drum when he died. Unfortunately, he did not lay out the façade, so that when he was dead it was possible to revive the long-nave project, and to extend the front of the building with unhappy consequences for the proportions of his dome. The parts that he did complete consist in the main of a giant order of pilasters, multi-layered on

framing strips, bearing an enormous entablature and surmounted by a high attic storey, with short pilaster-like elements corresponding to the giant order below. The bays framed by these pilasters contain huge tabernacle windows of very varied shape, two large ones in the main bays and four smaller openings in the narrow bays, and the attic also has windows varying in size and shape. Some are true windows, lighting the interior, others are blind niches, serving only a decorative function; but all through he has been concerned to compose new forms and combinations inspired by the language of classical architecture, so as to extend it for modern purposes. This is a further instance of the

point Vasari made in connection with the Laurenziana: Michelangelo never imitates the antique, but creates on a par with it.

During the years when the structure was being built, Michelangelo considered the problems presented by the dome. In July 1547 he wrote to his nephew Lionardo in Florence for detailed information about Brunelleschi's dome, and it seems that at one time he considered making the lantern octagonal in shape, like that of Florence Cathedral. Also, the final execution of the dome, by his pupil Giacomo della Porta between 1585 and 1590, on a pointed profile instead of the original idea of a hemisphere, is not without foundation in Michelangelo's own alternative projects. Dupérac, the French engraver and architect, who was in Rome from 1559 until well after Michelangelo's death, and who published a series of engravings of St Peter's, shows the dome as hemispherical, but otherwise much as it was eventually built. However, in view of Maderno's later lengthening of the nave, the heightening was just as well, for the present dome has difficulty in dominating the façade, seen from the Piazza, though it floats superbly, effortlessly, from a distance. One of Michelangelo's prime considerations was the buttressing of this massive cupola; he had before him, always, the example of the Pantheon, a hemispherical dome 142 feet across, apparently entirely unbuttressed. He also had in mind Brunelleschi's *cupolone* for Florence Cathedral, very pointed, octagonal, and strengthened at the bottom by the lobes of choir and transepts and by the exedrae between them. Bramante's inspiration had been to raise the 'dome of the Pantheon upon the arches of the Temple of Peace' (that is, the basilica of Constantine); Michelangelo clearly believed that visible buttressing would be a regressive form, since none of his drawings ever shows any, and the recurrent enlargement of the central piers shows that this inspiration had dominated all the architects of the basilica, except San Gallo. In fact, the dome is borne by the gigantic piers as its main support, though they, of course, receive considerable strength from the structures which abut on them. Some idea of the dimensions of this church can be obtained from one comparison: St Paul's in London, which is 365 feet high outside, would fit inside St Peter's, whose interior dome is 370 feet from the floor, and all eight of Wren's massive piers would fit into one of St Peter's.

Upon St Peter's he laboured until the end of his life, working for nothing, since he considered it as an offering to God. Other architectural commissions undertaken included the redesigning of the Capitoline Hill, the designing of a new entrance gate to the city, the Porta Pia, though this was largely built by his assistants, the abortive designs for the Florentine church in Rome, S. Giovanni dei Fiorentini, and for the mother church for the Jesuit Order, which he offered to build for St Ignatius Loyola, whom he knew personally. S. Maria degli Angeli was built from 1561 onwards out of the remaining tepidarium of the Baths of Diocletian for a convent of Carthusians; unfortunately, it was so reconstructed and redecorated by Vanvitelli in 1749 that little of Michelangelo's rather gaunt church survives but the general form, the articulation of enormous antique columns, and the sailing quality of the vaults, which are the original Roman vaults repaired. The funerary chapel for the two Sforza cardinals in S. Maria Maggiore was his last essay in interpenetrating volumes. Here three systems of vaulting occur: a quadripartite vault above the main space, apsidal ribbed domes over the shallow niches containing the tombs, and a semi-circular barrel vault over the altar; these disparate spaces are held together visually by strongly projecting angles with huge

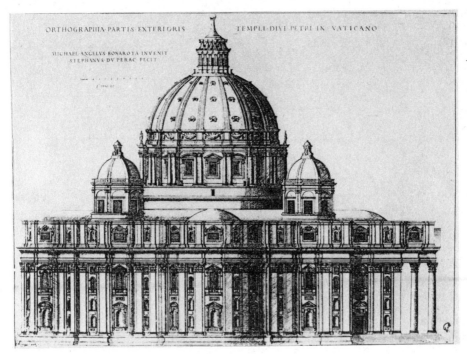

ORTHOGRAPHIA·PARTIS·EXTERIORIS TEMPLI·DIVI·PETRI·IN·VATICANO

MICHAEL·ANGELVS·BONAROTA·INVENIT
STEPHANVS·DV·PERAC·FECIT

119 Dupérac Engraving of Michelangelo's project for St Peter's

columns, and the interior is executed with plain plaster and travertine stone, usually only used for exteriors. He had also, in 1550–51, rebuilt Bramante's witty and amusing semi-circular stair at the end of the Vatican Belvedere. The niche was rebuilt as a two-storey structure with a suite of rooms, the space being taken on the courtyard side which meant that the stairs had to go. Michelangelo's flight is like that designed for the front of the Senate, and the top terrace was used, about 1615, for the antique Pine Cone formerly in the atrium of Old St Peter's.

The redesigning of the Capitoline Hill, the focal point of Roman political history, going back to the Caesars and looking outwards across the city towards the conquered world, required long and detailed planning. Under the Senate were –

are still – the remains of the Tabularium or Archives, and on the high point to the north is S. Maria in Aracoeli, built on the top of the Tarpeian Rock, the foundation rock of Rome. A palace for a lay legislature had been built on the south side of the raggedly open space of the Campidoglio in the fifteenth century, but until Paul III initiated the new works in 1537 almost nothing had been done to give secular Rome the kind of civic centre that all self-respecting Italian cities by then possessed. This was because, despite figure-head senators, the seat of true government was in the Vatican; when the Senate was erected on the antique ruins, and the statue of Marcus Aurelius moved from the Lateran, both were made to look across the empty waste towards new Rome, instead of across the Forum.

121

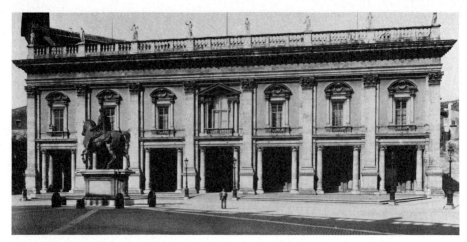

120 MICHELANGELO Capitoline Palace

Except for designing the new base for the equestrian statue placed in the centre of the piazza, which must have involved some replanning of the whole square, Michelangelo was not closely concerned with the project until after 1547; he would not collaborate with anybody from San Gallo's 'clan', as he called them. Between 1547 and 1612, work proceeded slowly but steadily. Michelangelo's designs for the piazza consisted of an ordered façade for the Senate, two palaces to north and south, a grand stairway up the hillside to the piazza, and a carefully designed pattern in the paving like a radiating star with three stressed points directed at the main egresses from the piazza. Also, the two palaces – the Conservatori on the south, and the Capitoline on the north – were to be so aligned that the square narrowed towards the steps. This not only fitted the existing structures, but reinforced the enclosed quality of the space. The present Senate only retains from Michelangelo's original design the use of a giant order and the lowest storey treated as a basement against which the double flights of the grand staircase were placed; the present stair is without the important projecting portico at the top, and has a fountain below instead of the antique River Gods which he intended to incorporate. For the Conservatori (virtually the town-hall of Rome) he designed a front consisting of a giant order bearing a huge entablature and cornice, with a balustrade over it; the bays of the façade between the giant pilasters have an open loggia below and a series of grand windows above – solid over void, that is. Each opening of the loggia is framed in an order of columns, the entablature of which forms the base upon which rests the order framing the great window above, so that a lesser order is enclosed within a greater one; the giant pilasters are backed by framing elements so that his usual layering device is also present. On the back wall of the loggia large pedimented doorways correspond to the row of windows in the upper storey; the pediments alternate – all segmental above enclosing large shells, all triangular below, and these doors are set between columns responding to the order on the outside of the loggia, so that every part of the design contributes to a coherent

122

whole. After Michelangelo's death, the Campidoglio, like St Peter's, was also finished by della Porta. No complete designs for the Senate seem ever to have been made, and Dupérac's 1568 engraving appears to be derived from sketches and possible statements of intention; della Porta changed the staircase by omitting the baldaquin or portico at the top, and finished the façade on his own initiative; he also built the central window of the Conservatori, which was probably planned to be the same size as the others, and over the huge opening he placed a triangular pediment jammed tightly between the framing pilasters; and he altered the paving pattern to a mundane radiating spoke system, with four entrance points stressed. This has now been relaid with Michelangelo's radiating star pattern – a still centre enclosing the symbol of power, yet one from which power radiates. The

return bays of the Conservatori were doubled, making the block from the side look like a truncated palace façade instead of a loggia; the Capitoline palace opposite was built in the seventeenth century.

Basically, Michelangelo's architecture is sculpture, in that he models the units as if they were free-standing statues, and the elements as if they were the limbs and features of a figure. He concentrates on movement, on a sense of tension and vitality, and every element no matter how small contributes to the enrichment of the surface, and to the contrasts of void and solid, light and shadow. He is endlessly inventive, in planning, in his detail, and in his sense of proportion, and the freedom with which he created a whole vocabulary of new architectural forms was of vital consequence not only to his contemporaries and successors, but also well into the Baroque.

121 DUPÉRAC Michelangelo's design for the Capitoline Hill. Engraving

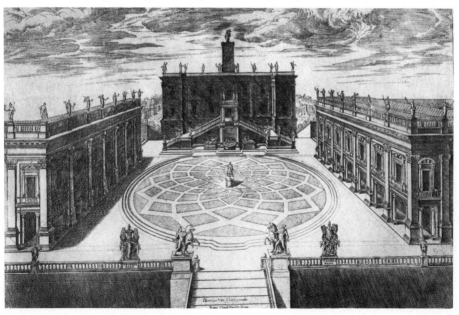

Chapter Six

Mannerism

If one removes from an account of sixteenth-century art in Rome Raphael and all Michelangelo's works, then little is left. Only Sebastiano del Piombo and Giulio Romano remain as major painters, and not just as visitors, like Vasari, Ammanati and Salviati, with the architects Peruzzi, Vignola, Giacomo della Porta and Domenico Fontana.

Raphael's large workshop contained one major artist: Giulio Romano. He grew up virtually in the studio, and became Raphael's chief assistant at about the time of the Stanza dell'Incendio – that is, about 1515 or 1516. The point at which he first appears is a problem largely governed by his age at his death in 1546. The hospital record of his death says that he was forty-seven, which makes him born in 1499. Two lines of argument are then open; either he was an infant prodigy, able to create independently from about the age of sixteen, or else the hospital record (which is probably based on a statement by his widow) is wrong, and Vasari, who knew him, was nearer the truth when he places his birthdate in 1492. If Vasari is right, he would have been about twenty-three when he is first identifiable as a distinct personality in Raphael's studio. Much of the change in Raphael's art, towards stronger chiaroscuro, less centralized compositions, greater movement and emotional expression in the figures, which

appears after the Stanza della Segnatura, has been associated with Giulio, as if the pupil rather than the master had been in control. It is absurd to suggest that he introduced these features, particularly since they appear in the *Heliodorus*, which, if 1499 is the right birthdate, would make him a major influence on Raphael at the age of fifteen. It is more reasonable to suppose that Giulio followed Raphael's development, which, from about the time of the Tapestry Cartoons and the Stanza dell'Incendio, tended towards those features which, commonly, are associated with the development of Mannerism.

Mannerism is a term requiring rather careful definition, for unlike Early or High Renaissance, and, later, Baroque, it cannot be equated strictly with a period and used as an equivalent and defining label for all the works produced in a specific time bracket. It is a much more selective definition, for it is a label only for certain works of a certain kind produced by certain artists between about 1520 and 1590, and only in certain parts of Italy. The term itself was invented in the 1920s because the old divisions of High Renaissance and Baroque left a large body of sixteenth-century Italian art which could not properly be included under either head without making stylistic nonsense of both definitions. The perfectly sound time-label of Late Renaissance exists in German and

would, indeed, be a far better denomination for the art produced after 1520 than has resulted from the blanket use of the term Mannerist. Recent years have seen determined efforts to define Mannerism more narrowly, but this is rendered difficult unless it can be entirely divorced from its period connection and confined to style, as has, in fact, partially occurred with the confusing back-formation of 'Quattrocento Mannerism' used sometimes to describe certain aspects of Botticelli and Filippino. In its artistic context the term originates with Vasari (it is in common usage very much earlier in literary and social contexts), who uses '*maniera*'as an equivalent of 'style' in its absolute sense (... in the style of...), and in the figurative sense as a qualitative judgement (... in a beautiful style ...), in which sense it is allied with '*grazia*' an omnibus term for grace, beauty, lightness, charm, pleasingness, spontaneity, and a host of other desirable aesthetic equivalents of those social qualities that Castiglione, in 'The Courtier', deems essential for good manners and conduct. Later, probably because the term degenerated somewhat socially, and came to be equated with artificiality of behaviour and displeasing affectation, seventeenth-century criticism – notably Bellori – regarded *maniera* as an undesirable quality, inimical to the true representation of nature. It is in this sense that Vasari's application of *maniera* came to be used as a description of the kind of style which he himself practised, and which the seventeenth century clearly, and rightly, saw was a development from the late style of Raphael and characteristic of a particular type of art produced in Rome and Florence after 1520.

Mannerism can be quite easily recognized and defined: in general it is equated with a concentration on the nude, often in bizarre and convoluted poses, and with exaggerated muscular development;

with subject matter either deliberately obscure, or treated so that it becomes difficult to understand – the main incident pushed into the background or swamped in irrelevant figures serving as excuses for displays of virtuosity in figure painting; with extremes of perspective, distorted proportions or scale – figures jammed into too small a space so that one has the impression that any movement would burst the confines of the picture space; with vivid colour schemes, employing discordant contrasts, effects of 'shot' colour, and the use of colour, not for descriptive or naturalistic purposes, but as a powerful adjunct to the emotional impact of a picture. In architecture, it concentrates on violations of the rules governing accepted usage of the classical orders, and on irrational and unpredictable dispositions of space, combinations of features, treatment of surfaces. It is invariably accompanied by rich decoration, and often by elaborate illusionism. In sculpture, it is discerned in the change from High Renaissance frontality and simplicity of presentation to a search for multiplicity of views and silhouette, elongation of forms, and exaggerated effects of perspective and scale in reliefs. A Mannerist statue must be walked round, for all its angles of view are equally important. But it is quite clear that this definition cannot possibly describe all the works of art produced during the greater part of the sixteenth century, even in Rome and Florence, which are the true homes of Mannerism; there is a very great deal that escapes the net. It is almost totally inapplicable to Venice and its province, except where an individual artist – such as Pordenone – deliberately cultivated Mannerist characteristics and used them as forms of Grand Manner painting to impress provincial patrons, with, one suspects, the intention to '*épater le bourgeois*'. Neither is it a consistent quality

within the *œuvre* of an artist: for instance, Salviati's grandiose *Triumph* frescoes in the Palazzo Vecchio in Florence, painted in 1545–48, are not Mannerist in the sense that this term can be applied to his slightly later frescoes in the Palazzo Farnese in Rome [166]. Bronzino, who is one of the most relentless practitioners of the style in his figure paintings, sometimes carries the characteristics into his portraits, but by no means always.

In painting the style implies a deliberate derivation from late Raphael and from Michelangelo's *Last Judgement* and the Cappella Paolina frescoes; in architecture, from Michelangelo again, in the Medici Chapel, the Laurenziana, and the Roman works, and also from Raphael's late palaces and the Villa Madama; in sculpture, by extension from Michelangelo's paintings in which the figures are, so to speak, conceived as sculpture in a single plane, and from antique sculpture 'Raphaelized'. Few of Michelangelo's figures except perhaps the *Risen Christ*, one of his less successful works which he declared to have been spoilt by an assistant, have the all-round quality, though the *Moses* of the Tomb, and the *Slaves* now in the Louvre are not absolutely frontal. When the term Mannerist comes to be applied outside Italy, then its accuracy of definition is slightly blurred. It implies, for its full impact, a knowledge of what had gone before – of the High Renaissance, in fact –and this is particularly true of the architecture. The point of Mannerist architecture is in its violations of the High Renaissance and classical forms and canons; for countries whose preceding architectural style was Gothic, the whole point is lost. Northern Mannerism exists, but it is not the same kind of thing; it is the imitation of Italian forms of the mid- to late-sixteenth century in the North because they were new, fashionable, and expressive of a freshly acquired culture. That the most

imitated forms happened to be Mannerist ones is because they were the most recent to evolve in Italy, and also more sensationally obvious.

While Raphael lived, Giulio's artistic personality was naturally somewhat obscured by his master's fame and responsibility for work executed in the studio. It is by working backwards from his achievements after Raphael's death that he emerges with distinct characteristics that differentiate him from Raphael: rather fat forms, strongly modelled in a heavy chiaroscuro, expressive heads and gestures tending towards the over-emphatic, turgid colour with inky shadows, congested compositions built up in layers, but with sudden, unexpected plunges into a distant vista, seen through a door or between columns. Even where his entire responsibility seems certain, as in parts of the Farnesina decoration, or in the Stanza dell'Incendio, there is also evidence that Raphael never completely relaxed his control, so that Giulio's forms reflect ideas that Raphael himself held. After 1520 he completed the *Transfiguration* (which was sufficiently far forward to be exhibited over Raphael's bier, as Vasari recounts), and the Sala di Costantino, the last of the sequence of Stanze where Raphael's Roman career had begun, is entirely by him. The frescoes, dedicated to the history of the early Church, present several novelties; whereas the Raphael Stanze had been painted round the windows and doors clearly upon wall surfaces, the Sala di Costantino takes over the Farnesina device of the awning and transfers it to the walls, turning the pictures into fictive tapestries. Between them are pedestals supporting fictive statues at the base of which sit allegorical figures of Virtues, and all the way round underneath runs an elaborate dado painted with scenes in grisaille. The fake tapestry device may also have been suggested by the tapestries hung

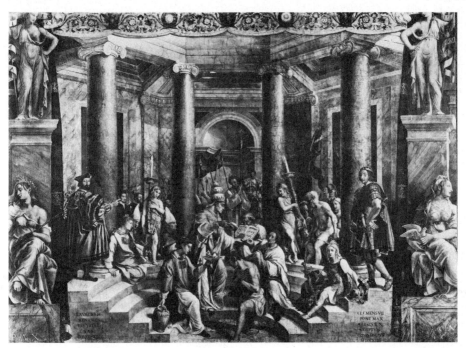

122 GIULIO ROMANO Sala di Costantino, *Baptism of Constantine* 1520–24

in the Sistine Chapel; there is, too, the example of illusionism in the Sistine Ceiling, where fictive architecture is inhabited by figures and interspersed by painted bronze medallions and statues of *putti*. As a treatment for very large walls it has the advantage of breaking up the decoration into sections of reasonable size. It was a device with a great future. The scenes themselves contain the now customary mixtures of heroic narratives set amid a large cast of attendant supporting figures – mothers and children, beggars, dogs, exclamatory bystanders, dwarfs, pages – all arranged in beautiful poses. Two scenes have elaborate architectural settings. One is a modified view of the Lateran Baptistery: the other is an idealized view of Old St Peter's, which, however, may contain a good deal of truth about the *confessio* and apse, for in 1524

parts of the Constantinian basilica still stood. The *Battle at the Milvian Bridge* is the next great battle scene after Leonardo's abortive one in Florence, and the struggling mass of men and horses in the centre possibly reflects the prototype which Raphael himself would have known, and which would certainly have been known also to Penni, the Florentine assistant whom Giulio inherited from Raphael. In 1524 Giulio decided to accept the long-standing invitations of the Gonzaga, and moved to Mantua, leaving the Sala di Costantino unfinished, but with designs ready for assistants to complete. His decision to leave Rome may have been prompted by the scandal over a set of illustrations to Aretino's immoral verses, for which he is said to have made the drawings. Be that as it may, he journeyed with Castiglione to Mantua, where he

127

spent the rest of his life, converting the city from a swampy backwater into a place filled with palaces and set about with splendid ducal villas. Little now survives, for most of the architecture was in brick with stucco surfaces, there being no stone locally, and damp and neglect have completed the ravages that wars began.

His great surviving monument is the Palazzo del Tè just outside the town on what was then an island occupied by the stables of the most famous stud in Europe. It was not built as a place to live in, but as a classical *villa suburbana* to be used for festivities. It is a single-storey building round a square court, with a great garden ending in an exedra, reached across a moat that served as fishponds. Each façade is pierced by a loggia, so that the palace has two axes, one leading through from the original main entrance (the present main entrance was not designed as such) into the garden, and the other ending in a blank wall at the back of the south side, where the façade was never finished. As one approaches the villa one thing is im-mediately clear: this is not a repetitious arrangement of bays about a central doorway, but a balance of contrasts, with a tense conflict between enormous rough keystones and heavily rusticated windows and doorways clasped between smoothly surfaced pilasters – giant pilasters, embrac-ing in their short, stumpy form the main storey and the mezzanine above, with a plain string course running behind them like a ribbon threaded through from one end to the other. The order is very plain Tuscan Doric, with rusticated bases formed in the stucco, like masses of wriggling worms. Inside the main door (the original west one) – a colonnaded and coffered barrel-vaulted tunnel to the courtyard – another curious device is met with: the columns on either side are only roughly hewn, not smoothly finished as they should be, but enclosed in a muff of rough 'stone' (only they are made of stucco) to suggest a half-finished ap-pearance. This is a parody of the great vestibule of the Palazzo Farnese in Rome, a slightly pretentious joke to ape the

123 Giulio Romano Courtyard of the Palazzo del Tè 1526 onwards

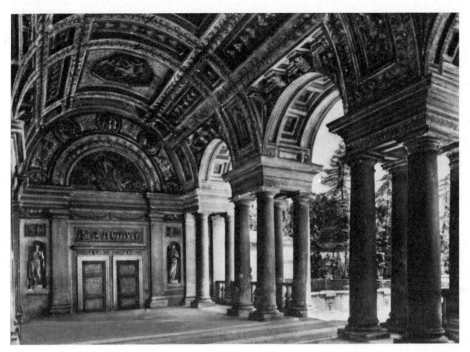

124 Giulio Romano Loggia of the Palazzo del Tè

splendours but only to do it by halves. The west façade, with the triple arched entrance, is split down the centre with an almost solid wall, so that the two halves of the loggia are quite separate, one looking outwards, originally across the water to the city, the other inwards to the court. On the garden front, the loggia opens splendidly like the one at the Villa Madama which Giulio had helped to decorate: from the garden side three great arches borne on blocks of four columns give into a barrel-vaulted space, decorated entirely with the type of relief plaster and painted decoration derived from Nero's Golden House which had been the inspiration for the Villa Madama. Here all is lightness and delicacy, gay, frivolous almost, and infinitely graceful, for the façade to the garden is a sequence of these arches, not

equally spaced, but all variations on the theme of the antique motive later to be called the Palladian motive. Turn back from the loggias into the courtyard and the full force of the contrasts strikes one: this is a building turned inside out, for the court has thunderous, fortress forms, heavy columns clinging to the rusticated walls, framing deep niches and pedimented blind windows, and supporting a Doric entablature where the triglyphs are slipping loosely and dangerously from the frieze so that on one side the order appears to be broken and ruinous. Inside is a long sequence of variously shaped rooms, with elaborate ceilings and mosaic floors, some ceilings coffered, some painted, one room devoted to the glories of the stud, others to fanciful mythologies, and, in the Sala di Psyche, the story of Psyche treated so as to

129

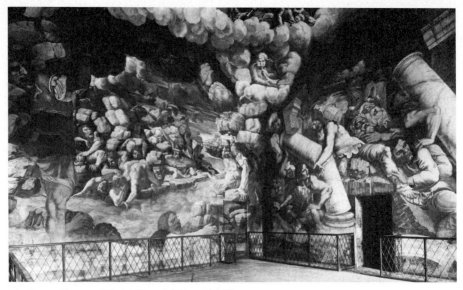

125 GIULIO ROMANO Sala dei Giganti, Palazzo del Tè 1532–34

be highly suited to the licence and moral freedom which it was one of the objects of the villa to serve. In the far corner of the long enfilade of rooms, Giulio devised a surprise: the Sala dei Giganti is ill-lit – purposely – so that the paintings on the walls are the more astonishing. In the centre of the coved ceiling is the temple of Jove, supported on clouds, while Jove himself surrounded by the affrighted gods and goddesses of Olympus hurls down his thunderbolts upon the presumptuous Titans who tried to storm the sacred mountain, and who lie crushed under the weight of temples and rocks tumbling about them in a cataclysmic earthquake. Originally, a shattered fireplace blended perfectly with the falling rocks so that its flames added their reality to the fictions on the walls, and the floor of carefully set pebbles masked the point where the decoration began. This is the epitome of Mannerist decoration – this blend of the real and the false, of the witty, sophisti-

cated and amusing in the imagery with the seriousness of the moral content of the myth, the contrast between the consciousness of the solidity of reality and the imaginativeness of the terrifying carnage on the walls.

Giulio's only assistant of merit in the Tè was Primaticcio, who was with him for five or six years until 1531, when Giulio, who, unlike Raphael, never tolerated collaborators of any stature, got rid of him by having him sent to France in response to a request of Francis I's to Federigo Gonzaga for an artist of quality. Primaticcio was responsible for the Sala degli Stucchi, which is decorated with splendid friezes and ceiling lunettes of fine plaster reliefs. Giulio's other Mantuan works were decorations in the vast warren of the old Castello – the Reggia – where among other things, he painted a ceiling in the Sala di Troia. This room has a vaulted ceiling above a cornice, and Giulio here invented the perspective illusion of scenes

taking place in an imaginary space above eye level. His incidents from the Siege of Troy are set on the cornice, and the centre of the ceiling is filled with clouds in which float zephyrs and other figures, while on the walls below the cornice are histories of Troy conceived in the more usual manner as flat pictures. This also was an idea with a future.

His other surviving architectural works are the house he built for himself and the internal façades of the tiltyard in the Reggia. His own house is best contrasted with Raphael's, for it is as wilful as the Roman one is serene. No order decorates the façade: the windows follow in a quick sequence in the *piano nobile* (the fourth bay on the left of the door was added in 1800), each one with a triangular pediment jammed tightly within the relieving arch which has a heavily rusticated framework around it; below the string-course, which doubles as a window-sill, is a basement storey of more roughly rusticated blocks cut into by simple square windows below which is a real basement with small window heads just peeping out of the ground as if they had slipped down into the earth. The door is quite plain, but the sharply pointed pediment above it is merely the string-course poked upwards while the architrave of the door also reappears threading its way along the basement between the rustications of the window frames. There is an entablature although there is no order to support it, and the rich garlands in the frieze are looped up over the tiny attic windows, while the bottom of the entablature rests directly on the projecting blocks of the

126 GIULIO ROMANO His own house in Mantua, façade *c.* 1544

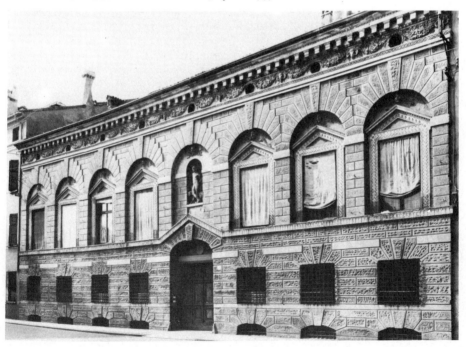

127 GIULIO ROMANO Courtyard of the Cavallerizza, Reggia, Mantua

keystones of the main window arches. Over the door is a niche conspicuously smaller than the windows, containing an Apollo, and in the head of every arch a mask caught like a nut in crackers between the pediment and the keystone. The result is controlled and disturbed, symmetrical yet perversely unbalanced. The tiltyard, or Cavallerizza, now much restored and rebuilt, is a long courtyard divided evenly into bays, with a heavy rustication throughout, wide arches below and heavy windows above, the bays divided by twisted, unevenly fluted columns derived ultimately from the twisted columns in Old St Peter's. The effect is colourful in the chiaroscuro sense, and of a fascinating perversity, since the column forms are at such variance with the fortified look of the rest of the wall. These emotional uses of the contrasts of plain and rough surfaces, of broad and flattened arches bearing heavy blocks simulating rough hewn stone, of simple Doric entablatures borne on the richest kind of decorative columns, creating effects of light and shadow, of movement, of confusion between forms

proper to interiors and exteriors, and the sense of unease and astonishment caused to the knowledgeable spectator by the distortions of the classical canons, are the basic vocabulary of Mannerist architecture. It is essential that the spectator looks at it with a discerning eye to recognize the violations, for in these surprises lies the essence of the style. One of the fascinating things about Giulio is the isolation in which he worked after his move to Mantua; so far as it has been possible to discover, he never visited Florence (for he travelled to Mantua via Loreto), or went further afield than Ferrara and Bologna, so that he could have known nothing by Michelangelo later than the *Moses*, nor could he have known much about Florentine developments, or Correggio in Parma. His only outside contacts, for that matter, were with Titian when he passed through Mantua on his way to Rome in 1545, when Vasari visited him in 1544, and when Cellini also visited him. Yet his perspective illusionism in the Palazzo del Tè, where figures stand upon the very edge of the frame and are painted in the most violent foreshortening, or float heavenwards so that they present chiefly the soles of their feet, are ideas current in Italy a decade or so later, and in particular in Parma at almost the same moment. But it is not so odd when one remembers that the great exemplar of illusionism in Mantua was Mantegna.

Baldassare Peruzzi was born about 1481 and began as a painter in Siena. He came to Rome about 1503, and died there in 1536. He went into the Bramante shop, and produced a plan for St Peter's which is a variation, though simplified, of Bramante's centrally planned project. He also built two palaces in Rome: the Villa Farnesina between 1509 and 1511, and the Palazzo Massimi alle Colonne, which is his last work. The Farnesina was built for the Sienese banker Agostino Chigi for whom

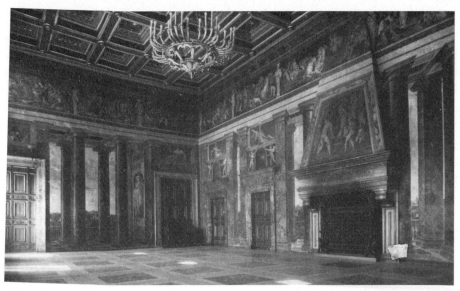

128, 129 Peruzzi Sala delle Prospettive, Villa Farnesina, Rome, with detail of painted colonnade *c.* 1515

Raphael decorated the Farnesina with the *Galatea* and supervised Giulio Romano's Loggia decorations of the story of Psyche. The Farnesina was planned much on the lines of a *villa suburbana* – not as a place of residence, but a pavilion at which to spend the hot summer days. It consists of a central block with two wings projecting on the garden front, and between them an open loggia (now glazed in), where the painted decorations are. Originally the outside walls were also frescoed, but now the only part of the exterior decoration is the richly ornamental frieze. Upstairs, in the *gran salone*, Peruzzi painted one of the early Roman illusionistic decorations. At first sight, it appears as if the room opens on to a loggia, through the columns of which there is a view of Rome; in fact, all is illusion, and loggia, columns, and statues in niches, are all painted. After the death of Raphael in 1520, Peruzzi became joint head of the works at St Peter's, but he

133

could do little, and after the Sack, during which he suffered great hardship, he escaped to Siena. He was re-appointed to the works at St Peter's in 1530, but did not return to the city permanently until 1535, and he died there in the following January. During these last years he designed the Palazzo Massimi alle Colonne, for a family of brothers who shared the site, but required separate houses. The façade is the first to accept the requirements of the site to the extent of curving with the street corner on which the palace stands, and the forms display strange dissonances which have caused it to be called the first truly Mannerist building, though in fact it was built long after the Palazzo del Tè. The columns of the portico are spaced irregularly, and are coupled and then single with a closing pilaster, with an equally odd rhythm in the windows above, and these

130 PERUZZI Façade of the Palazzo Massimi alle Colonne, Rome c. 1535

again are surmounted by small mezzanine and attic windows with the flat leatherwork patterns of northern Mannerism around them, and are almost without projection in a rusticated wall surface. The courtyard has the staircase offset, to rise into a large, elaborate loggia, and the curious disposition of the front windows is reflected here by the strange openings below the loggia, which look like windows, but are, in fact, designed to give extra light to the entrance loggia behind the columns, but they so confuse the delimitation of the storeys that they effectively disguise the disproportion between the ground and the first floors.

Sebastiano del Piombo, who came from Venice to work on the decoration of the Farnesina, found himself part of the Raphael circle. He did some decorative frescoes there, but his portraits during these years are his finest works. He manages to combine the feeling and psychological interest of Giorgione's portraits with Raphael's largeness of manner: the so-called *Dorothea* in Berlin, or the portrait of *Cardinal Carondelet with his Secretary*, with the typically Venetian still-life interest in the foreground, and the splendidly Roman colonnade behind, show his development of a blend of Venetian and Roman characteristics. It is also obvious that Sebastiano's rich Venetian colour influenced Raphael somewhat, particularly in the Stanza dell' Eliodoro, and he was to have an effect on Michelangelo as well. Round about 1516, Sebastiano transferred his admiration from Raphael to Michelangelo, to the point that he described Raphael and his assistants as 'quel sinagogo' – 'that clan'. The new influence is clear in works like the Viterbo *Lamentation* and the *Flagellation* in S. Pietro in Montorio, which is reputedly based on a Michelangelo drawing. Certainly, Michelangelo did provide him with drawings for his compositions, notably for

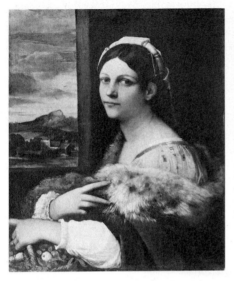

the *Pietà* now at Ubeda in Spain. The rivalry with Raphael was accentuated by the commission for the *Raising of Lazarus* (1517–19), painted in competition with the *Transfiguration*, but it is not in vast machines of this order that his virtues are obvious, so much as in simpler dramatic subjects like the stark Viterbo *Lamentation* or the rich colour and sober form of small devotional works like the *Madonna and Child with a Donor*, in London. While his portraits continue to be superb, his conscious attempts at grandiose feeling become empty and even vapid. In 1531 he took minor orders on receiving a papal sinecure of the Seal, hence the Roman name of Sebastiano 'del Piombo'. Vasari records that he became very lazy with the passage of time, and immoderately addicted to the pleasures of the table. He died in 1547. His slight influence on Michelangelo was in the direction of enriching the colour of some of the figures in the *Ancestors of Christ* in the Sistine Ceiling; here and there one of them shows a more Venetian painterly feeling and a looser technique.

131 SEBASTIANO *Dorothea c.* 1512

132 SEBASTIANO *Cardinal Pole c.* 1537

133 SEBASTIANO *Cardinal Carondelet with his Secretary c.* 1512

134 SEBASTIANO *Raising of Lazarus* 1517–19

135 VIGNOLA Plan and section of the Villa Giulia, Rome 1550

Of the other architects, Fontana was principally an engineer who, in conjunction with Sixtus V during his short papacy from 1585 to 1590, replanned Rome as a modern city, laying out the new roads which are still its main arteries, and bringing in new aqueducts to supply the great fountains of the Acqua Felice and the Trevi. Giacomo della Porta became official Architect to the Roman People, and had a hand in every large project in Rome until his death in 1602, but little he built is memorable on its own account. With Fontana, he erected Michelangelo's dome of St Peter's, which they altered somewhat in the process, and he also completed the Campidoglio, where he altered Michelangelo's design for the central window of the Conservatori, the exit roads and the pavement pattern. He finished Vignola's Gesù, where he spoilt the façade by changing the design altogether.

The great architect in Rome after Michelangelo was Vignola. He was born near Modena in 1507, and he began by drawing classical antiquities in Rome in the mid-1530s, and in 1541–43 he spent eighteen months in Fontainebleau with Primaticcio. He first appears as an architect at the Villa Giulia built for Pope Julius III from 1550 onwards, working in association with Vasari, who seems to have been the *entrepreneur* for this commission, and Ammanati who did the sculpture and the garden design. The main block of the villa has a strongly rusticated entrance porch in a flat façade, five bays wide, with heavy keystones and rusticated coigns below, with a simpler, flatter, more decorative treatment in the upper storey. From the garden side the contrast is complete, for to the uncompromising rectangles of the front corresponds a wide, sweeping semicircular loggia with colonnaded openings

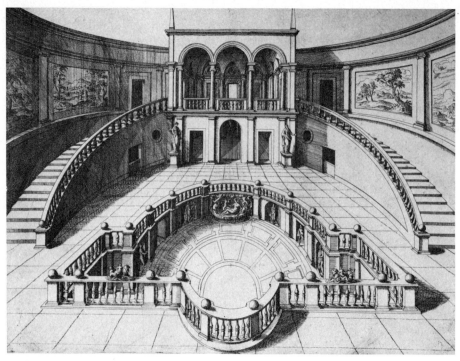

136 VIGNOLA Nymphaeum of the Villa Giulia

137 VIGNOLA Garden front of the Villa Giulia

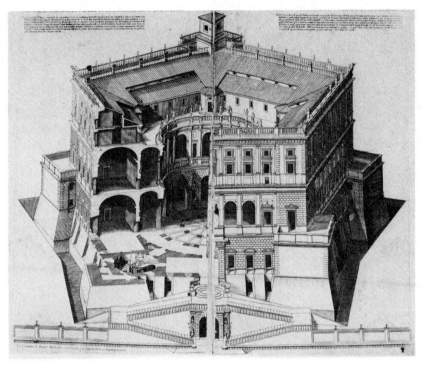

138 Vignola Section of the Villa Farnese, Caprarola

on either side of a triumphal arch entrance, the barrel vaults of the loggia being painted with a charming decoration of vine arbours. The long garden is enclosed by a decorative wall pierced by a door; once through this another complete surprise meets the eye, for the garden here is sunken, and descends by semi-circular staircases to a deep nymphaeum, where the water-lilies grow in the fountain that continues into a grotto, and behind, at the top of more staircases is a simple garden ending in a little temple. The whole charm of the place is in its evocation of coolness, of dripping rocks and statues sprayed by jets of water, of an escape from the sun and the public side of papal life to privacy and relaxation.

The villa at Caprarola was not the same kind of retreat. It was the centre of the Farnese estates, and was begun originally about 1521 by Antonio da San Gallo the Younger and Peruzzi as a fortified pentagon, but remained no more than foundation and a basement until Vignola began work there in 1559. The house – which served rather the same purpose as the 'prodigy' houses of the newly landed English gentry seeking to mask the newness of their wealth and power – contained suites for summer and winter residence, built around a circular courtyard with arcades up and down, and a very flat barrel vault to the lower arcade. Inside, a circular stair rises, like the winding stair Bramante built in the

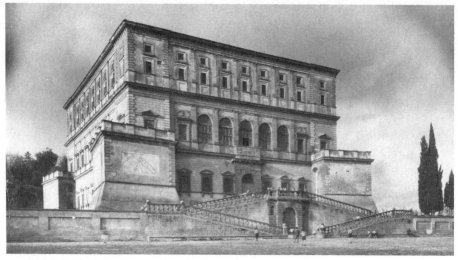

139 VIGNOLA Villa Farnese, Caprarola, after 1559

140 VIGNOLA Courtyard of the Villa Farnese

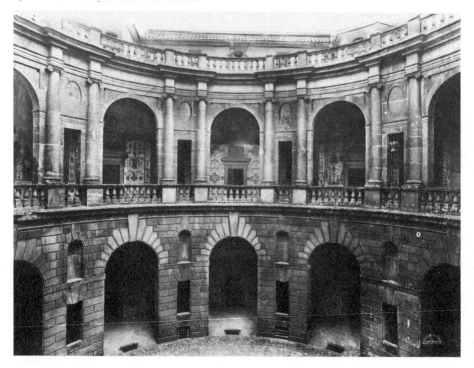

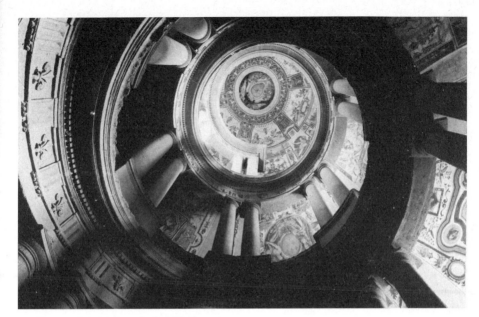

141 VIGNOLA Spiral staircase in the Villa Farnese

Vatican Belvedere, to the *gran salone*. The most striking feature of Vignola's architecture is its careful avoidance of any of the more obvious Mannerist tricks, such as those in the Palazzo del Tè. What he essays is, in some ways, a return to Bramante's simplicity and order, and an escape from the visual confusions and richness of ornament of Michelangelo. His detailing is flat, his rustication shallow, his arches plain, his order kept deliberately to Doric and Ionic, and while the famous staircase is very decorative, there is no change in the order as there was in Bramante's, but only a restrained Doric throughout. Vignola, in fact, achieves the surprising feat of converting Bramante into another kind of classical model, like antiquity.

His churches were equally influential. The Gesù – the mother-church of the Jesuit Order – was begun in 1568 on a very strict brief prepared by his patron, Cardinal Farnese, which laid down the importance of the preacher being audible in all parts. This limited the building to a wide, barrel-vaulted nave, for acoustic reasons, and Vignola's solution was a return to the plan of Alberti's S. Andrea in Mantua of 1470, in that he adopted the aisleless form with deep side chapels, leading to a wide crossing with an apse behind the main altar. The site made this necessary also, and only clerestory windows light the nave, which in turn means that the domed crossing is in a blaze of light. Vignola's original designs called for restraint, bareness even, in the interior decoration, but during the seventeenth century the church received one of the most exuberant Baroque decorations, so that the interior no longer corresponds to the architect's ideas. Neither does the façade, for Vignola died in 1573 when the church was only at cornice level. Giacomo della Porta finished it, adding his own façade, which is far from being as

142 VIGNOLA Plan of the Gesù,
Rome 1568

143 VIGNOLA Engraving of design for the façade
of the Gesù 1570

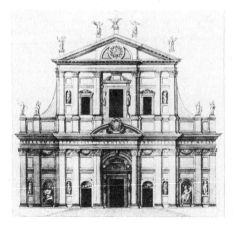

interesting or sensitively worked out as the original design. The Gesù, as the chief church of the most militant religious Order, was extremely influential, since most Jesuit churches followed it everywhere the Order penetrated.

During the work on the Villa Giulia Vignola built a tiny church, S. Andrea in Via Flaminia, close by. This he designed as a rectangle, with an oval dome over it, though from the outside the novelty of the shape is not immediately apparent. In his small church, S. Anna dei Palafrenieri designed at the end of his life for the papal grooms and built chiefly by his son, he transfers the idea of an oval dome to the ground plan, giving the church an axis on the length of the oval by the position and depth of the entrance and the main altar. The walls of the chapel are articulated by large columns, and from these rise the ribs of the dome. From these simple beginnings came the interest in circular and oval plans during the Baroque period, for Bernini's S. Andrea al Quirinale and Borromini's S. Carlino are elaborations of an idea which started with Vignola. It is, however, important that all these small centrally planned churches were primarily private chapels, not grand or parish churches designed for large congregations. For these, Vignola's Gesù remained the preferred model. Vignola's remaining work of lasting importance was his great illustrated treatise, 'Regola delli Cinque Ordini d'Architettura', published in 1562. It is far more scholarly than Serlio and, with Palladio's 'Quattro Libri' of 1570, established the type of the learned yet informative work which lies at the base of academic example and precept. It became the textbook of all aspiring architects, and also of their patrons, and its countless editions spread the academic view of antiquity and of Bramante and Renaissance architecture far and wide over Europe.

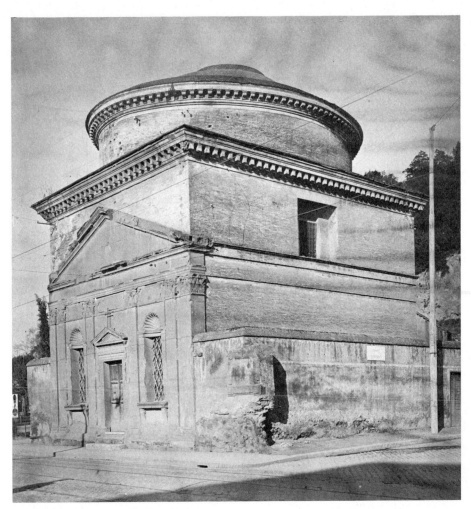

144 VIGNOLA S. Andrea in Via Flaminia, Rome 1554

Florence

145 SARTO *The Miracles of S. Filippo Benizzi* 1509

When Leonardo went back to Milan, and Michelangelo went back to Rome to make the Julius Tomb (as he thought), both in 1506, and Raphael left to begin work on the Stanze in 1508, the artistic centre of gravity moved from Florence to Rome. These were to be lean years politically, and until Michelangelo returned to Florence in 1516 to work for the glory of the Medici family imposed as rulers by a Medici Pope, there was little public patronage. Fra Bartolommeo's works were mostly for

churches, but he was to die so soon after that his late form of Roman-inspired grandeur found no continuator.

Andrea del Sarto was born in 1486. Vasari says that he was a pupil of Piero di Cosimo, but internal evidence suggests that Raffaellino del Garbo, a late Quattrocento painter with a very fine technique, may have been, if not his formal teacher, certainly his most important one. By about 1506 he was sharing a studio with Franciabigio, who had been a pupil of Fra Bartolommeo's assistant Albertinelli, and in 1511 they were joined by the sculptor Jacopo Sansovino on his return from Rome. About this time, Sarto had Pontormo and Rosso as pupils, and late in 1524 Vasari, then thirteen, came to him as a pupil for about two years. Vasari's short connection gives great verisimilitude to his life of Andrea del Sarto. It is obvious that he loathed Lucrezia, his master's wife, and that he did not have a very high opinion of Sarto's character, so that it is difficult to estimate how much of his interpretation is plain libel, and how much of it is based on an all too intimate knowledge.

Sarto's first works were frescoes of the *Miracles of S. Filippo Benizzi* in the entrance courtyard of the SS. Annunziata, painted in 1509, followed in 1511 by his first frescoes in the little cloister of the lay confraternity of the Scalzo. This commis-

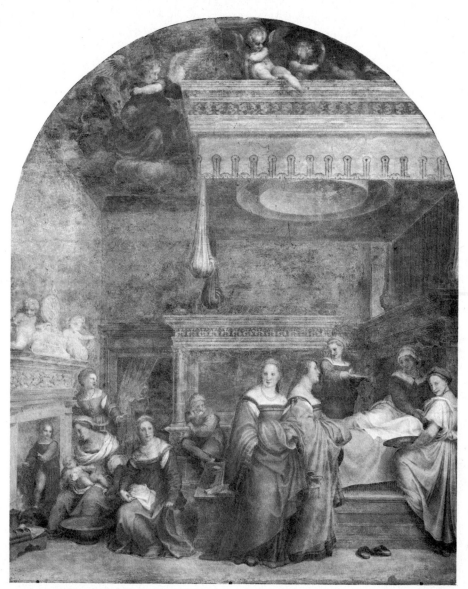

146 SARTO *Birth of the Virgin* 1514

sion for monochrome frescoes of the life of the Baptist continued intermittently until 1526. In 1513/14 he was again working in the Annunziata courtyard, painting the superb fresco of the *Birth of the Virgin*, which contains in the group of women in attendance upon the new mother a portrait of the beautiful Lucrezia, who was widowed in 1516, and whom he married shortly after. In the early summer of 1518 he accepted an invitation from Francis I to go to Fontainebleau, but only one or two paintings can be associated with this visit, which ended late in 1519, when he came home again ostensibly to fetch his wife. Vasari's story is that Sarto embezzled a large sum of money given him by Francis I to buy works of art, and he certainly made a very large bank deposit immediately upon his return and later built himself a house and studio. He probably visited Rome soon after the French journey, lived through the terrible siege of Florence in 1529/30, and died of plague immediately afterwards. Vasari's unflattering account of Lucrezia not only accuses her of ruining her husband's career, but also of abandoning him on his deathbed.

Sarto's great gifts are such that he has been acclaimed as the perfect artist, the painter who never made a mistake. His impeccable draughtsmanship is full of feeling, his simple colour schemes are tender, his dazzling technique, whether in oil or fresco, makes difficulties seem non-existent. The influence of Leonardo led him to develop soft modelling and the telltale smile, and later he combined these with an unmistakable type of face with dark smudgy eyes, short nose, and wide slightly open mouth – Lucrezia's famous face. The really great development is in his use of chiaroscuro. If one compares his most outstanding altarpiece, the *Madonna of the Harpies* – so called from the little figures on the pedestal – of 1517, with any of the grand Raphael ones (the *Sistine*

Madonna is almost contemporary) the first thing that is clear is the derivation from Raphael. The Madonna has close links with such Raphaels as the roundel of *Poetry* in the Segnatura ceiling, and there is the same exaltation of the Mother of God to a superhuman state, the same stress on the God Child, the same subtlety in the alternation of the poses of the two saints and in their relationship to the Madonna and to the spectator, the same spatial affinity. In the Raphael the field is closed by the empty sky and by the sharp frontal plane of the curtain and the little angels; in the Sarto there is a wall behind the Madonna and the shallow space is marked off in front by the step on which the small pedestal stands. There is a similar idealization in the Madonna and the saints, the same restriction to the barest essentials of a *sacra conversazione*. But when one considers the way in which this simple group is constructed in terms of chiaroscuro, then the differences become vital to an understanding of the new trends which Sarto represents in Florence. The light in the Raphael is an even, clear illumination which makes the subject plain; the Sarto has a glancing, moving, intermittent light which gives mystery and emotion to the group. It is composed of fitful ´gleams, which strike and glance away again, so that the picture becomes a vision, half-glimpsed in a half-light, and the patches of light and dark are as episodic as passing sunlight.

This treatment of light is consistent throughout the artist's *œuvre*, for it is present in a tentative form as early as the Dresden *Marriage of St Catherine* of about 1512, and is at its grandest in the late *Madonna and Saints* in the Pitti painted in 1525/26. The use of this kind of patchwork of light and shadow is less pronounced in his frescoes, largely because the medium lends itself less readily to strong chiaroscuro (the difference of technique often

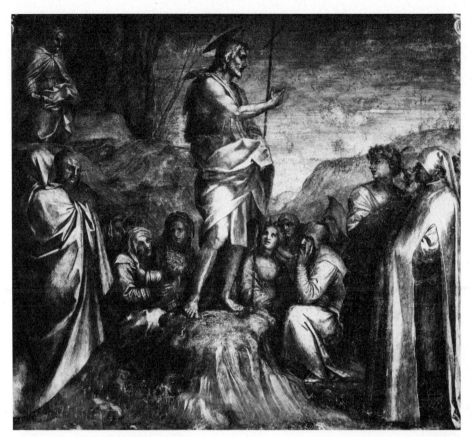

147 SARTO *St John the Baptist preaching* 1515

vitiates comparisons between frescoes and easel pictures); yet it occurs. The magnificent *Birth of the Virgin* of 1514 combines a shadowy background with sharply stressed figures and objects, like the sheet, the towel on the woman's lap, the bunched up bed-curtains; the Scalzo frescoes, which are his longest series, use this device constantly. In fact, the Scalzo frescoes may have encouraged this kind of lighting by being in monochrome, thus tending to exaggerate contrasts of light, and because of the variation in the normal fresco technique which he used for them – a very

thick, impasted fresco laid upon a middle tint. Though Michelangelo was working in Florence throughout the greater part of Sarto's later career, only rarely is there a reflection of his influence – Isaac, in the late *Sacrifice of Abraham*, in its dependence on the figure of Victory is one instance – though he is constantly affected by the power and vigour of Michelangelo's drawing. What is more striking is the use of Dürer's engravings. Vasari is very hard upon Pontormo for doing this, but he passes over Sarto's borrowings from them in silence.

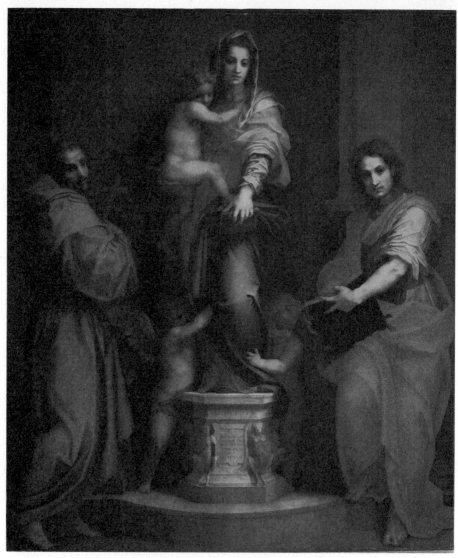

148 SARTO *Madonna of the Harpies* 1517

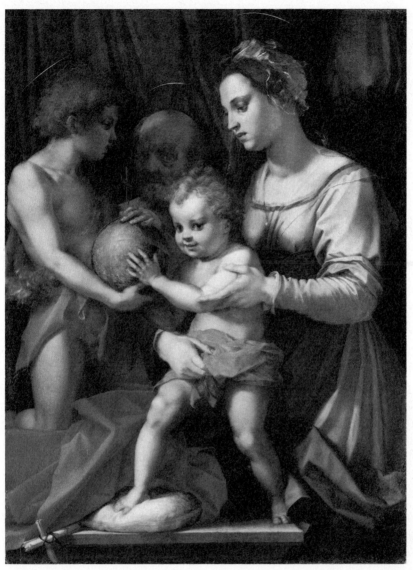

149 SARTO *The Holy Family c.* 1529

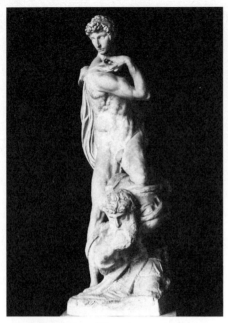

150 MICHELANGELO *Victory* 1527–30

151 SARTO *Sacrifice of Abraham*

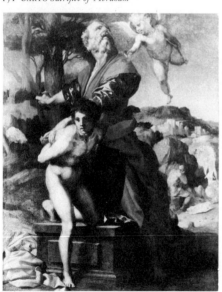

Franciabigio, with whom Sarto shared a studio for a couple of years, was born in 1482/83 and died in 1525. He was a channel through which the influence of Fra Bartolommeo reached Sarto, since Franciabigio was Albertinelli's pupil until the latter abandoned his partnership with the Frate to become an innkeeper in 1511, at the same moment that Sarto finally found that he could tolerate Piero di Cosimo's eccentricities no longer. At first their styles were very close, but by 1514, when both artists completed frescoes in the Annunziata courtyard, painted virtually in competition, it was clear that Andrea had excelled him, for in a rage Franciabigio destroyed part of his *Marriage of the Virgin*. His *Last Supper* in the Convent of the Calza, also of 1514, is Ghirlandaio's old-fashioned scheme brought up to date by vaguely Leonardesque gestures and groupings, and by a striving towards Raphael's ideal classicism of type. He is at his best as a portrait painter, with something of Lotto's introspective sensitiveness.

All Andrea del Sarto's pupils achieved eminence. Jacopo Pontormo, who was born in 1494, was first with Albertinelli, and possibly also with Piero di Cosimo, before coming – more as an assistant – into Sarto's workshop. His first works are strongly influenced by Fra Bartolommeo, and in 1516 his *Visitation* in the Annunziata courtyard shows the impact of his elders, with few hints, despite the way the subject is set into the picture space, and the woman and boy sit on the steps, of the turmoils to come. In 1518 he finished the *Madonna and Child with Saints* in S. Michele Visdomini in Florence. This picture is as epoch-making as Leonardo's *Last Supper*, in that it is a watershed for the emergence of the completely new stylistic development of Mannerism. It is a strange, almost convulsive work, blending uneasily forms derived from Leonardo and Raphael, with

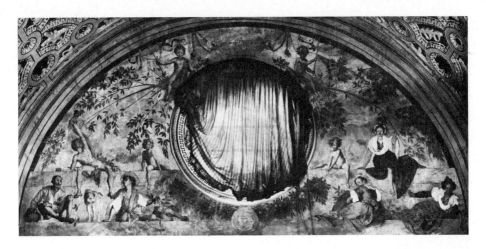

the Frate's ecstatic gestures and expressions, and the flickering patchwork of light and shadow superimposed on the negation of depth which first appears in Sarto. What this new attitude could lead to is clear from the *Joseph in Egypt* panel from a series painted to decorate a room between 1515 and 1518. Here the thesis proposed by Mannerism is fully elaborated: the painter is no longer to be bound by perspective, or by the necessity of presenting his subject in a rational, objective manner. He may use light and colour, chiaroscuro and proportion as he pleases; he may borrow from any source he chooses; the only obligation upon him is to create an interesting design, expressive of the ideas inherent in the subject, and the various parts need bear no relationship to each other. The colour must be evocative and beautiful in itself.

In 1521 he was commissioned to paint a large decoration in the Medici villa at Poggio a Caiano, in a scheme on which Sarto and Franciabigio were also employed. Eventually, Pontormo's part was limited to a lunette round a large circular window; there is practically no internal cohesion between the marvellous figures in his fresco, which merely sit or lounge in

152 PONTORMO Lunette from Poggio a Caiano *c.* 1521

153 FRANCIABIGIO *Portrait of a Man* 1514

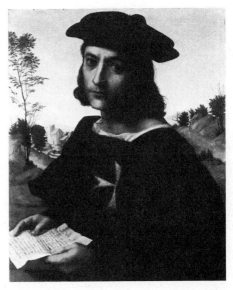

151

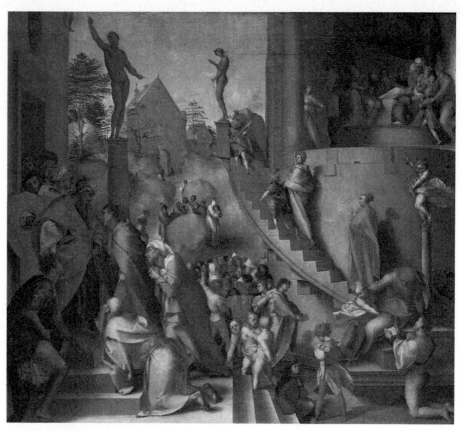

154 PONTORMO *Joseph in Egypt* 1515–18

almost abstract detachment under the
drooping branches of a willow tree. The
light is warm and glowing, the colour
restrained and clear, the feeling gay and
lighthearted, and the drawing of the nude
man and the garland-bearing urchins
proves his close study of Michelangelo's
Battle cartoon. Pontormo has a definite
physical type, very tall with long legs and a
compact head with a symmetrically oval
face containing small features with huge
wide-open eyes and a little half-open
mouth – a face that is a screen upon which
the emotions, chiefly of griefs and anxiety,

are reflected. He is at his greatest in his
religious works, such as the frescoes of the
Passion in the Certosa di Val d'Ema, near
Florence, done between 1522 and 1525.
These are now no more than ghostly
remains, and in comparison with his earlier
(and later) works they can hardly be called
Mannerist, for despite the occasional use
of strongly *repoussoir* figures and an
extreme expressiveness of face and gesture
they are admirably clear, and their delicate
and muted colour has little of the dramatic
overtones of the S. Felicità *Deposition*. It is
in these frescoes that he borrowed from

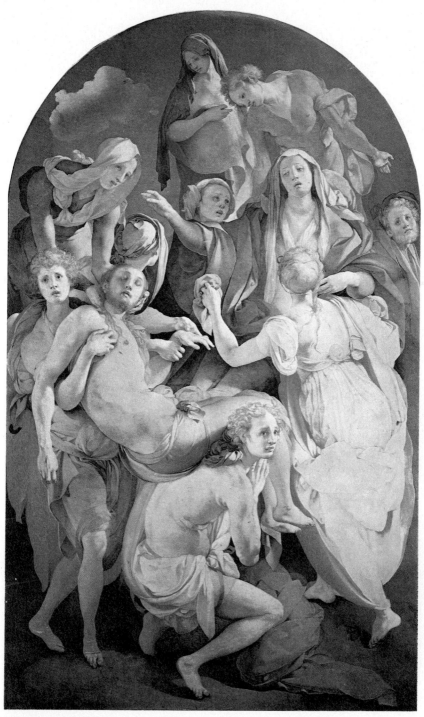

155 Pontormo *Deposition c.* 1528

156 Attributed to VASARI. Drawing after Perino del Vaga *Martyrdom of the Theban Legion*

157 PONTORMO *Halberdier c.* 1527

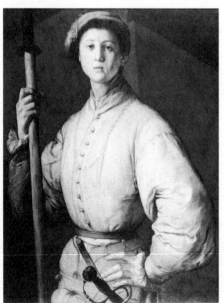

Dürer, to the scandal of Vasari, who was quite blind to the scope which Dürer's engravings and woodcuts offered to artists seeking for new means of expression.

The very dark chapel in S. Felicità in Florence contains a superb *Annunciation* frescoed on the wall on either side of the window, symbolizing the Incarnation through which light came to the world, and upon the altar is a *Deposition* which continues the words of the Creed by representing the Sacrifice which the Mass celebrates. The colour of the *Deposition* takes into account the darkness of the chapel, so that it glows with an unearthly radiance of pinks, greenish blues, pallid flesh tones, and a vivid orange-scarlet. The forms of the dead Christ depend ultimately on Michelangelo's *Pietà* in St Peter's, but this work was now so well known that it is no evidence for Pontormo's having visited Rome; the influence of Michelangelo results partly from his having been in close contact with him in Florence, and partly from the impact of Perino del Vaga's cartoon for the *Martyrdom of the Theban Legion*, done in Florence in 1522–23. This work is filled with nudes in poses that demonstrate the artist's ability to design figures interesting in themselves apart from any meaning they may have in the context, and it caused great excitement by introducing Roman ideas of Raphaelesque inspired idealization, and antique decorative motives, while its subject stimulated an interest in the dramatic possibilities of horror subjects. It reinforced the ever-active impact of Michelangelo's *Battle* cartoon, by renewing the concentration on the heroic nude, which was now to be joined to the new dramatic use of colour, which almost superseded Sarto's imaginative chiaroscuro. Pontormo himself painted a *Martyrdom of the Theban Legion*, which is almost an epitome of all the characteristics of Mannerism in their most exaggerated form, but it is

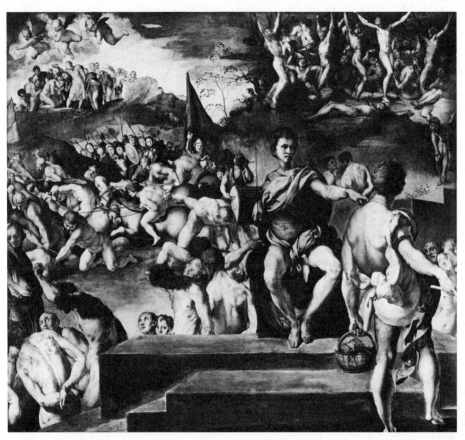

158 PONTORMO *Martyrdom of the Theban Legion c.* 1528/29

possible that its date – about 1528–29 – may account for much of his fascinated concentration on horror and violence. His last works were considered to be failures in his own lifetime and are known only from his drawings; but he was among the really great draughtsmen of the sixteenth century. Pontormo was also a surprisingly fine portrait painter, perhaps because he endows his sitters with a vivid expressiveness and an air of neurotic sensibility. In his late years he became distinctly eccentric, and there were times when he lived the life of a recluse, refusing to see even

Bronzino, who was practically an adopted son. He died in 1556.

Rosso and Pontormo virtually created Florentine Mannerism between them. Rosso was born in 1495, and his formative years are very obscure. Vasari was unable to assign him a master, commenting that he had ideas opposed to those who could have taught him, and he seems to have excelled Pontormo in individuality. He is clearly identifiable from about 1513 on, painting in a style which turns accepted Raphaelesque classicism upside down: compositions in the forms used by Fra

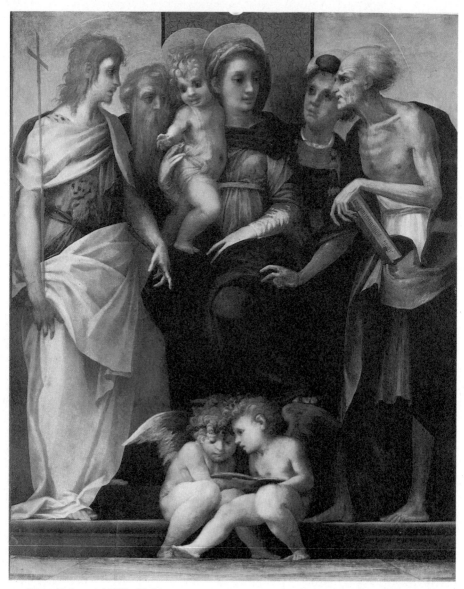

159 Rosso *Madonna and Child with Saints* 1518

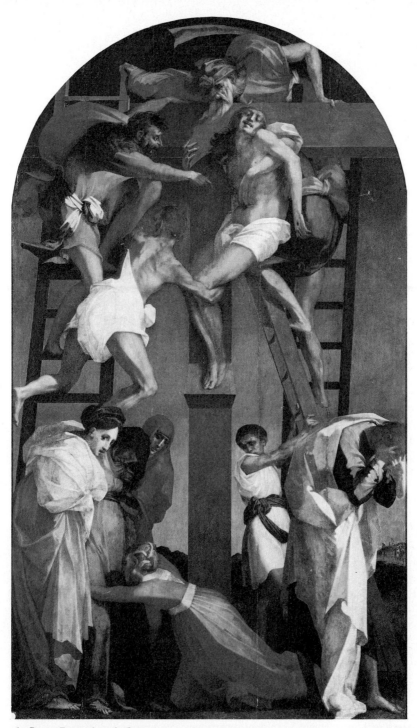

160 Rosso *Descent from the Cross* 1521

161 MICHELANGELO *Pietà*. Drawing *c.* 1519/20

Bartolommeo and Sarto, but without the construction of the one or the draughtsmanship and chiaroscuro of the other. Compared with Sarto's and Pontormo's performances in the Annunziata courtyard, Rosso's nearby *Assumption* of 1517 is a thin and bloodless affair, with schematized versions of Pontormo's stylized facial types and the Frate's rhetorical gestures. His altarpiece of the *Madonna and Child with Saints*, painted in 1518 for the Hospital of S. Maria Nuova, filled the commissioners with dismay when they saw it sketched in, for the saints looked to them like devils; his first ideas must, then, have been considerably toned down in execution, yet the results are often bizarre enough. The skinny St Jerome, with limbs like a praying mantis, the distracted Lear-like character glaring over the Child's shoulder lead on to the ghostly apparitions in the altarpiece painted for the parish church of Villamagna near Volterra, and prepare one for the very considerable shock of the *Descent from the Cross* in Volterra itself, painted in 1521. In this work the main character is the colour, and the colour is devoted to one end: a

violent and emotional expressiveness which overrides everything else, and seeks only to provoke in the spectator a thrill of horror and grief comparable with that which shattered the men and women who helped to lift Christ from the Cross and bury Him. The drawing is not conceived as a means of describing forms, but as a means of stating ideas. The light is not a normal illumination nor even a poetic evocation: the scene is lit as if by lightning, and in the blinding flash the figures are frozen in their attitudes and even in their thoughts, while the great limp body of the dead Christ, livid green with reddish hair and beard, dangles perilously as His dead weight almost slips from the grasp of the men straining on the ladders. He too acknowledges, as the Pontormo *Deposition* does, Michelangelo's Roman *Pietà*, but the Christ of his *Deposition* is far more closely connected with a drawing for a *Pietà* which Michelangelo made about 1519–20, and which haunted Rosso to the end of his life. His later *Pietà* painted in Rome, and now in Boston, is derived from it, and even the Paris one, despite its violently emotional colour, is a recension of the ideas of Michelangelo (with whom, incidentally, he was on very good terms). In 1523 Rosso went to Rome, and in 1527 was trapped there by the Sack, during which he is said to have undergone terrible sufferings. After the Sack he seems to have wandered restlessly around central Italy, ill, fearful of local hostility, involved in quarrels, yet dragging his large commissions after him from one resting place to another. Then he decided to go to France, passed through Venice on his way, and by the end of 1530 finally arrived at the French court, where he worked until the end of his life ten years later. Vasari, rather unkindly, said he committed suicide, but this must be wrong, since apparently he received a normal burial. Yet the nature of his art makes the statement plausible.

In Rome he was impelled by his admiration for Michelangelo to develop a grandiose treatment for the nude, which, seen through the Mannerism of his vision, produced such works as the extraordinary *Moses defending the daughters of Jethro* – a mass of huge bodies, jumbled in a violent struggle at the feet of a pallid semi-nude shepherdess surrounded by her frightened sheep. The fantastic quality of his imagination, which emerged in his early drawing of the *Skeletons*, leads him to create pictures which never portray an event, but re-create its emotional impact. For Rosso, form has nothing to do with relief, and only peripherally with idealized nature: it is the means by which ideas are made visible.

The second generation in Florence consisted of Bronzino, Vasari, Salviati, as the chief painters, and Bandinelli, Cellini, Ammanati and Giovanni da Bologna as sculptors. Bronzino, born in 1503, was in Pontormo's studio from childhood, and from 1539 onwards was the chief court painter to the Medici ruler, Cosimo I, and his wife Eleanora of Toledo. For her he decorated the chapel in the Palazzo Vecchio, with frescoes of astonishing incoherence and fantastic colour, filled with the usual Mannerist conception of men in extreme foreshortenings and exaggerated musculature, and women of the most pallid and coldly classical beauty. The allegory painted in 1545, and destined to be sent to Francis I, *Venus, Cupid, Time and Folly*, is of a rebarbatively frigid eroticism; in these years Bronzino also worked as a tapestry designer. Except for a visit to Rome between 1546 and 1548, he was in Florence until his death in 1572, working as a court artist, with portraits bulking large in his *œuvre*. They are exceptional in beauty and influence: cold, haughty faces, studied detachment, and aloof nobility seem to betray the watchful repression of emotion and the deadened

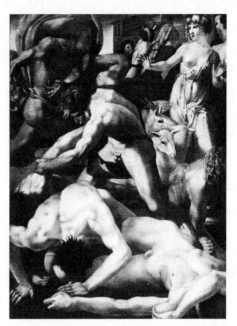

162 Rosso *Moses defending the daughters of Jethro* c. 1523

sensibility resulting from life under a violent and capricious tyrant. From Cosimo's time onwards, art in Florence is mainly court art, for he believed in patronage as an appanage of power. He could not tempt Michelangelo back from Rome, but all the others he employed at times, and some constantly, interesting himself also in the establishment of Academies of Arts and Languages, drawing thus a veil of culture and learning over his harshly repressive police state. His long reign – 1537–74 – covers virtually the full development of Mannerism, and its transition from the early stages of its revolt against classical perfection, with Pontormo and Rosso, to the final chilling inanities of the late decorations in the *studiolo* of the Palazzo Vecchio.

Vasari played the part of an impresario. He was born in 1511 and died in 1574; after being a pupil of Sarto and Bandinelli, he

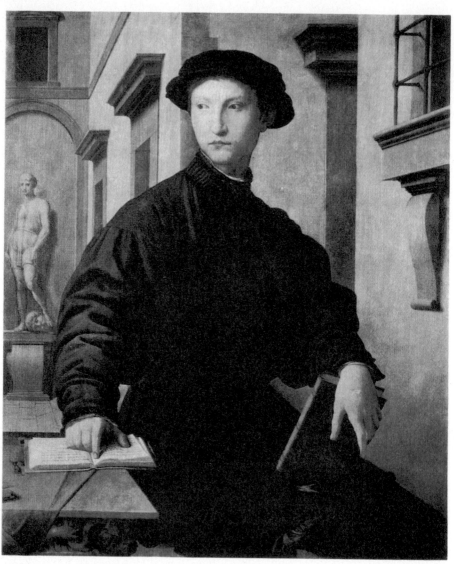

163 BRONZINO *Ugolino Martelli c.* 1535

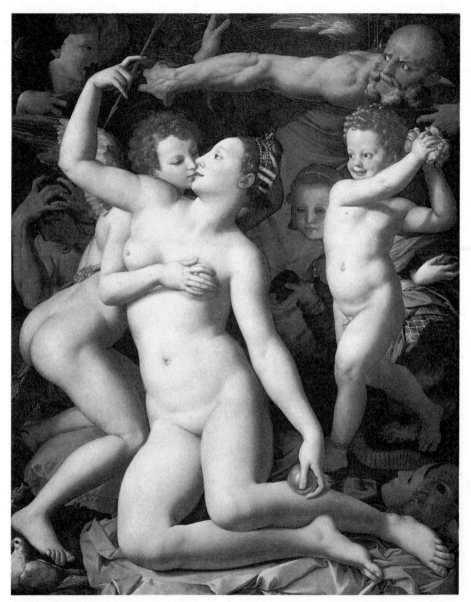

164 BRONZINO *Venus, Cupid, Time and Folly* 1545

finally emerged as a passionate admirer of Michelangelo. He travelled round Italy, after the murder of his first patron, Alessandro de' Medici in 1537, painting wherever work was to be found, and it was during these years that the idea of the 'Lives' was born in him. In Rome he directed the building of the Villa Giulia for Julius III, did fresco decorations in the Cancelleria and the Vatican, and in Florence built the Uffizi – his major work – and painted frescoes in the Palazzo Vecchio and in the dome of Florence Cathedral, displaying the extent of his erudition and the limitations of his artistic talent. His great monument is the 'Lives', first published in 1550, on a severe scheme as an account of the arts of the past culminating in the Life of Michelangelo – the only living artist to appear – and a history of the fall and regeneration of the arts through the efforts of Tuscans. The success of the book was enormous, and in 1568 he published a second, enlarged and revised, edition, containing the lives of many other living artists. From the historical standpoint this is all to the good, but it involved a corresponding weakening of his original thesis. Vasari took his work as a historian very seriously, and did his best to be accurate in his facts and attributions. The 'Lives' has been much attacked for its errors, but without it the history of the arts in Italy would be almost

165 VASARI Screen from the Uffizi, built between 1560 and 1574

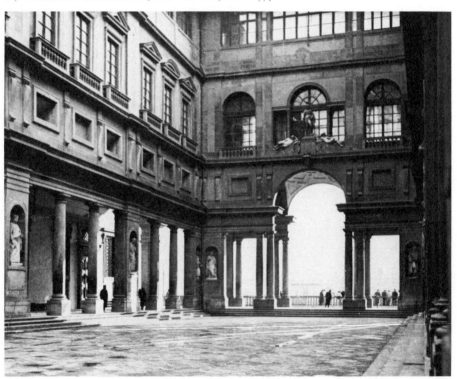

166 SALVIATI *Triumph of Ranuccio Farnese* after 1553

irrecoverable, and despite his faults it must be remembered that he is four hundred years nearer the events than his critics. Michelangelo, who first thought poorly of him, came to appreciate his ability and devotion, though after the publication of the 1550 edition he virtually dictated a rival life of himself which Condivi, his pupil, wrote up in 1553; but Michelangelo's view of his own career is as partisan in a different way as Vasari's, and his inaccuracies are deliberate.

Salviati is a more interesting painter than Vasari, whose close friend he was. He was in the Sarto workshop about 1529, and after the Siege, Vasari and he were together in Rome, where the influence of Raphael, and of sophisticated Raphael followers like Giulio Romano and Perino del Vaga, affected him deeply, as did Rosso. He also gathered ideas from his travels through north Italy, in Mantua, Venice and probably Parma, to judge from the impact of Parmigianino. He was always restless and peripatetic, with an elaborate decorative style, involved imagery, and fantastic perspective, managed in

a consummate technique combining Michelangelesque drawing with the pale, brilliant colour general among Mannerist fresco painters. His splendid portraits and the *Triumphs* in Florence are probably his least Mannerist works, his frescoes in the Palazzo Sacchetti and the Farnese palace in Rome his most – and in fact the Farnese frescoes (his last major work before his death in 1563) are among the most extravagant, amusingly witty, and sophisticated in all the genre.

Possibly the most interesting of the non-Florentine Mannerist painters was Beccafumi. Born in 1485/86, he belongs to the High Renaissance generation, and his death in 1551 brought to an end the long, and always emotionally directed, succession of great Sienese painters. His years in Rome from 1510 to 1512 coincided with the period of the Stanze and the Sistine Ceiling; yet soon after his return to Siena in 1513 his work displayed characteristics normally associated with the Mannerism of the next decade. His later use of lurid colour, extraordinary perspective and elaborate *contrapposto* probably reflects a

167 Salviati *Bathsheba goes to King David*, Palazzo Sacchetti 1552–54

168 SALVIATI *Charity c.* 1554/58

169 CELLINI *Perseus* 1545–54

knowledge of these stylistic elements in Central Italian painting, gained through the dispersal of artists after the Sack.

Of the sculptors, Bandinelli (1493–1560) was the least content and most unfortunate, for he had to compete with the fiery and uninhibited Cellini. His lumpish *Hercules and Cacus* of 1534 – described as a 'sack of walnuts' – displays its inadequacies only yards away from Michelangelo's great *David*, which it was his avowed intention to surpass, and his major contribution to the arts was the part he played in establishing Academies (his first was as early as 1531) as art-schools, whereby eventually the workshop system of apprenticeship was superseded, not, perhaps, without as much being lost as was gained by the change.

Cellini is as famous a writer as he is a sculptor, for his 'Autobiography' is the raciest of all accounts of an artist's life, and also deeply revealing on the subservient relationships general between artists and their patrons. His reputation probably owes as much to his memoirs as it does to his art. He lived from 1500 to 1571, was trained as a goldsmith, went to Rome in 1519, and after his adventures during the Sack came back to Florence, and went on to France in 1537 to become one of the team of Italians working for Francis I. His *Nymph* (Louvre: of 1543–44) was once at Anet, and the celebrated salt-cellar in Vienna was begun in Rome and finished for Francis I. In 1545 he left France abruptly for reasons which he was perhaps wise not to have made very clear, and settled in Florence to become the great partisan of Michelangelo and the bane of Bandinelli's life. Fortunately he never attempted the aggrandisement of form or complication of pose adopted by the usual Michelangelo follower, but rather his synthesis of form and meaning. His masterpiece, the *Perseus* (1545–54) was commissioned for its present position in

170 AMMANATI *Marine God* from the *Neptune Fountain* 1563–75

the Loggia dei Lanzi, and designed to withstand the competition of Michelangelo's *David* and Donatello's *Judith*, and to put down Bandinelli's *Hercules*.

Ammanati was born in 1511, and died in Florence in 1592. He was trained by Montorsoli, one of Michelangelo's assistants on the Medici Chapel, and also by Sansovino in Venice, and in Rome worked under the direct supervision of Michelangelo. His *Neptune Fountain* in Florence barely justifies this splendid background, and the most attractive parts of it are the bronze figures of nymphs and satyrs on the basin. It plays a large part in the history of the monumental fountain, for the mixture of the solidity of statuary and the evanescent patterns of light and moving water became a favourite sixteenth-century form. Ammanati also worked as

an architect, designing the Ponte S. Trinità (1567–70) and the rusticated courtyard of the Pitti Palace (1558–70), as well as being involved in some aspects of the Villa Giulia in Rome.

The greatest sculptor in Florence after Michelangelo left was Giovanni da Bologna, a Fleming, born in 1529, who went to Italy to study about 1554. On his way home from Rome he stopped in Florence – and stayed there until he died in 1608. He is the creator of types so distinctive that he is the epitome of all the ideas of grace, movement, classical beauty, strength and expression current in the age of Mannerism. The *Rape of the Sabines*, of 1582, in the Loggia dei Lanzi, is the very type of the Mannerist group, with multiple viewpoints and the maximum of movement and drama possible, and in his figures of Venus

167

171 BECCAFUMI *Birth of the Virgin*

172 GIAMBOLOGNA *Rape of the Sabines* 1582 173 GIAMBOLOGNA *Venus*

– mostly for fountains, but many as small bronzes – Giambologna achieves the Mannerist ideal in elongation and in conscious courtly elegance. His fountains are masterpieces: the *Neptune Fountain* in Bologna, of 1563–67, was his first, followed by a splendid series for various Medici villas and gardens, which includes the *Samson slaying the Philistine* (begun about 1565, now in London, Victoria and Albert Museum). With Michelangelo, he is a formative influence on the Baroque; Bernini, for instance, though he reacted against the multiple viewpoint, remained strongly affected by the drama and expression of Giambologna's works, and the development of fountain sculpture became one of the great arts of Baroque.

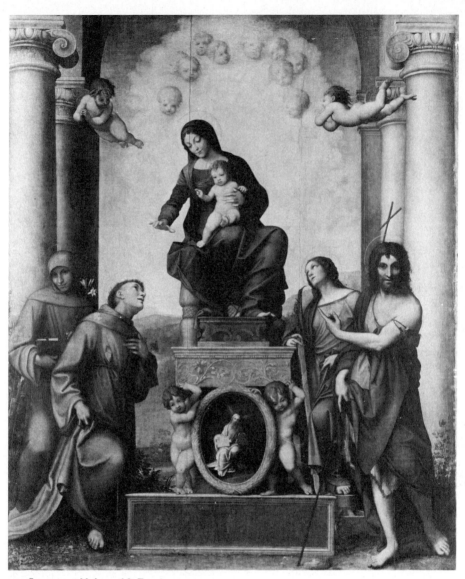

174 CORREGGIO *Madonna of St Francis c.* 1514–15

Parma

At first sight, one would not think of connecting the hard, linear, exploratory style of Mantegna with Correggio's soft modelling, fluidity of pose and melting tenderness of expression. Yet there is a tradition that he was Mantegna's pupil. He was born, probably in 1489, at Correggio, some thirty miles from Parma, and he could have been in Mantegna's workshop in Mantua, also some thirty miles distant, at about fifteen years of age, and a pupil for at least two years before Mantegna died in September 1506. The point at which tradition gives way to evidence is in the resemblances between Correggio's earliest works and Mantegna's late ones. The *Madonna of St Francis*, so called from the St Francis in the group of four saints at the base of the throne, is his earliest certain work, and was commissioned in 1514. The pose of the Madonna and the gesture of her right hand is so close to Mantegna's late *Madonna of Victory* that it is patent that one inspired the other. Correggio also adapted the trellis of the arbour behind Mantegna's Madonna for the framework of his first big decoration. Moreover, if one moves outside the certain works, some small devotional pictures attributed to Correggio point firmly to his having come from Mantegna's circle. The influence of Leonardo is obvious in the *Madonna of St Francis* – in the Baptist, for instance – but by this date this was a commonplace

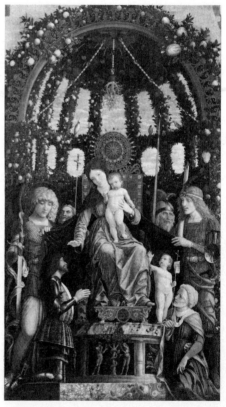

175 MANTEGNA *Madonna of Victory* 1495–96

176 CORREGGIO Camera di San Paolo, Parma (detail) *c.* 1518

177 CORREGGIO Dome of S. Giovanni Evangelista, Parma 1520–23

throughout northern and central Italy. Correggio seems also to have gone further afield than Mantua, probably to Florence, for there are aspects of his tender handling, and the sweetness of his Madonna and Child groups, and in the way the light and shadow form islands of brilliance and depth rather than a flowing illumination, that suggest a powerful influence from Andrea del Sarto. His life is fairly well documented, but there are quite long gaps when he could have been away from home: from 1511 to 1514, from mid-1515 to late 1516, for most of 1518 (when he was probably in Parma), and again a long gap of nearly two years in 1531–32. He uses the grand poses and gestures developed by Roman and Florentine artists, and a similar articulation of his pictures by swinging rhythms; in his later works there is an intensity of religious emotion, and complexity in the composition, that presage

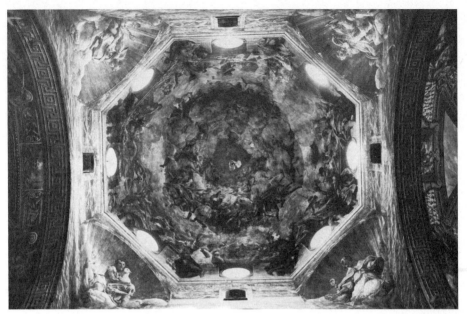

178 CORREGGIO Dome of Parma Cathedral 1526–30

the movement and drama of the Baroque.

The first of his decorations is in the Camera di S. Paolo in Parma, probably painted in 1518. It is a vaulted room, the ceiling of which is covered by frescoes representing a trellised arbour (like Mantegna's in the *Madonna of Victory*, and also recalling the divisions in the Farnesina decoration) with lunettes below filled with allegorical subjects in grisaille. It raises immediately the question of where he had been before this, for it is difficult to conceive of any artist not aware of the decoration of the Sistine Ceiling or the Farnesina creating *putti* of this heroic kind and mythologies of this lighthearted character. The problem is made more acute by the dome of S. Giovanni Evangelista in Parma, painted between 1520 and 1523, on the theme of St John's visions on Patmos. Here he is clearly inspired by Mantegna, with a ring of apostles seated round the cornice below the clouds through which floats upwards the figure of the Risen Christ. The strongly illusionist figures in sharp foreshortening, the ascending Christ soaring upwards into the cloudy sky, go back ultimately to the ceiling of the Camera degli Sposi, which did not have a great deal of influence until Correggio and Giulio Romano, since it was in the private apartments of the Gonzaga family, and therefore not easily to be seen. On the other hand, several of the figures in the ceiling are clearly dependent on Michelangelo's Sistine Ceiling, and there is an additional fragment of evidence in his practice of using his cartoons twice over, the second time with the figures reversed. He does this for some major figures and even more frequently in the angels and the *putti*; Michelangelo also did it in the *Ignudi* in the earliest stages of the Ceiling and through-

173

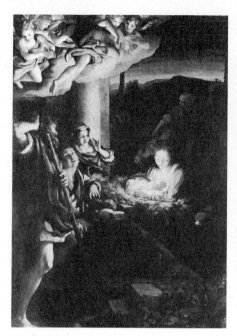

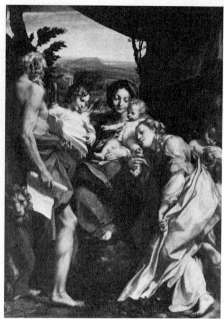

179 CORREGGIO *Nativity 'La Notte' c.* 1530

180 CORREGGIO *Madonna of St Jerome 'Il Giorno'*
c. 1527–28

out for the *putti* behind the thrones, and
the spandrel figures on either side of them.
It is an old device, but one which it is
surprising to find revived in such a context
and on such a scale, though Parmigianino
was to use it later at the Steccata.

The third great dome decoration is in
the cathedral in Parma, and was done
between 1526 and 1530. This is a much
larger dome than S. Giovanni, more
pointed, octagonal, and on squinches
instead of pendentives. The angles have
been plastered out in the upper part so as
to make a rounded surface, and the shape
of the squinches forced Correggio to
strengthen the chiaroscuro in the figures
he painted on them. The decoration
(which represents the Assumption) is
arranged in rising tiers: the apostles stand
upon the cornice at the base, between the
round windows that light the dome, and

above them rise, like so many concentric
wreaths, a mass of moving figures,
twisting, turning, breaking in and out of
the clouds, supporting the rising figure of
the Virgin as she soars heavenwards. All
the devices he had used in the Camera and
S. Giovanni are also used here; there is
good reason for believing that Correggio
drew from small models which he posed
for the figures of the angels, for instance,
and he also used the reversed cartoon
method for variety in poses. Both
Correggio's domes are strangely closer to
Baroque than they are to other Re-
naissance works; the congested, swirling
mass of figures, the ecstatic quality of the
gestures and expressions, the way in which
the light suffuses the groups, seem to leap
ahead by at least a century. The same
feeling pervades his many altarpieces and
mythological pictures. Only once, after the

early *Madonna of St Francis*, did he follow the High Renaissance form of raising the Madonna well above her votaries; in general he does just the opposite, and makes her the centre of a confused crowd of adoring saints and angels, pressing in upon her from all around, so that she draws the eye into the depth of the picture along the gestures and movements of the surrounding figures. He uses, too, the delicate *sfumato* technique of Leonardo, with limpid colour and without the murky shadows of Leonardo, or the dark, shot, effects of Giulio Romano or the Florentine Mannerists. In the famous nightpiece of the *Nativity* the Child lying in His mother's arms in the manger is the source of light for the whole picture: Virgin, shepherds, angels in the very solid clouds overhead are suffused with the light emanating physically from the Infant, underlining in the most deliberate way the literal significance of the texts concerning the Light born amid darkness that comprehended it not. The Child had often been portrayed emitting rays of light, but it is rare (though it does occur in the Netherlands with Geertgen) that the Child is made the only source of light, but for the pallid dawn suffusing the distant sky. In this picture, Correggio stands at the head of a long line of Tenebrists, for this treatment of the scene becomes common enough in the seventeenth century.

181 CORREGGIO *Danaë* c. 1531/32

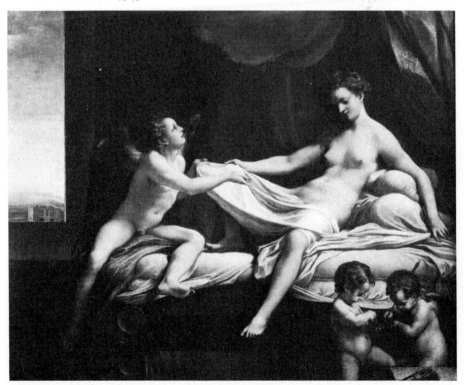

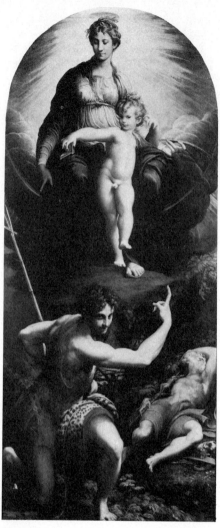

182. PARMIGIANINO *Madonna and Child with St Jerome*
1527

The almost equally famous *Madonna of St Jerome* is the absolute antithesis (hence the contrasting nicknames of 'Night' and 'Day' which the pictures acquired in the eighteenth century), for here all the figures are suffused with light, which weaves in and out, and across the forms, so that the picture has a restless, flickering quality. The composition is a favourite form of his: a short, shallow pyramid, tipped backwards with huge repoussoir figures on either side, and the front plane stressed by some *putti*. He frequently gives this shape to his groups, in his dome pendentives as well as in his easel pictures, in mythologies as well as religious subjects. For instance, in the *Danaë*, of about 1531/32, the small *putti* serve to push back into space the soft, sensual body of Danaë, who trails her slender, golden leg over the edge of the bed as she leans backwards on the pillows, and the same device is found in the *Jupiter and Antiope* of about 1523/24. These are the secular counterparts of his tender, ecstatic Madonnas and saints: meltingly sensual eroticism is inherent in both. He learned early the haunting quality of the Leonardo half-smile, for it flickers constantly over the faces of his figures, saints, Venuses, Madonnas, and nymphs alike, and his gifts as a colourist were such that Giulio Romano, faced with the *Danaë* and the *Leda*, newly arrived in his patron's collection in Mantua, declared them to be of such perfection that he had never seen colouring anywhere that could compare.

Although Parmigianino was born in Parma in 1503, and was commissioned to paint frescoes in Parma Cathedral in 1522, and in S. Giovanni Evangelista in 1522–23, there is no evidence that he was ever directly Correggio's pupil. Certainly, he was strongly influenced by him, but late in 1523 he was in Rome, where the major influences on him became those of Raphael, whom he wanted to succeed, and Rosso, with whom he was closely as-

183 PARMIGIANINO Ceiling of S. Maria della Steccata, Parma 1531–39

sociated. He also knew Perino del Vaga and Giulio Romano in Rome, so that he was in contact with all the painters at the heart of the Mannerist development. In 1527 he was working on the huge _Madonna and Child with St Jerome_ during the Sack of Rome; this picture betrays his mixed artistic allegiances, the Madonna adapted from Raphael, yet with more than something of Michelangelo's heroic quality, the Baptist deriving distantly from Leonardo's celebrated gesture, and the St Jerome adapted from Correggio's figure of Daniel in the small frescoes under the arches in S. Giovanni Evangelista. The strongly modelled forms and lighting make the picture very Roman in feeling; one of the most telling characteristics is the enormous scale (over eleven feet high),

and the rigorous 'Roman' draughtsmanship – no tender handling and soft light slipping over the forms and bathing them in Correggio's unearthly radiance, but a minute particularization with firm edges and a heavy chiaroscuro. Eventually he escaped from the horrors of the Sack of Rome, and after wandering about through Bologna, Verona, and Venice, he returned to Parma by 1530. There he was commissioned to paint frescoes in the church of S. Maria della Steccata but this work was fraught with difficulties between the patrons and the artist to such a point that they eventually sued him for the execution of the contract. They also tried to get Giulio Romano to take over part of the work, for which he did eventually provide drawings, but only with great misgiving

177

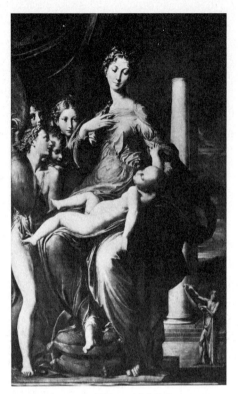

184 PARMIGIANINO *Madonna del Collo Lungo c.* 1535

Heaven, with strongly Raphaelesque features and long graceful hands; she sits enthroned, wrapped in a blue mantle draped carelessly over her white gown, and upon her lap the Christ Child lies sleeping, while angels crowd upon her from the side and watch with ecstatic expressions over the curiously elongated figure of the sleeping Child. Behind the Madonna is an enormous void, filled in the distance by the unfinished columns of a building, and at the base of the colonnade is a tiny gesticulating figure with a scroll. The violent dissonances of scale between the foreground and the background, the fantastically elongated proportions of the figures, the conscious disposition of limbs in poses of the most contrived gracefulness, all tend to create a feeling of exaggerated and sophisticated elegance. The *Madonna with St Zacharias* (Uffizi), with the aged prophet in the foreground serving as a repoussoir, the melting St Catherine filling the same function in the Bologna *Madonna with Saints*, are further instance of his use of deliberately Raphaelesque types of the most *recherché* elegance in form and pose. Parmigianino's great strength lay in this elegance and distinction and in his rigorously firm draughtsmanship; his weakness lay in his own temperament. Whether or not it was the horrors of the Sack that disturbed him, or his tormented neurosis was inherent, the result was the same; he died in tragic circumstances in 1540, and Vasari describes him as having changed from an elegant and delicate person into an unkempt and almost savage creature, obsessed with alchemy.

because of his reluctance to interfere between another painter and his patrons.

Parmigianino's most famous work, beside the unfinished Steccata figures, is probably the Madonna known as the *Madonna del Collo Lungo* ('of the long neck'), one of the key works in the development of Mannerist painting. The Virgin is in every way the Queen of

Venice and the Veneto

For virtually ten years after the Sack of Rome in 1527 there was no money or scope for patronage in either Rome or Florence. Venice escaped the worst of the wars and invasions, and became a place of refuge chiefly for architects, since the great differences between Venetian and Central Italian painting made it difficult for painters from outside to compete with the native product. In architecture, things were rather different, in that Venice was still a Gothic city, overshadowed by a great Byzantine past. Long after classical forms had become the norm in Florence, the Ca' d'Oro, built between 1427 and 1436 as a masterpiece of Venetian Gothic, was far from being the last example of palaces in similar style. The form of Venetian palaces is different from Florentine, in that land in Venice is very precious, and few but the very grandest houses could have internal courtyards. The chain of palaces on the Grand Canal tended to turn the city into a sequence of façades, so that the architecture developed a definitely scenographic quality. The normal form of Venetian palace has the ground – or water-level – floor reserved to kitchens and other offices, and on the first floor a great living-room in the middle of the building looks out on to the fascinating pageant of everyday life on the city's main thorough-fare. The first introduction of new forms came as late as the 1480s, but hardly consisted of more than the systematization of the façade on a central axis, with the *gran salone* in the middle over the entrance, the staircase relegated to the back of the house, and the grouping of the principal windows in an ordered bay sequence. This type of ordered façade still co-existed with a modified Gothic window form, and even as late as the Palazzo Vendramin-Calergi, by Mauro Codussi, finished in 1509, the two-light arched top window, enclosed in a round-headed arch with a roundel in the centre, is the accompaniment to a Central Italian use of a classical order, even if this is treated with a good deal of latitude in the arrangement of coupled and single columns on the same façade.

After the Sack, Sanmicheli and Sansovino came to Venice and both became architects to the State. Serlio also came, and published the first parts of his treatise in Venice, but he left for France in 1540, and does not appear to have been much employed. Michele Sanmicheli was a Veronese, born in 1484, who went to Rome when he was sixteen and trained in the workshop of Antonio da San Gallo. He was in Orvieto from 1509, and worked in that district for nearly twenty years before returning to his native Verona, which belonged to Venice. He worked mainly on fortifications, not only in the Veneto, but in Venetian territories overseas – Corfu, Dalmatia, Crete – that had to be defended

against the Turk. His buildings are, therefore, few; mostly palaces in Verona and Venice, some fine gateways, and the Cappella Pellegrini attached to the church of S. Bernardino in Verona. His city gates present a strongly rusticated, and defensive side to an aggressor, and are closely based on the forms of Roman gates, and on the courtyard façades of the Palazzo del Tè. In his palace designs he ranges from simple variations on Raphael's house, made more decorative by sculpture round the windows, to very elaborate structures, richly decorated, with extra floors contrived by inserting mezzanines and attics within the main divisions marked out by the orders articulating the façades. The Cappella Pellegrini is a centrally planned chapel with a coffered dome, based ultimately on the Pantheon, but here again the Roman device of the twisted fluting,

185 SANMICHELI Palazzo Grimani, Venice, begun in 1550s

186 SANMICHELI Palazzo Bevilacqua, Verona *c.* 1530

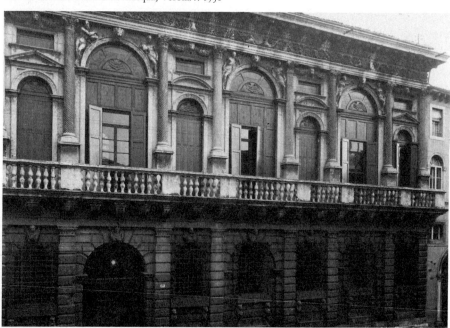

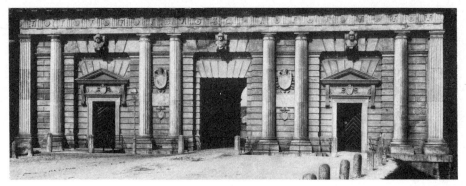

187 SANMICHELI Porta Palio, Verona *c.* 1557

which he knew from a Roman gate in Verona, Porta dei Borsari, is a legitimate borrowing from a classical source. He died in Verona in 1559.

Jacopo Sansovino was born in Florence in 1486 and died in Venice in 1570. He began as a sculptor under Andrea Sansovino, whose name he adopted, and he continued working as a sculptor even after he settled in Venice and became the chief architect to the city. He was in Giuliano da San Gallo's workshop in Rome in 1505–06, and thus in the Bramante circle, and first began building in 1518. He was appointed City architect in Venice in 1529, and worked there to the end of his long life, his greatest buildings being the Library, the Mint, and the Loggia at the base of the Campanile; he also made the great courtyard staircase at the Doge's Palace and the two statues at the top, and built several of the most splendid palaces on the Grand Canal.

The long façade of the Library is deliberately rich and decorative. It was a public commission intended for splendour of effect; it faced the Doge's Palace across the Piazzetta, and had a similar arcade system on the ground floor, echoing the Procuratie buildings on the far side of the Piazza di S. Marco, and made a continuous

open loggia for the little shops which have always been a feature of the square. Sansovino used the form of the double arcade, Doric below and Ionic above, like a Roman courtyard, with the window arches in the upper storey richly ornamented with sculpture on the keystones and in the spandrels, and a superbly rich frieze with swags and *putti* under the cornice, the whole crowned by a balustrade with obelisks and statues to make a decorative line against the sky. The Mint, next door, had a rusticated order, totally different proportions, much squatter (the top storey is a later addition), and intentionally defensive in appearance as well as fireproof inside, with only vaulted rooms and no wood in the construction. The object was to make the Venetian gold coinage visually stable as well as safe. The little Loggia of the Campanile is really an even richer continuation of the Library. All these façades tell as sequences of voids spaced out by richly decorative columns and arches, and form a superb foil to the arcade system of the Doge's Palace and St Mark's on the other side of the square. Add to these architectural effects the pale pink and cream of the pattern of the stonework of the Doge's Palace, the warm russet brick of the Campanile, the mosaics of the

181

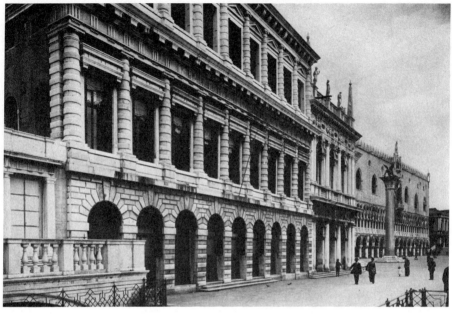

188 SANSOVINO The Mint, Venice, begun *c.* 1537

189 SANSOVINO Palazzo Corner della Ca' Grande, begun 1537

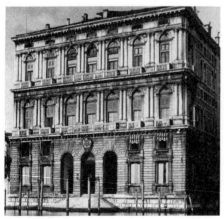

basilica, the green copper domes, the dazzling light and the dancing reflections off the water, and the result is a deliberate scene-setting designed to achieve magnificence of effect, and also a colourful pictorial quality, completely unarchitectural in the Roman and Florentine sense, but admirably suited to the site and to the character of Venetian art.

The Library was begun in 1537, and was not finished until after Sansovino's death. But Sansovino's architecture had a major effect on Venetian art; he introduced the new forms of Florentine and Roman Renaissance buildings into Venice, even though he made them richer and more decorative than they ever were in their original habitat, and this influenced Venetian painting towards an even greater opulence of effect. The architecture of Veronese's religious and secular de-

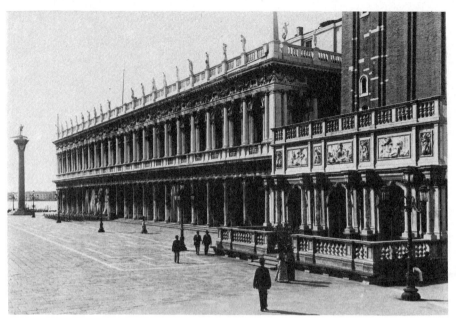

190 SANSOVINO Library and Loggetta, Venice, begun 1537

corations is inspired by Sansovino: the splendid loggias in the vast banqueting scenes that pass as the *Marriage at Cana*, or *Christ in the House of Levi*, or that form the background to the *Darius* in the National Gallery, London, are derived from these superbly decorative buildings, which the painter modified always in the direction of greater richness. Titian was only rarely interested in painted architecture; few of his scenes, except the *Presentation*, have anything more than the sketchiest indications of an architectural setting. Tintoretto's architecture is much more fantastic than anything Sansovino ever built, and he borrows largely from Serlio for many of his very curious constructions.

Andrea Palladio, too, acknowledged his debt to Sansovino by designing the Basilica in Vicenza as a modified version of the Library. He was born in 1508 and died

in 1580, and spent most of his life in Vicenza, where he designed a number of splendid palaces, and the celebrated villas in the neighbourhood which exercised so great an influence on English eighteenth-century architecture. He also built churches in Venice, and one of them – S. Giorgio Maggiore, on the marvellous island site across the lagoon facing St Mark's – is worthy to rank among the world's most beautiful churches. The Basilica, which was not a church, but a recasing of a medieval hall in order to restore and enlarge it, is in two storeys like the Library, and introduces at the beginning of his career in 1549 the so-called Palladian motive (which is classical by origin) of a triple opening consisting of a central arch borne on columns, flanked by a rectangular opening on either side, similar to the window arrangement in the

183

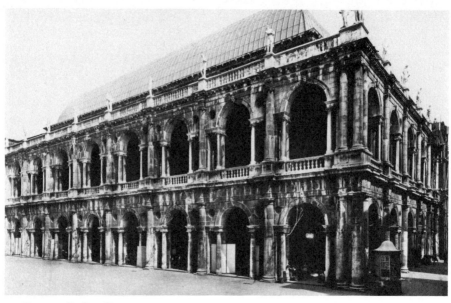

191 PALLADIO Basilica, Vicenza 1549 onwards

192 PALLADIO Palazzo Chiericati, Vicenza, begun in 1550s

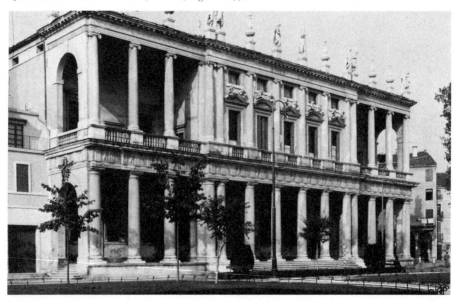

Library. Palladio's Basilica also stresses the verticals more than Sansovino does, and the total effect is one of an alteration of strong members framing large voids to create a bold sequence of light and dark. His palaces in Vicenza acknowledge distantly the forms evolved in Raphael's House, and in Giulio Romano's House in Mantua, but vary their systems of a basement supporting a colonnaded façade with great skill and inventiveness. All Palladio's palaces are built of brick, faced with stucco; most have a plan symmetrical about a central axis, and often the rooms inside are also planned to repeat about the axis of the courtyard; they all combine convenience with an air of discreet opulence. His villas pursue these aims even further, for they combine the usefulness of a working farm in the midst of a family estate, with the convenience and delight of a country villa lived in during the oppressive heat of the summer months. They are inspired by the classical *villa*

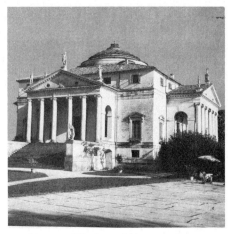

193 PALLADIO Villa Rotonda, begun 1567

194 VERONESE Frescoes in the Villa Maser, begun *c.* 1560

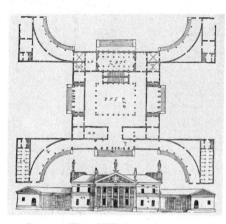

195 PALLADIO Plan of Villa Mocenigo

rustica type of country house, and are quite different in purpose from the classical *villa suburbana* of which Raphael's Villa Madama, or Giulio's Palazzo del Tè, are grandiose examples. The Villa Rotonda, of 1567–69, built on a slight eminence as a cubic block with symmetrically planned rooms round a central domed circular hall, with four identical colonnaded porticos with wide flights of steps, one on each of its four fronts, is justly his most famous building; but the Villa Maser, much smaller and more intimate, with its interior decorated by Veronese with superb frescoes, or the Villa Malcontenta, where the steps flow down on either side from the grand colonnaded portico towards the calm waters of the Brenta Canal in which it stands reflected, are creations as full of genius as they are of variety and charm. Some of these very grand villa designs remained merely as designs, published in 1570 in his treatise, 'Quattro Libri dell'Architettura' – one of the most influential of all architectural treatises, and the foundation of English Palladianism – and in them the central villa block extends on either side in wings attached by quadrant arcades, to combine comfort and

grandeur with economy and utility, as he himself described them.

Palladio's Venetian churches are of great splendour. Both S. Giorgio Maggiore (1566) and the Redentore (1576) were designed for the ceremonial visits paid yearly by the Doge, but whereas the Redentore is restrained and modest in decoration, as befits a Franciscan church, S. Giorgio, a wealthy Benedictine house, is of great richness, built of pale Istrian stone, with a red and white chequerboard marble floor and white marble statues in niches in the aisles, giving an effect of cool magnificence. The façades of both churches are totally new in design. Instead of the usual two-storey front, with a pedimented upper part joined by volutes to the wider lower part extended on either side to front the aisles – the commonest type of Counter-Reformation and Baroque type derived ultimately from Alberti's Early Renaissance design at S. Maria Novella in Florence – Palladio creates a façade of two storeys, by impacting two classical temple fronts one upon the other, a tall one for the central part, and a wider, squatter one extending over the side aisles; and he unites them by continuing the details of one to become part of the main members of the other. This novel form he first tried out in the façade of S. Francesco della Vigna in Venice, where he was employed to make a new front for an existing church. Both S. Giorgio and the Redentore have large domed, apsidal east ends, with screens separating the monastic choir from the high altar, and large transepts with apsidal ends and semi-domes. Both were used for the impressive choral music written for St Mark's, which required the use of separate choirs to create the full polyphonic effect, but S. Giorgio, as much the larger church, also had space for altars in wide aisles (the Redentore is aisle-less), most of them containing splendid altarpieces, and for a pair of pictures in

the choir flanking the high altar, painted by Tintoretto – *The Gathering of the Manna* and the *Last Supper*, his last important works.

A large part of Titian's main works during the most productive part of his career consisted of official portraits of the Doge, histories and battle pieces for the adornment of the Doge's Palace, and paintings for the Doge's private chapel in the palace: all these perished together with the history paintings done from the early fifteenth century onwards by Pisanello, Gentile da Fabriano, Gentile and Giovanni Bellini, in the great fire of 1577. This loss means that almost nothing is known of the forms and style he evolved for dealing with this type of work. In 1545/46 he visited Rome, where he painted Pope Paul III and his Farnese relatives in a group which remains one of the most shattering documents about the Pope and his sycophantic family – and which remained unfinished probably for that

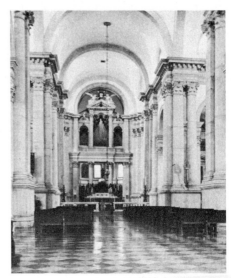

196 PALLADIO S. Giorgio Maggiore, Venice (interior)

197 PALLADIO S. Giorgio Maggiore, Venice, façade

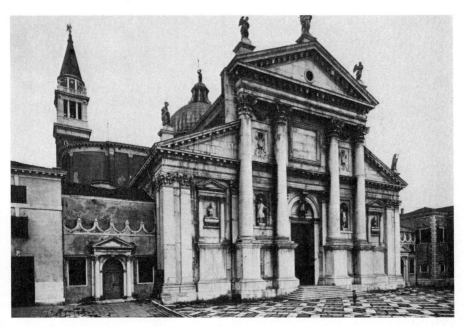

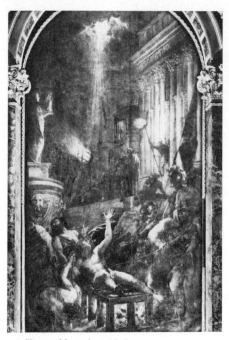

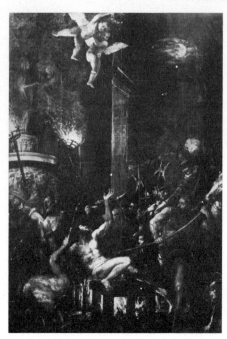

198 Titian *Martyrdom of St Lawrence* 1548–57 199 Titian *Martyrdom of St Lawrence* 1564–67

reason. He also experienced Michel-angelo's *Last Judgement*, and the great Roman works of the maturity of the High Renaissance. It would be idle to claim that he was unaffected by them. In, for instance, the *Martyrdom of St Lawrence* painted in the late 1540s, many details suggest his study of these works, from the vehemence of the figures to the different sources of light with which the picture is shot through. The series of splendid nudes – the Danaës and the Venuses of the late 1540s and the 1550s – are clearly influenced not only by Roman painting but by the great collections of antique statues in the Vatican. In 1548/49, and again in 1550/51, he visited the Imperial Court at Augsburg, to paint official portraits which set the type of such works for all court artists onwards. After the Emperor's abdication in 1555, when his Spanish dominions passed to

Philip II, the Spanish king acquired a constant stream of *poesie* – as Titian himself described his mythological subjects – which included the wonderful *Diana and Callisto* on loan to Edinburgh, the *Rape of Europa* in Boston, and the later version of the Roman *Danaë*, still in the Prado. Philip also bought a large number of copies and versions of his earlier mythologies, as well as religious works, such as the second version of the *Martyrdom of St Lawrence* for the Escorial, and the pair of *Entombments*, poignant rethinking of an old theme. It was this concentration by Philip upon the art of Titian that made him blind to the peculiar merits of El Greco.

Titian's life was as long as Michel-angelo's, beginning and ending a decade later. There are, in his art, breaks as distinct as those in Michelangelo's, though they are expressed in a different way. As a

188

painter exclusively, he was one artist, so to speak, whose style changed, modified, developed, through one art over almost seventy years, where Michelangelo was three artists, whose ideas were expressed in sculpture, painting and architecture, and whose ideas in one art were constantly modified by his experiences in another medium. The Medici Chapel contains ideas which are new – startlingly so – but it is also in many ways a continuation of processes of thought which start quite clearly in the Sistine Ceiling, and both the Ceiling and the Chapel are expressions of ideas which Michelangelo first conceived for the Julius Tomb. The architecture of

the Laurenziana is perhaps the moment when a major change of thought occurred, yet not only is it contemporary with the Chapel, but some of the forms he used in it are extensions of ideas first put forward in the Chapel, and in turn these works conditioned his approach to the *Last Judgement*, the Farnese Palace, St Peter's, and the Campidoglio. The changes in Titian's art are both stylistic and conceptual: as he grew older his technique changed from the limpid clarity, the warm sunniness of *Sacred and Profane Love* or the *Andrians* to the more clotted richness of the later *poesie* – the *Diana and Actaeon* or the *Lucretia*. The same technical changes

200 TITIAN *Diana and Actaeon* 1559

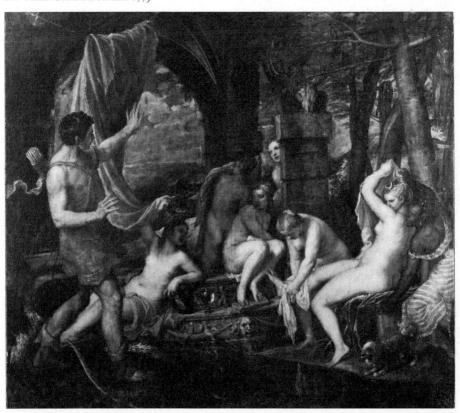

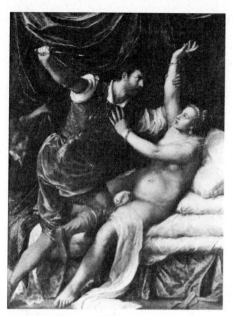

201 TITIAN *Tarquin and Lucretia c.* 1571

202 TITIAN *Jacopo Strada* 1568

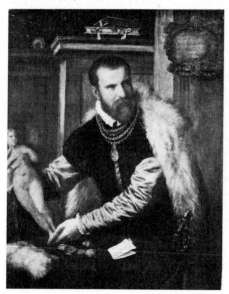

appear, naturally, in his religious pictures as well: the calm, triumphant serenity of the *Pesaro Madonna* is succeeded by the greater emotion, expressiveness in colour, design and dramatic feeling of the late Prado *Entombments*. What also changes is the kind of subject that inspired him, or the manner of his approach to it. Instead of the joyous openness of, say, the *Bacchus and Ariadne* where, despite the dark undertones of the myth, all is light and colour and revelry, he later chooses the story of Actaeon, or the unhappy Callisto, or the betrayed Lucretia – dark horrors concealed beneath the brilliant colour and the surface richness. In his religious works, the delight and innocence of the early Madonna pictures – the National Gallery *Madonna and Child with St Catherine*, or the Louvre *Madonna with the Rabbit*, for example – give way to darker, more heroic subjects such as the horrific *Martyrdom of St Lawrence* or the tragic *Crowning with Thorns*, full of flames and torchlight, agony and terror, blood and violence. It is not just a matter of age and maturity bringing with them pessimism and an acceptance of suffering, since there are enough examples of great artists who lived to be old men – Tiepolo, Ingres or Renoir for instance – whose work never expresses a sense of doom. In Titian, the reflection of the changed climate of the mid-century affects his selection of motives rather than his vision, in that he does not see his subjects in terms of fantastic light effects or strange perspective arranged for its dramatic possibilities, as Veronese and Tintoretto later do, but only uses them incidentally as they fit the chosen subject, like subordinate clauses used to help the meaning he wishes to convey. The distinction may be a subtle one, but there is a difference of character between Titian and his great successors. Even in his portraits, usually the last form to be affected by such stylistic changes, this difference also appears, as may im-

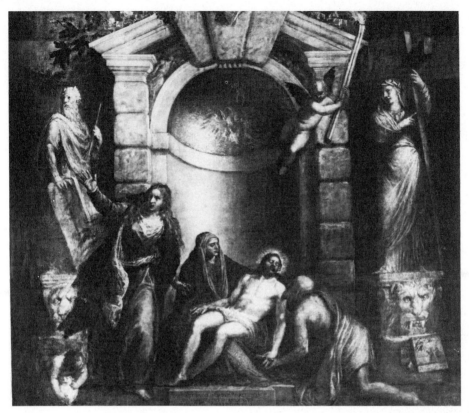

203 TITIAN *Pietà* 1573–76

mediately be seen by comparing the late
Jacopo Strada with the early *Young Man with
a Glove*, or the confident serene patricians
in the *Pesaro Madonna* with the more
troubled faces and expressions in the great
Vendramin family portrait. Yet, for all
these subtle transitions of mood and
thought, Titian's art retains a splendid
homogeneity and, even at his most
questing moments, he retains his poise and
a kind of forthright confidence. Fear and
doubt never seem to have touched him as
they touched Michelangelo, and he never
knew physical danger as Rosso and
Parmigianino knew it; his darker subjects
seem to suggest more a spiritual catharsis
than the vivid experiences which lie
behind the tormented imagination of
many of the Mannerists.

Titian's art in the late years changed
from the splendid optimism of his early
religious pictures, and the confident
serenity of his spacious portraits, into a
troubled manner, in which the forms are
enveloped in mystery and the colour
expresses the most intense feeling. Only
for a very short time was he affected by
Central Italian Mannerism, which for a
fleeting moment pushed him into experi-
ments with lighting effects and strained

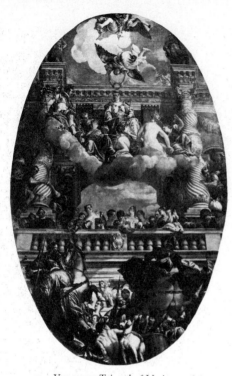

204 VERONESE *Triumph of Venice* c. 1585

poses. Much is known about his technique, for it was described by Palma Giovane who finished the *Pietà* destined by the artist for his own tomb, and not completed at his death. 'He laid in his pictures with a mass of colour which served as a groundwork for what he wanted to express . . . Underpainting in plain red earth [probably Venetian red] for the half-tones, or in white lead. With the same brush dipped in red, black or yellow he worked up the light parts, and in four strokes he could create a remarkably fine figure . . . Then he turned the picture to the wall and left it for months without looking at it, until he returned to it and stared critically at it, as if it were a mortal enemy . . . By repeated revisions he brought his pictures to a high state of

perfection, and while one was drying he worked on another . . . He never painted a figure *alla prima*, and used to say that he who improvises can never make a perfect line of poetry. The final touches he softened, occasionally modulating the highest lights into the half-tones and local colours with his finger; sometimes he used his finger to dab a dark patch in a corner as an accent, or to heighten the surface with a bit of red like a drop of blood. He finished his figures like this and in the last stages he used his fingers more than his brush.' He died in the middle of a terrible visitation of the plague, in 1576, having outlived his friends Aretino and Sansovino, and at the moment when the arts in Venice were divided between the opulent display of Veronese, and the introspection of Tintoretto.

Paolo Veronese was, as his name indicates, born in Verona, about 1528. A typical man of his age, he reflects a large number of influences – Titian, Michelangelo, Giulio Romano, Parmigianino all contribute something to the extrovert and splendidly decorative qualities of his art. Rarely does Veronese stir one either by his insight, or by any emotion or tenderness; he amazes, exhilarates by his energy and brilliance, by his colour, the number of figures knitted into a composition, by the daring and complexity of his feats of illusionism and perspective.

His first works show mainly the influence of Titian's Pesaro altarpiece, in their use of the asymmetrical setting of the figures with huge columns and high pedestals, but after he arrived in Venice, about 1553, where he worked continuously until his death in 1588, he began the illusionistic ceilings for S. Sebastiano, with the story of Esther, a form he continued first in his dazzling frescoes for the Villa Maser, built by Palladio, and then in the Doge's Palace. The Villa Maser frescoes probably follow a visit to Rome in

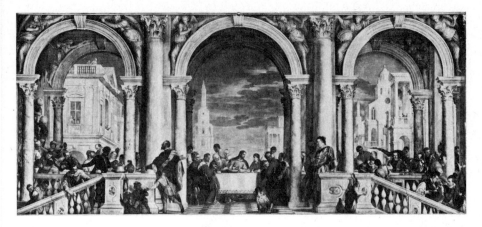

205 VERONESE *Feast in the House of Levi* 1573

1560, and they are important, not only for their sheer delight and their suitability to their beautiful setting, but also because they introduce pure landscape panels, as a genre on its own, thus paralleling ideas which were being developed in Fontaine-bleau. The Doge's Palace frescoes came mostly after the 1577 fire, and include the magnificent *Triumph of Venice* in the Sala del Maggior Consiglio of about 1585, an example of illusionism which presages the most fantastic produced by Roman Baroque painters a half century later. In 1573 he found himself in trouble with the Inquisition, accused of indecorum through his introduction of figures of German mercenaries, buffoons, dogs, and such-like light relief into his huge pictures in which a scene of secular feasting has a religious motive concealed somewhere in the crowds. His defence – that the artist is free to fill his canvas as he pleases, and cannot be blamed for disposing a large crowd of supernumerary extras on his stage – is the classic defence of the artist against the limitations which a philistine might seek to impose on his vision. The Inquisitor, in this case, had the last word, since Veronese did in fact rename his picture the *Feast in the House of Levi*. Some of his smaller religious works, such as the *Baptist*

206 VERONESE *The Baptist preaching c.* 1565

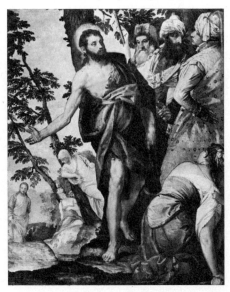

preaching of the mid-1560s, combine an almost Mannerist viewpoint with astonishing colour and unusual composition, and many of his mythologies are of a memorable eroticism, which often manages to be amusing as well. His large family pieces – the Cuccina family, presented to the Virgin in a *Madonna and Child* of about 1571, now in Dresden, or the Pisani family in the *Family of Darius before Alexander* of about 1565–70, in London, are extensions of the normal religious picture with donors, which have the result of confusing the borderline between the religious and the secular, since the portrait aspect often takes precedence over the content. This kind of licence is surprising in a painter who was known for his strict religious observance, and for the probity of his morals. His most striking figures are certainly his opulent, golden-haired Venetian women, trailing their brocades behind them like slow-moving, majestic, jewel-studded galleons drifting across the lagoons. With these splendid

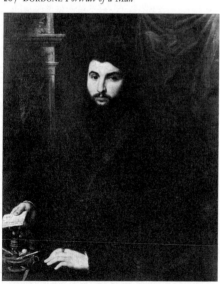

194

creatures, half vision, half real, rank his true portraits, which, though few, make an interesting contrast with Titian's. They concentrate perhaps less on the character of the sitter than on his – or her, for some of his finest are of women as magnificent as any of his saints or Venuses – social position, and in this he followed rather than led along the path Paris Bordone had marked out.

Of the lesser men, Bordone (1500–71) came from Treviso, and from his training and life in Venice followed in the wake of Titian, except that he developed into a portrait painter in a style which blended Titian's colour and ease, with something of the Florentine court painter's frigidity and concentration on the social presence of his sitter. He was in great demand as a portraitist, visited France in 1538, and was in Augsburg in 1540, where his Venetian richness influenced the German court painters such as Amberger and Pencz probably as much as did Titian, in that the externals of his style were more easily imitated than Titian's deeper qualities of perception. Bonifazio de' Pitati was a man of Titian's, rather than Veronese's generation, being born in 1487, and he was a pupil of Palma Vecchio. He ran a large workshop in Venice, and imitated Titian and Giorgione, though aspects of his art range very widely indeed, and Lotto and Bordone are reflected in him as well. He died in 1553. Andrea Schiavone, a Dalmatian from Zara, who died in Venice in 1563, must have been working from the late 1520s. He is recorded as self-taught, mostly by imitating Giorgione and Titian, and also the engravings of Parmigianino, and possibly Correggio as well. Certainly, he imports into Venice a strangely ecstatic quality, absent as a rule from Venetian art, and his shot colour schemes and violent effects of *contrapposto*, support the argument that Central Italian Mannerism was important in his development. It is from

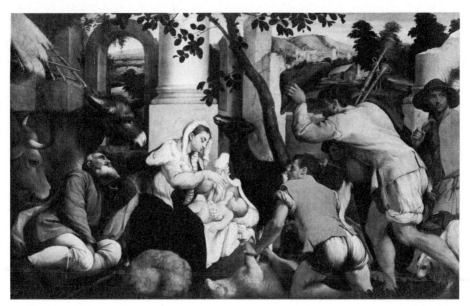

208 BASSANO *Adoration of the Shepherds* 1540s

Schiavone's studio that Tintoretto probably came, despite his claim in later years to have been a pupil of Titian.

The other important painter contemporary with Tintoretto was Bassano. This was the name of a family of painters called da Ponte, who came from Bassano in the mountains above Venice. The father, Francesco, was a modest follower of the Bellini; his son Jacopo, born between 1510 and 1518, lived and worked most of his life in Bassano, where he died in 1592. He was the genius of the family, developing a bold, energetic style out of his training with Bonifazio de' Pitati and the influence of Titian. He evolved a new kind of subject – the rustic genre scene, with animals and herdsmen, peasants and farm servants, set in mountainous and stormy landscapes, and his religious pictures also exploit the same vein, with flocks of sheep and cattle accompanying the adoring shepherds to the manger. His dark and lowering landscapes, the profusion of his still-life details, the dramatic nature of his lighting effects, his sharp perspective, are features that sometimes follow, but sometimes accompany, Tintoretto's similar experiments. His sons Francesco, who committed suicide in the year of his father's death, and Leandro, who lived until 1622, worked in the Venetian end of the family business, and continued their father's style, with stronger influence from Tintoretto. Leandro also painted very fine dark portraits, in a style dependent on Tintoretto's.

With Tintoretto the Renaissance in Venice comes to an end. He was born in Venice in 1518, and very little is known of his early years, except that he claimed to have been in Titian's studio – from which tradition has it that he was expelled for caricaturing the master – and possibly worked with Schiavone and Paris Bordone. No work can be ascribed to him

before 1545, although he figures in the records as an independent painter by 1539. What he aimed at was clear enough. He sought to combine Titian's colour with Michelangelo's drawing, and in this thoroughly Mannerist design he was completely successful, because, in fact, though he borrowed from both, he derived from neither. He knew the principal works by Michelangelo and Raphael through engravings and casts; he could have known them in no other way, since he is not recorded as ever having left Venice, but by now the traffic in engravings was such that very little of note was not generally known throughout Italy, and in northern Europe. He must also have owned small models of Michelangelo's Medici Chapel figures, since drawings exist of the recumbent tomb figures in positions which could not have been drawn otherwise. From the first he develops a counterpoint of swaying figures, composing his pictures in friezes; the figures are aligned in a series of sharp and almost unrelated verticals, broken only by a few broad gestures. The figures, in, for instance, the *St Ursula and her Virgins* of about 1545, swing in a long, slow zigzag from one side of the picture to the other right back into the far depths, the front plane being filled in the arched top by the swift plunging flight of the angel. The magnificent *Esther* at Hampton Court, also of about 1545, is a perfect example of another Mannerist device: the momentary movement caught and held. Everything is in motion; the king rises, Esther slips fainting towards the ground, her women move to catch her, the crowd strains forward to see, and the instant the artist has recorded is as transitory as the passage of time itself.

In 1548 he made his reputation with the *Miracle of St Mark rescuing a Slave*; in point of time, it is contemporary with the beginning of Veronese's career, and with

Titian's maturity. It was for him what the *Assumption* had been for Titian, and before beginning it Tintoretto had subjected himself to a patient training in Florentine draughtsmanship, largely to modify the kind of loose Mannerism which he had enjoyed until now, and which Bonifazio de' Pitati specialized in. The composition of the *Miracle of St Mark* is very carefully worked out; each figure is balanced by another, each motive matched by a counterpart, and though the picture is a very large and crowded one, even the most subordinate figures are fitted in with scrupulous care. The St Mark plunging to save the captive who had called upon him in his extremity is a daring figure in the most unusual foreshortening, and the colour – strong, singing, unexpected in its contrasts and harmonies – is sudden, brilliant and astonishing. This is the first picture in which Tintoretto displays all that he had learned from Titian, and makes full use of the start which Titian gave him stylistically, but, true to his own vision, he concentrates his forces into a single fleeting moment, and carries it all through in one surging movement and rhythm. Michelangelo makes a brief appearance in the figures over the distant door, and the plummeting St Mark could derive equally from the Sistine Ceiling, or Raphael's Loggie decorations.

But the Mannerist elements could not long remain dormant. In the *Presentation of the Virgin* of 1551–52 the space is irrational, the steps essential to the iconography are used as much to break up the flow of the composition as to hold it together, and the perspective is used to increase the contrasts in the size of the figures, which are scattered about so as to enhance the tension, just as the light and shadow is used to increase the drama. Vasari, when in Venice, praised this picture as Tintoretto's finest work; Vasari disapproved of Tintoretto entirely and

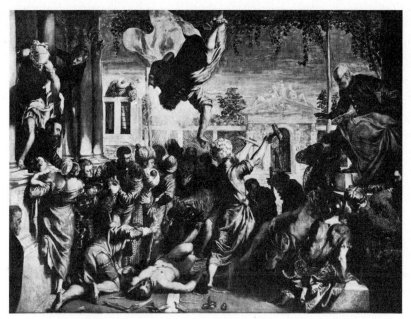

209 TINTORETTO *Miracle of St Mark rescuing a Slave* 1548

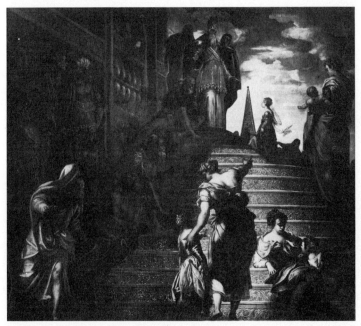

210 TINTORETTO *Presentation of the Virgin* 1551–52

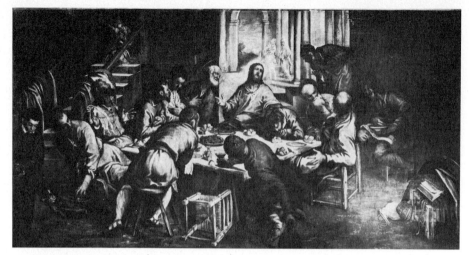

211 TINTORETTO *Last Supper*, S. Trovaso *c.* 1560

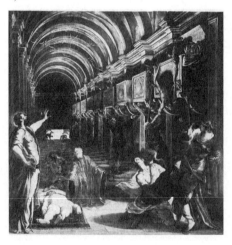

212 TINTORETTO *Discovery of the body of St Mark* 1562

considered he had no knowledge of drawing to the point that he could find no better excuse than to say that he treated art as a joke. This uneasiness, and the incomprehension that Vasari was not the only critic to feel, seem to derive from Tintoretto's use of colour, for he used his colour, not as Titian and Veronese did – to amplify the splendour of their forms– but to create a mood, and one moreover of tension and emotion. Emotion in Veronese appears but rarely – perhaps in such a work as the *Baptist preaching*, and then it is artistic emotion dependent on the play of strange and beautiful colour in an unusual composition; in Titian emotion does not begin to appear until he is getting old, and his zest is diminishing – for most of his life he was too assured and too sanguine in temperament for emotion. But with Tintoretto the emotion is always near the surface to be expressed through movement, taut composition, and cool, disturbing colour.

If one compares, for instance, the *Last Suppers* he painted at varying stages through his career, the way his thought

changes becomes much clearer to understand. The one in S. Marcuola in Venice, painted in 1547, is a traditional rendering of the scene, with a centrally planned composition with groups of apostles exactly balanced on either side of Christ, and the outside of the scene closed by two allegorical figures personifying Faith and Charity. The *Last Supper* in S. Trovaso in Venice, painted about 1560, also has a central plan, in that Christ is in the middle, but the alignment has been exploded into a lozenge-shaped grouping, seen from above as if from a balcony, with the bursting out of the composition stressed by the overturned chair, and by the way some figures fling themselves away from the table, not for dramatic reasons inherent in the incidents of the Last Supper, but for contrived and trivial reasons such as reaching for more wine or another dish. In the background, the brilliant daylight in the arcades shines behind Christ, and upon the bright columns against which Judas is darkly silhouetted; and a mysterious staircase rises from a gloomy corner into shadowy recesses above.

Like Titian, Tintoretto kept a huge shop; no one could have got through all he painted without one. The system on which he worked was quite different from that in Titian's or Veronese's shop, in that he never kept his assistants to making copies or close versions of finished works, or even merely to the preparatory stages of his huge commissions, but used them to make enlargements of his sketches, and on extensively altered variants of his pictures. There was, therefore, more freedom and much less repetition, which is reflected in the immense variety of his *œuvre*. He sacked the works of others, too; the *Last Judgement* in S. Maria dell'Orto contains whole figures lifted out of the Sistine Chapel *Last Judgement*, and also echoes it in the confused, fragmented arrangement. A work of this kind, like the enormous

213 Tintoretto *Morosini*

Paradise painted in 1584–87 for the largest hall in the Doge's Palace, or the huge *Battle of Zara* also painted for the palace in the same years, shows him striving for effects he could achieve easily, yet with them winning victories which have added little to his fame. The works done for the State after the great fires of 1574 and 1577 in the palace account for the importance of his shop, and for his frank re-use of old compositions, reversed and slightly varied for new purposes.

In 1562 he was commissioned to paint three pictures from the Legend of St Mark for the Scuola Grande di S. Marco: *St Mark rescuing the Saracen*, the *Discovery of the body of St Mark*, and the *Removal of St*

199

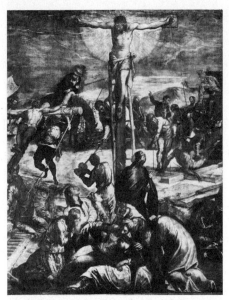

214 TINTORETTO *Crucifixion*, Scuola di S. Rocco (detail) 1565

215 TINTORETTO *Road to Calvary*, Scuola di S. Rocco 1566

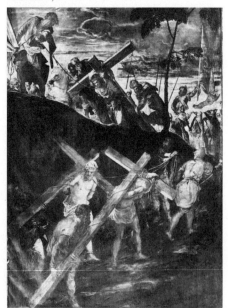

Mark's body. All three display that constant quality of the subject being caught at the most sudden and fleeting moment; the saint jerking the sailor from among his companions in the rowing boat; the saint appearing to identify his body from among the many housed in the row of wall-tombs suspended like balconies along the vaulted hall, with the extraordinary light appearing under the door rising like a shutter at the end of the hall to reveal grotesque little figures peering underneath; the violent thunderstorm miraculously provided to conceal the theft of the holy body from the storm-racked piazza where the ghostly little church rises like the folly in an eighteenth-century park to close the long vista plunging into space. He began working for the Scuola di S. Rocco soon after – in 1564. The confraternity held a competition to select an artist, but Tintoretto won by the unfair trick of painting the actual ceiling decoration and fixing it in place – a trick which made him many enemies, but secured him the commission for the whole of the decoration of the Scuola's vast halls, upstairs and down, and he worked for them for the rest of his life, painting his last work for them in 1588. During this time he was also constantly working for the State, for other confraternities, and for churches and monasteries. He also painted many portraits, though these exhibit much less inventiveness than Titian's, and are closer to Bassano's simple effigies. Yet none excelled him in the portrayal of old age.

The Scuola di S. Rocco is on two floors, and has three rooms. On the walls of the small room – the Albergo, or council room – he painted the *Crucifixion*, *Christ before Pilate*, and the *Road to Calvary*, in an indescribable panorama filled with men and horses, soldiers, executioners, and crowds of curious onlookers, with a poignant group of the fainting Virgin collapsed in the exhaustion of grief and

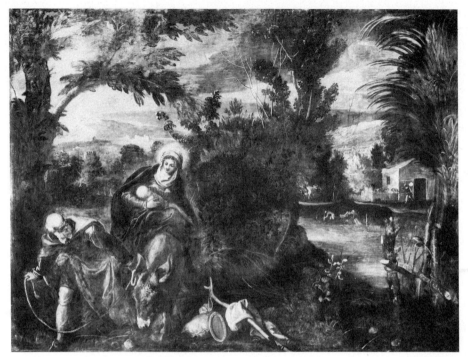

216 TINTORETTO *Flight into Egypt*, Scuola di San Rocco 1583–87

horror at the foot of the Cross. Between 1576 and 1581 he decorated the Upper Hall with the Life of Christ in huge canvases seventeen feet high, and from 1583 to 1587 he painted the Lower Hall with scenes from the Life of the Virgin, in canvases over twelve feet high. Unfortunately, later restoration has made these pictures dark and gloomy, where their original technique was filled with light and colour, but the extraordinary visionary effect can be gauged from the moonlit landscape in the *Flight into Egypt*, where the fronds of the trees seem to be flung on to the canvas with strokes as broad and free as if housepainters' brushes had been used.

Occasionally he painted mythologies, though basically he was a religious painter. The *Venus, Mars, and Vulcan* (Munich) pokes fun at the classical story of adultery, and Mars, caught in his mistress's bedroom, hides under the bed; the *Muses* (Hampton Court) are an excuse for displaying his ability in painting the nude in the elegant *contrapposto* of Central Italian Mannerism; the Doge's Palace decorations forced him to such mythologies as should glorify Venice, as well as enable him to compete with Veronese. At the end of his life he clearly, triumphantly, returned to the form of composition he had started with: the vast frieze composed in zigzags, or with plunging perspectives, for of this kind are the canvases in S. Giorgio Maggiore, of the *Gathering of the Manna* and the *Last Supper*, painted from 1592 until the year of his death in 1594. They are treated as mystic meals, type and antitype

201

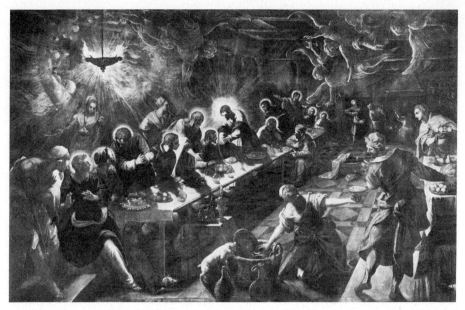

217 TINTORETTO *Last Supper*, S. Giorgio Maggiore 1592–94

from Old and New Testament, the *Manna* filled with groups in rhythmic movements leading the eye backwards into the crowded distance beyond the trees, the *Last Supper* with the great table splitting the room diagonally, and dividing the apostles from the group of busy servants. The scene is irradiated by flickering light with a crowd of moving, turning figures, yet never loses, amid the complexity and restlessness, that dramatic and religious feeling, which is enhanced rather by the contrasts of the corporeality of the human beings and the ghostly angelic figures filling the upper air as if they emanated from the flaring lamp or from the unearthly radiance surrounding Christ. The apostles argue among themselves about the meaning of Christ's action in the institution of the Eucharist, and this treatment of the drama in the Upper Chamber as a vast religious ceremonial seen as a contemporary event illustrates not only the difference between Leonardo and Tintoretto, but is the measure of the changes in the religious and intellectual climate during the hundred years that separate the two representations of the *Last Supper*.

The last word is with the *Entombment* of 1594. In this last work Tintoretto sums up the ideas that had first moved him, and ends with a grandeur and a pathos that achieves his ambition to combine Titian with Michelangelo, by equalling both and yet transcending neither.

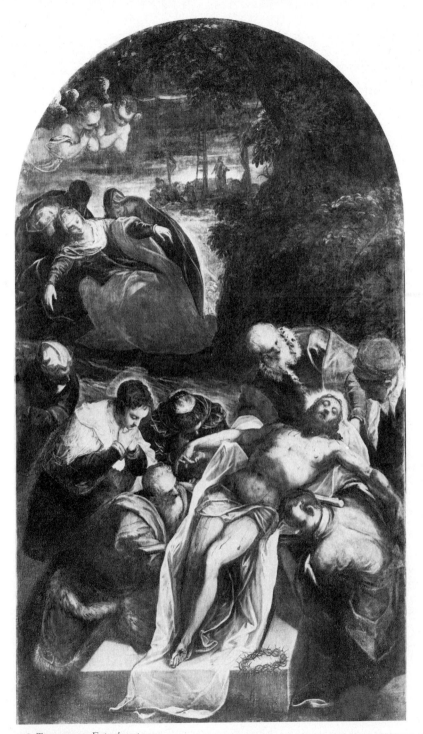

218 Tintoretto *Entombment* 1594

Envoi

The story of the High Renaissance contains several moments when it is possible to take stock of what has already happened, and examine the way later developments stem from, or are influenced by, what has gone before. One such climacteric came in 1520. In that year Raphael died at the height of his career and at a moment when his art was poised to take a new direction, and Michelangelo began the planning of the Medici Chapel, to evolve for it a style which would lead him to completely different modes of expression from those he had used in the Sistine Ceiling. Another was in 1527, the year when the Sack of Rome filled all Christendom with a shock of horror and shame and unrighteous exultation, even greater than the shock caused by the fall of Constantinople in 1453. There was yet a third in the middle 1530s. Andrea del Sarto's death in 1531 removed prematurely the one considerable Florentine who pursued, with almost unchanging directness, ideals that can be defined as essentially High Renaissance ones: clarity, sensitivity, simplicity and nobility of form, allied to richness of colour, a magnificent and poetic use of light and shadow, sheer physical beauty, and technical brilliance. Correggio's early death in 1534 eliminated an artist whose style, though more ecstatic, more emotional, than Sarto's, expressed very similar ideas. In 1534 Michelangelo left Florence for good, thereby relegating it – and this despite the real achievements of the next generation – to a subsidiary position, so great was not only his genius but also the aura of his fame. Michelangelo's very long life (he lived to be eighty-eight) meant that the span of his creative years, lasting until 1564, gave him a career three times as long as Raphael's,

and twice as long as any of his major contemporaries except Titian. In fact, Michelangelo outlived several of the younger men upon whom his own later Roman style was a decisive formative influence.

It seems reasonable, therefore, to consider the years from about 1495 to about 1530 as a unit, though even this brief period presents several facets. One of the most interesting of these reflects the opinions which were held at the time concerning the differences of style between work's done in the years immediately after the turn of the century and those of the 1520s and 1530s. The distinction between the early years – Bramante's Roman years and the beginning of Raphael's Roman career – and the later Roman works of Raphael can almost always be defined as a question of enrichment. The early years, now extolled as the highest point of clarity and balance, were then considered only as a preparatory stage leading to the rich ornamentation and complexity of the last decade of his short life. Those characteristics of order and control, which were so powerful a reaction against the chaotic elaboration of much of late Quattrocento art, and for which one could quite appropriately borrow Winckelmann's description of Greek art as 'calm grandeur and noble simplicity', were held at the time to have produced no more than dryness and a chilly bareness. It was the later Cinquecento wealth of decorative enrichment, complicated planning, elaborate poses, graceful gestures, and dramatic facial expressions, that were considered both as the true reflection of the antique and representative of the new style. And this is exact, in that the two most recent important discoveries of antique sculpture

were the Apollo Belvedere and the Laocoon – one the epitome of grace and refinement, the other highly dramatic, emotional, complicated in its poses and its use of three figures linked physically and psychologically to form a narrative group. In considering the impact of classical Rome upon Renaissance art, it must never be forgotten that the antique itself changed through new and exciting discoveries, and new ways of looking at and interpreting the past, so that the classical influences which helped to form the Early Renaissance and those which worked so powerfully upon the High Renaissance are the same in name, but often very different indeed in nature. The differences between the House of Raphael, for instance, and the Palazzo Branconio dell'Aquila are not only the measure of a change in architectural thought between Bramante and Raphael, but are also indicative of a change in the kind of classicism fashionable, admired, and imitated a decade later. Vasari is explicit about the importance attached to decoration in the Preface to the third part of his Lives: 'This spontaneity enables the artist to enhance his work by adding innumerable inventive details, and, as it were, a pervasive beauty to what is merely artistically correct . . . abundance of beautiful clothes, the imaginative details, charming colours, many kinds of building and various landscapes in depth that we see depicted today.'

Venice was the only part of Italy to escape the worst ravages of the long wars that culminated in the Sack of Rome and the Siege of Florence. It was also the part that remained least profoundly affected by the changes in religious thought stemming from the Counter-Reformation and the Council of Trent. In Venice, therefore, the High Renaissance seems to linger on with the kind of magnificent afterglow that a long and brilliant sunset imparts to a summer's day at a moment when the

weather is about to break. It is true that the later years of Titian and the architecture of Sansovino appear as a mature and thoughtful extension of the confident splendours of the early years of the century. But Sansovino was a refugee from the disasters that tore the political, artistic and religious fabric of Italy apart, and all his architecture was created after the Sack, so that his style is better seen in the context of later ideas and forms. The same argument applies also to Sanmicheli.

If one looks from the eager, confident serenity of the *School of Athens* or the *David*, to the complexity and anxiety running as an undercurrent in the *Transfiguration* or the Medici Chapel, then the change of mood, perception, thought, and environment, mark the end of an era and the opening of a new stage. Just as the mid-1490s were a watershed between the Early and the High Renaissance, so the mid-1530s form a watershed between the High Renaissance and the art of the second half of the sixteenth century in which Mannerism is so conspicuous and compelling a feature. Moreover, although a trickle of Italian ideas and forms spread north of the Alps in the first years of the century, it was not until the second half that the trickle became a flood and the whole of Western Europe was affected by, and came eventually to participate in, the Renaissance.

By the 1530s, therefore, the first phase of the High Renaissance was over. In 1520 Raphael died, and after Giulio Romano went to Mantua in 1524 the Raphael studio broke up. Politically, the third decade of the sixteenth century was disastrous. In 1525 Francis I of France was defeated and taken prisoner at the Battle of Pavia, and the French domination of north Italy was replaced by the deadening domination of Spain. In 1527 came the terrible Sack of Rome by the Spanish and German armies of the Emperor Charles V; in the same year the Medici were once more expelled from

219 FEDERICO ZUCCARO *Allegory of Design*

Florence, but after the Siege of 1529 the city was forced to accept a Medici ruler as Duke. One of the results of the Sack was the dispersal of most of the artists working in Rome. Some, like Sanmicheli and Sansovino, fled to the security and stability of Venice; others, like Rosso, wandered neurotically about, unable to settle after the disaster that had shattered their world. But the stylistic changes that dominate the second half of the century were by no means the result of the upheavals. Far from it: all were inherent in the modifications which Raphael himself had introduced into the style which he had created in Rome between 1510 and 1520. By far the most important of these changes was the search for more decorative, more elaborate, more sophisticated forms, which bit by bit overlaid the rather stark simplicity of the first phase of the High Renaissance,

and in the development of these changes Michelangelo played a significant part. His style had always contained a greater degree of complexity than that of any of his contemporaries, and, once Raphael had gone, he dominated Italian art like a Colossus. Only in Venice, as ever resistant to influence from central Italy, was Titian able to maintain independence, although he himself was strongly affected by the more troubled atmosphere that was prevalent there after 1540.

With a few notable exceptions, the end of the century saw a general decline of inspiration, and the 1570s was a decade of deaths. Eleven of the artists mentioned in these pages died in that decade. The exceptions were Venice, where Tintoretto continued to produce with an undiminished vigour until his death in 1594, and Florence, where Giovanni da Bologna worked into the early years of the next century, though Florentine painting was far below the level attained in sculpture. In Rome the architecture of Giacomo della Porta continued to be competent, though unimaginative and pedestrian. The main painters of the end of the century were feeble Mannerists, like the brothers Taddeo and Federico Zuccaro. Taddeo, who died in 1566, painted turgid frescoes in the Vatican, and decorated the Villa at Caprarola for the Farnese with complicated and eulogistic fresco cycles, which were completed after his death by his brother Federico, who lived until 1609. Federico travelled widely, was in Antwerp and France in 1574, and even came on to England, where he left behind a reputation for having painted Queen Elizabeth which furnishes half the country houses of England with lifeless effigies of very dissimilar doll-like creatures decked out in the most extravagant clothes and jewels. His only portrait of the queen with any claim to authenticity is the one in Siena, and even this is contested. He finished the

220 TIBALDI Ceiling decoration in the Palazzo Poggi, Bologna, begun 1553

frescoes in the dome of Florence Cathedral which Vasari's death had prevented him from completing, and found when he went to Spain in 1585 that Philip II was still only interested in Titian's kind of art. In 1593 he established in his own house in Rome an Academy of which he became the first head in 1598, and this house itself is an extraordinary Mannerist conceit, since the doors and windows are fashioned like giant's faces. During the last years he concentrated on theories of art, and in particular on theories of ideal beauty and design. His bloodless and lifeless painting is the best commentary possible on the kind of art which he sought to encourage.

The only other artist of repute who had a similarly peripatetic career was Pellegrino Tibaldi, whose energy of style and determined use of violent perspective are based on a desire to push the ideas of Michelangelo to their furthest limit. He also blended the influence of Parmigianino and Niccolò dell'Abbate with Michelangelo, to produce colourful and fantastic decorations, like those, for instance, in Bologna in what is now the University. He worked in Milan as an architect, in association with St Charles Borromeo, the Archbishop, building among other churches S. Fedele in a typical Counter-Reformation style. He was in Spain as well, from 1587 onwards, and there supervised the decoration of the Escorial, for which he painted forty-six frescoes in the cloisters. In 1596, he returned, noble and rich, to Milan, where he died in the same year. Of his energy and versatility there is no doubt, and many of his ceilings are astonishingly daring and inventive. The influence of Pellegrino on the Carracci in

Bologna was important for the development of their decorative style, yet like Zuccaro he is a man very much at the end of a tradition, at a moment of pause before new forms and ideas revivified the arts in the seventeenth century.

Largely, this dying fall is one of the accidents of history. The three main events of the century were the Reformation, the Sack of Rome, and the Council of Trent, and the third was the outcome of the other two. The Council, called to restate the articles of belief of the Catholic Church in the face of the Reformation, to reform abuses within the Church, and to unify the liturgy, also laid down certain rules affecting the arts, particularly in religious painting. It opened in 1545, and closed finally in 1563, and the decrees which affect the arts were promulgated in 1563. It was after the Council's ruling on decorum in religious paintings that Pius V had many of the figures in Michelangelo's *Last Judgement* furnished with loincloths. On the whole, the arts benefited from the decrees, after the first wave of uncertainties, though these naturally affected the development of late Mannerist art. Ultimately it was the renewal of confidence and rise of fervour and strength in faith that led to the great upsurge in the arts that characterizes the Baroque.

Chapter Ten

The Renaissance in the North

FLANDERS

No one could pretend that the art of the Netherlands after the death of Hugo van der Goes in 1482 – with one or two exceptions – was of the interest and quality of the preceding half century. The great generation of the van Eycks, Roger van der Weyden, Bouts and Hugo was succeeded by men who exploited much the same field, and whose works are full of charm, but, principally, they provide a lesson in the spread of ideas, in the indigestibility of many of those ideas, and in the mutations they underwent in the process of their adaptation. Neither Matsys nor Mabuse provide the sonorous majesty of Jan van Eyck, nor the deep pathos of Roger, nor the wilder, more heartrending emotion of Hugo. They are competent, lively, versatile, curious, with a keen eye ever open for what may be useful among the new ideas floating about in their world. Van Orley brings his immense competence to the building up of a successful business as an art-merchant; no order too small, prompt execution, high charges, only the best materials and workmen used. Lucas van Leyden comes near to greatness and genius, and almost as a bonus offers the nineteenth-century qualities of temperament and bohemianism. Gerard David, who lived on until 1521, was so imbued with the style and feeling of the fifteenth century that although he knew the Italianate style of the

new century – he could hardly have escaped doing so, since he lived in its home, Antwerp, from 1515 to 1521 – he remained almost totally unaffected by it. The one great genius is Bruegel.

Quentin Matsys looks forward where David looks back, so that the sixteenth-century style of the Antwerp Mannerists starts with him as its first major exponent. One of the reasons for the shift in style was economic. By the end of the fifteenth century Bruges and Ghent were declining towns, still rich and prosperous, though not what they had been in the heyday of the Burgundian empire. Antwerp, which in those days had been a mudflat fishing harbour, rose steadily in importance as a port because the canals upon which both Bruges and Ghent depended were not only silting up, but also because one of the consequences of the Portuguese maritime discoveries during the fifteenth century was a steady increase in the burthen of ships, for which they needed deeper anchorage. Antwerp, a deep-water port, was also a more useful Western seaboard terminal than the inland harbours of Ghent and Bruges, and, like London and Lisbon, it flourished on the slow but steady rise in trade from waters outside the Mediterranean. A further reason for its rise was the steady removal of foreign warehouses formerly centred on Ghent and Bruges, because of the more liberal

221 MATSYS *St Anne* triptych 1509

trading policy of the Antwerp guilds, which were less monopolistic and less riven by bitter faction.

Quentin Matsys was born in Louvain in 1464/65, and died in Antwerp in 1530. Although he is known to have been established in Antwerp by 1491, the earliest certain date for a work is 1507, when the *St Anne* triptych was commissioned, and he signed and dated it in 1509. The *St Anne* altar is very large – the centre panel is about 7 by 8 feet – and in subject it is essentially northern, for the Holy Kinship, based on a vision of a St Colette Boilet, a local saint who died in Ghent in 1447, became very popular in the second half of the fifteenth century in Flanders and Germany. In form it sticks to the traditional *sacra conversazione* type, and many details, such as the heavy draperies and the use of a landscape background, are reminiscent of the fifteenth century. But the colour is very different: pale, blond, light blue, clear, and very impressive in the use of these pallid tonalities, while the detail of, for instance, the little domed tabernacle with porphyry columns, the use

of caricature types, suggests experiences outside the earlier Flemish repertory. The landscape itself is quite different. Gone are the quiet pastoral scenes of Bouts or Hugo; now the landscape is eventful, and full of lively details of craggy mountains, castles, horsemen, torrents and peaks. The new trend in landscape painting was dominant in the North for almost the whole of the century – until, in fact, the rise of the Dutch landscape painters in the seventeenth century, with their interest in the local scene. This change almost certainly reflects influences from abroad, for Patinier, who was a strict contemporary of Matsys, displays an even more fantastic form of it, derived partly from Italy – from Leonardo, Mantegna and the Milanese – and partly from Germany – from Dürer, Altdorfer, Cranach and the Danube School. Dürer is the most likely source, since he was readily available in engravings, but the currents in these ideas are very involved indeed, since Florentines in the mid-sixteenth century were also using the engravings of Dürer and Lucas van Leyden, so that the influences work in a

kind of circle. But even in 1509, in the *St Anne* altar, or in Matsys's later *Lamentation* triptych of 1511, there is still no attempt to treat the central panel and the wings in a unified scheme, or even in one scale. The figures chop and change position in the artist's created space purely according to the needs of the story, and never because of any inner logic. His concern is with surface enrichment, more elaborate detail, still-life interest, and contrasts in facial expressions and gestures between the good and bad characters in his narratives. There is no attempt to solve problems presented by crowds of figures, for it is not unity or impact of an artistic kind that he is striving for, but impact through the weight of narrative detail.

In his portraits, Matsys is a far more organized artist. He uses the forms and language of Roger or Memlinc, but gives more space to his figures, more light and shadow to render the feeling of arrested movement, and wide, splendid landscapes in the background give air and the sixteenth-century feeling for setting. Is this the repercussion of Italian example in the North, or is it derived once more from Dürer, who, in any case, had twice been to Venice by this date? As well as the simple type of straightforward half-length portrait, Matsys created another kind: the genre type depicting a scholar in his study, of which the best examples are the *Egidius* at Longford Castle, and the copy of a lost original of *Erasmus* in the Corsini Collection in Rome. This is an adaptation of the usual iconography of a *St Jerome*, such as the one in Detroit, which is probably a late fifteenth-century copy of an original which may go back to Jan van Eyck, and for Erasmus would have the added point that he was the greatest of all Jerome's commentators. A letter from St Thomas More to Erasmus, dated 1517, mentions the portraits of Egidius, while Erasmus must have sat for his when on his way to

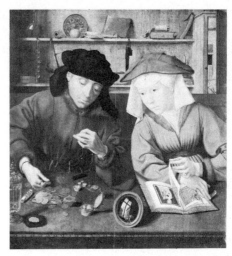

222 MATSYS *Money Changer and his Wife* 1514

223 MATSYS *Egidius* 1517

224 MATSYS *Madonna and Child c.* 1527

Basle through Antwerp. Again, the in-
fluence of Dürer's engraving of *St Jerome in
his Study* of 1514 is probably of more
relevance to the development of this type
in the North than, for instance, any remote
knowledge of Antonello's *St Jerome*. The
still-life clutter of shelves, books, and
other paraphernalia as a setting for a
portrait also has connections with Petrus
Christus's *St Eligius as a Goldsmith*, which
in turn links up with Matsys's *Money
Changer and his Wife*, dated 1514, parti-
cularly in the little mirror on the table – a
distant echo of Jan van Eyck's *Arnolfini*
marriage portrait. The Banker or Money
Changer picture in turn seems to have
given rise to an interest in an extraordinary
subject – that of Tax Gatherers. The most
exaggerated versions of this are by
Marinus van Reymerswaele, who was
active between about 1509 and about 1567.
No one has yet explained why these
caricature types, commemorating one of
life's less pleasant concerns, should have

occurred at all, much less have become so
popular that about thirty versions of it are
known, but the taste for caricature and
'moral contrast' subjects also include
examples like Matsys's *Ill-matched Pair* – a
low-life genre scene descended from the
iconography of the Prodigal Son, to
become in turn the ancestor of the Flemish
tavern picture. It is, therefore, possible
that all these odd subjects contain a
symbolism of the contrast between good
and evil, or a moral example, the point of
which may have been clearer then than it is
now. But the interest in caricature and a
rather equivocal moral lesson is important
for the future.

If Matsys went to Italy, then it ought to
have been before 1519, when he bought
himself a house in Antwerp, frescoed the
façade and put up a polychromed statue
that made it one of the sights of the town.
When Dürer came to Antwerp in 1520 he
visited the house, but Matsys was away.
Evidence that by this date copies of
Leonardo were in circulation in the North
is provided by the *Grotesque Woman* in the
National Gallery, which was fairly cer-
tainly made from a Leonardo drawing now
in Windsor, and stronger evidence is to be
found in the *Madonna and Child* at Poznan.
The omission here of the St Anne does not
disguise its derivation from Leonardo's
St Anne cartoon in the Louvre, but this
divorce between the main figures, and the
substitution of a typical Flemish land-
scape, suggests that the copy was only a
fragmentary one. Though the basic idea is
recognizably Italian, the language is a
borrowed one, and stems neither from his
previous work nor from what one can
assess as his own mental processes. It is a
Fleming speaking Italian with a strong
native accent, not the outcome of the
thought, tradition and training which
formed the artist.

Jan Gossaert is called Mabuse because
he came from Maubeuge; he was in the

225 MABUSE *Adoration of the Magi c.* 1503–06

Antwerp guild by 1503, but a work such as the large *Adoration* in the National Gallery, London, is so old-fashioned in its fifteenth-century outlook – high viewpoint, mystery play narrative, indecisions of scale in the angels, and a *horror vacui* accumulation of fantastic detail – that it is probably his Guild 'master-work' and dates from about 1503–06. In 1508 he went to Rome, which means that he was there immediately before the revolution effected by the major works of Michelangelo and Raphael. At first, he continues much as before, for the *Madonna and Child* in Palermo has all the

226 MABUSE *St Luke painting the Virgin c.* 1514

227 MABUSE *Neptune and Amphitrite* 1516

flamboyance of German woodcarver's Gothic, mixed with *putti* derived from Ferrarese paintings of the 1480s. Then he realized that the things he had seen were unknown in the North, and quite suddenly he changed completely. He began to produce pictures which mix in the strangest manner the kind of draperies and attitudes of traditional northern painting, with Italianate architectural features at first incorporating late Gothic details, as in the *St Luke painting the Virgin*, of about 1514 in Prague, and then by about 1518, in another version of the subject in Vienna, becoming as Italianate as possible, with details inspired by an uneasy mixture of Botticelli, Mantegna, Fra Bartolommeo and Filippino Lippi, with architectural fantasies of a Milanese character. The result is a florid, mannered, rather nightmarish style, in which nothing essential is assimilated and only the externals imitated. He also introduced a different kind of secular subject: classical mythologies. The *Neptune and Amphitrite* in Berlin, signed and dated 1516, is heavily dependent for the figures upon Dürer's *Adam and Eve* print of 1504 [256] and there are other instances such as a *Hercules and Dejanira*, and a *Danaë*, as well as drawings of the Spinario and a hermaphrodite statue. It would not be worth instancing examples of such Italianisms if the particular could not be made to furnish a generalization: it is that when northern artists suffered the impact of Italian art, it was necessary for them to be very great geniuses – like Dürer or Bruegel – if their independence was to survive, and in 1516 or 1517, a major work by Raphael arrived in Brussels, for the Sistine Chapel tapestries were woven there and the Cartoons remained in Flanders afterwards.

In his own day, Bernard van Orley was called the Raphael of the North, which speaks rather more for Raphael's fame than it does for northern judgement. He was born in Brussels about 1488, and died

228 VAN ORLEY *Trials of Job*. Centre panel 1532

229 VAN ORLEY *Dives and Lazarus*. From wings of *Job* altarpiece

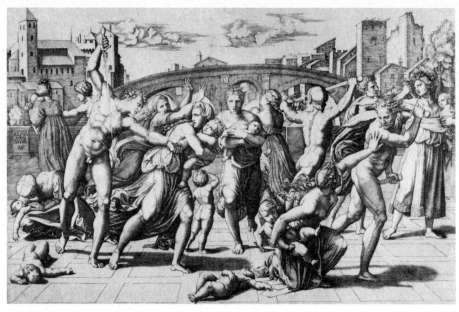

230 RAIMONDI *Massacre of the Innocents*. Engraving after Raphael

there in 1541. His principal patrons were successive Regents of the Netherlands, Margaret of Austria and Mary of Hungary, the first an aunt, and the second a sister of the Emperor Charles V, so that the familiarity of the patron with Italian work of the finest kind is also to be reckoned with as a factor in the spread of Italianism in the North. Van Orley is at his best in portraits – such as the splendid 'scholar in his study' one of *Georg van Zelle* dated 1519 – and in his tapestries, which both reflect his experience of Raphael, and disseminate Italianism. In his major altarpiece, the *Trials of Job*, dated 1532, in Brussels, the central panel of the destruction of Job's children, and all except one small part of the wings, which contain the story of Dives and Lazarus, have only the sort of references to Italian art that would be got from hearsay – Job's stricken children remind one of, but are not copied from,

Signorelli's *Fall of Antichrist* in Orvieto, and the architecture in all the scenes has the type of dumpy marble column and Milanese panels and friezes of grotesques that Mabuse also used. The narrative is very vehement: Dives at his feast, the beggar expiring at his gate, the death of Dives, and his plea in Hell for a drop of water to ease his thirst. But who is this unhappy sinner? Is he not Heliodorus, lying beneath the hoofs of the avenging angel's horse? And how does he come to be Heliodorus, rather than Ananias from the Cartoons?

The other great factor, besides the first-hand exposure through travel to Italy, and contact with imported works, was by means of engravings. The frontispieces of books, so frequently incorporating architectural motives, illustrated Books of Hours with decorative borders, illustrated editions of Herodotus, Petrarch, Lives

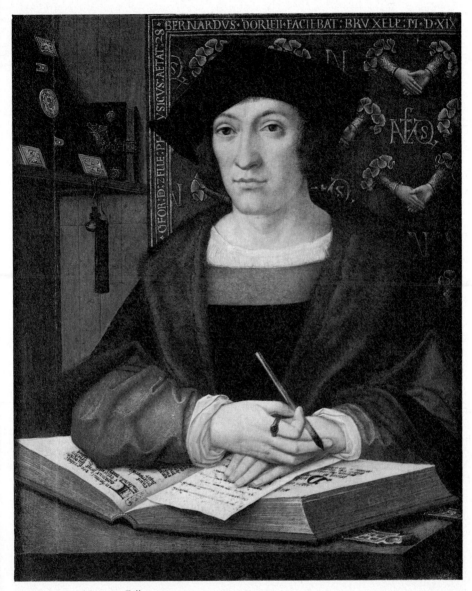

231 VAN ORLEY *Georg van Zelle* 1519

of the Saints, that came in increasing volume from Italian, particularly Venetian, presses, were one of the means of diffusion, and artist's prints – those of Mantegna in particular, and of other Mantuan, Venetian, Ferrarese, and Florentine engravers and the celebrated plate by Bramante – were probably even more important because they would have had more authority. But most important of all were the engravings of Marcantonio Raimondi, who was born about 1480, worked in Venice as a forger of Dürer's prints, and then moved to Rome about 1510 where he became the principal diffuser of ideas and works emanating from Raphael and his circle. After the Sack he returned to Bologna, and there disappears from view. He was extremely prolific: over three hundred engravings are known, and these spread all over Europe not only the works of Raphael and his school, but antique sculptures, fantastic allegories, portraits, mythologies, genre scenes by many hands. To these must be added the works of Dürer, Cranach, Urs Graf and Lucas van Leyden.

Lucas was reported to have been extremely precocious – a competent painter at fifteen – that is, by about 1510. He spent most of his time in Leyden, and married a rich woman there in 1515, which may account for some of his later vagaries. Dürer visited him in 1520, and he went on a short journey with Mabuse in 1527, when he entertained local artists lavishly, perhaps in imitation of Dürer during his Netherlandish journey in 1520–21. He died fairly young – about 1533 – and believed himself to have been poisoned by

232 LUCAS VAN LEYDEN *Magdalen returning to the World*. Engraving 1519

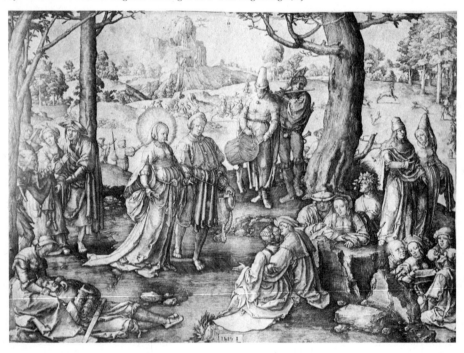

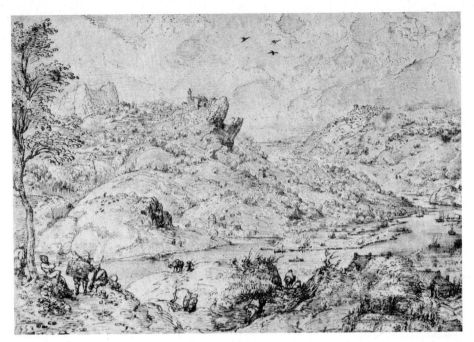

233 Bruegel *Alpine Scenery.* Drawing 1553

his rivals, whom he avoided by working in bed. There are few paintings, but his output of woodcuts was large enough to suggest that he was a busy, though not prolific artist, although this accords ill with the dilettante picture of the travelling, the lying in bed, the wining and dining in yellow silk clothes. His paintings have the most beautiful fluid brushwork, the soft, loaded brush squiggling with a liquid calligraphic line, and wonderful colour; not surprising as Matsys's *St Anne* is, by its all-over pallor and blueness, but surprising in detail. Green shadows, mauve shadows, little flushed patches of pink or pale greeny-blue, so that flesh has an almost impressionist quality of colour, and then into the melting variety of tint he drops a firm incisive line, a hard edge flicked in and out with consummate mastery. His woodcuts can be dated from 1510 on, which, if

he was truly born in 1494, makes his youthful performance very impressive indeed. Many of his subjects are close to Dürer's, and sometimes also to Schongauer, with great play made with the draperies in rather archaic systems of folds. Sometimes they are additions to the inventive iconography of the North; sometimes he brings to his woodcuts the virtuoso qualities of line of his best paintings, or grades the thickness of his line according to the depth in space – a hallmark of the very best Dürer technique.

The temper of the mid-century is shown by an artist like Jan Scorel, who travelled all over Germany, and into Italy, went to Jerusalem on a pilgrimage, arrived back in Venice in 1521, made his fortune by being in Rome at the right moment to be practically the only artist patronized by the Dutch pope Hadrian VI, came back to

234 Lucas van Leyden *Self-portrait c.* 1509

235 SCOREL *Magdalen*

Utrecht full of the influences of Giorgione, Palma Vecchio, Raphael and Michelangelo, and later went to France. At his worst, he is a self-conscious imitator; at his best, he has a striking gift for vivid characterization in rich and evocative colour. The drawings of his pupil, Maerten van Heemskerck, made in Rome in 1532–35, are among the most vivid and important records of the state of St Peter's and of Roman antiquities in those years, and the style he brought back with him combines Italian fluency and spaciousness with northern realism – particularly in his

fine portraits – and also with deliberate Italianisms designed to impress his patrons.

The South became such a magnet that Bruegel, immediately after he became a member of the Antwerp Guild in 1551, set off on a journey that took him across France and down through Italy as far as Sicily. He was in Rome in 1553, and returned across the Alps about 1554. This long and arduous journey had a considerable influence on his development of new forms in landscape, while the art of Italy seems to have had almost no impact at all.

221

236 BRUEGEL *Dulle Griet* 1564

After his return, he began working for engravers on popular prints, and the kind of terror-fantasies that Bosch had specialized in. He then evolved an entirely new subject matter in his pictures based on proverbs; he adapted the ideas of the inner meanings of the still-life, gestures, and setting in religious pictures to a new iconography of moral significance based on the illustration of everyday life and manners. Sometimes entirely fantastic, like the *Dulle Griet* or the *Triumph of Death*, but more often either entirely realistic, like the *Wedding Feast*, or hovering on the borderline between reality and a dreamworld, like the *Land of Cockaigne*, or the *Parable of the Blind*, these pictures are sermons on the vices and follies of mankind, and were recognized and prized as such in the painter's lifetime. In his last ten years (he died in 1569) he produced vast landscapes based ultimately on the experiences of his Alpine journey, often with this moral content, like the *Magpie and the Gallows*, but also, in the great series of the *Months*, all but one of which are dated 1565, with the profounder thesis of the unity of mankind and nature. Far from being the simple, earthy character suggested by the nickname 'Peasant', Pieter Bruegel was a man of erudition, the friend of humanists, and greatly appreciated by an enlightened patron, Cardinal Granvelle, Philip II's minister in the Netherlands.

His contemporaries, meanwhile, bogged down in the imitation of Italian forms in all too literal a sense. Painters like Aertsen and Bueckelaer converted their vast still-lifes of market and kitchen scenes into religious pictures by disguising the

237 BUECKELAER *Christ in the House of Martha and Mary* 1565

238 FLORIS *Last Judgement* 1565

239 BRUEGEL *Parable of the Blind* 1568

240 BRUEGEL *Stormy Day* 1565

241 BRUEGEL *Magpie and the Gallows* 1568

background figures as Christ in the house of Martha and Mary, or the Prodigal Son. More usually, the realism is confined to sober and often sensitive portraits, like those of the Pourbus family, while the subject pictures – such as those by Martin de Vos, Floris, and the members of the Pourbus family in their grand manner moments – become the battlefield of Raphael-inspired idealism and Michelangelo-inspired nudes, with a consequent incoherence of style. They adopt Italian ideas and forms, but are necessarily lacking in the classical tradition which

made the development of those ideas natural in the South, so that they are merely a matter of fashion, of using the up-to-date language. Ideas from Leonardo, such as the Leda twisted pose, and the smoky *sfumato* modelling; ideas from Raphael, derived from the Cartoons, through Marcantonio, from school works imported into the North; fragments of Michelangelo's *terribilità*. In architecture, they were so conditioned by the florid quality of late Gothic that the simplicity and severity of the best Renaissance work was ignored in favour of the confused and

fantasticated Certosa at Pavia, or the elaboration of the courtyard of the Doge's Palace in Venice. The term Flemish, or Antwerp, Mannerism is a useful, but also a confusing one, convenient as a label to distinguish the art of this epoch from earlier Flemish painting; yet there is really nothing Mannerist about it at all. Mannerism, properly, can only refer to Italian art, in the sense that it is a result of, and a sequel to, High Renaissance forms and ideas. The North merely adopts the vocabulary, as the outward sign of an admired and coveted standard of education and culture, but the inner meaning of the language is a closed book. Only a few men, like Dürer, Bruegel and Holbein, understood the gulf.

FRANCE

The importance of the sudden emergence of the School of Fontainebleau is because its repercussions reached far beyond the place from which it takes its name. It became a main centre for the diffusión of Italian Renaissance ideas in northern Europe, because instead of a slow permeation of northern art by ideas from Italy, the new style sprang from the direct patronage of Francis I with the completeness of Minerva springing fully armed from Jupiter's head. Though there had been hints during the mid-fifteenth century of Italian ideas in the miniaturists and tombmakers, by the turn of the century the invasion of France by Italian forms was as overwhelming as the military invasions of Italy by the French, of which they were the direct result. The French invasions of 1494 and 1499, which opened northern eyes to the splendour of Italian life and art, resulted particularly in the importation of Milanese forms, since Milan was the city they controlled for the longest time. The cluttered, confused, over-decorated Certosa of Pavia accorded well with the elaborate forms of Late Gothic current in the North, but under Francis I quite another attitude prevailed. His view of kingship, and the role for which he cast himself in European politics, was that of a dominant central power, and he required a courtly magnificence as a suitable setting for his position. Italian luxury, splendour and art were not just attractive in themselves; they were things which would put him on a par with other monarchs – if not actually enable him to excel them. To this end, he imported such major artists as he could; Michelangelo he failed to obtain, but he did get the ageing Leonardo. Rosso he imported in 1520, Primaticcio in 1532; Niccolò dell'Abbate, Vignola, Serlio, Andrea del Sarto, Cellini, all came; some stayed, some went back; but the work they left behind was decisive in that from this 'infection' from Italian sources Gothic died, to be replaced at first with hybrid and garbled forms of Italianism.

Only prestige came of Francis's capture of Leonardo; but in Rosso the King acquired an artist of ability, whose acute sufferings at the time of the Sack of Rome had exacerbated an already highly-strung temperament. Primaticcio was at first overshadowed by his compatriot, but after Rosso's mysterious death in 1540, he came into his own and reigned supreme for the rest of his long life. Sarto's brief unhappy stay had little more effect than Cellini's stormy one; Vignola, who was in France for about eighteen months in the early 1540s at the very beginning of his career, never had the influence of the far less intelligent, but more accommodating Serlio. Between them, however, they prepared the ground for an impetus which was to be naturalized by the end of the century, and which would provide the forcing ground for the greatness of French

seventeenth-century art. Rosso from a background of the Volterra *Deposition*, Primaticcio from the Palazzo del Tè, brought with them, not the serene art of Raphael or of Michelangelo's Sistine Ceiling, but the conflict and obscurity, the contortion, tension and complexity of the years which saw the Sack.

Francis concentrated his patronage on the decoration of the Château of Fontainebleau, and this decoration is the keynote of the new style. Painted allegories, mythologies, histories, all extolling the glory of the King, were framed by figures, trophies, garlands, cut leather panels, *putti*, executed in stucco in a relief so high as to be almost free-standing. The figures are tall, slender, elegant; the garlands and strapwork intertwine so that the frame is more vivid and splendid than the picture enclosed in it. Tapestries of similar type, easel pictures concentrating on the all-important female nude, portraits emulating the elegance of Bronzino's Medici court portraits, imaginary landscapes with enormous panoramas of mountain ranges and shadowy cities peopled by the characters of mythology like tiny puppets against a fantastic backcloth, religious pictures with involved imagery and tortured *contrapposto*, even the minor arts of miniatures, jewellery, textiles, all show the impact of Fontainebleau, and that search for luxuriance and sophistication which is the hallmark of Francis's court.

The Fontainebleau decorations included a Long Gallery, a Ballroom, and rooms for the King, the Queen, and the King's mistress, the Duchesse d'Étampes. Only a fraction survives, since much was destroyed in later rebuildings, and most of the paintings were drastically restored in the nineteenth century. The wonderful stucco figures framing the mutilated pictures have a curious ancestry, for they are a three-dimensional form of the

242 PRIMATICCIO Stucco decoration at Fontainebleau *c.* 1541–45

painted friezes of fictive sculpture in, for instance, Giulio Romano's Sala di Costantino decorations, or the dado of caryatid figures painted by Perino del Vaga under the frescoes in the Stanze to replace the inlaid woodwork destroyed during the Sack. After Rosso's death, Primaticcio continued without a major collaborator until the arrival about 1552 of Niccolò dell'Abbate. His main contribution was his fantastic landscapes, which are a genre quite apart from either the poetic realism found in late fifteenth-century Italian pictures, or the homely kind in the background of the Raphael Cartoons. They have a dreamlike quality with extremes of light and colour, rainbows and flickering storms: odes with the impact of incantations. This feeling for mood in landscape is not entirely new, since it can be found in earlier works inspired from different sources. The *Eva Prima Pandora*, painted by Jean Cousin the Elder about 1538, shows the result of Rosso and Cellini in the nude figure, but the rocky landscape of the grotto and the open vista beyond betray more than a nodding acquaintance with Leonardo and the engravings by the Danube school of landscape painters. One

243 NICCOLÒ DELL' ABBATE *Orpheus and Eurydice*

of the difficulties besetting French painting at this moment is the diversity of influences to which it was open.

In portraits a whole gallery of new sources is obvious: the *Pierre Quthe* of 1562 by François Clouet is patently influenced by Bronzino's court portraits, and also by Holbein and the Pourbus family in Flanders. These same influences blend in the *Lady in her Bath* of *c.* 1570. This is the classic portrayal of a Royal mistress in her official role, cool, beautiful, aloof, bejewelled even in her bath, accompanied by the trappings of her state – fine rooms, a noble child in the arms of its leering, accomplice-nurse, the sly Love-child stealing the fruits, the flower of passion in her hand. Yet the influence of the *Mona Lisa* is there

too, for this picture seems to have accompanied Leonardo to France, and many versions – some close to the original, some virtually parodies – exist, with nude versions rather more popular than the reticent original. There was also a market for evocations of the Raphael 'Mistress' portrait – the nude, bejewelled *Fornarina* which it is so hard to credit to Raphael himself, despite, and perhaps because of, the blatant signature – tricked out in classical trappings so as to combine provocativeness with the respectability of a learned language. The Bronzino *Venus, Cupid, Time and Folly*, sent to Francis I by Cosimo I, was undoubtedly one of the main vehicles for the introduction into France of the erotic nude, with steely

244 CLOUET *Pierre Quthe* 1562

draughtsmanship, and hauntingly frigid colour. And the Bronzino version of Michelangelo's cartoon of Leda, itself descended from the *Night* of the Medici tombs, crossed with influences from Correggio's and Titian's *Danaë* subjects, crossed in turn with Primaticcio's stucco figures brings the wheel full circle in a work such as the Master of Flora's *Birth of Cupid*. Primaticcio's art, in fact, remained the most potent, since it was the longest, and the readiest available, translation of Italian art into French.

But to introduce new ideas at a central point of diffusion, and to engender by their means a new indigenous school are quite different things. The second generation of native French artists at Fontainebleau produced no men of the quality of Rosso and Primaticcio. Too often they were attracted by the showy and fantastic elements in their Italian models, such as extremes of perspective and *outré* colour, and too many works founder in confused form and in an overt eroticism which implies only a superficial understanding of the true nature of Renaissance art. The Wars of Religion put an end to nearly all patronage in the later years of the century, and when the arts began to revive under Henry IV the original Fontainebleau sources were still drawn on, plus the Flemish Italianizers who imported still further distortions into what they took from Italy. People like Ambroise Dubois, a Fleming who settled in France, where he died in 1614, or Toussaint Dubreuil, who died in 1602, continue the fantastic distortions, the erotic nude; but the spark is dead, and the weak drawing, and the

245 COUSIN *Eva Prima Pandora c.* 1538

246 CARON *The Massacres of the Triumvirate* 1566

confusions of space and scale, mask the poverty of imagination and style. Only Antoine Caron, who died in 1600, still impresses as an extreme of sophisticated court art; his pictures look like gigantic ballets, and were probably inspired by them, for ballet was one of the great amusements of the court of Catherine de' Medici, the queen mother, and his chief patron.

Francis I's third important acquisition was Sebastiano Serlio. He was a Bolognese, born in 1475 – which makes him considerably older than Rosso or Primaticcio – who had been in Rome as an assistant to Peruzzi, who was himself one of Bramante's men. After the Sack, he went to Venice and there began to work on an illustrated treatise for the use of architects and their patrons. He dedicated one of the volumes to Francis I in 1540, and was then invited to France and given the control of the building works at Fontainebleau. His treatise eventually became a major work

with an impact enhanced by the fact that he sprang, so to speak, from the fountainhead. That he had been unable to compete in Venice with Sansovino should have suggested something; but in the new climate of France, passionate interest in Italian art was coupled with naïve ignorance and inexperienced taste. Serlio's tactful suggestions for the conversion of old-fashioned Gothic houses into modern Italianate palaces, and his showy designs for gateways, staircases, chimney pieces, which – however far they departed from what an educated Italian would have built – were believed to be examples of the pure, new fashion derived from antiquity, were received with welcoming approbation. His books were best-sellers; Dutch, German, English editions (books One to Five, 'by Sebastian Serly', London 1611, were from the Dutch edition) spread Serlio's version of Italian Renaissance architecture all over Europe. His buildings in France were very few and his influence

247 CLOUET *Lady in her Bath c.* 1570

was utterly disproportionate to his attainments. The curious thing is that he found a market at all, since he had to compete with Lescot and Philibert de l'Orme, both of whom had a far better understanding of the Italian style than he had, and, in the case of Philibert, was an architect of genius who worked for three years in Italy.

Very little survives of Primaticcio's buildings; the grotto at Fontainebleau of about 1543 is typical of the fantasy type of architecture inherited from Giulio

Romano – massive piers with figures of imprisoned giants incorporated into the rustication, derived from the Michelangelo *Slaves* of which the pair now in the Louvre were owned by the Connétable de Montmorency at Écouen by 1546. By 1568, the date of the wing known as the 'Aile de la Belle Cheminée', Primaticcio is far closer to Vignola who was by that time the most important representative of the new Academic movement, a combination of the 'back-to-Bramante' trend with the reaction against Giulio Romano's waywardness, which Primaticcio would have known about from his visit to Italy in 1563.

Pierre Lescot, who was born about the turn of the century and died in 1578, was not – as was usually the case – trained as a mason, but received a learned education and may even have been to Rome in his youth, though his only certain visit was in 1556, too late to affect his architecture. His great surviving work is at the Louvre, where the keep was demolished to make space for a square court which he began in 1546. Later the project was doubled in size to form the present Cour Carrée, though this larger scheme was not carried out until well into the seventeenth century. His buildings, at the south-east corner of the courtyard, are very classical, with pure proportions and excellent detail, ornamental but with real understanding of the orders. He retains the common form of the

248 Master of Flora *Birth of Cupid c.* 1540/60

'frontispiece' – that is, the surviving idea of the towered gateway – treated as an important feature on the central axis of the building, but this traditional shape is rationalized into new combinations. The detailing is superb, with very high quality sculpture, probably by Jean Goujon, who also created, with Lescot, the large Salle des Caryatides, where the gallery is borne on female figures, according to a form described by Vitruvius. The other great sculptor of the period was Germain Pilon. Basically, his inspiration derives from the Fontainebleau stuccoes, but he develops a wonderfully flowing movement, which is deeply expressive.

In Philibert de l'Orme, France produced the first northern architect fit to stand among the great Italians. He was born in Lyons about 1505/10, the son of a mason, and came to Paris about 1540 – that is, about the time that Serlio arrived. His first

249 SERLIO Frontispiece to Book V (first published 1547)

work after this was the country house of S. Maur-lès-Fossés, near Paris, now destroyed. This was not unlike the Palazzo del Tè in design, being four-square round a court but with a double storey articulated by a giant order for the main block – the first appearance of a properly designed Order, and certainly of a giant order, in the North. Philibert also designed Anet for Diane de Poitiers, the mistress of Henry II, though only the gateway and the chapel remain on the site, and the central frontispiece has survived by being built into the École des Beaux-Arts in Paris. This is another example of the old medieval gate-tower lingering on to be rationalized into the new systems by a sequence of orders properly in proportion, one above the other. The gateway at Anet achieves its decorative effects by purely architectural means, using blocks of masonry and balustraded terraces to create masses of light and shadow, so that the fanciful devices of clockwork hounds and stag at bay on the top, and the Cellini *Nymph* that once filled the tympanum, fall into their proper places as adjuncts to an architectural system. The chapel is centrally planned, with all walls, pediments, doorways, windows and interior barrel vaulting following the curves of the outside walls, while inside it is articulated by a superbly proportioned Corinthian order, with a beautifully cut inscription as the only decoration in the frieze, and the spirally coffered dome is reflected in the inlaid pattern of the floor. This is no longer – and the date is in the early 1550s – a mere imitation of the superficial effects of Italian forms, such as Serlio dealt in. Philibert's two treatises on architecture, written during the years after his royal patron's death in 1559 and continued until his own death in 1570, when he was suffering the disgrace which resulted largely from his own arrogance during his period of favour, are not only manuals of

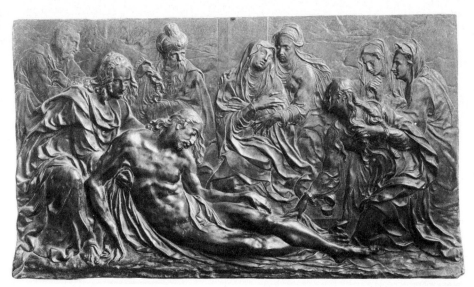

250 PILON *Deposition*. Relief *c.* 1580/85

251 LESCOT Cour Carrée, Louvre, begun 1546

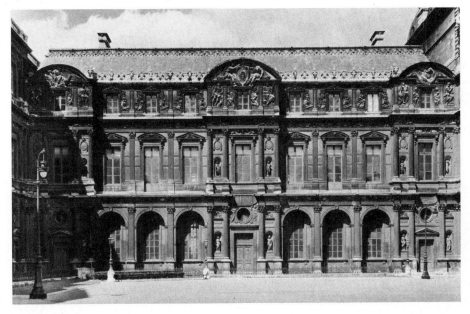

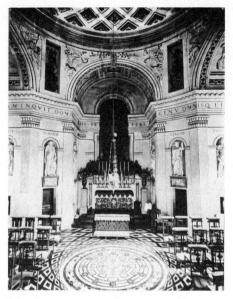

252 PHILIBERT Interior of Chapel at Anet 1549-52

253 PHILIBERT Gateway at Anet 1552

instruction for the professional, but are valuable for their insistence on theory, so that they offer to architect and patron alike a means of achieving Sir Henry Wootton's famous dictum on architecture: 'firmnesse, commoditie, and delight'.

Before the French invasions of Italy the main art of the North had been architecture. It still remained so, though there is a case for arguing that the death of Gothic was a major loss, not compensated for by the ill-conceived forms of Renaissance by which it was initially superseded, for these amounted to little more than the addition of new style ornament to Gothic forms, in the belief that Renaissance art was nothing but an alternative kind of decoration. With men like Lescot and Philibert de l'Orme, or Goujon and Germain Pilon, this belief gave place rapidly to a grasp of the fact that Italian art is fundamentally a matter of form and proportion. Painting expanded from an art previously confined to manuscript illumination, altarpieces, small devotional works, little portraits, into a monumental art. Huge schemes of

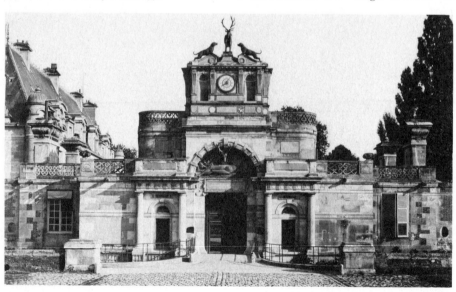

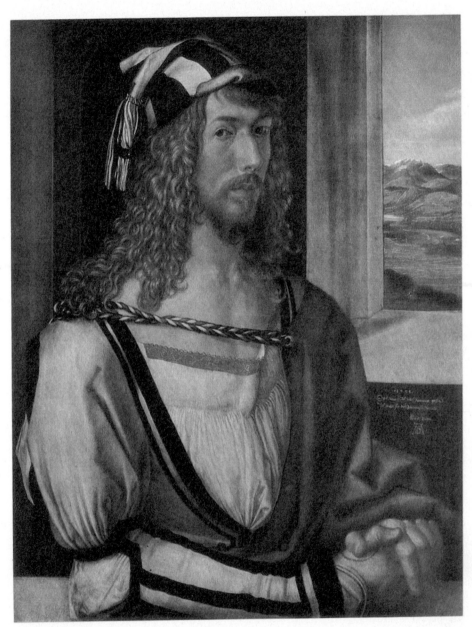

254 DÜRER *Self-portrait* 1498

decoration, like that at Fontainebleau, were exceptional, but the introduction of new subject matter – that is, the secularizing of painting through the development of alternatives to religious pictures, the increased scope possible in landscape and portraiture – reflects the general widening of intellectual horizons which is the special achievement of the Renaissance. The Renaissance painter, like his contemporary in scholarship, enabled the man of his time to stand outside himself and look at himself, his achievements, and the world about him, in a spirit of enquiry and detachment; it enabled him to create an

image of himself. It made him conscious of himself, enlarged his stature, gave him dignity and self-confidence. The impact of the Renaissance in Fontainebleau may seem, when one looks at the dwindling lamps that the bright Italian lights became, but a poor end for so much hope and effort, but the world of Philibert de l'Orme is really the true moment of the birth of the Renaissance in the North. It was in this new world that Poussin and Philippe de Champaigne were introduced to an art founded on the Italian classics. And within twenty-five years this seed would be like the mustard tree of the parable.

GERMANY

Albrecht Dürer towers over all the artists of his age in the North by the inventiveness and intellectual qualities of his art, by the size of his *œuvre*, and in its impact on the art of his times not only in the North, but in Italy as well. He was born in 1471 in Nuremberg, and after a training in engraving, in the making of woodcuts for book illustration, and in painting, he travelled extensively, working in Germany and in Basle before visiting Italy for the first time in 1494. He had already had contacts with Italian art through Mantegna's engravings, and his stay in Venice of about six months opened his eyes still further to the nature and quality of Italian art, enlarging not only his artistic vision but also giving him an insight into the difference between the status of the artist in Italy as a creative force, and his far humbler workman role in Germany, where he was no more than just another kind of craftsman. The fruits of his first Italian journey were immediate. They can be seen in his early portraits, particularly in the self-portraits such as that of 1498 in the Prado, or that of 1500 which twists the iconography of Antonello da Messina's *Blessing Christ* to a new secular purpose

reflecting, perhaps, his conviction that the artist's creative faculty is an earthly parallel to the spiritual order of Divine creation. His large woodcuts of such unusual subjects as the *Men's Bathhouse* of 1497 exploit forms and compositions reflecting Italian influence. In the portraits he extends the traditional Flemish donor portrait into the wider field of the secular portrait. They still have the taut quality which informed Leonardo's early portraits, such as the *Ginevra de' Benci* (which must originally have shown the sitter's hands) or his *Cecilia Gallerani*, painted immediately after his arrival in Milan, these being the only Italian predecessors of Dürer's half-length portraits with hands, though Dürer could not have known either of them at first hand. But his portraits have the Venetian sense of air and space around the sitter, and the even earlier betrothal self-portrait of 1493 as well as the later ones have the distinctly self-conscious air of what must be among the earliest – if not actually the first – northern self-portraits painted to gratify personal vanity. They are a deliberate enlargement of the field of portrait painting, akin to Leonardo's creation of a new type in the

Mona Lisa. The woodcut of the *Men's Bathhouse* is a new exploitation of the male nude as the artist's major concern, though here given a new significance through his detailed study of unidealized nature being dedicated to so unusual a secular subject.

The series of the *Apocalypse*, issued in 1498, also broke new ground. This was the first printed book which an artist had ever created entirely on his own, printing the text himself and illustrating it with a frontispiece and a tailpiece, and fourteen full-page woodcuts. Dürer condenses the narrative pictorially so that it gains immeasurably in impact, and uses for his work on the block a technique similar to that which he had already begun to use in engravings such as the *Prodigal Son* of 1498. In this moving image he parallels his technical virtuosity with the invention of an entirely new iconography for this traditional subject. In its imaginative force, its richness of imagery, and its technical accomplishment, the *Apocalypse* ranks with any of the great artistic turning-points of art – with Leonardo's *Last Supper* or Michelangelo's Sistine Ceiling. One of the difficulties confronting Dürer at this period was that his technical requirements were so high that few craftsman-engravers could meet them, so that a great deal of the exacting and exhausting work had to be done by the artist himself.

In 1505 he returned to Venice. By this time he had achieved such entirely Renaissance works as the *Adam and Eve* of 1504, which combine his fantastic ability in engraving with an almost inexhaustible wealth of iconographical detail and a knowledge of classical sculpture – the Adam is very obviously derived from the Apollo Belvedere, and the Eve appears to be a variation of one of the figures in the classical group of the Three Graces in Siena (now in the Opera del Duomo), both of which were known in the last years of the fifteenth century.

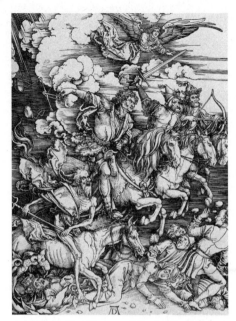

255 DÜRER *Four Horsemen of the Apocalypse* 1498

256 DÜRER *Adam and Eve* 1504

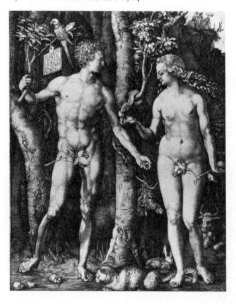

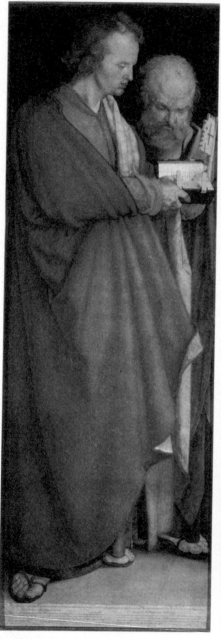
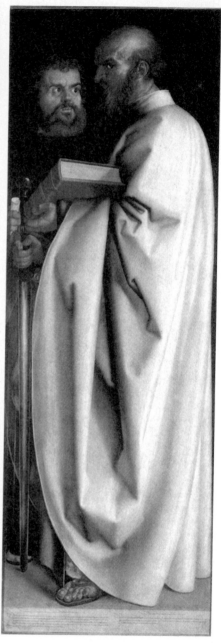

257 DÜRER *Four Apostles* 1526

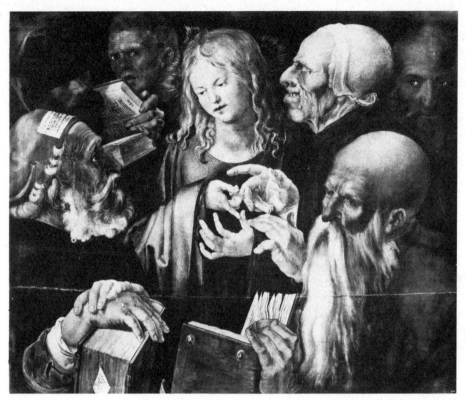

258 DÜRER *Christ among the Doctors c.* 1505

His second visit to Venice took place under very different circumstances from his first one. He was now famous and established, able to mix with scholars and humanists, connoisseurs and artists, and instead of wonderment and bewilderment at the variety and strangeness of Italian life and customs, he turned to the study of Italian artistic theory. Moreover, by this time Leonardo had passed through Venice, leaving, it would appear, a cartoon for the *Christ among the Doctors* commissioned by Isabella d'Este, a commission which he evaded by returning to Florence. This cartoon exercised a powerful effect on Dürer who, during his first visit would have been aware of Leonardo's stature

only by repute, but now could see a work by his own hand. He imitated it in his extraordinary version of the same subject, and described it himself as 'a picture the like of which I have never painted before'.

On his return to Nuremberg he faced his great problem even more directly. He was no longer a workman, dutifully filling orders for clients who, like as not, only regarded him as the best because he was the most expensive and because the Elector of Saxony patronized him. His aspirations as a humanist, as a theorist on art, as a mathematician learned in geometry and optics, must have appeared to them as time-wastingly eccentric as it did to his nagging and uncomprehending

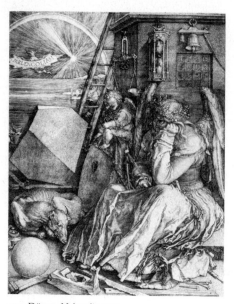

259 DÜRER *Melencolia* 1514

management of large groups of celestial figures, reminiscent of an up-dated Last Judgement by Roger van der Weyden or Memlinc, with a traditional medieval Seat of Mercy, modernized in its new approach to anatomy and chiaroscuro.

Between 1511 and 1514 he produced some of his greatest woodcuts and engravings: the *Great Passion* and the *Life of the Virgin*, both published as books about 1511, and the single plates of the *Knight, Death and the Devil, St Jerome in his Study*, and the *Melencolia*, all have multiple layers of thought expressed with the greatest technical virtuosity so that they can be admired as works of art while being read as books on philosophy and humanism.

In 1520, in order to obtain confirmation of the pension awarded to him by the Emperor Maximilian, he travelled to the Netherlands to the court of Charles V, leaving as a record of this journey, during which he was fêted as the most famous artist of his age, a fascinating diary which records the things that most impressed him: the Ghent Altar, portrait drawings of people he met and places he visited, a couple of lions, a beautiful hound, a grotesque walrus, and even a note of the few times he dined with his uncongenial wife. His journey, however, destroyed him, for he contracted malaria by venturing into the swamps of Zeeland to see a whale, which had been washed out to sea before he got there, and the fever relentlessly undermined him so that his last years until his death in 1528 were troubled not only by the religious controversies which threatened his work but also by continual ill-health. His last paintings of the *Four Apostles*, designed as wings for a large *sacra conversazione* abandoned because the new religious climate of the Reformation in Nuremberg rendered its execution impossible, renew his debt to Bellini, while incorporating into the characteri-

wife. This change in his attitude to his art is directly due to knowledge of the status achieved by Mantegna and Leonardo, and to his personal friendship with Giovanni Bellini. His bitter discontent broke out in a letter written from Venice to his great friend Pirckheimer, himself a learned and cultured man, trained in the Universities of Pavia and Padua, and well able to understand the artist's frustration in Nuremberg: 'Here I am a gentleman; there I am a parasite.'

His work as an engraver did not, of course, exclude painting. His early religious works had quickly covered the ground from a clumsiness and confusion resulting from ill-digested Mantegna to open competition in the now very damaged *Madonna of the Rose Garlands*, painted for the German confraternity in Venice during his second visit there, with the rich variety and brilliant colour of Bellini. The *Holy Trinity* of 1511 combines the detailed

zation of the four saints the novel themes of the four ages and the four temperaments of Man.

The quality of his mind determined the character and range of his art, yet also limited it. He was basically an observer, trained in, and supreme in, the most exacting of techniques – copper engraving – who employed precise observation to express visions. For him, the artist was the particular representative of God, a creator from nothing, from blank paper and crude inks and paint, of visions of eternity and representations of nature. Yet he was also intimidated by the realization that no art, much less artist, could ever begin to approach the mystery and power of God. For him, inspiration had to be directed by theories, by principles, and great art without the control of knowledge and the discipline of learning was impossible. He knew himself to be deficient in the formal training which was part of the normal Italian studio practice, and he set himself to remedy his deficiencies by patient study and experiment, and to help his successors by creating for them a written theory, a body of knowledge which, when he expounds the mathematics of perspective, is reasonable enough. But his views on Ideal Beauty, which he felt to be the core of an artist's practice, start from a standpoint which utterly defeats his object, since he believes that since Man is imperfect he cannot create perfection; the Ideal, the Perfect, is possible only for God, and Man cannot compete with God, much less equal Him.

Dürer so overshadowed his contemporaries that it is sometimes difficult to realize that he was dead by 1528, and that for about a quarter of a century afterwards most German artists only reflect a small portion of his achievements, and rarely escape his influence. One of the facets of his art is sometimes developed a little further in invention and expression, as the

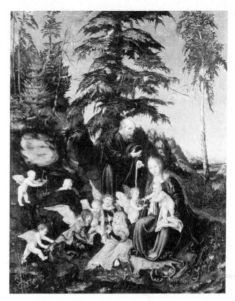

260 CRANACH *Rest on the Flight* 1504

so-called Danube School painters did in landscape. In fact, the term Danube School is a complete misnomer, in that it was never a 'school' in the sense of a group of artists working together with a common aim. The members of it were contemporary, but there was little or no contact between them, and only two of them were in any way connected with the Danube. Roughly, the painters usually grouped under this head are Cranach the Elder, who worked mostly in Wittenberg for the Electors of Saxony, Altdorfer who worked in Regensburg, and Wolf Huber, and only the last two have anything to do with the Danube. What they all have in common is a feeling for landscape, not just a background, but as a subject in itself, and they share also a predilection for large, shaggy fir trees, which make an expressive – even romantic – effect.

Lucas Cranach, who was born in 1472, was in Vienna probably from 1500

243

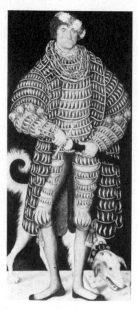

261 CRANACH *Duke Henry of Saxony* 1514

262 CRANACH *Duchess Katherine* 1514

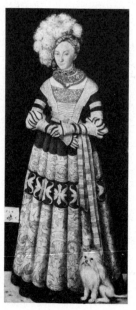

onwards, and in 1505 went to Wittenberg to become court painter to the Elector Frederick the Wise, who was also one of Dürer's patrons. He had already developed his landscape interests by 1503, for a *Crucifixion* of that year combines landscape with a mixture of late Gothic emotion and the imagery of Dürer, and by 1504 his *Rest on the Flight* has developed a full-scale Dürer quality in the figures with the marvellously evocative forest scene, including the curious tattered fir tree. As a portrait painter he had nothing to learn from Dürer – witness the grand *Cuspinian* portraits of 1504–05 – and he always sets his sitter with the amplitude and feeling for personality – the anti-effigy quality – of the best northern artists, perhaps Matsys as well as Dürer.

The result of the large workshop his court patronage forced him to establish was to make him unadventurous, formally stylized, with overtones of a very odd sophistication. He made history in that full-length portraits, not connected with religious subjects as donors, seem to be his invention. *Duke Henry of Saxony*, and *Duchess Katherine* are dated 1514, but both are highly formalized, almost heraldic effigies, with a lifeless, signboard quality, and nothing of the space and colour of the superb *Cuspinian* pair. In the portrait of Cardinal Albrecht of Brandenburg, painted in 1527, the sitter is portrayed in the now-fashionable 'scholar-in-his-study' setting, but has only a minimal return to the feeling and movement of his early style. After the beginning of the 1520s, Cranach became interested – and, more unfortunately, so did his patrons – in mythological subjects of a pseudo-humanist type, and from then on come the series of Venuses, some betraying more clearly than others their origins in Venetian art. The *Sleeping Venus* of 1518, the *Judgement of Paris* of about 1530, stress not only the narrow confines of the workshop but a

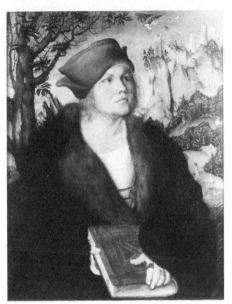

263 CRANACH *Dr Johannes Cuspinian* 1504–05

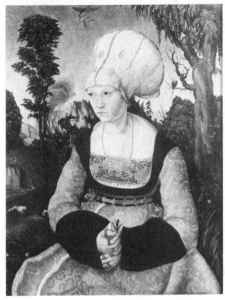

264 CRANACH *Anna Cuspinian* 1504–05

265 CRANACH *Judgement of Paris c.* 1530

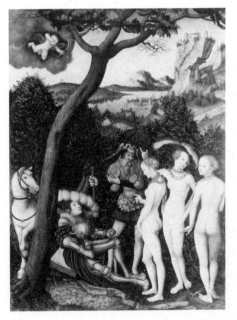

curious blend of erotic curiosity and undercover sensuality. Cranach was a lifelong friend of Luther; the best portraits of Luther are by him, and he made propaganda prints for him. But one of the results of the Reformation was to alter the type of religious painting. Certain subjects remained: the Old Testament ones, part of the Passion such as the Crucifixion, and subjects which combined religious with moral lessons, such as the Woman taken in Adultery, or Christ among the Children; but the old range of the Life of the Virgin, or of the Saints, the *sacra conversazione*, the miracle subject, had gone, and the humanist-cum-classical matter had to fill the gap. Hence the spate of·Venuses, some entirely nude, some merely made naked by the addition of necklaces, wisps of transparent veiling and huge cartwheel hats. They were immensely popular, and highly prized all over the North as *objets de*

266 ALTDORFER *St George* 1510

vertu, evidence of culture and learning. Cranach also made many engravings, and illustrated a Lutheran bible, but technically his engravings are not in Dürer's class. His etchings – a new development in graphic art that Dürer had only touched on in passing – combine the Danube School landscape with something of Dürer's tradition, and are probably the best part of his graphic work. Some of his late portraits approach the early *Cuspinian* pair, and are important in that by this time portraiture had also become one of the outlets for patronage in the North, to replace religious art. There is a good deal of confusion between the works of the elder Cranach and those of his workshop, and his sons: Hans who predeceased him in 1537 (Cranach the Elder died in 1553), and Lucas II who lived until 1586, particularly in the 'court' subjects and the more hack portraits.

Altdorfer was a Bavarian born about 1480, who lived until 1538. He seems to have settled in Regensburg about 1505, and eventually became city architect and a town councillor. Regensburg is on the Danube, and in 1511 – and probably earlier as well – he travelled down the river and then south into the Alps, where the scenery moved him so deeply that he became the first landscape painter in the modern sense. His earliest pictures show poetic imagination and a strong sense of mood, and they also have something of the best of Dürer and early Cranach. In the tiny *St George* of 1510 the landscape has become all important, and the figure of the saint is lost amid the thick forest. Altdorfer's figures are invariably the complement of his romantic landscapes; for them he borrows from Dürer's inventive iconography, but the panoramic setting is personal, and has nothing to do with the fantasy landscapes of the Netherlanders. His greatest work is the Florian altar of 1518, most of which is still in the monastery, near Linz, for which it was painted. The main part consists of a central portion of four panels in two tiers, and two wings of two panels one above the other, painted on both sides. Inside is the Passion, and the wings have scenes from the martyrdoms of St Sebastian and St Florian. Some of the panels have a curiously visionary narrative quality – all the details seem sharpened and the emotional aspect heightened by a tangle of weeds hanging from a wall, by bare boughs against the sky, by a flaring, lurid sunrise, or a sunset of scarlet and gold suffused with dark purplish stormclouds above deep green cliffs and forests. He uses distortion in his forms and exaggeration in gesture and expression to produce dramatic and powerful emotional effects, and the colour serves the same end, so that in the *Battle of Alexander the Great* of 1529 he involves all nature in the conflict in a vast

panorama, pale citron to blood red, with gold and purple and dusky shadows, and cold, gleaming lights on the water and the hills. This is much closer to the northern type of fantasy landscape, while at the same time it recalls Leonardo's cosmic visions of alpine storms and cataclysms. It is a different kind of thing from the passionate observation of nature found in his smaller pictures, where the landscapes can only have been painted for the love of rendering the effect of light on stone and verdure, and the strange shapes of tattered trees. Occasionally, an Italian detail crops up – the architecture in some of his Florian panels is derived from Bramante's famous engraving, some show even more wild fantastication than the Certosa, and this again is probably derived from books, though here and there a figure is so like Mantegna as to suggest that his alpine views were a result of travelling into northern Italy, from whence he returned with ideas that furnished his imagination with vividly new forms.

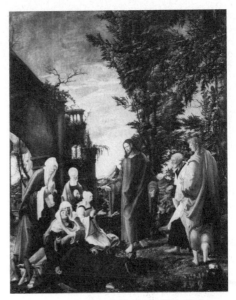

267 ALTDORFER *Christ taking leave of His Mother* *c.* 1517

Wolf Huber was probably his assistant at some time around 1510, sharing his feeling for poetic landscape, particularly in his drawings, which have no subject but the vast panoramas of mountains, forests and sky. The other great centre of patronage was Augsburg, which was the seat of the Imperial court. Hans Burgkmair and Jörg Breu, the elder Holbein, Strigel, and a little later Amberger, Georg Pencz and Seisenegger, principally portrait painters, are the core of the Augsburg painters, and men upon whom Dürer had less influence than the direct impact of Italy, particularly Venice after the Emperor Charles V began to buy pictures by Titian. Burgkmair, Breu and the elder Holbein painted mainly religious pictures, the other men settled mainly for portraits, now bulking almost as large as woodcuts in artists' output. Burgkmair visited Italy several times, and imports into Augsburg

268 ALTDORFER *Recovery of the body of St Florian.* Florian altar 1518

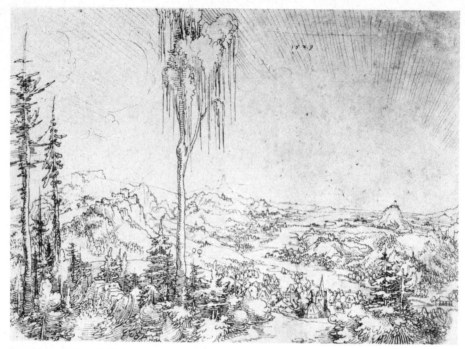

269 HUBER *The Danube Valley* 1529

a strong north Italian flavour, while Holbein the Elder sticks closely to late Gothic traditions, with a haphazard Italianism derived from Burgkmair working through his flaccid forms. It is not for his own works that he is interesting, but because his large shop was the forcing-ground for his extraordinary son.

Hans Holbein the Younger was born in Augsburg in 1497/98, and, with his brother Ambrosius, who died in 1519, was trained in his father's shop. But the shop broke up in 1514, and the father moved to Isenheim; the two sons went to Basle, and worked there partly as painters, partly for publishers, and Hans, in 1515 or 1516 came in contact with Erasmus. He also began painting portraits, the finest of them being the pair of *Jacob Meyer and his Wife*. Meyer

was the Burgomaster of Basle, and he represented the rise of a successful bourgeois merchant to high civic office in a University town. The drawings made for these portraits prove that right from the start Holbein developed his technique of working from drawings. In 1517 he left Basle, went to Lucerne, and may even have gone on to Italy; he was away two years, returned to become a citizen in 1520, and married – not very successfully on the evidence. In 1519 he painted Bonifazius Amerbach, a scholar, collector, friend of Erasmus, who became a great collector of Holbein's work, as was his son – perhaps the first example of one collector buying consistently one artist's work. The great Amerbach collection was bought in 1662 by the City of Basle – the first case of civic

248

patronage of this kind. Possibly the Amerbach portrait could support the argument that he had been to Italy in the interval; it is warmer in tone, fuller in modelling than the Meyer pair. The superb *Dead Christ* of 1521 was perhaps inspired by Grünewald's Isenheim altar, and may originally have been the predella of a now lost altarpiece. It is utterly realist, grim, with no religious atmosphere to relieve its starkness, more the portrait of a dead hero than a dead Christ, and completely unItalian. The Solothurn *Madonna and Child with Saints* of 1522, the *Passion* altar of 1521–25, or the Oberried altarpiece of about 1520–21, of which only part survived the iconoclasm of the Reformation, could all be used to support the thesis of an Italian journey before 1520; but by now the traffic in engravings made it much easier for an artist to assimilate Italian ideas. In 1521 he was commissioned to paint decorations in the City Council Chamber – a commission obtained through Meyer. It consisted of colonnades with figures representing the stock examples of law-givers, prophets, virtues and the like, but long before the decoration was completed changed religious conditions made alterations in the content necessary, and the work was broken off in 1522–23 after Meyer was dismissed from his Burgomastership. Later, on one of his return visits to Basle in 1530, Holbein took it up again in a rather different style, but it was more probably failure in technique than neglect that caused the frescoes to decay, so that they were finally obliterated in 1827. Drawings for the frescoes exist, as they also do for house façades painted in Basle, which also display a very definite northern Italian character. During this period he was working continually for publishers, notably for Froben, who published Erasmus, and Thomas More's 'Utopia'. He made the title page for the 1522 Luther New Testament, and

270 AMBERGER *Christoph Fugger* 1541

271 BURGKMAIR *St John the Evangelist on Patmos* 1518

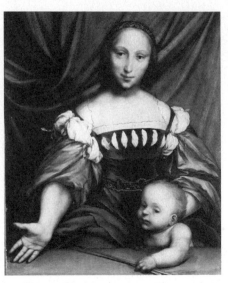

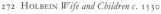

272 HOLBEIN *Wife and Children c.* 1530 273 HOLBEIN *Magdalena Offenburg as Venus* 1526

designed the 'Dance of Death', 1523–26, and the 'Alphabet of Death', of 1524. Both these add the new bitterness of the Peasants' War to the medieval theme, and he varied the iconography of the Dance, by substituting the idea of Death striking unexpectedly at representatives of every human occupation and type. For political reasons the 'Dance of Death' was first published in Lyons in 1538, in Latin and French, and was so popular that it went through ten editions in twelve years.

By 1523 Holbein had established his reputation as a portrait painter with three portraits of Erasmus, who had now settled in Basle, and two of these were sent to England in 1524. The major religious work of this period was again painted for Burgomaster Meyer – the *Madonna and Child* with the Meyer family as donors, which must, for religious reasons, have been finished before 1526, when, in any case, Holbein left Basle. This very fine

work, and the two portraits of *Magdalena Offenburg*, one dated 1526, once more raise the question of an Italian journey, and it seems inescapable that by this time he must, in fact, have gone at least to north Italy, possibly after he was in Lyons in 1524. The portraits of Magdalena are very Raphaelesque in type, but the Meyer *Madonna* and other portraits have a distinct air of Moretto, Lotto or Savoldo, influences which were less likely to have been transmitted by means of engravings.

In 1526 he made his first journey to England, travelling through the Netherlands and visiting Matsys in Antwerp. He had letters of introduction from Erasmus to More and to William Warham, Archbishop of Canterbury; he stayed eighteen months, and then returned to Basle until 1532. He found that the religious troubles had become worse, that pictures were now being torn from churches and burnt, and iconoclastic riots occurred. He

worked again for publishers in Basle and Lyons, did some designs for stained glass (which survived as an art in Basle despite religious troubles, since it was a major local industry), endeavoured to continue the Council Chamber decorations, painted a few portraits, including the terrible one of the wife and children he was so soon to abandon – terrible because of a pitiless realism and a chillingly dispassionate observation almost without feeling. Attempts were made by the council to retain him, a pension was offered, but Holbein, who had done well out of his English visit, was determined to go once civil war had broken out again in 1531. Possibly the *Noli me Tangere*, with its strange lighting and lurid colour, was painted about now, but in 1532 he turned his back for good on Basle and returned to London.

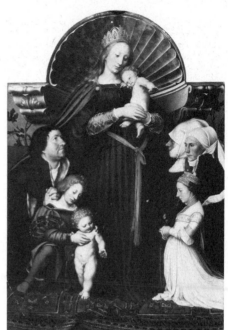

274 HOLBEIN *Madonna and Child c.* 1525

ENGLAND

When Holbein arrived in England in 1526, his letters of introduction from Erasmus secured him a welcome from the household of the most enlightened humanist in the land. It is possible that he did some work for the court, and the portraits of *Sir Henry* and *Lady Guildford* indicate a link with the court, since Sir Henry was Comptroller to the Household. But his real field was with More and his circle.

The group of the More family now exists only in copies, and in the drawing made by Holbein himself which was sent to Erasmus. In 1529 Erasmus wrote to More about the pleasure he felt 'when the painter Holbein gave me the picture of your whole family, which is so completely successful that I should scarcely be able to see you better if I were with you'. This is by far the most elaborate of the humanist scholar-in-his-setting portraits, and as a composition is completely natural and yet very subtle in the way it preserves the family hierarchy. He also painted several versions of *Archbishop Warham*, clearly done from a drawing, continuing the method first worked out in the Meyer portraits. Two other important portraits date from this first visit: *Nicolas Kratzer*, Astronomer to Henry VIII, taking up the Erasmus type of scholar portraits, with a bravura display of still-life detail in the mathematical instruments surrounding him; and the double portrait of *Sir Thomas Godsalve and his son*, for the son was later connected with the Merchants of the Steelyard who became Holbein's chief patrons at the start of his second visit.

251

275 HOLBEIN *Thomas More and his Family*. Drawing 1527

276 HOLBEIN *Sir John Godsalve c.* 1528 277 HOLBEIN *Georg Gisze* 1532

278 HOLBEIN *Ambassadors* 1533

When Holbein returned in 1532, More was on the point of falling from power, and during the next four years the painter found his market among the German merchants. The portrait of *Georg Gisze* of 1532 was the display sample which brought in custom, for it is a fantastic piece of bravura still-life painting, excelling even the Kratzer portrait. Until now, Henry VIII had paid no attention to the artist, but he seems suddenly to have realized after seeing the *Ambassadors*, that Holbein was a painter who could put him on a par with Francis I. Royal patronage was continuous from 1536, beginning with the great dynastic family portrait of Henry VII and Elizabeth of York, and Henry VIII with Jane Seymour, lost in the fire at Whitehall in 1698. Part of the cartoon survives, and a poor copy gives an idea of what the original aimed at. The cartoon of *Henry VIII* served as the basis for the numerous portraits of the King, painted to be sent abroad, mostly accompanying marriage embassies, and the main idea behind Henry's patronage was not the

253

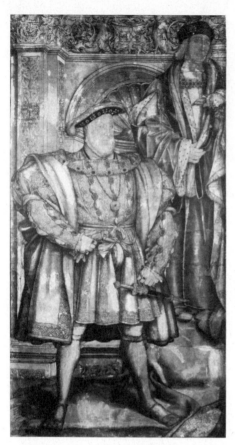

the portrait and convert it into an effigy, yet he never loses sight of the character of his sitter. In his portrait of *Jane Seymour* he is merciless towards her narrow, pinched, hypocritical face, her mean, sharp eyes, her pursed mouth and hard thrusting chin; Cromwell's cruel, pig-like features are done full justice; and even his royal master's unamiable character is not in any way glossed over by favourable posing or attempts at idealization.

His designs for Henry VIII's palace at Nonesuch suffer from his passion for detail, since it – as much as his patron's uneducated taste – led him into Certosa-like excesses of ornament. But these must have represented opportunities for the kind of large-scale work in which he had been thwarted in Basle, and which, equally, he had little scope for in England. He portrayed Henry as Solomon in one decoration at Whitehall, and a group of the *Presentation of the Charter to the Barber-Surgeons* shows Henry so much larger than the other figures that it is clear that he is using the medieval iconography of religious painting for modern secular purposes. What this dispassionate realist, who portrayed his half-blind and sick wife with such unemotional exactness, made of a commission which required him to represent the gross and bloated King, whom he had already had to portray as Solomon, virtually in the guise of God surrounded by humble votaries gathered about him as lesser beings than he; what he made of a milieu in which this distortion of human and spiritual values could occur, is perhaps best understood from the hard, set, disillusioned gaze with which he portrayed himself. Even in his death he was cheated, for he died of plague in 1543, at the age of only forty-six. The tragedy of Holbein is that, as one of the great artists of his age, he found himself constrained by the accidents of politics to work for patrons who had no use for any other form

encouragement of the arts for themselves, but as objects of court policy embodying and bolstering his dynastic claims. Holbein's technique of painting from drawings was strengthened by his practice as a court artist, but slowly his style became more linear, partly because of the demand for precise detail and partly because painting only from drawings leads to a decline in the atmospheric quality of colour and the sensitiveness of handling. The inclusion of legends and armorial bearings tends also to reduce the reality of

of art than portraiture; while this made of him one of the great portrait painters of all time, it was, nevertheless, a crippling limitation of his genius.

If Holbein had a studio, then remarkably little trace of it remained after his death. The John Bettes who signed a *Portrait of an Unknown Man* (Tate Gallery) in 1545, may have been an assistant of his, but neither Guillim Scrots nor Gerlach Flicke could have been. Scrots (who used to be known as Stretes) came here from the Netherlands in 1545, and Flicke from Germany in 1547. Scrots is the finer artist, painting in a distinctly Italianate style with a good deal of Moretto in it; he is responsible for the series of distinguished portraits – possibly commemorative – of the *Earl of Surrey*, who was executed in the winter of 1546–47. They are all full-length portraits, and this form, invented in Germany, seems to have taken root in England more rapidly than it did elsewhere. Holbein's *Ambassadors* of 1533 is usually referred to as the first instance in England, but there is a life-sized, full-length, seated portrait of *Richard II*, which should be earlier than 1399, and even if it were a commemorative effigy would not be much later than the first decade of the fifteenth century. There is also the Holbein group of the More family, painted in 1527, which contained at least five standing figures besides the seated ones. Since the Nostell Priory copy is 8 by 13 feet, it seems reasonable to suggest that Holbein's original group must have been life-sized as well, and may in fact have been a cartoon, like the later dynastic group of Henry VII and VIII, and intended to become a wall decoration. This would explain why it is mentioned as a 'water-colour', and would also explain features like the perspective, the furniture, the hangings, the clock on the wall, and the view through the open door. It would in fact be an extension into portraiture of the Council Room

280 HOLBEIN *Self-portrait*. Miniature 1543

281 SCROTS *Earl of Surrey* 1546 or later

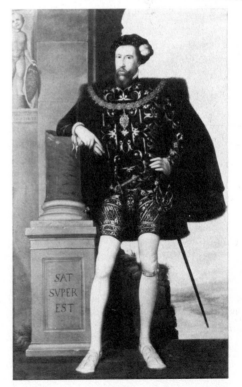

255

282 MOR *Queen Mary* 1554

283 EWORTH *Lady Dacre* 1540

decorations, or the house-façade paintings in Basle.

During Mary's reign, the most considerable foreign artist to appear, somewhat fleetingly, on the English scene was Anthonis Mor, a Netherlandish court portrait painter much employed by Philip of Spain and the Hapsburg courts in Flanders. Mor, or Moro, to give his name its common Italianate form, was in England in 1554 to paint a marriage portrait of Mary for Philip II, and his cold, Bronzino-like type of professional face painting continued the realist and detached tradition of Holbein, merely adding a little more amplitude to the setting, as befitted the mid-century and an artist who knew at first hand what portraits were like in Rome, Florence and Venice.

The most interesting painter working continuously in England after Holbein was Hans Eworth, the Master of the HE monogram. He was an Antwerp man, who came here after 1540 and died about 1574. His portraits, all on panel, have the objectivity of Holbein, but with slightly more humanity; he also painted allegorical subjects – if the identification of the slightly differently shaped HE monogram on them is right. He is an artist with a strong sense of pattern and immense ability in detail, but except for the rather clumsy adulatory allegories on the glory of Elizabeth, which would reflect the world of his employment as a court masque designer, there is no repercussion in England of trends in Fontainebleau or in Italy. Elizabeth's favourite painter, with a monopoly in her portraits secured by a patent, was Nicholas Hilliard. He is the first native artist of whom anything like a life history or a proper corpus of works can be established; he was a goldsmith, born in 1547, who painted miniatures as part of his jeweller's art, and was doing so from about 1560, his first portrait of Elizabeth being dated 1570. His 'Portraits in littel'

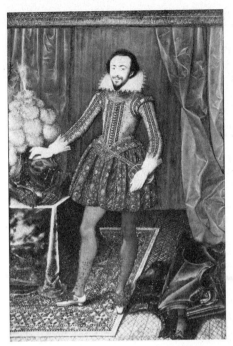

284 HILLIARD *Young Man amid Roses c.* 1590

285 OLIVER *Richard Sackville, Earl of Dorset* 1616

are as jewel-like as their settings, and their style is explained in his treatise 'The Arte of Limning' written in 1600, which echoed his conversations with the Queen in their agreement that portraits were '. . . best in plain lines and without shadowing'. His transparent flesh tints, and the perfection of his treatment of forms in terms of pure light, have almost nothing in common with Holbein, Eworth or Mor. Hilliard achieved something that they never attempted: a degree of idealization, of seeing the best in a sitter, totally alien to their dispassionate, and sometimes unfriendly pursuit of an exact likeness. A contemporary appreciation of his art is to be found in one of Donne's poems of, probably, 1597: '. . . a hand, or eye By Hilliard drawne, is worth an history By a worse painter made', and Haydocke, in his 'Tracte Containinge The Artes of curious Paintinge', published in 1598, compared him to '. . . the milde spirit of the late worldes-wonder Raphael Urbine'. By 1600 he was in financial difficulties, perhaps because his chief pupil Isaac Oliver was able to rival him technically, while having a much more up-to-date style, with overtones of French and Italian painting. Oliver was French by origin, since he had come to England in 1568 as the child of Huguenot refugee parents. He visited Venice in 1596, and had ambitions towards grander forms than portrait miniatures; he wanted to extend painting 'in littel' to history painting, and is recorded as making fine copies in drawing after Parmigianino. He never feared shadows in his faces, and developed the backgrounds of his miniatures in great depth, with rich

257

details of Turkey carpets, embroidered hangings, and feathered helmets. He often painted full-length figures, which are less common in Hilliard's works, where the flamboyant figure of the *Earl of Cumberland* of about 1590, or the exquisite Mannerist elegance of the *Young Man amid Roses*, also about 1590, is the more outstanding for being unusual. Oliver's miniatures are often very rich in colour and very high in key: the *Earl of Dorset*, for instance, wears embroidered blue stockings and short-hose, and stands in front of rich blue curtains, and red velvet table cloth. After Elizabeth's death in 1603, Hilliard was confirmed by James I in all his official patents, but Oliver had the greater popularity at court, where Hilliard's poetry and imagery was somewhat old-fashioned. Oliver died first, in 1617, and Hilliard, eighteen months later in 1619.

The great art form of the sixteenth century in England was not painting – sculpture existed only as funerary monuments, the greatest of which were the Tudor tombs in Henry VII's Chapel by the Italian Torrigiano – but architecture, for this was an art which combined pride of possession and display in land, with the deep need of a new aristocracy and landed class, which had acquired wealth and property as a result of Henry VIII's distribution of confiscated monastic lands, to put down roots in their new possessions. Hence the evolution from the convenient but asymmetrical and untidy forms of the medieval manor to the grand, many-storeyed, many-windowed mansion, designed on a central axis and frequently based on plans derived from Serlio and Palladio, and built of stone. Sometimes the inspiration was French, as it was with the first Somerset House, in the Strand, built about 1549 and later demolished, but generally it was the kind of classical Italy that inspired John Shute, the writer of the first book on architecture

in English, and the first Englishman to describe himself as an 'architect' on the title page of his 'The First and Chief Groundes of Architecture', of 1563. Shute had been sent by his patron, the Duke of Northumberland, to Italy about 1550, but his early death in 1563 left little but the influence of his well-illustrated volume. This is a passably good imitation of an Italian textbook, and shows not only that he knew how to improve on Serlio, but that he also knew such classics as Fra Giocondo's illustrated edition of Vitruvius of 1511, Alberti's treatise in its earliest illustrated form, published in Florence in 1550, and Barbaro's edition of Vitruvius, published in 1556 with Palladio's illustrations. Vignola's 'Regola delli Cinque Ordini . . .' of 1562, and Palladio's 'Quattro Libri dell'Architettura' of 1570, came too late to affect Shute. There were also Flemish and German architectural books, such as those by Hans Blum of 1550, Vredeman de Vries from 1562 onwards, Wendel Dietterlin from 1593, but these had little practical influence except occasionally as models for decorative details. Another stimulus to the rising interest in architecture, theoretical as well as practical, can be found in the engraved title pages of books printed on Italian presses, since these often contributed indirectly to the ever-widening dissemination of classical architectural forms.

Many great houses of the Elizabethan age display a curious mixture of Italianate detail with the surviving habits of Perpendicular Gothic, in the combination of classical orders with the huge areas of glass in a framework of rectilinear mullions and transoms. Kirby in Northamptonshire, begun in 1570 and now a ruin, is the first instance in England of a giant order. The house is built around a central courtyard; the entrance wing has an arcaded loggia facing on to the court and the piers of this

loggia are faced with a giant order of pilasters, the four outer ones fluted and the central pair carved with a rich candelabra ornament running up to their very fanciful capitals. On the other side of the court, the main living quarters consist, on one side, of the great hall rising through the entire height of the building, and on the other of living rooms in two storeys. The entrance, in the centre, also serves as the screens passage of the hall. Kirby was probably built by Thomas Thorpe, the father of the John Thorpe who laid the first stone of Kirby when he was a child of six, and who became, at the beginning of the next century, an important architect and surveyor.

Queen Elizabeth's minister William Cecil, who began Burghley, near Stamford, in the 1550s, not only finished the house on a huge scale between 1572 and 1587; he also built an even more grandiose mansion for one of his sons at Theobalds in Hertfordshire. Theobalds had five courtyards, with great turreted corner blocks linked by lower wings borne on arcaded loggias, but its splendour vanished for ever in 1650, and its influence can only be sensed in its contemporaries and in successors such as nearby Hatfield, also built by the Cecils. Burghley begins traditionally enough with an old-fashioned centrepiece in the middle of the entrance front – a tower gateway with projecting windows compressed between tall turrets. In the great arcaded courtyard, however, the main feature is a second huge tower, built up from arches flanked by niches with columns on either side, rising in a sequence of orders to the enormous square clock face supported by heraldic lions and crowned by a tall pyramidal steeple. Cecil imported architectural books to help him with his vast building projects: he had Philibert de l'Orme's 'Nouvelles Inventions Pour Bien Bastir . . .', first published in 1561, sent from Paris, and he

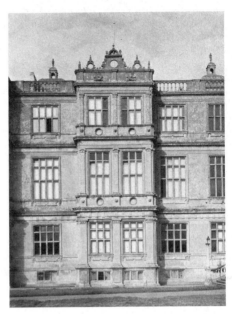

286 SMYTHSON Longleat 1572–80

probably also knew Philibert's other works, the 'Premier Tome de l'Architecture' of 1567, and the invaluable books by du Cerceau – the 'Architectura' of 1559, and the first and second volumes of his 'plus excellents Bastiments de France', which first appeared in 1574. The character of the clock tower at Burghley suggests an attempt to consider a building not merely as an assemblage of decorative features applied erratically to the outside of a traditional structure, but as blocks of masonry arranged so as to create a structure coherent and valid in itself, much as Philibert had done in the gateway, chapel, and frontispiece of Anet, or Bullant had done at Écouen in the 1550s, where one of the main entrances, known from an engraving by du Cerceau, closely recalls the Burghley clock tower.

Serlio's books on architecture had a considerable effect on the best of the late sixteenth-century architects, Robert

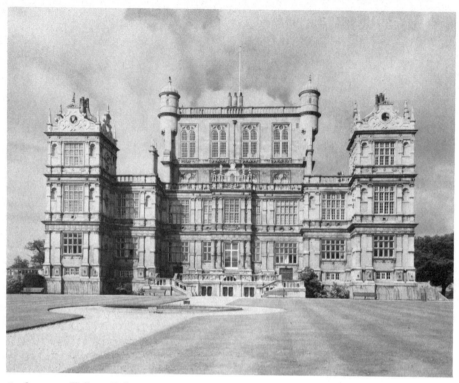

287 SMYTHSON Wollaton Hall 1580–88

Smythson, who was described as an architect on his tomb in 1614. Smythson was born about 1536, and first appears as one of the men working on Longleat, building for the third time under the exigent eye of its owner, Sir John Thynne, after the fire that gutted it in 1567. Smythson did not design the house, which in the main was rebuilt on the foundations and lower courses of the previous structure, but from 1572 onwards he was largely responsible for recladding it with its present façades – a rhythmical arrangement of salient and retreating bays, three storeys high, articulated in a rising sequence of Doric, Ionic and Corinthian orders. Longleat is now not much more

than a shell since its symmetrical exterior masks the early nineteenth-century alterations to its original four courtyards, two of which were combined into one, and the thorough Victorian remodelling of the interior. But from the outside the pattern of light and dark made by the huge windows in the golden stone is as rhythmic as the alternation of bays and the skilful use of the orders to divide the storeys. The house is crowned by a balustrade, now bearing later statuary, and by elaborate carved gables over the bay windows. Small domed turrets, many of them belonging to the earlier stages of the house, pierce the flat roofline, and, together with the numerous decorative chimneys, give an

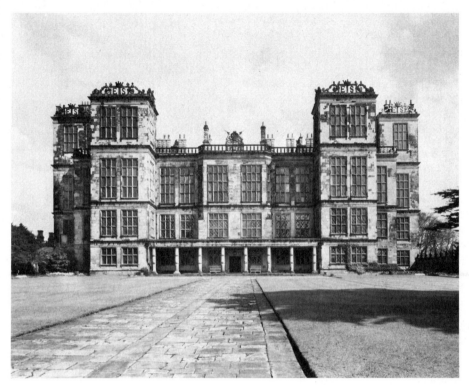

288 SMYTHSON Hardwick Hall 1590–97

impression similar to that made, on a far more lavish scale, by Chambord, from which the device of the little turret rooms designed to serve as a kind of summertime arbour, was probably derived.

After Longleat, virtually finished by 1580, the year Thynne died, Smythson began Wollaton, a house at once more spectacular and less coherent than Longleat. The main body of Wollaton is symmetrical about a central axis, just as Longleat is on the outside, but at Wollaton there is no interior courtyard and a great hall towers above the surrounding structure, imparting a deliberately medieval air to the house. It looks at first sight as if an older hall had been encased in a later

rebuilding, since the windows of the hall are two-light, round-headed openings in contrast to the huge rectilinear windows of the outer parts of the house, and the corners of the hall are trimmed with projecting watch-towers, decorative and totally belying their apparent function. There is more decoration, too, in the little niches and the strap-work pediments over the massive towers that form the corner blocks. In fact, Smythson derived the plan from Serlio, and he found in de Vries patterns for the rich detailing of the cartouches, the strap-work of the pediments, and the carving on the hall screen.

Between 1590 and 1597 Smythson built Hardwick Hall for the celebrated Bess of

261

Hardwick, the widow of the Earl of Shrewsbury for whom he had built the now destroyed Worksop Manor. In plan, Hardwick is almost as symmetrical inside, about its central great hall, as it is on the outside, and the great hall, rising through the two lower storeys provides for communication between the two halves of the house and also serves as a centrally placed main entrance leading from the colonnaded loggia. 'Hardwick Hall, more glass than wall' the saying goes, and the gigantic rectilinear windows, in their advancing and retreating bays and towers, create a marvellous effect of movement, and of the mass of the house being yet more void than solid. It is one of the characteristics of these huge areas of window that they permitted considerable variation in the height of the rooms behind them, so that the floor levels of what appear to be clearly defined storeys are by no means all on the same plane. This means that sometimes windows came in awkward places – low down or very high up – inside the rooms, though preserving the regular pattern on the outside, and it involved a maze of small staircases within the structure. This, again, was a feature largely eliminated in the seventeenth century, when smaller windows and, on the whole, more compact houses tended to greater evenness of room height. Hardwick is typical of this kind of infinitely varied room design, for the great hall runs through two floors, and the long gallery also runs through two floors, but not the same two, and in the tower blocks the room heights vary as between one block and another.

All these great Elizabethan houses mark the change, social as much as architectural, in the nature of the great hall, for instead of being the central feature of a house, as it had been in the fifteenth century, its role now was purely a show one. It was still included for use on grand occasions, as at Hatfield (1607–12), but the family now inhabited private apartments instead of presiding over the communal life which made sense of the old type of great hall. It is one of the instances of an architectural form long outliving the purpose for which it was originally designed, for it persisted until in the seventeenth century it finally became no more than an entrance vestibule, as at Charlton, Blackheath (1607), and the neighbouring Queen's House, Greenwich (begun in 1616). It was inevitable that the staircase well should also merge with it, so that it becomes a central area of communication: a connecting unit rather than a focal point.

The Queen's House, which developed this new concept of the central hall, also marked the end of the last splendid phase of the 'prodigy' house, and with Inigo Jones English architecture joined the main current of Renaissance inspiration. It is curious to think that the years which saw the final burst of the Perpendicular in the completion of Henry VII's chapel at Westminster Abbey, finished about 1520, are the years in which Michelangelo was designing the architecture of the Medici Chapel – already the second stage of Renaissance architecture in Italy; that Longleat and the Gesù are contemporary; and that when Hardwick Hall was begun Palladio had already been dead for some ten years. When Inigo Jones completed the Banqueting House in Whitehall in 1622, a totally new era had already opened in the arts of Western Europe.

The Renaissance in Spain

Three factors govern the development of the arts in Spain during the sixteenth century: the centralization of power in the monarchy under Ferdinand and Isabella, confirmed under Charles V, which diminished the nobility and reduced the bourgeoisie to an insignificant status; the continual wars against the Moors and then the Turks, and the involvement of Spain in Italian, German and Netherlandish affairs through the vast inheritance of Charles V and his succession to the Empire in 1519; the identification of the crown with the Church. Virtually the only patronage was religious patronage; decoration, as it was understood in the North and in Italy found almost no scope, except in a religious context.

Renaissance architecture came into Spain in much the same way that it came into France: by the influence of foreign conquest. In the Spanish case, it was largely because Spain had in Naples a permanent foothold in the Peninsula. The influence of Italian forms becomes particularly strong in the second half of the sixteenth century, by which time the current was also working in the reverse direction, and Spaniards were travelling to Italy as much as Italians to Spain.

Basically, the 'Plateresque' style, so called because of its resemblance to silverware decoration, consisted of decorative forms added to buildings, particularly to tombs, so that it came to have in Spain much the same effect as Lombard ornament did in France. The belief that a 'modern' effect could be created by clapping Italianate detail on to traditional forms was as persistent in Spain as it was in France and England. True Italian influence is perceptible as early as the first decade of the sixteenth century, and is modified in the second decade in a more classical direction. Later, during the 1560s, Herrera's work led to much more austere forms which lasted until the end of the century.

The first building to show Italian influence was the Medinaceli Palace at Cogolludo, built by Lorenzo Vázquez for the Duke between 1492 and 1495. The symmetrical regularity of the façade is what counts, more than the decorative type of the rustication and the heavy cornice designed to achieve striking contrasts of light and shadow. The influence is from Filarete's designs for the Medici Bank in Milan, and so is Lombard rather than Tuscan or Roman.

The next important building to present parallels with Italian forms is the famous Hostal at Santiago de Compostela, built under Ferdinand and Isabella to house the pilgrims to the national shrine. This was designed by Enrique Egas, and built from 1501 onwards, largely following the type of plan with multiple courtyards on a grid

289 DIEGO DE SILOE Golden Staircase, Burgos Cathedral 1519–26

system evolved by Filarete for the great hospital in Milan. Another pious foundation, that of the hospital of Santa Cruz in Toledo, also attributed to Egas, was contemporary with the hostel in Santiago, and Egas built there what is almost certainly the first open-well staircase in Europe. Egas's son-in-law, Alonso de Covarrubias, designed the huge Alcázar at Toledo in 1537, but the structure is less Italianate than the surface decoration, which consists of heavily pedimented windows and a picturesquely rusticated top storey which bears little relation to the rest of the design, though it conforms to traditional Spanish building practice. The court of the Alcázar (unfortunately destroyed during the Spanish Civil War) was of quite another type: here the influence from the courtyard of the Cancelleria in Rome was obvious, and it is known to have been completed by Francisco de

Villalpando, who translated Serlio and introduced a far more perceptive use of Italian forms. Diego de Siloe shows a much closer appreciation of what Bramante had achieved. In the famous Golden Staircase at Burgos Cathedral (1519–26) he was actually using designs worked out by Bramante for the courtyard of the Belvedere, which suggests a first-hand knowledge of Rome. His designs for Granada Cathedral were at first rejected by Charles V, who found them too severely classical as a setting for the Gothic chapel housing the tombs of Ferdinand and Isabella, but the King was finally persuaded to accept them. The main feature of this design is the great internal domed rotunda within the choir – a church within a church, designed for the perpetual adoration of the Blessed Sacrament – reminiscent of Bramante's projects for St Peter's, and even more of the great central space of Pavia Cathedral with which Bramante was connected.

Another man much influenced by Bramante's architecture was the painter Pedro Machuca who had worked in Italy and returned to Spain in 1520. In 1527–28 he began the palace for Charles V in the Alhambra in Granada, the most striking feature of which is a large central circular courtyard one hundred feet in diameter, finished by Luis Machuca after his father's death in 1550, but apparently according to his design. This circular courtyard is based possibly on Raphael's designs for the courtyard projected for the Villa Madama, and has inside it a double colonnade, Doric below and Ionic above, with straight entablatures on both storeys. The façade of this unusual building is also extraordinary for its date, said to be about 1527, for it combines features from Bramante's and Raphael's Roman palaces with elements which do not appear in Italy before Vignola and Sansovino.

In 1555 the Emperor Charles V abdicated, to be succeeded as King of Spain by

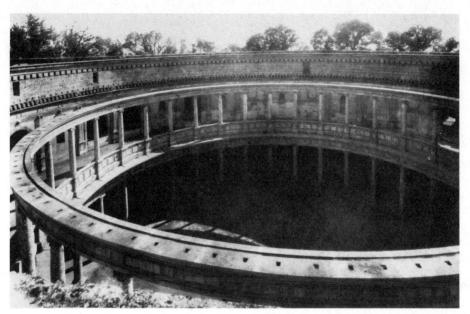

290 Pedro Machuca Courtyard of the Palace of Charles V, Granada, designed 1527–28

Philip II. His character, cold, unbending, rigorously devout, inclined him much more to Vignola's calm classicism and spare use of ornament than to the vagaries of Mannerist decoration, so that his instructions to Herrera for the style in which he was to build the Escorial are a rigid brief which his architect followed, as much by natural inclination as by command: '. . . simplicity of form, severity in the whole, nobility without arrogance, majesty without ostentation.' Herrera was not, however, the first architect to work on the design of the palace-monastery, which was also to contain a large church and a mausoleum. In 1559, the mathematician and philosopher Juan Bautista de Toledo was summoned to return from Naples to prepare a design which was based on Filarete's hospital in Milan – that is, a sequence of courtyards forming a large, subdivided rectangle, of a type which had,

for instance at Santiago de Compostela, already proved popular in Spain. Toledo died in 1567, four years after construction began, and an Italian, G.B. Castello of Bergamo, continued the work, though the design for the church when submitted at the King's command to the Accademia di Disegno in Florence met with much criticism.

Herrera finally succeeded to the post of chief architect in 1572, completed the work by 1584, and died in 1597. The Escorial is built of grey granite in a style of grim simplicity. The grid of courtyards divides it up internally within its cliff-like outer walls, pierced only by small windows in serried ranks five storeys high. The only notable feature of the palace section is the fine Imperial staircase in one of the side blocks – a stair with one flight rising in the centre to a landing from which a double flight rises on either side of

265

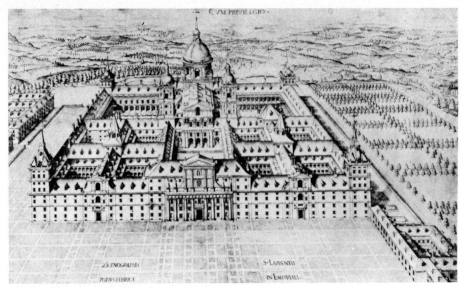

291 JUAN DE TOLEDO and JUAN DE HERRERA Escorial, built 1563–84. Engraving

the central one. This was built by Castello. The largest unit is the central church, with no more pomp than plain archways between Doric engaged columns, a plainly pedimented upper storey, and, as the only decoration, the six statues of the Kings of Judah on their plinths above the columns. The church is grandiose, with the unusual feature of a vaulted vestibule at the entrance over which is the choir, thus enabling the nave to be a square centrally planned space bounded by the piers that support the dome – piers copied from those of St Peter's. The interior is cold granite like the exterior, with the chapel of the high altar forming a rich contrast of coloured marble and gilded retable, over ninety feet high, flanked by the black marble funerary chapels of the Royal tombs, with their kneeling gilt-bronze statues of the dead. Most of the painting and sculpture in the Escorial was executed by artists whom Philip imported from Italy– Mannerist painters like Pellegrino Tibaldi,

Zuccaro, Luca Cambiaso, sculptors like the Leonis father and son – with the finest piece of Italian sculpture, the marble Christ by Cellini, hidden away behind the upper choir because it displeased Philip.

Spanish Renaissance sculpture was at first entirely dominated by imported Italian artists. Andrea Sansovino, Fancelli, the Gagini family from Genoa who had worked in Spanish Sicily, the Genoese Aprili, even Torrigiano after he had made the tombs in Henry VII's chapel in Westminster Abbey, came in the expectation of harvesting from the Italianate style newly planted in Spain. The first native sculptors of significance in the new style were Bartolomé Ordoñez and Diego de Siloe, who later became an architect. Both studied in Florence and worked in Naples before returning to Spain where their style was still strongly affected by Donatello and his followers and by the Florentine works of Michelangelo. Alonso Berruguete, son of the Pedro Berruguete

who possibly worked with Piero della Francesca in Urbino, was the finest Spanish sculptor of the sixteenth century. His style is expressive, and his technique outstanding, particularly in his wooden choir-stall carvings such as those at Toledo, where he achieves a notable dramatic quality, full of movement. His figures break out of their frames, and are filled with an emotional agitation which verges on the Baroque. Other foreigners, such as the Frenchmen Felipe Vigarny (Biguerny) who worked with Berruguete, and Juan de Juni (Joigny in Champagne) introduced a more Mannerist quality. Juni created in the 1540s at Valladolid a group of the *Lamentation over the dead Christ* in the tradition of the great Easter Sepulchres of northern Europe, of a passionate emotionalism. But the most characteristic works in sculpture in Spanish churches continued to be the enormous gilded and minutely carved retables built up in several storeys and crowded with carved and painted panels, such as the high altar made by Vigarny for the Capilla Real at Granada in 1521, or the even more fantasticated examples by Damián Forment, such as those at Saragossa (1509–12) and Huesca (1530–34), where an unequal battle is joined between overloaded naturalistic narrative panels and their pinnacled Gothic framework. Even where the Renaissance forms take over completely, as in those by Pedro Gamiz at Briviesca (1551–69) or Gaspar Becerra at Astorga (1558–60), the individual and often fine panels or figures are swamped by their over-elaborated setting. It is against this decorative *horror vacui* that Pompeo Leoni's tomb figures in the Escorial must be seen, in that the frigid and sober naturalism of his kneeling monarchs are subjected to the competition of elaborate decorations of heraldry, embroidery, cut velvets, tassels, jewels, armour, all executed in gilded bronze.

292 BERRUGUETE Choir-stall carving, Toledo Cathedral 1539–43

293 LEONI Tomb of Charles V, Escorial 1598

In painting, where Renaissance motives crept in, it was in a watered-down yet exaggerated form, provincial and mixed with Flemish influences, as in the work of Juan de Juanes. Anthonis Mor – or Antonio Moro – was the most prolific portraitist of the mid-century, with a practice which took him into all the Hapsburg courts of Europe, and sent him travelling from Rome to London. His successor was Sánchez Coello, a painter who trained in Portugal, where he executed some religious works, before he became Court Painter to Philip II in 1557. His style is the rigid, formal one evolved by Mor for the representation of state personages as icons to be distributed among all the Hapsburg connections of Europe, but it is more summary, with less sensitive modelling even though he does occasionally betray the influence of Titian.

Two men express the Spanish ideal fully: Luis Morales and El Greco. Morales is documented from 1547 in Badajoz, where he spent most of his life, dying there in 1586. He received some training from a Dutchman, but his style was based principally on Flemish Italianate painters who derived largely from Leonardo and his Milanese followers, and who transmitted to him a predilection for soft forms melting into dark shadows, and on Italian Mannerists such as Rosso, as well as Michelangelo and Sebastiano del Piombo, whom he could have known from engravings. Works by Sebastiano were in Spain: a *Deposition* at Ubeda in Andalusia, depends upon a Michelangelo drawing, and a *Christ carrying the Cross*, reminiscent of the Giorgione one, was painted about 1537 for a Conde de Cifuentes who lived in Toledo. It was in Spain until looted by Marshal Soult during the Napoleonic campaigns. There were also two works in the Spanish Royal collection: a *Christ carrying the Cross*, of about 1525–27, and a *Christ in Limbo*, of about 1528–30; if Morales had ever seen a

Sebastiano at all, and the iconography of some of his works suggests that he did, then the two in the Royal collection could have been seen about 1564, since he is believed to have worked for Philip II in Madrid then. All his pictures are of religious subjects, and he specialized in rather highly wrought *Depositions* and *Pietàs*, and also in very tender *Madonna and Child* groups; in fact, his tormented imagery and vision gained for him the nickname of 'El Divino'. It can be argued that since neither he nor El Greco ever had anything more than local popularity, and that neither was much patronized by Philip II, the 'Spanishness' of their vision is more convincing to foreigners than an actual fact. Spanish taste tended much more to the harsh realism of Navarrete ('El Mudo' – 'The Dumb'), whose *Martyrdom of St Lawrence* of 1579 in the Escorial is a forerunner of the sombre Caravaggism of the next century, and a fitting prelude to Ribera and Velazquez. Yet the intense religious emotion of Morales and El Greco fits in with the religious and literary climate of St Ignatius Loyola, St Theresa of Avila, and St John of the Cross.

El Greco was born in Crete in 1541, and possibly received some training in the late – but still surviving – Byzantine tradition of icon painting before he arrived in Venice in his early twenties. There are very few references to his Italian years, but a mention of him in a letter from the miniaturist Giulio Clovio to Cardinal Farnese in 1570 speaks of him as a young Cretan, a pupil of Titian, who had arrived in Rome. There is also a curious account of him in Mancini's 'Considerazioni sulla Pittura', which the writer continued adding to until his death in 1630: he says that El Greco was working in Rome in the time of Pius V (1566–72), that he had been with Titian, and was a successful painter who came to Rome when the city lacked artists of spontaneity and decisiveness of

style. He had so great a conceit of himself that when Pius proposed to cover the nudes in Michelangelo's *Last Judgement*, El Greco offered, if it were demolished, to paint another as good, and chaste and decorous in addition. This caused such great resentment that he was forced to retire to Spain, but since he arrived uninvited, he had to compete with Pellegrino Tibaldi, Federico Zuccaro, and several Flemings who had precedence at court through their work and their intrigues. 'So he left the court and retired to . . . where he died very old and forgotten.' Now Mancini is an unreliable authority, but there are sufficient things right in this note to make the rest credible. El Greco is recorded as being anti-Michelangelo, since he shocked Pacheco, Velazquez's teacher, by saying that Michelangelo 'was a good man, but could not paint'; he was a pupil of Titian; he did make one bid for court patronage in Madrid, and failed; he arrived in Rome in 1570, and Pius lived until 1572.

This connection between El Greco and Titian is sometimes discounted in favour of one with Tintoretto instead. Not only is his work deeply influenced by Titian, in style, in technique, with figures borrowed from him; but there is no such close connection between El Greco and Tintoretto. If one equates the early style of Tintoretto with the arrival of Mannerism in Venice, one must also remember that elongated figures, startling contrasts of colour and the use of acid and sharp colours, the placing of the main incident deep into the picture space, were all features of Central Italian Mannerism long before they appear in Tintoretto, and were known by the usual currents. The extravagant emotionalism, the wonderful use of violent contrasts of colour, and the force of the linear patterns associated with Tintoretto were developed far more after El Greco had gone to Spain than before.

294 MORALES *Pietà*

They derive, in many ways, from common sources: both used Byzantine ideas – El Greco because his earliest training penetrated his adopted style and his work came to be a synthesis of both; Tintoretto because as he grew older the force and eloquence of Byzantine models in Venice accorded with the direction his style was taking. But both also used Central Italian Mannerism as a well from which they drew what they needed for their own personal expression. Their independence of each other is vouched for by the fact that El Greco also used ideas derived from Bassano and Veronese. Even Titian himself in the late 1560s was moving towards the greater expressiveness which is the reflection of Mannerism in his work.

The early *Christ and the Money Changers* of about 1572–74 is only partly full of the things El Greco had seen in Venice during the last years; it must have been painted in Rome, for the architecture is that of a

269

295 EL GRECO *Christ and the Money Changers c.* 1572–74

basilica of an entirely Roman type, while the architectural background of some of his earlier pictures is derived from the plates of theatrical settings in Serlio. It has also four portraits in the foreground: Titian, his master, and Michelangelo, Giulio Clovio, his friend and protector in Rome, and Raphael. The composition is very odd, but the powerful oblique of the architecture is similar to that in both pictures of the *Healing of the Blind Man* (Dresden and Parma), and to the Washington version of the *Money Changers*, which is rather earlier. The curious shapes of the floor and its changes in level, the tightly packed mass of figures driven to one side, the opulent semi-nude women, the vigorous torsos of the young men, and, above

all, the colour, all point to experiments and borrowings, but also to a new vision. The odd device of the four mentors is patently derived from Salviati's *Visitation* of 1538 in S. Giovanni Decollato in Rome, and similar effects in the architectural setting and attendant figures occur there too. His early portraits – for instance, the one of Clovio in Naples, or of Giovanni Battista Porto in Copenhagen – depend not so much on Titian as on Bassano, who is probably also the inspiration for his wonderful candlelight pictures such as *Boy blowing on a Brand* (Naples, and elsewhere). One very grand portrait of Vincentio Anastagi, later a Governor of Malta, painted about 1575–76, suggests memories of Titian's state portraits, or of Veronese's

Paolo Guarienti in Verona. This was the tradition which Caravaggio later used for *Alof de Vignacourt*, and which was valid for Rubens and Van Dyck. By this time he had developed a vigorous and forceful style, which fits in with Mancini's opinion that no Roman artist had the spontaneity and firmness of his style. That he visited the North again at the end of his stay in Rome is suggested by his copy of Correggio's *Nativity*, '*La Notte*' in Parma, and also because immediately after his arrival in Spain his colour has a much more vibrant, singing quality than during the years in Rome, when he was gradually subdued, possibly by the influence of Michelangelo.

The commission for the high altar and a pair of side altars for S. Domingo el Antiguo in Toledo was given in 1577, and from a comment made by El Greco during the lawsuit over the payment for the *Espolio*, he apparently came to Toledo to paint them; the inference is that he went first to Madrid where he sought patronage unsuccessfully. All but two of the pictures on the high altar were later sold off and dispersed; the other altars remain in the church. The high altar consisted of an *Assumption* (Chicago), a *Trinity* (Prado), and four saints, of which two remain. The side altars contain a *Nativity* and a *Resurrection*. The derivation of the *Trinity* from Dürer's print of 1511 is perfectly obvious, yet the design has a coherence which does not immediately drive one into looking for prototypes. Above all, the scale is astonishing; so far as is known, El Greco had never before painted anything larger than about five feet wide, but this is nearly ten feet high, and nowhere is there any difficulty with the scale. The same applies even more to the *Assumption*, which is over sixteen feet high. Like all other *Assumptions* of the late sixteenth and seventeenth centuries, it is borrowed from Titian, though the changes are in the direction of a more Mannerist approach.

296 EL GRECO *El Espolio* 1577–79

The composition is more open than Titian's, and the emotion, though quieter, is more in keeping with Counter-Reformation ideas of contemplation of a mystery rather than excited witnessing of a miracle. In the *Resurrection* altar the reminiscences are strongly of the circular movement of the Cappella Paolina, with figures drawn from Pontormo and Parmigianino, and the *Nativity* is a variation on Correggio's theme. Immediately after the S. Domingo altars, the *Espolio* was commissioned for the cathedral sacristy. Many versions were later made and the studio produced numerous copies. The picture was nearly refused by the authorities, and El Greco

271

sued them for his fee. The objections appear at first sight to be usual ones of the visually uneducated – the figure of Christ was not dominant, heads of thieves and executioners are higher than His, the Holy Women are included, whereas the text says they watched from afar – but this is far more the result of a literal application of Counter-Reformation rules on propriety and decorum in pictures. Fortunately, the assessors declared that the picture was beyond price. With the exception of portraits, El Greco worked almost exclusively for the church, which was a powerful and insatiable patron; Toledo was the Holy City of Spain and contained nearly a thousand religious houses and churches, being more pious, more exclusively given over to religion than Rome itself. It had industries – it was famous for

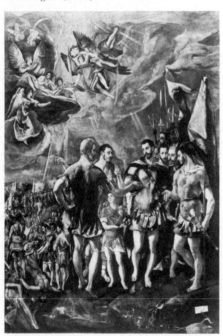

297 EL GRECO *Martyrdom of St Maurice and the Theban Legion* 1580–84

swords, jewellery, ceramics, weaving – and at the beginning of El Greco's residence was busy and prosperous, but at the time of his death whole districts were abandoned and grass grew in the streets.

The *Dream of Philip* (Escorial, Chapter House; sketch in the National Gallery, London) was painted for Philip II about 1579, and must be seen against the background of Titian's *La Gloria*, which is an allegory of salvation, with Charles V, Philip's father, as the chief penitent intercessor; in the *Dream*, which is an allegory of the Holy League against the Infidel, Philip is granted a vision of a salvation that can only be obtained by uniting Christendom against heresy, which is being destroyed in the mouth of Hell immediately behind him. Eventually, El Greco received an important commission in 1580 for a *Martyrdom of St Maurice and the Theban Legion*, destined for the chapel of the Escorial. He delivered it in 1584, and Philip immediately rejected it. The King's secretary, Siguenza, wrote: 'The picture does not please His Majesty, and that is no wonder, for it pleases few, although it is said that there is much art in it and its author understands much, for there are excellent things of his to be seen.' Philip only loved one thing besides religion, and that was art; but it was the deep, rich, sonorous, passionate art of Titian that he loved, full of wonderful harmonies of form and sensibilities of colour, and conforming still to the ideas current in the High Renaissance. The *St Maurice* (now in the Escorial Sacristy) reflects the troubled art of Pontormo and the famous cartoon by Perino del Vaga which so excited Florence in 1523. It has all the dispersion of effects, the flaring, startling colour, the odd long shots into tight groups of figures in the far distance, that characterize Mannerist works, and betoken a dark cast of mind, an anxious questing for new solutions to old prob-

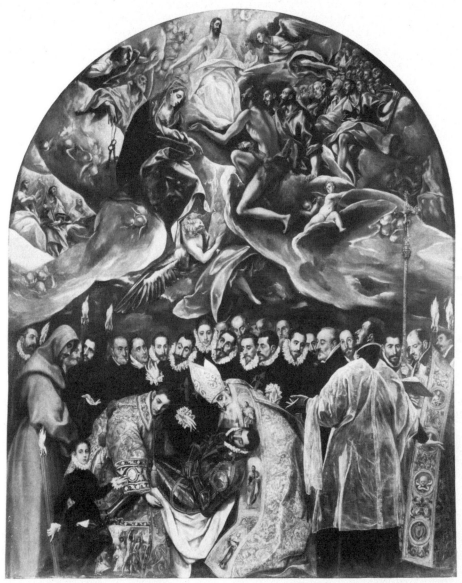

298 EL GRECO *Burial of Count Orgaz* 1586

lems. The trouble, basically, was that El Greco's art reflected a world which Philip refused to recognize. He turned from the one artist who could have solved all his problems of patronage, all the difficulties over the decoration of the Escorial which drove him to import inferior Italian art and artists, because he could not accept that the tension and the strain of El Greco's imagery was the true reflection of the world he had contributed so much to create about him.

In 1586 El Greco completed the *Burial of Count Orgaz*, the miracle of the faithful and charitable knight buried by Sts Augustine and Stephen before a crowd of mourners. Above the earthly apotheosis is the heavenly one, to which the angel bears the soul of the dead man to judgement and mercy. Not only does heaven lie over earth like a cloud, but like a curtain the vault of heaven is drawn aside to show the reward of piety. The heavenly part is not more visionary than the scene on earth: only differently so. The colour changes are more intense, more luminous, more strident, more of the bitter contrasts of blue and violet, and yellow and a shrill green. The forms are now beginning to transcend those of Italian Mannerism by accentuating the elongation of limbs, by giving them that curious nerve-drawn quality, and the strange feeling that the drapery they inhabit lives a life of its own with its own range of movement. There is also a certain return to Rosso and Pontormo, made vivid by the accidents of background. Both the Italians had experienced the terrors of war; in these years, until 1609, when the tragedy was virtually over in its immediate physical impact, El Greco was witnessing the expulsion of the Jews and the Moriscos. In 1585, the year before he began the *Orgaz*, he moved into a newly vacant twenty-four-roomed palace in the old Jewish quarter of Toledo; when he died there in 1614, his worldly possessions could have been put in a good sized trunk and his debts pursued him from the grave through the life of his spendthrift son. The Toledo he loved, and which recurs so often as a background in his pictures – in the *St Martin* and the *St Joseph* both of 1597, in the *Laocoon* of about 1606, in the two views of Toledo of about 1605–09, in the two late *Crucifixions* – dwindled in these years and died, just as the dead craftsmen rotted on the beaches or, driven into the sea, perished in overcrowded boats that no one knew where to go in, or were captured by

299 EL GRECO *St Martin and the Beggar* 1597–99

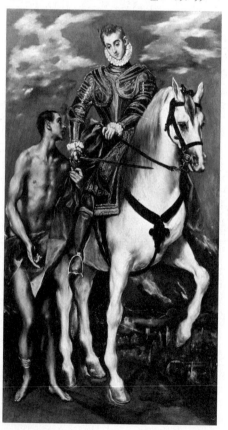

pirates and enslaved. Grass grew in the streets, the old prosperity of the steel workshops was gone, while bright Inca gold flowed in from the New World to destroy its own value by its profusion, and the only refuge from ruin was to seek a State sinecure so as to share in the gold that made trade impossible and work unnecessary, or to enter the religious houses that promised security amid the desolation.

The spiritual background of El Greco is in the atmosphere of the Spiritual Exercises of the Jesuits. If one compares his rendering of a scene with earlier versions he will never be found to linger over a casual assortment of bystanders; the crowd is strictly limited to the people who really matter – to the heart of the meaning. This is not merely the result of post-Tridentine precept, for Rubens's great religious pictures could never be placed outside the range of Tridentine art, yet they are never so limited in their means. The Spiritual Exercises suggest to the devout an imaginary presence at the event, seen in its simplest form and in its basic meaning. There is no evidence that El Greco practised the Exercises, as Bernini and Rubens did, but much in El Greco suggests that he knew and understood them, since one of the aims of the Exercises was to increase perception of spiritual states, and to promote the visionary and imaginative responses of the executant. Another factor was St John of the Cross. He lived in Toledo, where he was imprisoned by his enraged brethren who resented his attempts to reform his Order. Many of his poems seem to have welled out of him during his imprisonment and it is accepted that El Greco knew him. Many of St John's poems have the same intense, flickering, flame-like quality as El Greco's paintings, and in both the poet and the painter mystical experience is never destructive of form, but tends to heighten it and give it acute clarity of

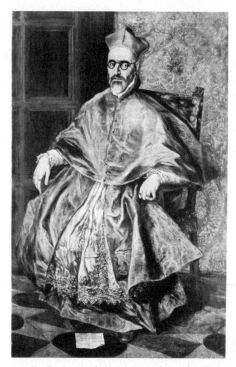

300 EL GRECO *Cardinal Guevara c.* 1600

expression. But this intensity of feeling can be paralleled in pictures where immediate religious experience is out of the question. The portrait of *Cardinal Guevara* of *c.* 1600 – the Chief Inquisitor – is an instance of this heightening of perception and of the uncanny selection of just that facet of expression which will most tellingly evoke the awful power and character of the sitter and his office. The Cardinal is dressed in a pale purple with a froth of cool lace echoing his grey beard and his pallid face, so that the effect is one of frigid majesty.

Even to the end of his life the forms of Italian Mannerism continued to inspire him. The *Pietà* in the Niarchos Collection of about 1580 should be compared with Titian's *Deposition* in the Prado, and Pontormo's S. Felicità *Deposition*, and then

275

referred back to the ever-present memory of the Michelangelo *Pietà* to see how lasting were these influences, and in the same way, the very late *Visitation* (Dumbarton Oaks) harks back to Pontormo's *Visitation* at Carmignano, not only in the way the figures, seen partly from below, are related to each other, but also in the relation of the figures to their architectural setting.

During all these years he had produced a stream of copies and versions of the Toledo *Espolio*. Over the years, small changes crept in, always to heighten emotional impact and tension.

His last works prompt the suspicion that the last years before his death in 1614 were increasingly sad ones. The faithful contemplate the punishment of sin, and behind lies Toledo, the Holy City, yet the sky is rent with storms and the light is lurid and frightening. The lovely view of Toledo painted about 1609, with the city basking in the glory of heavenly protection, its vast Lamaseries spread out over the hill and spilling beyond the walls in piety and pride, bright, luminous and clear, gives place to the Toledo painted probably a year or two later, with the dark and terrible storms behind the Laocoon making it glow luridly in the flicker of unseen lightning. Nothing is less truly Spanish than El Greco's art, for it was the culmination of Italian Mannerism. Morales in this sense was more truly Spanish, for his visions are pathetic without ecstasy, and his blend of Gothic emotion and harsh intensity of fact is more evocative of the Spanish mind than El Greco's more intuitive sensibility.

301 El Greco *View of Toledo* 1595/1600

This is a brief list of useful books, nearly all of them in English. All literature in periodicals has been excluded, and only a selection of monographs on major artists has been given.

Sources

By far the most important Italian source for the period is VASARI's *Vite* (1550 and, much enlarged, 1568): there is a complete English translation in 10 vols. by G. du C. de Vere, London, 1912–15, but the best English version of the Prefaces and twenty of the most important Lives is that by George Bull, London (Penguin Classics), 1965. The standard Italian edition is still that by G. Milanesi, 9 vols., Florence, 1878–85, but there is an excellent modern edition published by the Club del Libro, 8 vols., Milan, 1962–66, and an elaborate National Edition is being published by Sansoni, Florence, which includes the text of both the 1550 and 1568 editions, as well as exhaustive notes. Six vols. have so far appeared, 1966–.

For the Netherlands the most important source is KAREL VAN MANDER's *Het Schilder-Boek*, published in Alkmaar in 1604 and modelled on Vasari, but much inferior to him. There are French (Paris, 1884) and English (New York, 1936) translations.

Useful selections of translated excerpts from these and other sources will be found in E. HOLT, *A Documentary History of Art*, vol. II, New York, 1958; R. KLEIN and H. ZERNER, *Italian Art, 1500–1600*, New Jersey, 1966; and W. STECHOW, *Northern Renaissance Art, 1400–1600*, New Jersey, 1966. A critical discussion of the Italian sources will be found in A. BLUNT, *Artistic Theory in Italy, 1450–1600*, Oxford, 1940.

The standard bibliography is the indispensable *Letteratura Artistica* by J. VON SCHLOSSER-MAGNINO, revised ed. by O. Kurz, Florence, 1956. Most of the sixteenth-century Italian writers have been republished recently in the *Scrittori d'Italia* series or in *La Letteratura Italiana, Storia e Testi*.

For the historical background the reader should turn to such books as K. VERNON, *Italy from 1494–1790*, Cambridge, 1909; D. HAY, *The Italian Renaissance*, Cambridge, 1961; P. BURKE, *The Renaissance*, London, 1964, and *Culture and Society in Renaissance Italy, 1420–1540*, London, 1972; E. COCHRANE (ed.), *The Late Italian Renaissance, 1525–1630*, London, 1970; D. HAY (ed.), *The Age of the Renaissance*, London, 1967; M. PHILLIPS, *Erasmus and the Northern Renaissance*, London, 1949; A.G. DICKENS, *Reformation and Society in 16th Century Europe*, London, 1966, and *The Counter-Reformation*, London, 1968. L. VON PASTOR's monumental *History of the Popes* is essential for the history of the Church, and the relevant chapters in the *New Cambridge Modern History*, vols. I and II, 1957 and 1962, will be useful.

General histories of art include A. CHASTEL, *The Age of Humanism, 1480–1530*, London, 1963; M. LEVEY, *High Renaissance*, London, 1975; J. SHEARMAN, *Mannerism*, London, 1967; and O. BENESCH, *The Art of the Renaissance in Northern Europe*, London, 1966, as well as the volumes in the Pelican History of Art, Harmondsworth. These include A. BLUNT, *Art and Architecture in France, 1500–1700*, 1970; G. KUBLER and M. SORIA, *Art and Architecture in Spain and Portugal . . .*, 1959; S.J. FREEDBERG, *Painting in Italy, 1500–1600*, 1971; L. HEYDENREICH and W. LOTZ, *Architecture in Italy, 1400–1600*; G. VON DER OSTEN and H. VEY, *Painting and Sculpture in Germany and the Netherlands, 1500–1600*, 1969; J. SUMMERSON, *Architecture in Britain, 1530–1830*, 1963; and E. WATERHOUSE, *Painting in Britain, 1530–1790*, 1953.

Architecture

P. MURRAY, *Renaissance Architecture*, New York, 1971

R. WITTKOWER, *Architectural Principles in the Age of Humanism*, London, 1962

H. WÖLFFLIN, *Renaissance and Baroque*, trans. K. Simon, London, 1964

P. LETAROUILLY, *Edifices de Rome moderne*, 4 vols., Paris, 1840–57, and 6 vols., London, 1928–30 (superb drawings of the monuments)

c. VON STEGMANN and H. VON GEYMÜLLER, *The Architecture of the Renaissance in Tuscany*, 2 vols., New York, c. 1924 (an abridged version of *Die Architektur der Renaissance* ...)
P. MURRAY, *Architecture of the Italian Renaissance*, London, 1969
G. MASSON, *Italian Villas and Palaces*, London, 1959

Painting and Sculpture

S.J. FREEDBERG, *Painting of the High Renaissance* ..., Harvard, 1961
H. WÖLFFLIN, *Classic Art*, trans. P. and L. Murray, London, 1952
G. BRIGANTI, *Italian Mannerism*, London, 1962
C. GOULD, *Introduction to Italian Renaissance Painting*, London, 1957
C. CUTTLER, *Northern Painting*, New York, 1968
M.J. FRIEDLÄNDER, *Early Netherlandish Painting*, 14 vols., trans. H. Norden, Leyden, 1967–76 (relevant vols.)
J. POPE-HENNESSY, *Italian High Renaissance and Baroque Sculpture*, London, 1970

Monographs

A fuller list of monographs on individual artists will be found in P. and L. MURRAY, *Dictionary of Art and Artists*, London 1965 (the hardback edition). There is a useful Italian series, *L'opera completa di* ... , some titles from which have been translated into English.

Altdorfer: O. BENESCH, Vienna, 1943 (in-German)
Bramante: A. BRUSCHI, London, 1977
Bronzino: A. MCCOMB, Cambridge, Mass., 1928
Bruegel: F. GROSSMAN, London, 1955: for the drawings, L. MÜNZ, London, 1961, and C. DE TOLNAY, London, 1952
Cellini: *Autobiography*, trans. G. Bull, London, 1956
Clouet: P. MELLEN, London, 1971
Correggio: C. GOULD, London, 1977
Cranach: E. RUHMER, London, 1963
Dürer: E. PANOFSKY, Princeton, 1955; C. WHITE, London, 1971; M. LEVEY, London, 1964; H. WÖLFFLIN, trans. A. and H. Grieve, London, 1971
Eworth: R. STRONG, *The English Icon*, London, 1969
Giorgione: L. BALDASS, London, 1965; T. PIGNATTI, London, 1971

Giulio Romano: F. HARTT, 2 vols., Yale, 1958
El Greco: H. WETHEY, 2 vols., Princeton, 1962; J. GUDIOL, London, 1973
Hilliard: E. AUERBACH, London, 1961
Holbein: P. GANZ, London, 1950; for the Windsor drawings, K. PARKER, London, 1945
Leonardo: K. CLARK, London, 1958; L. HEYDENREICH, London, 1954; C. PEDRETTI, London, 1973
Lotto: B. BERENSON, London, 1956
Michelangelo: C. DE TOLNAY, Princeton, 1943 (in progress, 5 vols. so far); idem., *Art and Thought of Michelangelo*, New York, 1964; A. CONDIVI, *Life of Michelangelo*, ed. A. and H. Wohl, London, 1976; H. VON EINEM, London, 1973; H. HIBBARD, London, 1975. For the architecture, J. ACKERMAN, London, 1970
Morales: E. DU G. TRAPIER, New York, 1933; I. BÄCKSBACKA, Helsinki, 1962 (in English)
Oliver: Catalogue by G. REYNOLDS of Exhibition at Victoria and Albert Museum, London, 1947
de l'Orme: A. BLUNT, London, 1958
Palladio: J. ACKERMAN, London, 1966; L. PUPPI, London, 1975
Parmigianino: S. FREEDBERG, Cambridge, Mass., 1950; for the drawings, A. POPHAM, 3 vols., New Haven, 1971
Pontormo: F. CLAPP, Yale, 1916; for the drawings, J. REARICK, 2 vols., Harvard, 1964
Raphael: J. POPE-HENNESSY, London, 1970; for the drawings of Raphael and his circle, see the British Museum Catalogue by P. POUNCEY and J. GERE, London, 1962
Rosso: K. KUSENBERG, Paris, 1931 (in French)
Sanmicheli: E. LANGENSKIÖLD, London, 1938; Catalogue of the Sanmicheli Exhibition, Verona, 1960 (in Italian)
Sansovino: D. HOWARD, Yale, 1975
A. del Sarto: S. FREEDBERG, 2 vols., Harvard, 1963; J. SHEARMAN, 2 vols., Oxford, 1965
Smythson: M. GIROUARD, London, 1966
Tintoretto: H. TIETZE, London, 1948
Titian: H. TIETZE, London, 1950; H. WETHEY, 3 vols., London, 1969–75: E. PANOFSKY, London, 1969
Vasari: R. CARDEN, London, 1910; E. RUD, London, 1964
Veronese: A. ORLIAC, London, 1948
Zuccaro: J. GERE, London, 1969

List of Illustrations

Measurements are given in centimetres and inches, height before width

ABBATE, NICCOLÒ DELL' (c. 1512–71)

243 *Orpheus and Eurydice.* Canvas, 188 × 237 (74 × 93¼). By courtesy of the Trustees of the National Gallery, London

ALTDORFER, ALBRECHT (c. 1480–1538)

266 *St George*, 1510. Wood, 28 × 22 (11 × 8⅝). Alte Pinakothek, Munich
267 *Christ taking leave of His Mother*, c. 1517. Oil on canvas, 135 × 126 (53⅛ × 49⅝). Collection Sir Harold Wernher, Bt, Luton Hoo, Bedfordshire
268 *Recovery of the body of St Florian*, 1518. Florian altar. Deutsches Nationalmuseum, Nuremberg

AMBERGER, CHRISTOPH (c. 1500–61/62)

270 *Christoph Fugger*, 1541. Oil on wood, 97.5 × 80 (33⅞ × 31½). Alte Pinakothek, Munich

AMMANATI, BARTOLOMMEO (1511–92)

170 *Marine God*, 1563–75. Bronze. Neptune Fountain, Piazza della Signoria, Florence

ANDREA DEL SARTO (1486–1531)

145 *The Miracles of S. Filippo Benizzi; the Gamblers struck by Lightning*, 1509. Fresco. SS. Annunziata, atrium, Florence
146 *Birth of the Virgin*, 1514. Fresco. SS. Annunziata, atrium, Florence
147 *St John the Baptist preaching*, 1515. Fresco. Chiostro dello Scalzo, Florence
148 *Madonna of the Harpies (Madonna and Child with Sts Francis and John the Evangelist)*, 1517. Wood, 208 × 178 (81⅞ × 70¼). Uffizi, Florence
149 *The Holy Family (Borgherini)*, c. 1529. Oil on wood, 134.5 × 99.6 (53⅛ × 39⅜). The Metropolitan Museum of Art, New York. Maria De Witt Jesup Fund, 1922
151 *Sacrifice of Abraham*, 1524/29. Oil and tempera on wood, 175 × 138 (68⅞ × 56⅞). The Cleveland Museum of Art. Delia E. and L. E. Holden Funds

BARTOLOMMEO, FRA (c. 1474–1517)

15 *Mystic Marriage of St Catherine*, 1512. Oil on wood, 350 × 267 (137⅞ × 105⅛). Uffizi, Florence
16 *Madonna and Child with St Anne and the Baptist*, 1516. Oil on wood, 140 × 115 (55⅛ × 45¼). Cook Collection

BASSANO, JACOPO (c. 1510/18–92)

208 *Adoration of the Shepherds*, 1540s. Oil on canvas, 138 × 219 (54⅜ × 86¼). Royal Collection, Hampton Court. Reproduced by gracious permission of Her Majesty the Queen

BECCAFUMI, DOMENICO (1485/86–1551)

171 *Birth of the Virgin*. Oil on wood, 233 × 145 (91¾ × 57⅛). Accademia, Siena

BERRUGUETE, ALONSO (c. 1489–1561)

292 Choir-stall carving, 1539–43. Wood. Toledo Cathedral

BOLOGNA, GIOVANNI DA (1529–1608)

172 *Rape of the Sabines*, 1582. Marble, h. 410 (168⅞). Loggia dei Lanzi, Florence
173 *Venus* Fountain. Grotto Buontalenti, Boboli Gardens, Florence

BORDONE, PARIS (1500–70)

207 *Portrait of a Man.* Oil on canvas, 115 × 53 (45¼ × 20⅞). Louvre, Paris

BRAMANTE, DONATO (1444–1514)

17 *Architecture with figures*, 1481. Engraving, 70 × 51 (27⅝ × 20⅛). By courtesy of the Trustees of the British Museum, London
18 Interior of S. Maria presso S. Satiro, Milan
19 Baptistery of S. Maria presso S. Satiro, Milan
20 Section and plan of S. Maria delle Grazie, Milan. From Pica, 'Il Gruppo monumentale di S. Maria delle Grazie', Libreria dello Stato, Rome, 1937
21 Interior of S. Maria delle Grazie, Milan
34 Tempietto, S. Pietro in Montorio, Rome, after 1502
35 Cloister of S. Maria della Pace, Rome, 1504
69 House of Raphael. Engraving by Lafréry

BRONZINO, AGNOLO (1503–72)

163 *Ugolino Martelli*, c. 1535. Oil on wood, 102 × 85 (40¼ × 33½). Staatliche Museen, Berlin
164 *Venus, Cupid, Time and Folly*, 1545. Oil on wood, 146 × 116 (57½ × 45⅞). By courtesy of the Trustees of the National Gallery, London

BRUEGEL, PIETER (1525/30–69)

233 *Alpine Scenery*, 1553. Pen and ink drawing, 22.8 × 33.7 (9 × 13¼). By courtesy of the Trustees of the British Museum, London
236 *Dulle Griet*, 1564. Wood, 115 × 161 (45¼ × 63⅜). Museum van den Bergh, Antwerp
239 *Parable of the Blind*, 1568. Tempera on canvas, 80 × 154 (31½ × 60⅝). Museo di Capodimonte, Naples
240 *Stormy Day*, 1565. Wood, 118 × 163 (46½ × 64⅛). Kunsthistorisches Museum, Vienna
241 *Magpie and the Gallows*, 1568. Wood, 46.5 × 50.5 (18¼ × 19⅞). Landesmuseum, Darmstadt

BUECKELAER, JOACHIM (c. 1530/35–1573/74)

237 *Christ in the House of Martha and Mary*, 1565. Oil on oak, 113 × 163 (44½ × 64½). Musées Royaux, Brussels

BURGKMAIR, HANS (1473–1553)

271 *St John the Evangelist on Patmos*, 1518. Oil on pine, 153 × 124.7 (60¼ × 49⅛). Alte Pinakothek, Munich

CARADOSSO (c. 1452–c. 1526)

36 Foundation medal for St Peter's, 1506. Reverse: project for St Peter's. Obverse: Julius II. By courtesy of the Trustees of the British Museum, London

CARON, ANTOINE (d. c. 1600)

246 *The Massacres of the Triumvirate*, 1566. Oil on canvas, 142 × 177 (55⅞ × 69¾). Louvre, Paris

CELLINI, BENVENUTO (1500–71)

169 *Perseus*, 1545–54. Bronze, h. 320 (126). Loggia dei Lanzi, Florence

CLOUET, FRANÇOIS (d. 1572)

244 *Pierre Quthe*, 1562. Oil on wood, 91 × 70 (35⅞ × 27½). Louvre, Paris
247 *Lady in her Bath*, c. 1570. Oil on wood, 92 × 81 (36¼ × 31⅞). National Gallery of Art, Washington. On loan from the Samuel H. Kress Collection

CORREGGIO, ANTONIO (1494 or 1489–1534)

174 *Madonna of St Francis*, c. 1514–15. Oil on wood, 299 × 245 (117¾ × 96½). Gemäldegalerie, Dresden

176 Camera di S. Paolo, Parma. Ceiling detail, *c.* 1518. Fresco
177 Dome of S. Giovanni Evangelista, Parma, 1520–23. Fresco
178 Dome of Parma Cathedral, 1526–30. Fresco
179 *Nativity 'La Notte'* (*Adoration of the Shepherds*), *c.* 1530. Wood, 256 × 188 (100¾ × 74). Gemäldegalerie, Dresden
180 *Madonna of St Jerome 'Il Giorno'*, *c.* 1527–28. Wood, 205 × 141 (80¾ × 55½). Parma Museum
181 *Danaë*, *c.* 1531/32. Canvas, 161 × 193 (63⅜ × 76). Borghese Gallery, Rome

COUSIN, JEAN (1522–94)
245 *Eva Prima Pandora*, *c.* 1538. Oil on wood, 97 × 150 (38¼ × 59). Louvre, Paris

CRANACH, LUCAS (1472–1553)
260 *Rest on the Flight*, 1504. Oil on wood, 69 × 51 (27⅛ × 20⅛). Staatliche Museen, Berlin
261 *Duke Henry of Saxony*, 1514. Canvas (transferred from wood), 184 × 82 (72½ × 32¼). Gemäldegalerie, Dresden
262 *Duchess Katherine*, 1514. Canvas (transferred from wood), 184 × 82 (72½ × 32¼). Gemäldegalerie, Dresden
263 *Dr Johannes Cuspinian*, 1504–05. Oil on wood, 59 × 45 (23¼ × 17¾). Oskar Reinhart Collection, Römerholz, Winterthur
264 *Anna Cuspinian*, 1504–05. Oil on wood, 59 × 45 (23¼ × 17¾). Oskar Reinhart Collection, Römerholz, Winterthur
265 *Judgement of Paris*, *c.* 1530. Oil on wood, 104 × 72 (41 × 28⅜). Metropolitan Museum of Art, New York

DUPÉRAC, ÉTIENNE (1525–1604)
115 Michelangelo's plan for St Peter's, Rome. Engraving, 1568
119 Michelangelo's project for side elevation of St Peter's, Rome. Engraving, 1568
121 Michelangelo's design for the Capitoline Hill. Engraving, 1568

DÜRER, ALBRECHT (1471–1528)
254 *Self-portrait*, 1498. Oil on wood, 52 × 41 (20½ × 16⅛). Prado, Madrid
255 *Four Horsemen of the Apocalypse*, 1498. Woodcut, 39.3 × 28.3 (15½ × 11⅛). By courtesy of the Trustees of the British Museum, London
256 *Adam and Eve*, 1504. Engraving, 25.2 × 19.4 (9⅞ × 7⅝). Victoria and Albert Museum, London
257 *Four Apostles*, 1526. Oil on wood, each panel 215.5 × 76 (85 × 30). Alte Pinakothek, Munich
258 *Christ among the Doctors*, *c.* 1505. Wood, 65 × 80 (25½ × 31½). Collection Baron H.H. Thyssen-Bornemisza, Lugano
259 *Melencolia*, 1514. Engraving, 23.9 × 16.8 (9⅜ × 6⅝). Victoria and Albert Museum, London

EWORTH, HANS (d. *c.* 1574)
283 *Lady Dacre*, 1540. Oil on wood, 73.5 × 57.5 (29 × 22⅝). National Gallery of Canada, Ottawa

FLORIS, FRANS (*c.* 1517–70)
238 *Last Judgement*, 1565. Kunsthistorisches Museum, Vienna

FRANCIABIGIO (1482–1525)
153 *Portrait of a Man*, 1514. Wood, 60 × 45 (23¾ × 18). By courtesy of the Trustees of the National Gallery, London

GIORGIONE (*c.* 1476/78–1510)
73 *Laura*, 1506. Canvas affixed to spruce panel, 41 × 36 (16⅛ × 14¼). Kunsthistorisches Museum, Vienna

74 *Madonna and Child with Sts Francis and Liberale*. Wood, 200 × 152 (78¾ × 60). Castelfranco Cathedral
75 *Three Philosophers*. Canvas, 123 × 144 (48⅜ × 56¾). Kunsthistorisches Museum, Vienna
76 *Tempest*. Canvas, 78 × 72 (30 × 28½). Accademia, Venice
77 *Venus*. Canvas, 108 × 175 (42½ × 68¾). Gemäldegalerie, Dresden
78 *Concert Champêtre*. Canvas, 110 × 138 (43½ × 54¼). Louvre, Paris
79 *Portrait of a Young Man*. Canvas, 58 × 46 (22⅞ × 18¼). Staatliche Museen, Berlin

GIULIO ROMANO (1492 or 1499–1546)
122 *Baptism of Constantine*, 1520–24. Fresco. Sala di Costantino, Vatican
123 Palazzo del Tè, Mantua. Courtyard, 1526 onwards
124 Palazzo del Tè, Mantua. Loggia
125 *Giants crushed by an earthquake*. Fresco, 1532–34. Sala dei Giganti, Palazzo del Tè, Mantua
126 Façade of his own house, Mantua, *c.* 1544
127 Courtyard of the Cavallerizza, Reggia, Mantua

GRECO, EL (1541–1614)
295 *Christ and the Money Changers*, *c.* 1572–74. Canvas, 117.5 × 150 (46¼ × 59). Institute of Arts, Minneapolis. The William Hood Dunwoody Fund
296 *El Espolio*, 1577–79. Canvas, 285 × 173 (112¼ × 68⅛). Toledo Cathedral
297 *Martyrdom of St Maurice and the Theban Legion*, 1580–84. Oil on canvas, 444 × 302 (174¾ × 118⅞). Escorial, Madrid
298 *Burial of Count Orgaz*, 1586. Canvas, 487.5 × 360 (191⅞ × 141⅞). Sto Tomé, Toledo
299 *St Martin and the Beggar*, 1597–99. Oil on canvas, 190.8 × 98.1 (75⅛ × 38⅝). National Gallery of Art, Washington D.C., Widener Collection
300 *Cardinal Guevara*, *c.* 1600. Canvas, 171.5 × 108 (67½ × 42½). The Metropolitan Museum of Art, New York
301 *View of Toledo*, *c.*1595/1600. Canvas, 121.5 × 108.5 (47⅞ × 42¾). The Metropolitan Museum of Art, New York. Bequest of Mrs H.O. Havemeyer, 1929

HERRERA, JUAN DE, see TOLEDO

HILLIARD, NICHOLAS (1547–1619)
284 *Young Man amid Roses*, *c.* 1590. Miniature, oval, 13.5 × 7 (5¼ × 2¾). Victoria and Albert Museum, London

HOLBEIN, HANS THE YOUNGER (1497/98–1543)
272 *Wife and Children*, *c.* 1530. Oil and tempera on paper, mounted on wood, 77 × 64 (30¼ × 25¼). Oeffentliche Kunstsammlung, Basle
273 *Magdalena Offenburg as Venus*, 1526. Oil and tempera on wood, 34.5 × 27 (13⅝ × 10⅝). Oeffentliche Kunstsammlung, Basle
274 *Madonna and Child (Meyer)*, *c.* 1525. Oil and tempera on lime, 141 × 101 (55½ × 39¾). Granducal Castle, Darmstadt
275 *Thomas More and his Family*, 1527. Pen drawing on white paper. Kupferstichkabinett, Basle
276 *Sir John Godsalve*, *c.* 1528. Chalk drawing on pink priming, 37 × 29.5 (14⅝ × 11⅝). Royal Collection, Windsor Castle. Reproduced by gracious permission of Her Majesty the Queen
277 *Georg Gisze*, 1532. Tempera on oak, 96.3 × 85.7 (37⅞ × 33⅞). Staatliche Museen, Berlin
278 *The Ambassadors*, 1533. Oil on oak, 207 × 209 (81½ × 82¼). By courtesy of the Trustees of the National Gallery, London
279 *Henry VIII*, 1537. Cartoon, 257.5 × 137 (101⅜ × 54). National Portrait Gallery, London
280 *Self-portrait*, 1543. Miniature. Watercolour on playing card or vellum, diam. 3.5 (1⅜). Reproduced by permission of the Trustees of the Wallace Collection

HUBER, WOLF (c. 1490–1553)
269 The Danube Valley, 1529. Pen drawing, 22.4 × 31.7 (8⅝ × 12½). Kupferstichkabinett, Berlin

LEONARDO DA VINCI (1452–1519)
1 Adoration of the Kings, 1481. Wood, 243.8 × 246.4 (96 × 97). Uffizi, Florence
2 Mona Lisa. Wood, 97.2 × 53.3 (38¼ × 21). Louvre, Paris
3 Virgin of the Rocks. Oil on canvas (transferred from wood), 197 × 120 (77⅝ × 47¼). Louvre, Paris
4 Virgin of the Rocks. Wood, 189.5 × 120 (74⅝ × 47¼). By courtesy of the Trustees of the National Gallery, London
5 The Last Supper, c. 1497. Fresco, 420 × 910 (165⅜ × 358¼). Convent of S. Maria delle Grazie, Milan
6 Battle of Anghiari. Copy by Rubens, c. 1600–08. Black chalk, pen and ink, 45 × 63 (17¾ × 24¾). Louvre, Paris
7 Madonna and Child with St Anne. Wood, 168.3 × 130.2 (66¼ × 51¼). Louvre, Paris

LEONI, POMPEO (1553–1608)
293 Tomb of Charles V, 1598. Bronze. Escorial, Madrid

LESCOT, PIERRE (d. 1578)
251 Cour Carrée, Louvre, Paris, begun 1546

LOTTO, LORENZO (c. 1480–1556)
94 Madonna and Child with Saints, 1508. Canvas, 227 × 108 (101¾ × 42½). Recanati Museum
95 Portrait of Andrea Odoni, 1527. Canvas, 114 × 101 (44⅞ × 39¾). Royal Collection, Hampton Court. Reproduced by gracious permission of Her Majesty the Queen

LUCAS VAN LEYDEN (1494?–1533)
232 Magdalen returning to the World, 1519. Engraving. Gabinetto delle Stampe, Uffizi, Florence
234 Self-portrait, c. 1509. Oil on oak, 29 × 22 (11⅜ × 8⅝). Herzog Anton Ulrich Museum, Brunswick

MABUSE (d. c. 1533)
225 Adoration of the Magi, c. 1503–06. Oil on oak, 177 × 161 (69¾ × 63⅜). By courtesy of the Trustees of the National Gallery, London
226 St Luke painting the Virgin, c. 1514. Oil on oak, 109.5 × 82 (42½ × 32¼). Kunsthistorisches Museum, Vienna
227 Neptune and Amphitrite, 1516. Oil on oak, 191 × 128.5 (75¼ × 50⅝). Staatliche Museen, Berlin

MACHUCA, PEDRO (d. 1550)
290 Courtyard of the Palace of Charles V, Granada, designed 1527–28

MANTEGNA, ANDREA (1431–1506)
12 Entombment. Engraving, 33 × 46 (13⅛ × 18½). Bartsch No. 3. By courtesy of the Trustees of the British Museum, London
175 Madonna of Victory, 1495–96. Canvas, 280 × 166 (110¼ × 69½). Louvre, Paris

MASTER OF FLORA
248 Birth of Cupid, c. 1540/60. Oil on wood, 108 × 130.5 (42½ × 51¾). The Metropolitan Museum of Art, New York. Rogers Fund, 1941

MATSYS, QUENTIN (1464/65–1530)
221 St Anne triptych, 1509. Oil on canvas, 224.5 × 219 (88¾ × 86¼). Musées Royaux, Brussels
222 Money Changer and his Wife, 1514. Oil on canvas, 74 × 68 (29⅛ × 26¾). Louvre, Paris
223 Egidius, 1517. Oil on canvas, 73.5 × 55.5 (29 × 21⅞). Lord Radnor Collection

224 Madonna and Child, c. 1527. Oil on canvas, 110 × 87 (43¼ × 34¼) (landscape by Patinier). Museum, Poznan

MICHELANGELO BUONARROTI (1475–1564)
22 Battle of the Centaurs, c. 1492. Marble relief, 90.5 × 90.5 (35½ × 35½). Casa Buonarroti, Florence
23 Madonna of the Steps, c. 1491–92. Marble relief, 55.5 × 40 (22 × 15⅞). Casa Buonarroti, Florence
24 Angel for the Shrine of St Dominic, 1494–95. Marble, h. 51.5 (20¼). S. Domenico, Bologna
25 Pietà, 1498–99. Marble, 174 × 195 (68½ × 76¾). St Peter's, Rome
26 Bacchus, 1496–97. Marble, h. incl. base 203 (80). Museo del Bargello, Florence
27 David, 1501–04. Marble, h. 434 (170¾). Accademia, Florence
28 Entombment, c. 1504. Wood, 161 × 149 (63⅜ × 59). By courtesy of the Trustees of the National Gallery, London
29 Holy Family (Doni Tondo), 1503–04. Tempera on wood. Circular panel, diam. 120 (47¼). Uffizi, Florence
30 Madonna and Child with the Infant Baptist (Taddei Tondo), 1505–06. Marble relief, diam. 82.5 (43). The Royal Academy of Arts, London
31 Drawing of a Man. Preparatory study for a figure in Battle of Cascina cartoon (Pl. 32), 1504–05. Pen and brush, 42 × 28 (16½ × 11). By courtesy of the Trustees of the British Museum, London
32 Battle of Cascina. Copy by Aristotile da San Gallo. Cartoon (part). By kind permission of the Earl of Leicester
33 Madonna and Child, 1501–05. Marble, h. incl. base 128 (50½). Notre Dame, Bruges
47 Tomb of Julius II. S. Pietro in Vincoli, Rome
48 Moses, c. 1515–16. Detail of Pl. 47. Marble, h. 235 (92½). S. Pietro in Vincoli, Rome
49 Dying Slave, 1513. Marble, h. 229 (90½). Louvre, Paris
50 Rebellious Slave, 1513. Marble, h. 215 (84⅝). Louvre, Paris
51 Interior of the Sistine Chapel, Vatican
52 Central portion of the ceiling of the Sistine Chapel, Vatican
53 Drunkenness of Noah, 1508–10. Fresco. Sistine Chapel, Vatican
54 God separating Light from Dark, 1511–12. Fresco. Sistine Chapel, Vatican
55 Studies for the Libyan Sibyl, 1511–12. Red chalk, 29 × 21.5 (11⅜ × 8½). The Metropolitan Museum of Art, New York (Purchase 1924, Joseph Pulitzer Bequest)
56 Jonah, 1511–12. Fresco. Sistine Chapel, Vatican
57 Ancestors of Christ: Jacob and Joseph. Fresco. Sistine Chapel, Vatican
58 Zacharias, 1508–10. Fresco. Sistine Chapel, Vatican
59 Early Ignudo, 1508–10. Fresco. Sistine Chapel, Vatican
60 Late Ignudo, 1511–12. Fresco. Sistine Chapel, Vatican
101 Interior of the Medici Chapel, Florence
102 Madonna and Child, 1524–27 (unfinished). Marble, h. 223 (87⅞). Medici Chapel, Florence
103 Tomb of Lorenzo de' Medici. h. 178 (70½). Medici Chapel, Florence
104 Tomb of Giuliano de' Medici. h. 173 (68⅛). Medici Chapel, Florence
105 Vestibule and stairs of the Laurenziana Library, Florence
106 Vestibule wall of the Laurenziana Library, Florence, 1524–26
107 Last Judgement, 1535–41. Fresco. Sistine Chapel, Vatican
108 Last Judgement. Detail of Pl. 107
109 Conversion of St Paul, 1542–45. Fresco. Cappella Paolina, Vatican
110 Crucifixion of St Peter, 1546–50. Fresco. Cappella Paolina, Vatican

111 *Christ on the Cross, c.* 1541. Drawing in black and white chalk, 42 × 28.5 (16½ × 11¼). By courtesy of the Trustees of the British Museum, London
112 *Rondanini Pietà*, worked on until 1564. Marble, h. 195 (76¾). Castello Sforzesco, Milan
113 *Pietà*, late 1550s. Marble, h. 226 (89). Florence Cathedral
118 St Peter's, Rome. View of apse and dome
120 Capitoline Palace, Rome, designed *c.* 1539
150 *Victory*, 1527–30. Marble, h. 145.5 (57⅛). Palazzo Vecchio, Florence
161 *Pietà, c.* 1519/20. Drawing. Louvre, Paris

See also DUPÉRAC, Pls. 115, 119, 121

MOR, ANTHONIS (1519–75)
282 *Queen Mary*, 1554. Oil on wood, 109 × 84 (42⅞ × 33⅛). Prado, Madrid

MORALES, LUIS (d. 1586)
294 *Pietà.* Academia de S. Fernando, Madrid

MORETTO OF BRESCIA (*c.* 1498–1554)
90 *Portrait of a Man*, 1526. Canvas, 198 × 88 (78 × 35). By courtesy of the Trustees of the National Gallery, London

OLIVER, ISAAC (d. 1617)
285 *Richard Sackville, Earl of Dorset*, 1616. Oil on vellum or card, 23.5 × 15.5 (9¼ × 6⅛). Victoria and Albert Museum, London

ORLEY, BERNARD VAN (*c.* 1488–1541)
228 *Trials of Job*, 1532. Centre panel of altarpiece, 176 × 184 (69¼ × 72½). Musées Royaux, Brussels
229 *Dives and Lazarus*: (left) *Lazarus chased by a dog from house of Dives*; (right) *Death of Dives*, 1532. From wings of Job altarpiece, each 174 × 80 (68½ × 31½). Musées Royaux, Brussels
231 *Georg van Zelle*, 1519. Oil on wood, 39.5 × 32.5 (15½ × 12¾). Musées Royaux, Brussels

PALLADIO, ANDREA (1508–1580)
191 Basilica Palladiana, Vicenza, 1549 onwards
192 Palazzo Chiericati, Vicenza, begun 1550s
193 Villa Rotonda, Vicenza, begun 1567
195 Plan of Villa Mocenigo, Brenta, 1562. From Palladio, 'I Quattro Libri', 1570
196 Interior of S. Giorgio Maggiore, Venice
197 S. Giorgio Maggiore, Venice. Façade

PALMA VECCHIO (1480–1528)
96 *Portrait of a Woman.* Wood, 85 × 71 (33½ × 28). Poldi-Pezzoli Museum, Milan

PARMIGIANINO, FRANCESCO (1503–40)
182 *Madonna and Child with St Jerome*, 1527. Oil on wood, 343 × 149 (135 × 58⅝). By courtesy of the Trustees of the National Gallery, London
183 S. Maria della Steccata, Parma. Ceiling, 1531–39
184 *Madonna del Collo Lungo, c.* 1535. Oil on wood, 216 × 132 (85 × 52). Pitti Gallery, Florence

PATINIR, JOACHIM, see MATSYS, Pl. 224

PERINO DEL VAGA, see VASARI, Pl. 156

PERUZZI, BALDASSARE (*c.* 1481–1536)
128, 129 Sala delle Prospettive, *c.* 1515. Villa Farnesina, Rome
130 Palazzo Massimi alle Colonne, Rome. Façade, *c.* 1535

PHILIBERT DE L'ORME (*c.* 1505/10–1570)
252 Chapel at Anet. Interior, 1549–52
253 Château of Anet. Gateway, 1552

PILON, GERMAIN (*c.* 1535–90)
250 *Deposition, c.* 1580/85. Bronze relief. Louvre, Paris

PONTORMO, JACOPO (1494–1556)
152 *Vertumnus and Flora, c.* 1521. Fresco. Lunette from Villa Medici, Poggio a Caiano
154 *Joseph in Egypt*, 1515–18. Oil on wood, 96 × 109 (37¾ × 42⅞). By courtesy of the Trustees of the National Gallery, London
155 *Deposition, c.* 1528. Oil on wood, 313 × 192 (123¼ × 75⅝). Cappella Capponi, Sta Felicità, Florence
157 *Halberdier, c.* 1527. Oil on wood, 92 × 72 (36¼ × 28¾). Fogg Art Museum, Harvard University, Cambridge, Mass. Loan Mr Chauncey Stillman
158 *Martyrdom of the Theban Legion, c.* 1528/29. Oil on wood, 67 × 73 (26⅜ × 28¾). Pitti Gallery, Florence

PORDENONE, GIOVANNI ANTONIO (1483/84–1539)
97 *Crucifixion*, 1521. Fresco. Cremona Cathedral

PRIMATICCIO, FRANCESCO (1504/05–70)
242 Stucco decoration, *c.* 1541–45. Chambre de la Duchesse d'Étampes, Fontainebleau

RAIMONDI, MARCANTONIO (*c.* 1480–1527/34)
230 *Massacre of the Innocents.* Engraving after Raphael, 42.5 × 28 (16⅞ × 11). By courtesy of the Trustees of the British Museum, London

RAPHAEL (1483–1520)
8 *Mond Crucifixion, c.* 1502/03. Wood, 280 × 165 (110½ × 65). By courtesy of the Trustees of the National Gallery, London
9 *Madonna and Child (Ansidei)*, 1505–07. Wood, 274 × 152 (82½ × 58⅜). By courtesy of the Trustees of the National Gallery, London
10 *La Belle Jardinière, c.* 1507. Wood, 122 × 80 (48 × 31). Louvre, Paris
13 *Entombment, c.* 1507. Wood, 184 × 176 (72½ × 69¼). Galleria Borghese, Rome
14 *Bridgewater Madonna, c.* 1505. Oil on canvas, 81 × 56 (31¾ × 22). Duke of Sutherland Collection, on loan to the National Gallery of Scotland
37 Stanza della Segnatura, 1509–11. Vatican
38 *Disputa*, 1509. Fresco. Stanza della Segnatura, Vatican
39 *School of Athens*, 1509–11. Fresco. Stanza della Segnatura, Vatican
40 Study for the figure of *Poetry*, 1509. Grey chalk over sketch squared in black chalk, 36 × 22 (14⅜ × 8⅝). Royal Collection, Windsor Castle. Reproduced by gracious permission of Her Majesty the Queen
41 *Poetry Roundel*, 1509. Fresco. Stanza della Segnatura ceiling, Vatican
42 *Expulsion of Heliodorus*, 1511–14. Fresco. Stanza dell'Eliodoro, Vatican
43 *Mass of Bolsena*, 1511–14. Fresco. Stanza dell'Eliodoro, Vatican
44 Drawing, *c.* 1517. Red chalk, 59.5 × 19.5 (21½ × 7⅝). Chatsworth, Devonshire Collection. Reproduced by permission of the Trustees of the Chatsworth Settlement
45 *Fire in the Borgo*, 1514–17. Fresco. Stanza dell'Incendio, Vatican
46 *Liberation of St Peter*, 1511–14. Fresco. Stanza dell'Eliodoro, Vatican
61 *Portrait of Leo X and two Cardinals, c.* 1519. Oil on wood, 154 × 127 (60⅝ × 50). Uffizi, Florence

62 *Baldassare Castiglione*, c. 1516. Oil on canvas, 82 × 67 (32¼ × 26⅜). Louvre, Paris
63 *Madonna di Foligno*, 1512. Oil on canvas, 320 × 194 (126 × 76⅜). Vatican Museum, Rome
64 *Sistine Madonna*, c. 1513. Oil on canvas, 265 × 196 (104⅛ × 77⅛). Gemäldegalerie, Dresden
65 *'Feed my Sheep'*, 1515–16. Tapestry cartoon. Victoria and Albert Museum, London. On loan from the Royal Collection. Copyright reserved. Reproduced by gracious permission of Her Majesty the Queen
66 *Death of Ananias*, 1515–16. Tapestry cartoon. Victoria and Albert Museum, London. On loan from the Royal Collection. Copyright reserved. Reproduced by gracious permission of Her Majesty the Queen
67 *Galatea*, c. 1511. Fresco. Villa Farnesina, Rome
68 *Wedding Feast of Cupid and Psyche*, 1516–17. Fresco. Villa Farnesina, Rome
70 Loggia of the Villa Madama, Rome
71 *Transfiguration*, 1517–20. Oil on wood, 400 × 279 (157½ × 109⅞). Vatican Museum, Rome
72 *Study of heads of two Apostles* (detail), c. 1517. Drawing, 49 × 36 (19¼ × 14⅛). Ashmolean Museum, Oxford

ROBBIA, LUCA DELLA (1400–82)
11 *Madonna and Child*, c. 1450. Terracotta plaque, h. 81 (31⅞). Spedale degli Innocenti, Florence

ROSSO, GIOVANNI BATTISTA (1495–1540)
159 *Madonna and Child with Saints*, 1518. Oil on wood, 172 × 141 (67¾ × 55½). Uffizi, Florence
160 *Descent from the Cross*, 1521. Oil on wood, 375 × 196 (147⅝ × 77¼). Volterra Cathedral
162 *Moses defending the daughters of Jethro*, c. 1523. Oil on canvas, 160 × 117 (63 × 46). Uffizi, Florence

SALVIATI, FRANCESCO (1510–63)
166 *Triumph of Ranuccio Farnese*, after 1553. Farnese Palace, Rome
167 *Bathsheba goes to King David*, 1552–54. Fresco. Palazzo Saccheti, Rome
168 *Charity*, c. 1554/58. Oil on wood, 156 × 122 (61⅜ × 48). Uffizi, Florence

SAN GALLO, ANTONIO DA (1485–1546)
114 Farnese Palace, Rome. Courtyard
116 Plan for St Peter's, Rome
117 Model for St Peter's, Rome. Museo Petriano, Rome

SANMICHELI, MICHELE (1484–1559)
185 Palazzo Grimani, Venice, begun 1550s
186 Palazzo Bevilacqua, Verona, c. 1530
187 Porta Palio, Verona, c. 1557

SANSOVINO, JACOPO (1486–1570)
188 The Mint, Venice, begun c. 1537
189 Palazzo Corner della Ca' Grande, Venice, begun 1537
190 Library and Loggetta, Venice, begun 1537

SARTO, see ANDREA DEL SARTO

SCOREL, JAN VAN (1495–1562)
235 *Magdalen*. Oil on oak, 67 × 76.5 (26⅜ × 30¼). Rijksmuseum, Amsterdam

SCROTS, GUILLIM (fl. 1546–56)
281 *Earl of Surrey*, 1546 or later. Oil on canvas, 198 × 122 (78 × 48). Mrs P.A. Tritton, Parham Park, Pulborough, Sussex

SEBASTIANO DEL PIOMBO (c. 1485–1547)
98 *S. Giovanni Crisostomo and Saints*, c. 1509. Canvas, 200 × 156 (78¾ × 61⅜). S. Giovanni Crisostomo, Venice
99 *St Louis*, c. 1508. Canvas, 245 × 122 (96½ × 48). Organ door of S. Bartolommeo a Rialto, Venice
100 *St Sinibald*, c. 1508. Canvas, 245 × 122 (96½ × 48). Organ door of S. Bartolommeo a Rialto, Venice
131 *Dorothea*, c. 1512. Oil on wood, 76 × 60 (29⅞ × 23⅝). Staatliche Museen, Berlin
132 *Cardinal Pole*, c. 1537. Oil, 122 × 94.5 (44⅛ × 37¼). Hermitage Museum, Leningrad
133 *Cardinal Carondelet with his Secretary*, c. 1512. Oil on wood, 112 × 87 (44⅛ × 34¼). Collection Baron H.H. Thyssen-Bornemisza, Lugano
134 *Raising of Lazarus*, 1517–19. Oil on canvas, 380 × 223 (149⅝ × 87¾). By courtesy of the Trustees of the National Gallery, London

SERLIO, SEBASTIANO (1475–1554)
249 Frontispiece to Book V (first published 1547 as 'Quinto Libro')

SILOE, DIEGO DE (c. 1495–1563)
289 Golden Staircase, Burgos Cathedral, 1519–26

SMYTHSON, ROBERT (c. 1536–1614)
286 Longleat, Wilts, 1572–80
287 Wollaton Hall, Notts, 1580–88
288 Hardwick Hall, Derbyshire, 1590–97

TIBALDI, PELLEGRINO (1527–96)
220 Palazzo Poggi, Bologna. Ceiling decoration, begun 1553

TINTORETTO, JACOPO (1518–94)
209 *Miracle of St Mark rescuing a Slave*, 1548. Oil on canvas, 415 × 543.5 (163⅜ × 214). Accademia, Venice
210 *Presentation of the Virgin*, 1551–52. Oil on canvas, 429 × 480 (168⅞ × 189). S. Maria dell'Orto, Venice
211 *Last Supper*, c. 1560. Oil on canvas, 221 × 413 (87 × 162⅝). S. Trovaso, Venice
212 *Discovery of the body of St Mark*, 1562. Oil on canvas, 55 × 48 (21⅝ × 18⅞) Brera Gallery, Milan
213 *Morosini*. Oil on canvas, 86 × 53 (33⅞ × 20⅞). By courtesy of the Trustees of the National Gallery, London
214 *Crucifixion*, 1565 (detail). Scuola di S. Rocco, Venice
215 *Road to Calvary*, 1566. Oil on canvas, 522 × 405 (205½ × 159½). Scuola di S. Rocco, Venice
216 *Flight into Egypt*, 1583–87. Oil on canvas, 421.5 × 579 (166 × 228). Scuola di S. Rocco, Venice
217 *Last Supper*, 1592–94. Oil on canvas, 365.5 × 569 (143⅞ × 224). S. Giorgio Maggiore, Venice
218 *Entombment*, 1594. Oil on canvas, 288 × 166 (113⅜ × 65⅜). S. Giorgio Maggiore, Venice

TITIAN c. 1487/90–1576
80 *Bishop 'Baffo' presented to St Peter*, c. 1503. Canvas, 145 × 183 (57⅛ × 72). Antwerp Museum
81 *'Ariosto'. Portrait of a Man*, c. 1510. Canvas, 64 × 44 (32 × 26). By courtesy of the Trustees of the National Gallery, London
82 *Flora*, c. 1515. Canvas, 79 × 63 (31⅛ × 24¾). Uffizi, Florence
83 *St Mark and the Plague Saints*, c. 1511. Canvas, 275 × 170 (108¼ × 66⅞). S. Maria della Salute, Venice
84 *Sacred and Profane Love*, c. 1515. Canvas, 108 × 256 (42½ × 100¾). Borghese Gallery, Rome
85 *Assumption of the Virgin*, 1516–18. Wood, 690 × 360 (22½ ft × 11¾ ft). S. Maria Gloriosa dei Frari, Venice

86 *Bacchus and Ariadne*, 1522. Canvas, 172 × 185 (67¾ × 72⅞). By courtesy of the Trustees of the National Gallery, London
87 *Venus of Urbino*, 1538. Canvas, 118 × 167 (65 × 76¾). Uffizi, Florence
88 *Madonna and Child with Saints and Donor (Pesaro Madonna)*, 1519–26. Canvas, 485 × 270 (16 ft × 9 ft). S. Maria Gloriosa dei Frari, Venice
89 *Young Man with a Glove*, c. 1520. Canvas, 100 × 89 (39⅜ × 35). Louvre, Paris
91 *St Peter Martyr*. Engraving by Martino Rota after Titian. 39 × 27 (15⅜ × 10⅝). By courtesy of the Trustees of the British Museum, London
92 *Presentation of the Virgin*, 1538. Canvas, 346 × 795 (11 ft × 26 ft). Accademia, Venice
93 *Emperor Charles V with his Dog*, 1532. Canvas, 192 × 111 (75⅝ × 43¾). Prado, Madrid
198 *Martyrdom of St Lawrence*, 1548–57. Canvas, 500 × 378 (16 ft × 12 ft). Gesuiti Church, Venice
199 *Martyrdom of St Lawrence*, 1564–67. Canvas, 175 × 172 (68⅞ × 67¾). Escorial, Madrid
200 *Diana and Actaeon*, 1559. Canvas, 190 × 207 (74¾ × 81½). Duke of Sutherland Collection, on loan to the National Gallery of Scotland
201 *Tarquin and Lucretia*, c. 1571. Oil, 187 × 145 (74⅜ × 57⅛). Reproduced by permission of the Syndics of the Fitzwilliam Museum, Cambridge
202 *Jacopo Strada*, 1568. Canvas, 125 × 95 (49¼ × 37⅞). Kunsthistorisches Museum, Vienna
203 *Pietà*, 1573–76. Canvas, 350 × 395 (137¾ × 153½). Accademia, Venice

TOLEDO, JUAN DE (d. 1567) and JUAN DE HERRERA (c. 1530–97)
291 El Escorial, 1563–84. Engraving after drawing by Herrera

VASARI, GIORGIO (1511–74)
156 *Martyrdom of the Theban Legion*. Drawing, 37 × 34.5 (14½ × 13½), after cartoon by Perino del Vaga (1500–46) of c. 1522/23. Fogg Art Museum, Harvard University, Cambridge, Mass. Charles Alexander Loeser Bequest
165 Screen from the Uffizi, 1560–74

VERONESE, PAOLO (1528–88)
194 Villa Barbaro, Maser. Frescoes, begun c. 1560
204 *Triumph of Venice*, c. 1585. Oil on canvas, 904 × 580 (355⅞ × 228¾). Ceiling, Sala del Maggior Consiglio, Palazzo Ducale, Venice
205 *Feast in the House of Levi*, 1573. Oil on canvas, 550 × 127.8 (216½ × 50¼). Accademia, Venice
206 *The Baptist Preaching*, c. 1565. Oil on canvas, 208 × 140 (81⅞ × 55¼). Borghese Gallery, Rome

VIGNOLA, GIACOMO BAROZZI DA (1507–73)
135 Villa Giulia, Rome. Plan and section, 1550. From Letarouilly, 'Édifices de Rome moderne', 1840–57
136 Villa Giulia, Rome. Nymphaeum. From a late sixteenth-century print
137 Villa Giulia, Rome. Garden front
138 Villa Farnese, Caprarola. Section. From Villamena, 'Iacomo Barotio', 1617
139 Villa Farnese, Caprarola, after 1559
140 Villa Farnese, Caprarola. Courtyard
141 Villa Farnese, Caprarola. Spiral staircase
142 The Gesù, Rome. Plan, 1568. From Sandrart, 'Insignium Romae Templorum', 1690
143 The Gesù, Rome. Façade, 1570. After an engraving by Cartari
144 S. Andrea in Via Flaminia, Rome, 1554

ZUCCARO, FEDERICO (c. 1540–1609)
219 *Allegory of Design*. Ceiling, Sala del Disegno, Palazzo Zuccari, Rome

Photographic Acknowledgments

Numbers in italics denote colour illustrations

ACL 80, 221, 228, 229, 236, 237; Alinari 1, 5, 11, 13, 15, 19, 22, 23, 24, 25, 26, 27, 29, 33, 42, 47, 48, 50, 51, 52, 54, 57, 60, 61, 67, 68, 83, 84, 87, 88, 97, 104, 105, 107, 108, 109, 112, 113, 118, 122, 126, 140, 145, 147, 150, 152, 158, 162, 169, 172, 173, 176, 177, 178, 180, 181, 184, 187, 188, 189, 190, 191, 203, 204, 206, 210, 211, 212, 220, 258; Anderson 37, 38, 46, 59, 92, 96, 99, 100, 102, 110, 114, 117, 120, 137, 166, 197, 198, 205, 209, 214, 215, 216, 217, 218, 282, 294; V. Aragozzini 18, 21; Arch. Fot. Vat. 39, 41, 43, 45, 53, 56, 58, 63, 71; Archives Photographiques 207; Brogi 101, 103; Bulloz 3; Courtauld Institute of Art 31, 106, 165; F. Foliot 161; Gabinetto Fotografico Nazionale 121, 183; Giraudon 2, 6, 7, 10, 49, 62, 78, *89*, 175, 222, 242, *244*, 245, 246, 250, 252, 253; B.P. Keiser *234*; A.F. Kersting 287, 288; Mas 93, 199, 289, 290, 291, 292, 293, 296, 297, 298; Georgina Masson 34, 70, 127, 128, 129, 139, 185, 186, 192, 193, 194; F.A. Mella *125*; Meyer 240; Linda Murray 35, 130, 170, 196; National Monuments Record 286; Godfrey New *81*, *86*, *90*, *154*, *164*, *243*; Jean Roubier 251; Royal Academy of Arts 16, 30, 223; Scala *74*, *76*, *82*, *85*, *94*, *98*, *146*, *148*, *155*, *159*, *160*, *167*, *171*, *239*; Edwin Smith 123, 141; Society for Cultural Relations with USSR 132; Soprintendenza ai Monumenti del Lazio, Rome 144; John Webb 267

Index

ABBATE, NICCOLÒ DELL' 207, 226, 227; *243*
Aertsen, Pieter 222
Agostino di Duccio 28
Alberti, Leone Battista 41, 43, 141, 186, 258
Albertinelli, Mariotto 19, 144, 150
Alexander VI, Pope 36
Altdorfer, Albrecht 95, 210, 243, 246–7; *266–8*
Amberger, Christoph 194, 247; *270*
Ammanati, Bartolommeo 105, 124, 137, 159, 167; *170*
Andrea del Sarto 91, 144–9, 150, 151, 154, 158, 159, 163, 172, 204, 226; *145–9, 151*
Angelico, Fra 14
Antonello da Messina 72, 212, 238
Apollo Belvedere 64, 205, 238
Aprili, Antonio 266
Aretino, Pietro 127, 192

BANDINELLI, BACCIO 159, 166, 167
Bartolommeo, Fra 14–15, 18–19, 39, 95, 97, 144, 150, 158, 214; *15–16*
Bassano, Francesco (I) 195
Bassano, Francesco (II) 195
Bassano, Jacopo 195, 200, 269, 270; *208*
Bassano, Leandro 195
Beccafumi, Domenico 163–6; *171*
Becerra, Gaspar 267
Bellini, Gentile 187
Bellini, Giovanni 71, 72, 74, 78, 79, 82, 83, 85, 86, 90, 93, 94, 97, 98, 187, 195, 242
Bellini, Jacopo 82
Bellori, Giovanni Pietro 125
Bernini, Gianlorenzo 142, 169, 275
Berruguete, Alonso 266–7; *292*
Berruguete, Pedro 266–7
Bertoldo di Giovanni 24, 25
Bettes, John 255
Blum, Hans 258
Bologna, Giovanni da 159, 167–9, 206; *172–3*
Bonifazio de' Pitati 194, 195, 196
Bordone, Paris 79, 194, 195; *207*
Borgia, Cesare 9
Borromini, Francesco 142
Bosch, Hieronymus 222
Botticelli, Sandro 7, 13, 14, 18, 75, 125, 214
Bouts, Dieric 209, 210

Bramante, Donato 19–23, 35–7, 41, 46, 64, 66, 68, 117, 118, 132, 142, 181, 205, 218, 231, 247, 264; *17–21, 34–5, 69*
Breu, Jörg 247
Bronzino, Agnolo 126, 155, 159, 227, 228–30; *163–4*
Bruegel, Pieter 209, 214, 221–2, 226; *233, 236, 239–41*
Brunelleschi, Filippo 20, 35, 99
Bueckelaer, Joachim 222; *237*
Bullant, Jean 259
Burgkmair, Hans 247–8; *271*

CAMBIASO, LUCA 266
Caradosso 36; *36*
Caravaggio, Michelangelo Merisi da 271
Cariani, Giovanni 91
Caron, Antoine 231; *246*
Carracci, the 207
Castello, G.B. 265, 266
Cavalieri, Tommaso 109
Cecil, William 259
Cellini, Benvenuto 132, 159, 166–7, 226, 227, 234, 266; *169*
Champaigne, Philippe de 238
Charles V, Emperor 188, 205, 242, 263, 264, 272
Chigi, Agostino 58, 65, 98, 105, 107, 109
Christus, Petrus 212
Clement VII, Pope (Cardinal Giulio de'Medici) 9, 48, 58, 68, 109
Clouet, François 228; *244, 247*
Clovio, Giulio 268, 270
Codussi, Mauro 179
Colosseum 35, 68
Condivi, Ascanio 163
Conti, Sigismondo de' 60
Correggio, Antonio 91, 95, 132, 171–7, 194, 204, 230, 271; *174, 176–81*
Cosimo I, Medici 159, 228
Council of Trent 205, 208
Cousin, Jean (I) 227; *245*
Covarrubias, Alonso 264
Cranach, Hans 246
Cranach, Lucas (I) 93, 210, 218, 243–6; *260–5*
Cranach, Lucas (II) 246
Credi, Lorenzo di 7

DANUBE SCHOOL, the 210, 227, 243–7
David, Gerard 209

della Robbias, the 15–16; *and see* Robbia, Luca della
Dietterlin, Wendel 258
Donatello 15, 24, 28–9, 54, 95, 116, 167, 266
Dossi, Dosso 79
Dubois, Ambroise 230
Dubreuil, Toussaint 230
Du Cerceau, Jacques Androuet 259
Dupérac, Étienne 123; *115, 119, 121*
Dürer, Albrecht 71, 147, 154, 210, 211, 212, 214, 218, 219, 226, 238–43, 244, 246, 271; *254–9*
Dyck, Anthony van 271

EGAS, ENRIQUE 263–4
Eleonora of Toledo 159
Elizabeth I 206, 256, 257
Erasmus 211, 248, 249, 251
Este, Alfonso d' 86
Este, Isabella d' 8, 30, 71, 241
Eworth, Hans 256, 257; *283*
Eyck, Jan van 8, 209, 211, 212

FANCELLI, DOMENICO DI ALESSANDRO 266
Farnese, Cardinal 141
Ferdinand and Isabella 263
Filarete, Antonio Averlino 263, 264, 265
Flicke, Gerlach 255
Floris, Frans 225; *238*
Fontainebleau, School of 226, 227–30
Fontana, Domenico 124, 137
Forment, Damián 267
Franciabigio 144, 150, 151; *153*
Francis I of France 9, 130, 146, 159, 166, 205, 226–30, 231

GAGINI, THE 266
Galli, Jacopo 27
Gamiz, Pedro 267
Geertgen tot Sint Jans 175
Gentile da Fabriano 187
Ghirlandaio, Domenico 7, 13, 14, 18, 24, 109, 150
Giocondo, Fra 258
Giorgione 71–9, 82, 83, 86, 87, 93, 94, 97, 98, 194, 221, 268; *73–9*
Giotto 24, 110
Giulio Romano 38, 57–8, 124, 126–32, 133, 134, 141, 163, 173, 175, 176, 177, 184, 186, 192, 227, 232–3; *122–7*
Goes, Hugo van der 209, 210

Golden House of Nero 68, 129
Gossaert, Jan, *see* Mabuse
Goujon, Jean 234, 236
Graf, Urs 218
Greco, El 188, 268–76; *295–301*
Grünewald 95, 249

HAYDOCKE, RICHARD 257
Heemskerck, Maerten van 221
Henry VIII 251–4, 258
Herrera, Juan de 263, 265–6; *291*
Hilliard, Nicholas 256–7, 258; *284*
Holbein, Ambrosius 248
Holbein, Hans (I) 247, 248
Holbein, Hans (II) 226, 228, 248–55, 257; *272–80*
Huber, Wolf 243, 247; *269*

JAMES I 258
John of the Cross, St 275
Jones, Inigo 262
Juanes, Juan de 268
Julius II, Pope 19, 30, 32, 36–7, 43, 44, 46–8, 56, 57, 60; *and see* Tomb of
Julius III, Pope 137, 162
Juni, Juan de 267, 268

LAGRAULAS, CARDINAL JEAN BILHÈRES DE 27
Laocoon, the 64, 87, 205
Leo X, Pope 44, 48, 57, 62, 99, 101
Leonardo da Vinci 7–14, 16, 18, 23, 27, 30, 42, 58, 59, 60, 71, 74, 79, 93, 127, 144, 146, 150, 171, 175, 176, 177, 202, 210, 212, 225, 226, 227, 228, 238–9, 241, 242, 247, 268; *1–7*
Leoni, Pompeo 267; *293*
Leonis, the 266
Lescot, Pierre 232, 233–4, 236; *251*
Lippi, Filippino 13, 14, 125, 214
Lotto, Lorenzo 91, 93, 94–7, 150, 194, 250; *94–5*
Lucas van Leyden 209, 210, 218–19; *232, 234*

MABUSE (JAN GOSSAERT) 209, 212–14, 216, 218; *225–7*
Machuca, Luis 264
Machuca, Pedro 264; *290*
Maderno, Carlo 66
Mancini, 'Considerazioni sulla Pittura' 268–9, 271
Mantegna, Andrea 16, 19, 29, 65, 94, 132, 171, 173, 210, 214, 218, 238, 242, 247; *12, 175*
Mary Tudor 256
Masaccio 24, 53
Master of Flora 230; *248*
Matsys, Quentin 209, 210–12, 219, 244, 250; *221–4*

Medici, Cardinal Giulio de', *see* Clement VII
Medici, Lorenzo de' 7, 25, 104
Memlinc, Hans 211, 242
Michelangelo Buonarroti 7, 9, 14, 16, 18, 19, 23–32, 36, 37, 42, 46–57, 58, 59, 60, 65, 66, 87, 91, 94, 98, 99–107, 109–23, 124, 126–7, 132, 134–5, 137, 141, 144, 147, 152, 154, 158, 159, 162–3, 166, 167, 173–4, 177, 188–9, 191, 192, 196, 199, 202, 204, 205, 206, 207, 213, 221, 225, 226, 227, 231, 233, 239, 262, 266, 268, 269, 270, 271, 275; *22–33, 47–60, 101–13, 118, 120, 150, 161; and see* Dupérac *115, 119, 121*
Michiel, Marcantonio 71, 72, 74, 97
Montorsoli, Giovanni Angelo 167
Mor, Anthonis 256, 257, 268; *282*
Morales, Luis 268, 276; *294*
More, Thomas 250, 251–2
Moretto da Brescia 93, 250, 255; *90*

NAVARRETE, JUAN FERNÁNDEZ DE 268

OLIVER, ISAAC 257–8; *285*
Ordoñez, Bartolomé 266
Orley, Bernard van 209, 214–16; *228–9, 231*

PACHECO, FRANCISCO 269
Palladio, Andrea 68, 142, 183–6, 192, 258, 262; *191–3, 195–7*
Palma Giovane 192
Palma Vecchio 79, 91, 93–4, 194, 221; *96*
Paolino, Fra 19
Parmigianino, Francesco 163, 174, 176–8, 191, 192, 194, 207, 257, 271; *182–4*
Patinier, Joachim 210; *224*
Paul III, Pope 109, 112, 121, 187
Pencz, Georg 194, 247
Penni, Giovan Francesco 127
Perino del Vaga 38, 154, 163, 177, 227, 272; *and see 156*
Perugino 13, 14, 15, 16, 18, 63, 109
Peruzzi, Baldassare 37, 117, 124, 132–4, 139, 231; *128–30*
Philibert de l'Orme 232, 234–6, 238, 259; *252–3*
Philip II of Spain 188, 207, 265–8, 272–3
Piero della Francesca 19, 21, 72, 267
Piero di Cosimo 14, 144, 150
Pilon, Germain 234, 236; *250*
Pinturicchio, Bernardino 36
Piranesi, Giovanni Battista 107
Pisanello, Antonio 187
Pius V, Pope 268–9
'Plateresque' style 263

Pollaiuolo brothers 13, 14
Pontormo, Jacopo 91, 95, 144, 147, 150–5, 158, 159, 271, 272, 274, 275, 276; *152, 154–5, 157–8*
Pordenone, Giovanni Antonio 91, 94, 125; *97*
Porta, Giacomo della 123, 124, 137, 141–2, 206
Pourbus family 225, 228
Poussin, Nicolas 238
Primaticcio, Francesco 130, 137, 226–7, 230, 231, 232–3; *242*

QUERCIA, JACOPO DELLA 25, 27

RAFFAELLINO DEL GARBO 144
Raimondi, Marcantonio 218; *230*
Raphael 7, 15–19, 29, 36, 37–47, 52, 57–70, 79, 85, 87, 94, 95, 98, 117, 124, 125, 126, 127, 129, 130, 133, 135, 144, 146, 150, 154, 155, 163, 176, 177, 178, 180, 184, 186, 196, 204, 205, 206, 213, 214, 216, 218, 221, 225, 227, 228, 250, 257, 264, 270; *8–10, 13–14, 37–46, 61–68, 70–2*
Rembrandt van Ryn 59, 116
Reymerswael, Marinus van 212
Ribera, Jusepe 268
Robbia, Luca della 15; *11*
Roberti, Ercole de' 28
Romanino 91
Rosso, Giovanni Battista 144, 155–9, 163, 176–7, 191, 206, 226–7, 230, 231, 268, 274; *159–60, 162*
Rubens, Peter Paul 59, 112, 271, 275

SACK OF ROME 38, 68, 107, 158, 177, 179, 204, 205, 208
St Peter's, Rome 36–7, 46, 57, 66, 117–20, 132, 133–4, 137; *36, 115–19*
Salviati, Francesco 112, 124–6, 159, 163, 270; *166–8*
San Gallo, Antonio da (II) 37, 116–18, 122, 139, 179; *114, 116–17*
San Gallo, Giuliano da 106, 181
Sánchez Coello, Alonso 268
Sanmicheli, Michele 179–80, 206; *185–7*
Sansovino, Andrea 181, 264, 266
Sansovino, Jacopo 144, 167, 179, 181–4, 192, 205, 206; *188–90*
Sarto, *see* Andrea del Sarto
Savoldo, Giovanni 79, 91, 250
Schiavone, Andrea 194–5
Schongauer, Martin 219
Scorel, Jan van 219–21; *235*
Scrots, Guillim 255; *281*
Sebastiano del Piombo 68, 72, 75, 79, 82, 91, 94, 97–8, 124, 134–5, 268; *98–100, 131–4*
Seisenegger, Jakob 91, 247

Serlio, Sebastiano 36, 142, 179, 183, 226, 231–2, 234, 258, 259, 261, 270; *249*
Sforza, Ludovico, 'Il Moro' 7–8, 10, 14, 23
Shute, John 'The First and Chief Groundes of Architecture' 258
Siege of Florence 107, 146, 205–6
Signorelli, Luca 14, 39, 110, 216
Siloe, Diego de 264, 266; *289*
Silvestre, Israel 35
Sistine Chapel, Vatican 13, 18, 19, 36, 42, 47–57, 58, 62–4, 65, 109–12, 127, 173, 189, 199, 214; *51–60, 65–6*
Sixtus IV, Pope 60
Sixtus V, Pope 137
Smythson, Robert 259–62; *286–8*
Stanze, Vatican 19, 36, 37–46, 124, 126–7; *37–43, 45–6, 122*
Strigel, Bernhardin 247

Theatre of Marcellus 35
Thorpe, John 259

Thorpe, Thomas 259
Thynne, Sir John 260–1
Tibaldi, Pellegrino 207–8, 266, 269; *220*
Tintoretto, Jacopo 91, 183, 187, 190, 192, 195–202, 206, 269; *209–18*
Titian 72, 74–5, 78, 79–93, 94, 97, 98, 116, 132, 183, 187–92, 194, 195, 196, 198, 199, 200, 202, 204, 205, 206, 207, 230, 247, 268, 269, 270, 271, 272, 275; *80–9, 91–3, 198–203*
Toledo, Juan Bautista de 265; *291*
Tomb of Julius II 19, 32, 36, 46–9, 57, 189; *47–50, 150*
Torrigiano, Pietro 258, 266
Tura, Cosimo 27

Uccello, Paolo 53

Vanvitelli, Luigi 120
Vasari, Giorgio, 7, 29, 57, 71, 75, 82, 105, 107, 111, 112, 120, 124, 125, 126, 135, 137, 144, 146, 147, 154,

155, 158–63, 178, 196–8, 205, 207; *156, 165*
Vatican 36–7, 64, 121, 162; *and see* Sistine Chapel *and* Stanze
Vázquez, Lorenzo 263
Velazquez, Diego 268, 269
Veronese, Paolo 182–3, 190, 192–4, 196, 198, 199, 269, 270–1; *194, 204–6*
Verrocchio, Andrea del 7, 13, 28
Vigarny, Felipe 267
Vignola, Giacomo Barozzi da 124, 137–42, 226, 233, 258, 264, 265; *135–44*
Villalpando, Francisco de 264
Vitruvius 234, 258
Vos, Martin de 225
Vries, Vredeman de 258, 261

Weyden, Roger van der 209, 211, 242

Zuccaro, Federico 206–7, 208, 266, 269; *219*
Zuccaro, Taddeo 206